Do You Remember?

Do You Remember?

CELEBRATING 50 YEARS OF

Earth, Wind & Fire

TRENTON BAILEY

UNIVERSITY PRESS OF MISSISSIPPI / JACKSON

The University Press of Mississippi is the scholarly publishing agency of
the Mississippi Institutions of Higher Learning: Alcorn State University,
Delta State University, Jackson State University, Mississippi State University,
Mississippi University for Women, Mississippi Valley State University,
University of Mississippi, and University of Southern Mississippi.

www.upress.state.ms.us

The University Press of Mississippi is a member of the
Association of University Presses.

First printing 2023
∞

Library of Congress Cataloging-in-Publication Data

Names: Bailey, Trenton, author.
Title: Do you remember? : celebrating 50 years of Earth, Wind & Fire / Trenton
Bailey.
Other titles: American made music series.
Description: Jackson : University Press of Mississippi, 2023. | Series: American made
music series | Includes bibliographical references and index.
Identifiers: LCCN 2022027163 (print) | LCCN 2022027164 (ebook) | ISBN
9781496843098 (hardback) | ISBN 9781496843104 (trade paperback) | ISBN
9781496843111 (epub) | ISBN 9781496843128 (epub) | ISBN 9781496843135 (pdf) |
ISBN 9781496843142 (pdf)
Subjects: LCSH: Earth, Wind & Fire (Musical group) | Soul music—History and
criticism. | Rhythm and blues music—History and criticism. | Funk (Music)—
History and criticism. | White, Maurice, 1941–2016—Criticism and interpretation.
Classification: LCC ML421.E185 B25 2023 (print) | LCC ML421.E185 (ebook) |
DDC 782.42164092/2—dc23/eng/20220718
LC record available at https://lccn.loc.gov/2022027163
LC ebook record available at https://lccn.loc.gov/2022027164

British Library Cataloging-in-Publication Data available

I dedicate this book to the memory of my mother, Mrs. Katie Bailey Motley. She loved me unconditionally and encouraged me to put God first in all my endeavors. My mother spoke my success into existence.

This book is also dedicated to the memory of my high schoolmate, great friend, and Alpha Phi Alpha Fraternity brother, Mr. Mario Yves Bell. He was one of my biggest supporters and constantly encouraged me to complete this project.

ય|

This narrative is a tribute to Mr. Maurice White, the founder of Earth, Wind & Fire. His music enhanced the soundtrack of my life, beginning in childhood. Because of Maurice's vision and expertise, the world became a better place.

Contents

Acknowledgments

First and foremost, I must give praise to the Most High Creator for giving me the zeal and tenacity to complete this project. I thank my mother, Katie Bailey Motley, for making it possible for me to listen to Earth, Wind & Fire at an early age. I must acknowledge my siblings for introducing me to Earth, Wind & Fire. Tonyus Chavers, Terry Chavers, and Tommy Bailey played their songs on the stereo while my other sibling, Tiffany Bailey Hall, and I danced to the music.

I am grateful for my research committee: Dr. Thomas M. Scott, Dr. Stephanie Y. Evans, and my Morehouse brother Dr. Marcellus C. Barksdale, who has been a mentor for several years. I appreciate the musicians who provided insight via interviews: Verdine White, Ralph Johnson, Sheldon Reynolds, Morris Pleasure, Morris James O'Connor, and Wayne Vaughn. I am also grateful to Philip Bailey and Maurice White for their autobiographical information. I must recognize the staff of the Robert Woodruff Library at the Atlanta University Center, especially Mrs. Yolanda Gilmore Bivins, for helping me get started.

I am thankful for my advisor and Alpha Phi Alpha Fraternity brother, Dr. Nathaniel Norment, who placed me on the right path to publishing this work. I appreciate my Fraternity and Morehouse brothers, Dr. Anthony Neal and Rev. Isaac Mullins, Jr. Dr. Neal provided literary advice and Reverend Mullins provided musical insight. I am also grateful for the moral support of my Morehouse brothers, Dr. Byron K. Edmond and Dr. Jamal Ratchford, and my Fraternity brother, Dr. Henry M. Carter.

I give recognition to Dr. Vicki Crawford, Dr. Leah Creque, Mr. Alvin Darden III, Ms. Pamela Heath, and Mr. James A. Stotts for blessing me when I needed it most. I thank Mr. John Paris and Ms. Trinity Bailey for their special favors and Mr. Tony Clark for his assistance. I also thank my Fraternity brother, Mr. Jerry Freeman, for leading me to the right source.

I must recognize those who have always been dependable resources: Mr. Terence F. Thomas Sr., Pastor Fred Bailey Sr., and Mr. Romel Andrews. Lastly,

I give thanks to my colleagues who have helped me along this journey. I am also thankful for all my friends and loved ones who continue to support and show their love for me. Because of all of you, this project has come to fruition.

Do You Remember?

Introduction

Earth, Wind & Fire (EWF) is one of the most successful bands in the history of popular music. Since the band's inception in 1970, they have sold more than ninety million records. This achievement makes EWF one of the best-selling bands of all time. They have also won numerous prestigious awards, including six Grammy Awards, four American Music Awards, and five Lifetime Achievement honors.[1] EWF is one of the first African American popular music bands to have mass crossover appeal. In 1975, EWF became the first African American music act to reach #1 on *Billboard*'s album and singles charts simultaneously. This was accomplished when their signature hit song "Shining Star" and the album *That's the Way of the World* both climbed to the top of the charts.[2]

Earth, Wind & Fire came of age in the early 1970s, as Black pride became a central element of African American popular music. This was a time when many African Americans were no longer marching and protesting to gain equality as they had during the African American civil rights movement of the 1960s. Instead, several African American artists used music to combat the harsh reality of American society. Earth, Wind & Fire became known for their unique sound and inspirational lyrics. Earth, Wind & Fire experienced their classic period from 1973 to 1983. This is when the band was most successful. During this time, EWF had several hits on the music charts, sold millions of records, sold out large concert venues, and won several awards. Most of the songs the band released as singles during this period became hit records. These hit songs include "Shining Star," "Serpentine Fire," "September," "Boogie Wonderland," "After the Love Has Gone," "Let's Groove," and many others. After the classic period, the band went on hiatus.

After this nearly four-year break, Earth, Wind & Fire made a comeback in late 1987 with the hit song "System of Survival" from the *Touch the World* album, and the band soon went on tour with a slightly different lineup. EWF continued to record music and tour the world. They proved to the world they were and are still a force with to be reckoned, and their many fans were

overjoyed to see and hear them again. And after more than fifty years, EWF continues to give fans a reason to smile and feel good.

I became a fan of Earth, Wind & Fire when I was a toddler. Their music was constantly played on the radio, and they made several television appearances. One of their first songs I fell in love with is "Shining Star." Although I was a small child when I heard it, I understood its message, and I believed I could impact the world when I got older. There are several other songs by EWF that became an integral part of my childhood, such as "Reasons," "Devotion," "Sing a Song," "Getaway," "Fantasy," and others. When I was in the second grade, I declared "September" my favorite song. I also felt a special connection to the group after finding out that Maurice White and I have the same hometown: Memphis, Tennessee. When I became a teenager and began to buy music, the first cassette I bought was *The Best of Earth, Wind & Fire, Vol. 1* The second cassette I bought was *The Best of Earth, Wind & Fire, Vol. 2.* It was clear to my family and friends that EWF was my favorite musical artist.

In addition to loving Earth, Wind & Fire's music, I was intrigued by their album covers and live performances on television. EWF is also known for having elaborate album covers which display Kemetic (ancient Egyptian) symbols. The lyrics of many of the band's songs also showcase Kemetic themes. Kemet is the original name of ancient Egypt. The terms *Kemetic* and *ancient Egyptian* are used interchangeably throughout this text. I was told about the amazing concerts of EWF by adults who attended, especially the *All 'N All* Tour. During its classic period, the band was known for spectacular concerts that featured pyramids, fancy costumes, and grand illusions. This made me become more fascinated with the band. They definitely stood out among other musical artists.

Earth, Wind & Fire has demonstrated remarkable versatility by delivering soulful ballads, spiritual anthems, Afro-Caribbean jazz, funk, and disco hits. The band's songs offered uplifting poetic lyrics with romantic and playful themes of universal brotherhood, spiritual enlightenment, and sentimental romance. The band leader, Maurice White, drew inspiration from his affection for ancient Egyptian thought and imagery to further embellish the band's unique image.[3]

The band that became known as Earth, Wind & Fire was created by Maurice White in Chicago, Illinois, in 1969 at the height of the Black Arts Movement. The Black Arts Movement began in 1965 and ended around 1975. This was a period when many African Americans had found a great sense of African pride. African Americans established their own beauty standards and adopted the slogan "Black is beautiful." Many African Americans were wearing African-inspired clothing, such as dashikis and kufi caps, and they were

wearing African hairstyles, such as cornrows and Afros. African aesthetics, specifically ancient Egyptian, are displayed in EWF's visual art.

In 1968, Larry Neal, scholar of African American theatre, described the Black Arts Movement as an eclectic group of Black writers, artists, and performers dedicated to defining and celebrating a uniquely "Black aesthetic."[4] African American artists defined aesthetics in their own terms. Aesthetics is the study of beauty and taste. These artists believed their primary duty was to speak to the cultural and spiritual needs of African Americans. They were reevaluating western aesthetics, the traditional role of the artist, and the social function of art.[5]

According to Floyd Barbour, who served as director of Afro-American Studies at Simmons College, the Black Arts Movement sought to liberate African Americans from what Neal calls "the Euro-Western sensibility" that has enslaved and oppressed African Americans since the beginning of the Trans-Atlantic slave trade.[6] Chicago, Illinois, as well as New York City, became the meccas of the national Black Arts Movement. The Black Arts of Chicago influenced several artists, and Chicago is the city in which Maurice White formed his band. In order to reveal the texture of the Chicago Black Arts Movement, it is necessary to unveil the full significance of the Affro-Arts Theater, a venue that influenced Maurice White.

The Affro-Arts Theater was founded in 1967 by the trumpeter Phil Cohran in the old Oakland Square Theater at 3947 South Drexel Boulevard. The theater became a focal point for growing Black consciousness among African Americans in Chicago. In addition, the Affro-Arts Theater symbolized the national aspirations of African Americans who sought to revitalize and elevate their social and cultural status. Clovis E. Semmes, professor emeritus of African American Studies at Eastern Michigan University, described Cohran as a respected musician who emerged as a mystic and visionary who saw divine purpose in music as a medium for inspiration, intellectual and spiritual elevation, and social development.[7] Phil Cohran found his greatest growth by working in Chicago with jazz wizard Sun Ra.

For Sun Ra, jazz was a means for preaching the unique gospel of Egyptology, astrology, ancient mysticism, Islam, and revised Christianity. He believed that funk musicians were like space warriors and music could be used as a weapon, as energy. The right note or chord can transport a musician into space using music and energy flow, and the listener could travel along with the musician.[8] As he developed musically, Sun Ra became engaged in Egyptology. He believed music could heal people physically and spiritually. Sun Ra's spirituality included a deep interest in outer space, a theme common in Egyptology.[9]

After leaving Sun Ra, Phil Cohran rededicated himself to developing an understanding of how African music was linked to world history and civilizations. As Cohran studied world civilizations, he concluded that "since Africa was the root source, he had to look at everything for its African elements." Cohran believed that his music should reflect his African consciousness.[10] It was this consciousness that inspired him to open the Affro-Arts Theater. He wanted African Americans to have a place where they could gather year-round.

Public dedication of the Affro-Arts Theater took place on Saturday, December 2, 1967. The theater attracted leading African American spokespersons, such as Stokely Carmichael and LeRoi Jones, as well as noted artists, including Oscar Brown Jr. and Gwendolyn Brooks. The theater presented films and plays dealing with liberation and Black consciousness. Maurice White spent much time observing musical rehearsals and performances at the Affro-Arts Theater. Quite significantly, Earth, Wind & Fire initially projected an African/Eastern rhythmic, tonal, and spiritual concept in their music, similar to what had come from Phil Cohran and the Affro-Arts Theater. Unfortunately, the Affro-Arts Theater fell on hard times and was forced to close in 1970.[11] But the theater had served as a beacon of hope for the Black Arts Movement and became an inspiration for the greatest funk band of all time: Earth, Wind & Fire.

During the Black Arts Movement, many African Americans rejected racial assimilation and looked instead to their own cultural roots for meaning and identity. Part of this process involved exchanging the traditional African American Christian heritage for an African religious perspective. This is one of the premier characteristics of funk music. Rickey Vincent, author of *Funk: The Music, the People, and the Rhythm of the One*, gives a detailed explanation of funk music:

> Funk music is deeply rooted in African cosmology—the idea that people are created in harmony with the rhythms of nature and that free expression is tantamount to spiritual and mental health. If we were to look into this African philosophy, the African roots of rhythm, spiritual oneness with the cosmos, and a comfort zone with sex and aspects of the body, we would find that funkiness is an ancient and worthy aspect of life. Thus, funk in its modern sense is a deliberate reaction to—and a rejection of—the traditional Western world's predilection for formality, pretense, and self-repression.[12]

Howard C. Harris also describes the essence of funk music: "Funk is a style of music in which elements of jazz, pop, rock, gospel, and the Blues are fused to create a rhythmic, soulful sound. Funk thrives on rhythm, and the art of it depends on the level of togetherness between the performers. It is, in essence, togetherness in motion."[13]

In funk slang, "the rhythm of the one" is an important expression that relates to the spiritual trance state associated with West African ritualistic dancing. Teresa Reed claims as in African ritual, the rhythms in funk encourage participants to dance, thereby creating and intensifying a collective *pulse*. Black identity and Black pride are central to the oneness and liberation emphasized in funk.[14]

At the dawn of the 1970s, many Black musical artists developed their styles toward the wide-open improvisations and soulful grooving associated with this funk music. Occasionally, acts, such as the Bar-Kays, defined their music as funk, and James Brown named himself the "Minister of New Super Heavy Funk" in 1974; but overall, there were no critics to give this style of music a definitive term. So, these artists were called "soul groups," "dance bands," "Black rock," "jazz funk," and even "super groups." Occasionally, they were called funk bands. Bands like War, Kool & the Gang, and Earth, Wind & Fire were constantly referred to by critics as groups that utilized a "fusion" of styles, as a "synthesis," and so on. This fusion was so common that it eventually became known as funk music.[15]

According to Kesha Morant, associate professor in Communication at Pennsylvania State University, funk music emerged out of a desire for a more confrontational approach to protest music. James Brown's most empowering song, "Say It Loud—I'm Black and I'm Proud," was more than a cry of protest; it was a call to action. The immediacy and intensity of the song resonated with African Americans unlike any other popular music that had come before.[16] Rickey Vincent declares that "Say It Loud" was a turning point in Black music. Never before had Black popular music explicitly reflected the bitterness of Blacks toward white people—and here it is done with ferocious funk.[17] The musical content encompassed self-empowerment, celebration, and self-love. It paved the way for improved self-esteem and community esteem, challenged social norms, and, most important, created a means for self-definition.

Morant declares that funk stands out among forms of Black music during the Black Arts Movement because it paralleled the transition of American society from the era of Jim Crow (1890s to 1960s) to the 1970s, the decade of "integration" and "equal opportunity." For many African Americans, the 1970s represented a paradox of social unrest and ubiquitous optimism.[18] This

optimism can be heard in many songs by Earth, Wind & Fire, such as "Sing a Song," "Getaway," and "Fantasy." Maurice White wanted EWF's musical pulpit to provide some healing. He felt that a lot of Black people were unhappy and depressed.[19] The inspirational messages in several EWF songs can be traced to Kemetic spirituality. White turned to Egyptology because he believed it encourages self-respect for Black people. He claimed that the rich heritage of Black people started in Egypt, and he wanted EWF to use Kemetic symbols to remind Black people of that rich and glorious heritage.[20]

Earth, Wind & Fire has been criticized for their use of Kemetic symbols. People have often accused the band of displaying images which contain evil themes. Some people have even claimed that their songs contain subliminal messages. This has come from a lack of understanding of ancient African religion. African religion and art have often been cited as spooky and evil.

In the United States and other Judeo-Christian societies, Egypt is depicted as the home of paganism, idolatry, and evil. In contrast, Judaism and Christianity are seen as hallmarks of monotheism, order, and righteousness. Donald Matthews, assistant professor of the History of Christianity and Black Church Studies at Colgate University, declares that, in biblical and world religion courses, students are taught that Egypt was the country that the Hebrews escaped from in order to develop a special relationship with the one true God. Egypt and most symbols associated with it have been relegated to irrelevance. Christians are taught to fear and despise Kemetic religion as the opposite of monotheism and the true faith.[21] White saw no reason to despise Kemetic spirituality; he believed modern people could learn from Kemetic spirituality.

Maurice White believed modern people could benefit from ancient Egyptian spirituality. His goal for Earth, Wind & Fire was to raise the consciousness of people. The band used their inspirational lyrics and visual art to achieve that goal. For over fifty years, EWF has inspired people all over the world, people from different faiths, races, and backgrounds.

This book examines the artistic life of Earth, Wind & Fire from 1970 to 2020. The first chapter details the formative years of Maurice White and the founding of Earth, Wind & Fire. Chapter 2 discusses the beginning of Earth, Wind & Fire's classic period and how they began to stand out among other soul music bands. Chapter 3 details EWF's rise to superstardom with *That's the Way of the World*. The albums *Gratitude* and *Spirit* are also discussed. The fourth chapter examines the *All 'N All* album and the popular tour that followed. Chapter 5 is about EWF's continued success in the late 1970s. Chapter 6 tells of EWF in the first three years of the 1980s. The albums *Faces* and *Raise!* are discussed. Chapter 7 details the two albums released during

the last year of EWF's classic period. The hiatus of the band is also discussed. The eighth chapter discusses EWF's comeback in 1987 with *Touch the World* and the challenges they endured with changes in the music industry. Chapter 9 discusses the difficult decision White had to make and how the band persevered throughout the 1990s. Chapter 10 deals with EWF's newfound popularity during the first six years of the twenty-first century and discusses the albums *The Promise* and *Illumination*. The eleventh chapter discusses the band's work from 2006 to 2012, including work with other artists. The final chapter discusses EWF's latest studio albums. In addition to awards and honors, the band's tours, public appearances, and fiftieth anniversary year are discussed.

Imagination

Earth, Wind & Fire is the brainchild of percussionist and singer Maurice White. White was born in Memphis, Tennessee, on December 19, 1941. He grew up very poor in a south Memphis housing project. His mother, Edna, had moved to Chicago, Illinois, and married a podiatrist named Verdine Adams Sr. Maurice remained in Memphis with his grandmother.[1] White's love for music started when he was around six years old. At this time, he befriended future record producer David Porter, and they sang in a quartet at Rose Hill Baptist Church.[2]

As the youngest member of the quartet called the Rosehill Jubilettes, White got his induction into life on the road, traveling to local churches. White stated, "Our goal was to be like The Soul Stirrers, a group whose members included guys like Sam Cooke and Lou Rawls. We wanted to be stars!" When he was twelve years old, White remembers seeing a local band parading through town. He declared, "I saw the guys in the shining suits, I heard the drum-and-bugle call, and I went home and broke a broom in half and practiced on the walls, the floor, wherever I could." This is when White's career as a drummer began in earnest.[3]

Sometime after developing a passion for drumming, White and David Porter entered Porter Junior High School in 1957. While in junior high school, Maurice White had a passion for doo-wop, which dominated the radio from his boyhood to teenage years. Doo-wop was a genre of R&B music consisting of close harmony vocals using nonsense phrases. White imitated drumbeats on hit records by beating on schoolbooks with drumsticks. In the eighth grade, he joined the school band and met Booker T. Jones, who is best known as the frontman of the band Booker T. & the M.G.'s. Jones played several instruments while White played the drums. Maurice White described Jones as the brother he never had while growing up. White also credited Jones's musical passion with helping him become more outgoing.[4] White stated, "Booker had a car and we drove around town thinking we were hip." As he recalled, Memphis in the late fifties was a "great breeding

ground for musicians. B.B. King, Carl Perkins, Elvis Presley, blues acts, jazz players like Phineas Newborn. . . . and Stax Records was about to start . . . there was a lot going on."[5] After leaving Porter Junior High, White enrolled in Booker T. Washington High School.

During his high school years, Maurice White formed a singing group with David Porter and two other friends, Tyrone Smith and Robert Davis. They called themselves the Marquettes. The Marquettes performed in talent shows at Washington High. In addition to singing, White began to play drums in different gigs around town, thanks to the encouragement of Booker T.[6] It was also during this time that White became obsessed with radio station WDIA in Memphis, the first radio station in the country completely dedicated to Black music. White wanted to be a part of the musical world he heard on WDIA. He formed other groups with David Porter. They performed at school dances, talent shows, sock hops, and other events at Washington High, from which White graduated in 1961.[7]

After graduating from Booker T. Washington High School, Maurice White moved to Chicago, Illinois. He studied percussion, jazz, and classical music formally at the Chicago Conservatory of Music.[8] In 1963, White was asked to play on a session for Betty Everett's soul classic "You're No Good" and started doing other sessions for her label, Vee-Jay Records. When producer Roquel "Billy" Davis hired White's friend Louis Satterfield as a studio musician at Chess Records, Satterfield recommended him to come on as a drummer.[9]

Maurice White worked at Chess Recording Company for five years, where he learned to master all types of music. At Chess, White worked with great recording artists, such as Etta James, Billy Stewart, Fontella Bass, and Ramsey Lewis.[10] White literally played on hundreds of records during his five-year tenure at Chess Records, 1962–67. He recalled, "I was in there every day from noon to six. Then I'd head off to the Chicago Conservatory of Music from 7pm to 10pm and then off to a gig."[11] In 1966, when the Ramsey Lewis Trio lost bassist Eldee Young and drummer Red Holt, Ramsey Lewis asked White to replace Holt. Lewis declared, "I knew Maurice could play those drums." Lewis claimed that White brought another color to drumming, playing in a variety of tempos and various drum licks, influenced by a fusion of R&B, classical, and gospel music.[12] Before joining the Ramsey Lewis Trio, White had formed a group in 1964 called the Quartet 4 that lasted until 1965.

As a young musician, Maurice White was drawn to people who were searching for enlightenment. He did not like conventionality. White often visited the Affro-Arts Theater on the South Side. He described it as a hip place of nonconformity, filled with Afrocentric thinkers teaching, yoga, music, and things dealing with art. It was a hub of new thought and a new kind of

consciousness for African Americans. The Affro-Arts Theater encouraged Black awareness. It was there he met poet Gwendolyn Brooks, poet/playwright/singer Oscar Brown Jr., and jazz musician Phil Cohran.[13] The Affro-Arts Theatre had a profound impact on how White established his own band.

For almost three years, White travelled the globe with the Ramsey Lewis Trio. White declared, "Ramsey was a great role model. He really helped me shape my musical vision. I learned about playing close attention to stage production from performing with him."[14] In 1969, White confided in Ramsey Lewis that he wanted to start his own band. White told Lewis that his band would play jazz and R&B. He also stated that his band would have choreography, some magic, and a horn section.[15]

Maurice White wanted to create music that had a universal appeal. He believed that music should be a positive force in people's lives and help them rise in personal stature.[16] White explained, "There was a vision I had of planetarium, Egyptology, all these things that would come together, and they grow with time."[17] According to longtime Earth, Wind & Fire vocalist Philip Bailey, the primary mission of Earth, Wind & Fire has been to raise people to a higher level of consciousness. White called it "the concept." He would talk about the concept for hours and stressed the importance of it.[18] This ideal notion led the band to present Kemetic (ancient Egyptian) themes in their lyrics and eventually, in their visual art, which is discussed later in this narrative.

Maurice White hooked up with two friends, keyboardist Don Whitehead and singer/songwriter Wade Flemons, who had written and sung the hits "Here I Stand" and "Easy Lovin" and, later, co-wrote "Stay in My Corner" for the Dells. Together they became a songwriting team called Hummit Productions, composing songs and commercials, and they eventually became a band they named the Salty Peppers. The Salty Peppers scored a regional hit with the single "La, La, La" on the Hummit label as well as on the TEC label in 1969. Capitol Records picked up the song and rerecorded it as "La La Time" for national distribution.

When the second single, "Uh Huh Yeah," didn't do as well, White decided to leave the Ramsey Lewis Trio (and eventually also Chicago).[19] The Salty Peppers had become a big band that included Maurice White, Don Whitehead, Wade Flemons, Chuck Handy, Pete Cosey, Louis Satterfield, Don Myrick, and the great recording artist Donny Hathaway.[20] As the band grew, so did White's dreams and ambitions. White decided to relocate to Los Angeles, California, in 1970.

In 1970, major changes were taking place in popular music. The Beatles disbanded, and Diana Ross left the Supremes to pursue a solo career. Maurice

White was also making changes. In addition to moving to Los Angeles on April 3, 1970, White decided to tweak the lineup of the band. He recruited jazz singer Sherry Scott, a native Chicagoan who stayed with the band for two years. Scott was already preparing to head out to Los Angeles when White called her looking for a female member for his band. Scott and White rode in his slope-back, pointy-tailed burgundy '69 Buick Rivera. Don Whitehead and Wade Flemons, along with another Chicago recruit, percussionist Yackov Ben Israel (Phillard Williams), rode behind them in a Volkswagen bus.[21] This was the beginning of Earth, Wind & Fire.

Maurice White also decided to enlist his younger half-brother, Verdine White, as bass guitar player.[22] Verdine recalled, "I'll never forget it. Maurice called me in April and asked how I'd feel about going to California. I'd never been anywhere, and I almost decided not to go. I was still in college. But literally, that Saturday afternoon, June 6, 1970, I went from one life to another."[23]

Verdine White was born on July 25, 1951. He started his formal music training in his preteens, studying the upright bass violin. After performing a few years with the Chicago Symphony Orchestra, he began his professional career playing the electric bass guitar in Chicago jazz clubs and in neighboring cities. Through this experience, he became one of the most electrifying bass guitar players in the world.[24] Maurice White declared, "Earth, Wind & Fire would have never become Earth, Wind & Fire without Verdine. A huge part of what built EWF was our live shows. Verdine, the ultimate Leo, had the energy to sustain us."[25]

With his younger brother on board, Maurice White also recruited trumpeter Leslie Drayton, guitarist Michael Beal, tenor saxophonist Chester Washington, and trombonist Alex Thomas. White now had the members he envisioned. Therefore, the original lineup of Earth, Wind & Fire consists of ten members: Maurice White, Sherry Scott, Don Whitehead, Wade Flemons, Yackov Ben Israel, Verdine White, Leslie Drayton, Michael Beal, Chester Washington, and Alex Thomas. But six of the original members would depart from the band within two years: Scott, Ben Israel, Drayton, Beal, Washington, and Thomas. With a unique group of musicians, Maurice White felt his band needed a unique name.

The actual conception of "Earth, Wind & Fire" blossomed after the move to Los Angeles. White recalled, "The first six months were rough, but one morning, while I was studying a book called *The Laws of Success*, which deals with inner-self, I decided that a group with a dynamic name and a new musical message was what I needed."[26] White declared, "At first, I thought of 'Fire' as a name, but that didn't sound so cool. I figured that fire needed a couple of other elements, and my being heavily into the astrological charts,

I consulted my horoscope sign (Sagittarius). I thought about water to put the fire out, but that didn't jive—it was too conflicting. So, I came up with the idea of Earth and Wind—those elements would mesh and create an on-going bond, and that was exactly what the group needed."[27]

This name change may have served as an indication of White's affection for ancient Egypt; the zodiac has long been associated with ancient Egypt. In *Nile Valley Contributions to Civilization*, Anthony Browder explains that the ancient Egyptians divided the heavens into twelve divisions in the southern sky, twelve divisions in the northern sky, and twelve divisions in the central sky. These thirty-six divisions were then divided among three seasons and from that portrayal emerged the regions for the twelve signs of the zodiac.[28] The moniker Earth, Wind & Fire was definitely unique for a pop music band. Over the years, the band would be nicknamed "The Elements of the Universe" or simply "The Elements."

Maurice White was intent on having the fledgling band stand out from other funk bands, not just musically but spiritually. He had them adhere to a strict vegetarian diet, and he didn't allow drinking alcohol or drug use. At that time, Ex-NFL player and actor Jim Brown co-owned a management company and got Earth, Wind & Fire gigs around town.[29] The management company was called BBC, short for Brown, Bloch, and Coby, featuring Brown along with talent rep Paul Bloch and entertainment lawyer Richard Coby. BBC managed the R&B pop group Friends of Distinction. BBC had also intervened on behalf of Muhammad Ali after he refused to be drafted into the army.[30] During this time, the band was developing their sound. In an interview with Sherry Carter on BET's *Video Soul*, White declared that Sly and the Family Stone was a great influence on Earth, Wind & Fire's sound. EWF began adding layers of funk, Latin, African, and Cuban rhythms, and free-form jazz. White made a demo for Earth, Wind & Fire, shopped it around, and Joe Smith of Warner Brothers signed them in 1970.[31]

EARTH, WIND & FIRE

By the early 1970s, a new type of Black popular music called the "message song" developed. Recording artists such as Marvin Gaye, Stevie Wonder, and the Staple Singers produced songs that contained social commentary on America. These message songs discussed love, humanitarianism, and social responsibility.[32] Earth, Wind & Fire has recorded several message songs throughout their career. This type of music appeared on the band's first album.

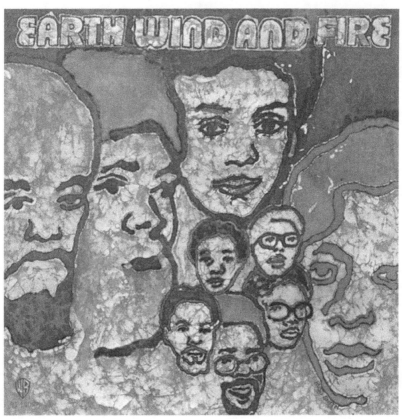

The *Earth, Wind & Fire* album cover displays a drawing of the band members.

Earth, Wind & Fire recorded their first album in 1970 for Warner Brothers: the self-titled *Earth, Wind & Fire*. The cover for the album is simply a drawing depicting the faces of the band members. For later albums, the covers would be more elaborate. As for the first album's sound, Maurice White declared, "The sound for the album we came up with was progressive, jazzy, and bluesy. All the songs were in tune with the concept of EWF: 'Help Somebody,' 'Moment of Truth,' 'Love is Life,' 'Fan the Fire,' 'C'mon Children,' 'This World Today,' and 'Bad Tune.' Each had a theme of social justice, spirituality, and self-reliance."[33] *Earth, Wind & Fire* was released in February 1971. It was produced by Warner Brothers staff producer Joe Wissert. The song "Love Is Life" was released as a single in the summer of 1971 and sparked a progressive underground following that helped boost the band onto the college circuit.[34]

"Love Is Life" was co-written by Wade Flemons, Maurice White, and Don Whitehead, as were most of the songs on the album.[35] It is a harmonious

ballad with a jazzy groove. "Love Is Life" peaked at #93 on the *Billboard* Hot
100 Songs chart on July 17, 1971. The song also climbed to #43 on the *Billboard*
Soul Songs chart on August 7, 1971.[36] Other tracks from *Earth, Wind & Fire*
could have done well had they been released as singles. "Help Somebody"
has a funky groove with Latin-inspired bridges and staccato horn notes. "Fan
the Fire" is a solid example of psychedelic funk that contains a strong fuzz
guitar and an aggressive bassline. The last track on the album, "Bad Tune,"
features Maurice White on the kalimba.

The kalimba is an ancient African thumb piano. According to Verdine
White, "It is a very difficult instrument to use because it requires tremendous
agility and power in the hands." Only a few artists have ever used the kalimba.
The kalimba Maurice White used has an electric amplification pickup and
has been an integral part of the total sound of EWF.[37]

Maurice White actually found inspiration for an African thumb piano
from Phil Cohran. When he visited the Affro-Arts Theater in Chicago, he
became fascinated with Cohran's unique instrument. Cohran had called his
invention the frankiphone (named after his mother Frankie), an invention
that became his calling card. White decided to refer to the instrument as
the kalimba. Significantly, Earth, Wind & Fire initially projected an African/
Eastern rhythmic, tonal, and spiritual concept in their music similar to the
music Phil Cohran produced at the Affro-Arts Theater.[38] White explained, "I
found a kalimba in a drum store one day in Chicago and I'd heard it being
played in an African band. I just didn't know what it was called. Anyway, I
bought it and decided to amplify it. I began using it during my years with
Ramsey but the first time I recorded with it was when we did 'Bad Tune' on
one of the Warner albums."[39]

White introduced the kalimba to millions of listeners by making it a
centerpiece of Earth, Wind & Fire's spectacular concerts. It was a staple of
the band's albums. White explained, "The kalimba represented my link to
Africa. It was my way of taking part of that culture and spreading it all over
the world." The instrument is a tangible example of EWF's special magic by
naturally synthesizing various genres of music and cultures into innovative,
accessible songs. The band made global beats and racial pride radio-friendly
and expanded the parameters of pop music forever.[40] *Earth, Wind & Fire*
peaked at #24 on the *Billboard* R&B Albums Chart on July 10, 1971.[41] This
debut album also received positive reviews from critics.

In a June 24, 1971, article for *Rolling Stone*, Lester Bangs described the
horn players as polished, but not too much. Bangs declared the lyrics as
preachy and similar to Motown records. The smooth harmonies are com-
pared to the popular music group the Fifth Dimension. Bangs also predicted

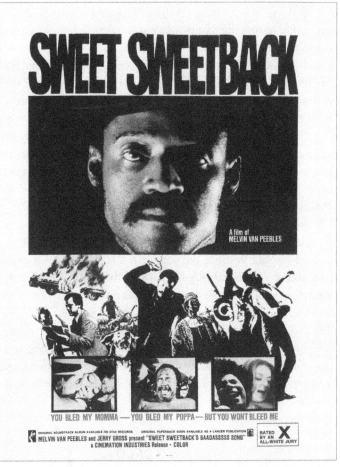

Sweet Sweetback movie poster. The soundtrack was performed by Earth, Wind & Fire.

Earth, Wind & Fire may become vastly popular.[42] AllMusic editor John Bush describes *Earth, Wind & Fire* as one of the band's finest albums. He declares the songwriting as strong and focused as the musicianship. According to Bush, the album boasts a set of flawless positive compositions, reflecting the influence of the African American civil rights movement with nearly every song urging love, community, and knowledge as alternatives to the increasing hopelessness plaguing American society.[43] *Earth, Wind & Fire* was not a commercial success.

Earth, Wind & Fire sold about thirty thousand copies. This was not bad for a debut album from an unknown, eclectic band.[44] The new fusion sound (a mixture of jazz, R&B, and funk) appealed to both the acid-dropping hippie

crowd and the hard-core funk revelers. Black and white college kids were hooked.[45] After testing the waters with *Earth, Wind & Fire*, the band decided to record their second album.

As Earth, Wind & Fire worked on their second album, a young author and aspiring filmmaker, Melvin Van Peebles, came in to meet them at the recommendation of his secretary, Priscilla Watts, who was dating Maurice White. Van Peebles asked the group about doing a soundtrack for his movie *Sweet Sweetback's Baadasssss Song*. He was looking for a band to play the music the way he wanted it. Van Peebles stated, "They were all starving to death on Hollywood Boulevard." But he enlisted their help in concocting a set of greasy funk and jazz loops that Van Peebles himself warbled and screeched over.[46] Van Peebles produced, composed, directed, and wrote all the music himself. Van Peebles recalls, "Since I had no money, I used good music as my tool. This had never been done before. Then everyone else copied."

Released on Stax Records, the soundtrack features a seven-minute gospel, jazz, and spoken-word title track, "Sweetback's Theme," which was on heavy rotation in Black radio. The album was sold in the foyers of the movie theaters, and it reached #13 on *Billboard*'s Soul LP charts. The album sold the film, and the film sold the album.[47] The album and movie unexpectedly became runaway successes and EWF became the first musical stars of the blaxploitation era, paving the way for Isaac Hayes's *Shaft* and Curtis Mayfield's *Superfly*.[48] After completing the soundtrack, the band continued to work on their second studio album.

THE NEED OF LOVE

Earth, Wind & Fire's second album, *The Need of Love*, was recorded on the Warner Brothers label and was released in November 1971. The cover for this album is another image of the band members, but it is an actual photo. The band members appear to be in a calm mood while dressed casually in what appears to be a room in an abandoned building. The album is a jazz-psycho-funk affair with only five songs: "Energy," "Beauty," "I Can Feel It in My Bones," I Think About Lovin' You," and "Everything Is Everything."[49] The only single from this album is "I Think About Lovin' You," which was released in January 1972.

"I Think About Lovin' You" is a soothing ballad written by Sherry Scott and features her on lead vocals. Maurice White was surprised that radio stations liked this song most of all the songs on the album. He believed "I Think About Lovin' You" reflects the peace and love vibe that Sherry Scott

THE NEED OF LOVE
EARTH, WIND AND FIRE

The *The Need of Love* album cover displays a photo of the band members.

brought to Earth, Wind & Fire.[50] The new Black consciousness of the early 1970s had been very masculine, bold, and pushy. Scott's feminine voice on the song was a refreshing reprieve.[51] "I Think About Lovin' You" peaked at #44 on the *Billboard* Hot Soul Songs chart on March 11, 1972.[52]

Sherry Scott's voice is also featured on the lead track, "Energy," in a spoken word segment. "Energy" is a free jazz tune that is nearly ten minutes long. This song displays Earth, Wind & Fire's instrumental versatility. The second track, "Beauty," is a ballad showcasing vocal harmony between the lead male vocalist and the backing female vocalists. "I Can Feel It in My Bones" is a gritty tune featuring fuzz guitar and horn riffs. "Everything Is Everything" is another gritty tune with a long organ intro. The song transitions to piano notes, followed by fuzz and bass guitars. Horn riffs are accompanied by powerful percussion. *The Need of Love* proved to be a good followup to *Earth, Wind & Fire*.

AllMusic editor John Bush describes *The Need of Love* as an ambitious LP with an abstract sense of composition.[53] *Billboard* called the album "a display of good potential rock and pop."[54] With a good album and a light hit song, Earth, Wind & Fire began touring, playing mostly for college audiences. Included in the schedule was a trip to Denver, Colorado, which was the home for an aspiring singer and musician named Philip Bailey.[55]

Philip Bailey was born on May 8, 1951. Along with his sister Beverly, who was a year older, he was reared in Denver by his mother.[56] Like Maurice White, Bailey began playing drums by using two sticks on a trash can. And also like White, a big band parade provided inspiration.[57] Bailey began his singing career at the age of fourteen in a large gospel choir called the Echoes of Youth. He also played the drums at sock hops and at venues around Denver. He soon moved from behind the drums and percussion to become a spotlighted singer and formed a local doowop band called the Soul Brothers. Another one of his groups was called the Dynamics. Bailey also played in a band called the Mystic Moods. He loved to sing the hits by the Temptations, Dionne Warwick, and the Supremes. He often mimicked the falsetto of the Temptations lead singer, Eddie Kendricks.[58] Bailey's last band in Colorado was a mixed group called Friends of Love. It was a large ensemble with three frontline vocalists, including Bailey on vocals and percussion. Another future Earth, Wind & Fire member, Larry Dunn, played organ for Friends of Love.[59]

After playing with groups in Denver, Bailey moved to Los Angeles, California. He was recruited to be the musical director for a gospel group called the Stovall Sisters, but the group broke up at the end of 1971. Bailey had to make a decision about staying in Los Angeles or going back to Denver. As fate would have it, on a Sunday afternoon, Maurice White and his brother, Verdine, stopped by Bailey's home and asked him to join Earth, Wind & Fire. Bailey eventually agreed to join. The White brothers had seen Bailey on stage on at least three occasions, but he did not sing a single note or audition on any instrument for an audition. Bailey recalled, "I realized that Maurice was serious about bringing a sense of dignity to the art form. This wasn't about hanging out, getting the girls. This was about the integrity of the art. That's what I was interested in."[60]

Maurice White was eager to start rehearsals with Philip Bailey. He wanted to incorporate his voice and conga playing with the band. According to White, Bailey's voice instilled in Earth, Wind & Fire a sound that became a mainstay in soul music. Having a falsetto voice in a band, as opposed to a singing group, brought a unique element to EWF. Bailey's percussion chops only added to the pot. His presence in the band was a relief to White because White never wanted to be the lead singer of EWF.[61]

Once Philip Bailey was officially in the band, he joined in the audition process to recruit other members. Bailey had put in a good word for keyboardist, Larry Dunn, who is also from Denver, and Dunn was hired after a brief audition.[62] Larry Dunn was a child prodigy who learned to play guitar, took piano lessons, and played baritone horn and trombone in the school orchestra. His first love soon became organ. Bailey and Dunn started playing in the clubs when Bailey was seventeen and Dunn was fifteen. In the beginning, they would show up to club gigs wearing fake mustaches to make themselves look older. Then, they realized the owners didn't care if they were underage.[63] In addition to playing organ, synthesizer, piano, keyboards, and clavinet, Dunn handled the responsibilities as musical director of Earth, Wind & Fire. He rehearsed the band for live stage performances and wrote many of the musical segues and medleys.[64] After Dunn joined EWF, a drummer named Ralph Johnson, from Los Angeles, also auditioned for the band.

Ralph Johnson was born on July 4, 1951. He took his first drum lesson at eight years old and then played around with garage bands. He played for clubs in Los Angeles. Johnson recalled, "Finally, in December 1971, Maurice and Verdine walked into a club I was playing at in Los Angeles on Crenshaw Boulevard, which is still there." The club is called Average Flat. Johnson added, "Next thing I know, I was getting a phone call, and they asked me if I wanted to audition. I said yeah, let me do that. And that started the whole journey."[65] Johnson was hired solely by Verdine White, because Maurice was absent during his audition.

By this time, five of the nine musicians who would make up the band for the rest of the 1970s were in place: Maurice White, Verdine White, Philip Bailey, Larry Dunn, and Ralph Johnson.[66] Maurice White also employed a woodwind player named Ronnie Laws, the younger brother of famed jazz flautist Hubert Laws. Like his brother, Ronnie was a very gifted and jazzy musician. White declared that Laws's audition blew him away: "He had the perfect musical foundation to accomplish what I wanted. I thought he was the best musician in the band."[67] Helena Dixon was enlisted for a short time to replace Sherry Scott. After Dixon quit, Jessica Cleaves, former lead singer of Friends of Distinction, was hired as the female vocalist.[68]

Maurice also hired a guitar player to replace Michael Beal. White chose a young session player named Roland Bautista. Unlike Beal, Bautista was much more of a rock-style guitar player.[69] Maurice and Verdine White auditioned Bautista. According to Maurice, Bautista and Verdine hit it off. Maurice explained, "They had chemistry, not only with their playing, but also in the physicality together, which made them good performance companions. Verdine's endurance was so over-the-top, he needed as many bandmates

as possible to keep up with him."[70] With this lineup, White was ready to move forward.

An audition for managers Bob Cavallo and Joe Ruffalo led to an association that remained uninterrupted until 1983. And Cavallo's management of guitarist John Sebastian led to a series of gigs as opening act for the popular pop/folk singer. A performance at Rockefeller Center introduced Earth, Wind & Fire to Clive Davis, who was then president of Columbia Records. Maurice White noted,

> Clive saw us and he loved what he saw. We were pretty out there. We were wearing leotards, kinda like fresh out of Haight-Ashbury. To say we were "colorful" would be an understatement. We had a lot of the "flower child" in us and our music. Well, we still had strong jazz overtones but we were starting to become a little more accessible, a little less self-indulgent.

Davis was hooked. He bought the band's contract from Warner Brothers in April 1972. Earth, Wind & Fire headed to the studio to record their third album.[71] The band also acquired a new manager named Leonard "Bafa" Smith. He had worked on Jim Brown's behalf as the road manager of the Friends of Distinction. When that group decided to leave Brown's management company, he assigned Smith to EWF. Leonard Smith became Maurice White's right-hand man for the next eighteen years.[72] Six months after its recording, Earth, Wind & Fire released their third album, *Last Days and Time*, in October 1972.

LAST DAYS AND TIME

Last Days and Time is the Columbia Records debut for Earth, Wind & Fire. Verdine White declared, "Clive just seemed to understand what we were about and we felt like we were being nurtured."[73] White declared that, from the beginning, he wanted EWF's album titles and artwork to be distinctive and personal. He wanted the Columbia Records debut to respond to America's political and racial situation and he wanted the album title to have a cautionary view of 1972. That environment made *Last Days and Time* feel like the perfect album title.

According to White, at Columbia Records, he could pick and choose who he wanted to do the artwork for the album. While the band was signed to Warner, he didn't have that freedom. With the freedom and support of Clive

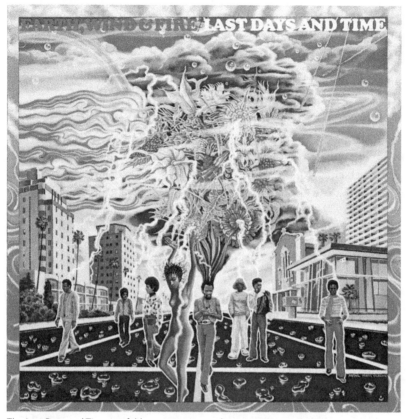

The *Last Days and Time* gatefold presents an apocalyptic setting.

Davis and the Columbia Records machine, White chose Mati Klarwein. Klarwein had done the cover art for Santana's *Abraxas* and Miles Davis's *Bitches Brew*, which really impressed White. Mati's surrealistic theme was a step up for the band. He did an excellent job of expressing the seriousness of the apocalyptic theme. It was just what White was looking for. Words, art, and music were in sync when it came to Earth, Wind & Fire's album presentations.[74] Philip Bailey claimed that what was most interesting about the artwork was that it leaned heavily on the transitional schematic drawings that Maurice first showed him and the other musicians when he was recruiting them to join EWF.[75]

Last Days and Time was produced by Joe Wissert. The album features eleven tracks: eight songs and three interludes. The songs include "Time Is on Your Side," "They Don't See," "Make It with You," "Power," "Remember the Children," "Where Have All the Flowers Gone," "I'd Rather Have You,"

and "Mom."[76] "Mom" reached #39 on the *Cash Box* Top R&B Singles chart in March 1973.[77] This song is a tribute to motherhood. "Mom" is a jazz tune that begins with an electric guitar and features congas and piano accents. The songs on *Last Days and Time* kept the band moving in the right direction.

"Make It with You" had been a #1 pop hit a year earlier for the group Bread; Earth, Wind & Fire's version has a Latin vibe. "Where Have All the Flowers Gone" was a folk classic by Pete Seeger; EWF's cover has a doowop style. Another special track from *Last Days and Time* is "Power." It begins with Maurice White on kalimba. The rhythm guitar joins in followed by Larry Dunn's clavinet. Ronnie Laws performs well on saxophone, and the bass line is slick. Near the end of the song, flute is played before kalimba closes out the jam. "Power" is sure to put the listener in a good mood. According to Maurice White, *Last Days and Time* was "spiritually different" from the two previous albums. White declared, "There's just more love in this album and in the group as a whole."[78] *Last Days and Time* received positive reviews from music critics.

AllMusic writer William Ruhlmann describes *Last Days and Time* as a mix of Motown pop, funk, and folk. He claims EWF succeeded in incorporating Sly and the Family Stone's gutbucket R&B and some of the fusion style of Weather Report into their music.[79] *Billboard* noted a dynamic soul rock style as the main ingredients of the album.[80] The album peaked at #15 on the *Billboard* Top Soul Albums chart on May 26, 1973.[81] The album did remarkably well considering the group was still developing a following. Eventually it would reach gold status. College radio played an important part in building Earth, Wind & Fire. Maurice White declared, "We started creating a strong underground audience and we were different. There was a lot of energy in our performances." Verdine White added, "We opened for everyone: Mandrill, War, Eddie Kendricks, B.B. King, the Stylistics, Funkadelic. We were the only group wearing tights, platform shoes, and no shirts; and our audiences were hip, young, Black and white."[82]

By the time Earth, Wind & Fire were ready to record their next album, Ronnie Laws and Roland Bautista had left the band. To replace Laws, Philip Bailey recommended Andrew Woolfolk, with whom he had played in Denver.[83] Woolfolk was born on October 11, 1950, in San Antonio, Texas. He became seriously interested in music at the age of thirteen. He attended Denver's East High School with Philip Bailey and Larry Dunn. Like Bailey, Woolfolk performed with the gospel choir Echoes of Youth. Woolfolk continued to study his craft throughout high school and college. He learned to play soprano and tenor saxophones, flute, and percussion.[84] At the time he was recruited to join Earth, Wind & Fire, Andrew Woolfolk was studying with

the famous jazz saxophonist Joe Henderson in New York. He auditioned for EWF and succeeded Ronnie Laws. To replace Roland Bautista, EWF hired two guitar players.

Somebody from the group New Birth told Earth, Wind &Fire about a young guitarist in Kentucky named Johnny Graham who was a funky and bluesy player. EWF sent him a plane ticket without having heard him play a note.[85] Johnny Graham was born August 3, 1951, in Louisville, Kentucky. He began playing the guitar professionally at the age of sixteen. He played for fun at dances and social events for several years before considering it as a profession. In college, Graham majored in music and developed his compositional skills to benefit his chief goal of writing.[86] The other guitarist that was hired is Al McKay.

Al McKay was born February 2, 1948, in New Orleans, Louisiana. He began to play guitar at the age of five and landed his first professional gig when he was eighteen. Before joining EWF, McKay worked with Sammy Davis Jr. and the Ike and Tina Turner Revue.[87] McKay landed the job with Ike and Tina Turner after correcting Ike on a mistake he had made on a cover of the Temptations' "Losing You." He had also worked with Pearl Bailey and the Sylvers.[88] With the new lineup, the band began work on their fourth studio album in early 1972. This album would make the band a strong entity in Black music.

Moment of Truth

In 1973, race relations in the United States were tense. African Americans were dealing with inadequate public schools, high unemployment, and poverty. These problems coincided with the apex of the Black Arts Movement. It is argued that during the Black Arts Movement, Black artists were united in their focus and concern, and they believed they had an obligation to lift the community. The artists focused on art as a concrete expression of sets of political and cultural principles. Their main hope was that the literary, musical, and visual works of Black artists would be politically engaged and socially uplifting.[1] At the height of the movement, funk music had become popular among African American musicians.

Funk music, as described by Rickey Vincent in *Funk: The Music, the People, and the Rhythm of the One*, is a deliberate reaction to—and a rejection of—the traditional Western world's preference for formality, pretense, and self-restraint.[2] In America, there has long been a line drawn between what is secular music and what is sacred music. This concept was foreign to enslaved Africans who did not distinguish between music for secular use and music for sacred consumption.[3] The notion that music outside of the church could not be sacred or spiritual was acquired from the Europeans. Some African Americans have always rejected this notion, but funk musicians rejected it in a more bold and profound manner. Earth, Wind & Fire is a prime example. EWF incorporates sacred messages into their songs, which may also be described as spiritual.

The term *spiritual* may be defined as relating to the spirit or the soul as opposed to the body or material matters. Spiritual matters are concerned with intellect or enlightenment. Spiritual matters also deal with the unseen and the supernatural, which usually refers to one's religion or faith. These themes are often found in the lyrics of Earth, Wind & Fire's songs. Several of EWF's songs are inspirational and focus on love and faith. A few of the songs even contain Kemetic (ancient Egyptian) spiritual themes, and various Kemetic symbols can be seen in the band's visual art.

Maurice White believed many of the world's sciences started in Egypt. He professed, "This is the core reason I turned to Egyptology. It encourages self-respect."[4] White also believed that African Americans were getting their self-respect from fraudulent sources. He declared, "Our history had been stolen and hijacked. Our rich culture didn't start on slave ships or in cotton fields, and it sure didn't start in the Cabrini-Green projects of Chicago." White proclaimed, "It started in Egypt. Egypt gave the planet mathematics, astronomy, science, medicine, the written word, religion, symbolism, and spirituality. Despite what centuries of distortion have told us, the civilized world did not start in Europe; it started in Egypt."[5] For years, people in the West have been indoctrinated to believe human advances should be attributed to Europeans and Africans have contributed very little to human civilization. White detailed another purpose for Egyptology. He stated, "I definitely believe in eternity and past lives and all that. Egypt is always related to something that is secretive. So, I studied Egyptology to learn more about it. It was a major influence in directing the group in a certain direction. It made us stand alone, stand apart from the groups."[6]

Earth, Wind & Fire have always been unique from their contemporaries: funk and soul bands. That was Maurice White's goal from the beginning. He stated, "From the very start, I had a commitment to be different in terms of music and what was projected on stage. Coming out of a period of social confusion in the seventies, I wanted EWF to reflect the growing search for greater self-understanding, greater freedom from the restrictions we placed on ourselves in terms of individual potential."[7] Because of the Vietnam War, young men were being drafted. Racism was persisting and police brutality was a serious problem for African Americans. This discouraged many African Americans from realizing their dreams. Becoming a better person, reaching your greatest potential, and escaping negativity are ideals found in the ancient Egyptian cosmological principles of Maat.

Maat is a comprehensive construct that existed throughout ancient Egyptian civilization. In its cosmological sense, it is the principle of order that informs the creation of the universe. In its spiritual sense, Maat is a goddess representing order or balance. And in its philosophical sense, Maat is a moral and ethical principle that all Egyptians were expected to exemplify in their daily actions toward family, community, nation, environment, and God.[8] Maulana Karenga, founder of the African American holiday Kwanzaa, declares that Maat is an interrelated order of rightness which requires and is the result of right relations with and right behavior toward the divine, nature, and other humans. As moral thought and practice, Maat is a way of rightness defined especially by the practice of the Seven Cardinal Virtues

of truth, justice, propriety, harmony, balance, reciprocity, and order. Maat is required for the ideal world, society, and person.[9] Through their music, Earth, Wind & Fire encouraged people to become better to make a better world.

Earth, Wind & Fire sang about love, ethics, and ancient spiritual wisdom. These themes can be found in Kemetic spirituality and others. When asked about a list of songs dealing with Egyptology, Ralph Johnson replied, "The list of songs would be too numerous." Johnson also declared, "Maurice's overall plan was to deliver a message of positivity, of how to respect your fellow man, and a message of love. We embraced that and we just kept going with it."[10] The positive messages of EWF can be heard on the band's fourth studio album, *Head to the Sky*.

HEAD TO THE SKY

Head to the Sky was released in May 1973. This album started the classic period for Earth, Wind & Fire, the time in which they would be most successful. The classic period would endure until 1983. The spiritual message that Earth, Wind & Fire sought to communicate to their audience was found in the album's title and title song: "Keep Your Head to the Sky." Obviously, this title suggests the concept of positive thinking for happiness, peace, and success. This concept gave EWF's audience an attractive alternative to problems of self-identification and self-respect. This album encourages people to feel good about themselves and to relate to God and nature in all their forms. People get from the world what they put into it.[11]

Head to the Sky may be attributed to the Black Arts Movement, the Black Power Movement, and the African American civil rights movement, which had given African Americans a newfound hope. Although Martin Luther King Jr. had been assassinated in 1968, many African American artists, such as Earth, Wind & Fire, believed that King's dream could become reality.[12] EWF preached a soul sermon on the theme that united the new Black cities of the 1970s and the most serious revolutionaries of the 1960s.[13]

While many African American musicians were recording songs about the depressing social conditions in America, such as war, poverty, and racism, Earth, Wind & Fire recorded songs about love and freedom from life's troubles. Although African Americans were living in an oppressive society, EWF chose to record songs about good times and infinite possibilities. Maurice White wanted to uplift humanity, so he created a band that represented universal truths.[14] Those truths include love, wisdom, and justice.

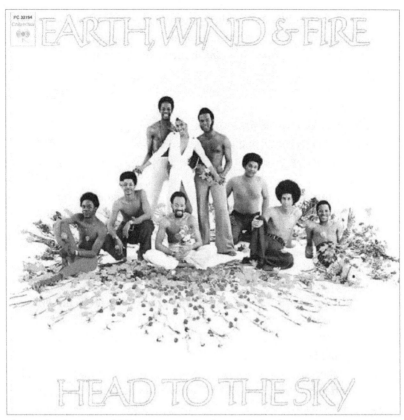

The *Head to the Sky* gatefold features an earthy photo of the band.

Head to the Sky was produced by Joe Wissert and features six songs: "Evil," "Keep Your Head to the Sky," "Build Your Nest," "The World's a Masquerade," "Clover," and "Zanzibar."[15] On the front of the album gatefold, the male band members are posing shirtless while Jessica Cleaves is in the center. It reflects the headspace they were in. They had abandoned the peacoats and turtlenecks of the earlier albums. They were wearing more jewelry and took on a more ethnic vibe.[16] For the inside sleeve, there is a similar photo. The first single "Evil," was released in June 1973.

"Evil" was written by Maurice White and Philip Bailey. It was the first song Bailey had written to appear on an Earth, Wind & Fire album.[17] "Evil" became Earth, Wind & Fire's breakout single. This was largely due to WDAS in Philadelphia and DJs Georgie Woods and Joe "Butterball" Tamburro. Disk jockeys could make or break a song or an artist's career.[18] "Evil" begins with

the sounds of a thunderstorm. Then, it quickly moves to a kalimba-laced intro, and the kalimba can be heard throughout the song. Unlike other artists, Earth, Wind & Fire teach lessons in life via their sophisticated mixture of rhythms.

> Maybe if we learn to pray,
> Life would lend us sunshiny days.
> And evil running through our brains,
> Turn to love and won't be the blame.[19]

The lyrics of this song encourage listeners to seek a higher power and seek love. "Evil" peaked at #25 on the *Billboard* Hot Songs chart on September 15, 1973, and rose to #19 on the *Billboard* Adult Contemporary Songs chart on September 22, 1973.[20]

While "Evil" was on the national charts, Earth, Wind & Fire had a series of sold-out appearances. They then began to take to the television airwaves on three different variety shows. The band kicked things off on ABC's *In Concert*. On September 29, 1973, they appeared on the syndicated *Don Kirshner's Rock Concert* along with the Rolling Stones. In the following month, EWF performed on *The Midnight Special*.[21]

In November 1973, EWF released the second single, "Keep Your Head to the Sky," written by Maurice White. It is the second track on *Head to the Sky*. The song embraces consciousness. EWF wanted their audience to realize that to be young, gifted, and Black, it was necessary to be awake and sensitive to the inner as well as the outer person. At that time, the early 1970s, the song gave hope to young African Americans. White wanted the Black men of Earth, Wind & Fire to inspire self-worthiness. His plan was to increase everyone's level of ethnic consciousness, forcing them to transcend into a philosophy that embraced all of humanity for the planet's higher good. Spiritual transcendence commentary began to proliferate in EWF lyrics in the early and mid-1970s.

To some extent, this type of commentary reflects disillusionment with the failure of political advocacy and the American civil rights movement and the Black Power movement to overcome structural inequalities. Between 1972 and 1975, the median income of Black families was stagnant and the unemployment rate for Black men jumped from 7 to 12.5 percent. Also, widespread resistance to busing to obtain public school desegregation arose during that time. These social conditions provide a context for the type of spiritual transcendence commentary exemplified by "Keep Your Head to the Sky."[22]

Prior to writing "Keep Your Head to the Sky," Maurice White had been questioning his purpose. He wanted to believe God was with him in spite of the challenges he was facing. The song is a testament to his faith.[23]

> Keep my head to the sky
> For the clouds to tell me why
> As I grew, and with strength
> Master kept me as I repent[24]

According to White, "Keep Your Head to the Sky" was built on simple, universal truths.[25] Universal truths can be found in many religions, including Kemetic spirituality, which is older than many of the world's current major religions.

The spiritual and ethical impact of Maat can be found in "Keep Your Head to the Sky." Maat gave the ancient Egyptians a sense of being at home in the world, a world in which evil could never be dominant for long and good would always be triumphant. In other words, consciousness of Maat provided a sense of confidence that goodness triumphs regardless of evil, disorder or other negatives in the world.[26] In this song, the listener is reminded to remain steadfast and keep the faith that good things will follow through in the end. This theme of optimism is found in several EWF songs. Philip Bailey's falsetto gives this song a peaceful vibe. At the end of the song, the music fades out, and Bailey sings in the highest octave, encouraging listeners to focus on the Highest Power. "Keep Your Head to the Sky" reached #23 on the *Billboard* Hot Soul Songs chart on January 5, 1974.[27] *Head to the Sky* ends with "Zanzibar," which features nearly fourteen minutes of instrumental prowess. *Head to the Sky* received positive reviews.

In *Rolling Stone*, Vince Aletti described the album's vocals as breathy and soothing without being too delicate, and he believes the band sounds like a cosmic choir. Aletti also claimed that, at its best, the music is fluid and enveloping, and most distinctive when Maurice White is playing the kalimba.[28] *Billboard* also stated that the band does everything well on this album.[29] *Head to the Sky* produced two top thirty hit songs: "Evil" and "Keep Your Head to the Sky." These songs are actually the band's first hit records. The album rose to #2 on the *Billboard* Top Soul Albums chart on August 18, 1973, and to #27 on the *Billboard* 200 chart on August 27, 1973.[30] *Head to the Sky* was certified gold on November 8, 1973, and eventually would be certified platinum on November 5, 1999, by the Recording Industry Association of America (RIAA).[31]

Head to the Sky was Jessica Cleaves's last album with the band. After a gig in Boston, Massachusetts, she left and disappeared. Prior to that, she had warned Maurice White that her husband was her first priority, and that if he needed her, she would leave the group. Band members claim she was using drugs and became a distraction. She began singing with George Clinton before she disappeared from commercial music altogether. After her departure, Maurice White decided to discontinue the female vocalist role in the band.[32] To build on the success of *Head to the Sky*, Earth, Wind & Fire looked forward to recording another studio album.

In the fall of 1973, Maurice White brought on Charles Stepney to add extra dimensions to the arrangements. It was White's hope that Stepney, a friend from his Chess Records days, would send Earth, Wind & Fire into gold and platinum record sales status and bring the material and performances into tighter focus. Charles Stepney was a musician, songwriter, producer, engineer, and arranger. He had worked with Rotary Connection and Minnie Riperton. With Stepney on board, EWF began working on their fifth studio album.[33]

OPEN OUR EYES

In November 1973, Earth, Wind & Fire travelled to Caribou Ranch in the Rocky Mountains to record *Open Our Eyes*. Caribou Ranch was owned by James Guercio, the manager of the rock group Chicago. Isolated and relaxing, with color televisions in each bedroom and a better mental space for creativity, Caribou afforded the band space to create one of their most eclectic albums. Charles Stepney was on board as associate producer and Joe Wissert was the CBS/Columbia staff producer.

Open Our Eyes was released on March 25, 1974. It features eleven songs: "Mighty Mighty," "Devotion," "Fair But So Uncool," "Feelin' Blue," "Kalimba Story," "Drum Song," "Tee Nine Chee Bit," "Spasmodic Movements," "Rabbit Seed," "Caribou," and "Open Our Eyes."[34] *Open Our Eyes* was reissued in 2001; that second edition is discussed in chapter 10. The gatefold photo for *Open Our Eyes* was shot at Caribou Ranch. For this album cover, Maurice White decided to have a group shot taken in the high altitude and thin air of the Rocky Mountains. The band members are featured in the photo wearing colorful costumes and robes. By looking at the photo, no one could imagine how bitter cold it was. The sleeve inside the cover features photos of the eight band members in bold seventies fashion with the Jupiter symbol in the center. Some of the members are posing with musical instruments.[35] The first single to be released from *Open Our Eyes* was "Mighty Mighty."

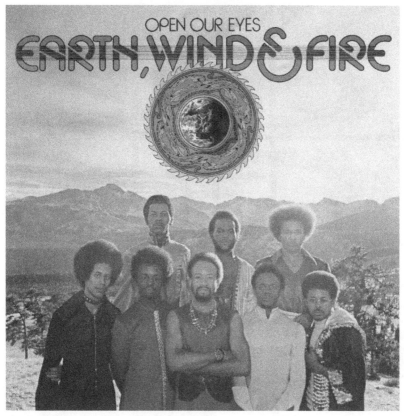

The *Open Our Eyes* gatefold shows the band members at Caribou Ranch.

"Mighty Mighty" was released on February 1, 1974. Written by Maurice and Verdine White, this is a funky track that begins with a bold horn arrangement, which becomes a part of the Earth, Wind & Fire signature sound. "Mighty Mighty" speaks of African identity. With the chorus line, "We are people, of the mighty, mighty people of the sun," this is one of the more inspirational songs by Earth, Wind & Fire. Maurice White told *Blues & Soul*, "There are certain aspects which have to be kept clean, things that relate directly to the Creator. By adopting a totally positive approach to our life, we can reflect this in our music." Regarding the recording of this track, Verdine White said, "I remember we just got into a groove, man. We just got into it. You know what I mean? That was one of our favorite songs to record and play."[36]

"Mighty Mighty" professes that people could overcome challenging circumstances with determination and self-belief. It encourages listeners to ignore negativity. The message was for everyone, especially African

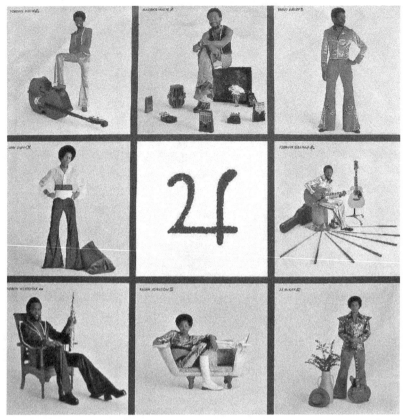

The *Open Our Eyes* sleeve features the band members in bold seventies fashion.

Americans, because racism is a blatant issue in America.[37] This song encouraged people to have pride in themselves.

> We are people, of the mighty
> Mighty people of the sun
> In our hearts lies all the answers
> To the truth you can't run from[38]

This song not only speaks to African Americans and other people of African descent; it also speaks to all of humanity. Maurice White stated, "Today we have scientific proof that all of mankind has African origins."[39]

"Mighty Mighty" became a breakout record for Earth, Wind & Fire. Bob Cavallo, an Italian American who once managed EWF, believed the song could have been bigger if some people hadn't perceived it as a Black power

message—or, as he used to joke, "Mighty Mighty—kill the whitey."[40] "Mighty Mighty" peaked at #4 on the *Billboard* Hot Soul Songs chart on April 27, 1974. It also peaked at #29 on the *Billboard* Hot 100 Songs chart on May 18, 1974.[41] After the success of "Mighty Mighty," EWF's popularity was steadily rising.

Earth, Wind & Fire was the only Black band to play at the California Jam on April 6, 1974. This music festival featured Emerson, Lake & Palmer, Black Oak Arkansas, and Rare Earth. EWF also opened for Sly Stone at Madison Square Garden. Maurice White recalled,

> Verdine wanted to hike himself up through a harness and fly through the air. I was a little apprehensive because I thought he might fall, but being an adventurous guy, I said "let's try it." That was the beginning. Within a year, Larry was spinning around on top of his piano and Ralph's drum platform gyrated. It was an expensive production and all the money we made went back into the production of the show. But the audiences, man, they went wild.[42]

Verdine White recalled, "Becoming aware of who I was made things start to happen for me. We don't describe our music; the audience does." Ralph Johnson noted, "Our music is earthy, danceable and covers all aspects relevant to the audience."[43] To continue pleasing their audiences, EWF released "Kalimba Story" on June 14, 1974.

"Kalimba Story" was written by Maurice White and Verdine White. Verdine White explained in an interview, "The song was written because we wanted people to know about the kalimba." Maurice White was considered one of the leading kalimba masters in the United States. Verdine White added, "We have been using the instrument since we began as a group and we feel that it will emerge as one of the leading instrumental forces in tomorrow's music. It is the type of instrument that can make things happen musically. And that is what we are all about."[44] The lyrics express Maurice White's zeal for the kalimba.

> If you lend an ear and you have no fear
> The vibration will move your mind
> It's new to you, sounds true to you
> Sacred music before its time[45]

"Kalimba Story" suggests that the kalimba has mystical power. A listener may be reminded of the Biblical story in which David played the harp for Saul. In 1 Samuel 16 it states that Saul was tormented by an evil spirit. Whenever the

spirit bothered Saul, David would play the harp, and the spirit would go away. The kalimba in the song also seems to have spiritual power. With its unique sound, the kalimba can offer listeners a spiritual experience. On August 24, 1974, "Kalimba Story" reached #6 on the *Billboard* Hot Soul Songs chart.[46] After "Kalimba Story" was released, Maurice White and Charles Stepney collaborated to work on Ramsey Lewis's 1974 album *Sun Goddess*.

According to Ramsey Lewis, Maurice White called and told him that there was an instrumental tune on the album that they were not going to use that would be bigger than "The In Crowd" (a 1965 hit by the Ramsey Lewis Trio). They took about three or four days to record the first tune, "Hot Dawgit," which Lewis thought would be the first single. But White said, "There's another tune, not really a song, more of a twelve-bar melody. But we need some voices on it." Several members of Earth, Wind & Fire worked on the session, in which White said, "C'mon Philip, we're gonna sing 'Way-yo, way-yo . . .'" White stopped, standing in the recording booth: "I want to put another rhythm part in it." The engineer asked him where he wanted to put the clave beat, and White stated, "On the solo."

This song became the album's title track. Ramsey Lewis declared, "You can hear him say that on the song to this day. Most people think he's saying, 'I want a solo.'"[47] The song "Sun Goddess" would not be released until the following year and is discussed in the next chapter. But the song "Hot Dawgit" was released at the end of 1974, credited to both Ramsey Lewis and Earth, Wind & Fire. "Hot Dawgit" reached #61 on the *Billboard* Hot Soul Songs chart on January 18, 1975.[48] After working with Lewis, the band soon began work on their sixth studio album. The band also released "Devotion" on September 7, 1974.

Written by Maurice White and Philip Bailey, "Devotion" expresses the band's spiritual side. The lyrics were inspired by Bailey going to catechism class when he was a boy attending Catholic school. Catechism is like Sunday school for Catholics, except students attend every day in the summer.[49] When singing the song in the studio, Charles Stepney asked Bailey to close his eyes and think about his mother. According to Maurice White, Bailey closed his eyes and sang the lyrics with a conviction White had never heard from Bailey in the studio. Stepney had gotten the emotion and the believability out of Bailey.[50] Bailey declared, "Maurice's whole vision was to kinda sneak a little jazz on people." That is evident in "Devotion."

"Devotion" was a minor hit but a major fan favorite. The song features sparkling chords, fusion-rich keys and a lusciously twisting bass line. The hooks are as subtle as they are unshakeable. "Devotion" is a tender song for a time when America felt anything but. White's mission to smuggle jazz into

the R&B and pop charts feels more sacred here than almost anywhere else in EWF's catalogue. Or as the song itself unabashedly states, "So our mission, to bring melody / Ringing voices sing sweet harmony." Its most memorable version can be heard on the 1975 live album *Gratitude*, where the band's rendition at the Omni Theater in Atlanta is like a gospel-funk revival.[51] The lyrics to devotion require emotion and spiritual insight.

> Through devotion
> Blessed are the children
> Praise the teacher
> That brings true love to many[52]

This song speaks to the importance of teachers in the world and their impact on children. It also alludes to the power of love.

"Devotion" is another inspirational song in the Earth, Wind & Fire catalogue that has become a favorite among EWF fans. "Devotion" peaked at #33 on the *Billboard* Hot 100 Songs chart on October 19, 1974, and at #23 on the *Billboard* Hot Soul Songs chart on November 2, 1974.[53] In addition to the three songs released as singles, *Open Our Eyes* includes the inspirational title track.

"Open Our Eyes" was first published in 1958. The song has been described as a prayer for peace and faith, which avoids the use of idiosyncratic jargon or the words *God, Jesus,* or *Christ*. Instead, the prayer is addressed to Father, Master, and Lord. Earth, Wind & Fire's rendition of the song would have conjured familiar images of the traditional Black church for many African Americans. Its praise of universal virtues, however, is in keeping with White's more global inspirational agenda.[54] "Open Our Eyes" is an old gospel song written by Leon Lumpkins and made popular by Jessy Dixon and the Gospel Clefs.[55] Like many African American musicians, Maurice White was familiar with gospel music.

As a child, Maurice White attended Rose Hill Baptist Church, which he described as a Pentecostal church where women often fainted, causing fear in some of the children. At this same church, he heard a lot about Hell's fire and brimstone from the pulpit, what people should and shouldn't do, and the need to give your life to Jesus to avoid eternal damnation.[56] Maurice White expressed his sentiments about recording "Open Our Eyes." He declared,

> When you hear the song "Open Our Eyes," check it out from the standpoint of feeling the song. In fact, I was in tears when I was sing-ing it. I went into the studio and said, "hey," I'm getting ready to lay this song out for you so fellas, do your thing for me. When I went in

to hear the playback I said "wow" that ain't me, but I could feel it. This is a very dear song to all of us. We are very excited about the album. It is very diversified.[57]

Maurice White's affection for Egyptology may have inspired him to interpret "Open Our Eyes" in a peculiar way.

"Open Our Eyes" is basically a prayer for enlightenment. Philip Bailey explains, "Our mission was to tell people, 'Hey, you're naturally high, and you can maintain that natural high by discovering who you are—by opening your third eye. We weren't just saying it, we were living it. . . . Maurice was the catalyst for all that. What we discovered through him is what we sang about."[58] The third eye that Bailey referenced is represented by the eye of Heru, which has been displayed in the visual art of Earth, Wind & Fire. The third eye is the spiritual eye that gives a person inner vision. As stated previously, this song is a prayer.

> Father, open our eyes, that we may see
> To follow thee. Oh Lord
> Grant us, thy lovin' peace, oh yeah
> And let all dissension cease.[59]

"Open Our Eyes" and the other three aforementioned songs helped *Open Our Eyes* become a popular album. And with the diversity of song on this album, EWF solidified their groove. "Drum Song" is a percussion track that features a funky bassline and Maurice White on kalimba. "Spasmodic Moments" sounds like a classic jazz sax instrumental. "Tee Nine Chee Bit" is a typical mid-seventies funk jam with street conversations and psychedelic guitar riffs. "Caribou" is a Latin-influenced track featuring harmonious vocal chants. *Open Our Eyes* received assured reviews from music critics.

In a May 9, 1974, *Rolling Stone* review, Ken Emerson describes *Open Our Eyes* as a pleasant mixture of Africana, Latina rhythms, well-mannered funk, smooth jazz, Sly Stone, Stevie Wonder, and the Fifth Dimension. Emerson claims the album has both disco and easy-listening appeal. Among the distinctive positive elements are Maurice White's kalimba, Andrew Woolfolk's fluent soprano sax, Philip Bailey's falsetto, and everybody's good humor.[60] Robert Christgau of the *Village Voice* describes the album as a complete impressive performance. On side one, the vocals come together. Maurice White provides tuneful, relatively unselfconscious songs over a light Latin-funk beat jarred by grunts, horn riffs, and keyboard squiggles. Side two is a survey of EWF's roots, from the kalimba-hooked "Drum Song" through street

rap through 1:41 of expert cocktail bebop.[61] The album rose to #15 on the *Billboard* Top Pop albums chart on May 18, 1974, and to #1 on the *Billboard* Top Soul Albums chart on May 25, 1974.[62] On November 21, 1986, *Open Our Eyes* was certified platinum by the RIAA.[63]

In the fall of 1974, while *Open Our Eyes* was still on the charts, Earth, Wind & Fire returned to Caribou Ranch to record their crucial follow-up album. This time, they arrived with a new band member. Maurice White decided more edge was needed on the drums and he enlisted his younger brother, Freddie White.[64] Freddie White was born January 13, 1955 in Chicago, Illinois. He was exposed to music at an early age by his talented brothers, Maurice and Verdine.[65] Freddie White became a professional drummer at the age of sixteen when he began playing with Donny Hathaway. He was hired as successor percussionist to Maurice White in 1974 when Maurice began to devote more time to writing and producing.[66] With Fred White on board, the well-known classic lineup of EWF was complete.

The classic lineup consists of nine musicians: Maurice White, Verdine White, Philip Bailey, Larry Dunn, Ralph Johnson, Andrew Woolfolk, Johnny Graham, Al McKay, and Freddie White. Except for Al McKay, all of these gentlemen would make up EWF until 1983. They are known by EWF fans as the Classic Nine. Al McKay would leave the band in 1981 and be replaced by returning musician Roland Bautista. Before their next studio album was released, Earth, Wind & Fire released a compilation album.

ANOTHER TIME

After recording five studio albums, Earth, Wind & Fire released their first compilation album in September 1974. *Another Time* was issued as a double album with a compilation of all the songs from the debut album *Earth, Wind & Fire* and from their second album *The Need of Love*. It also includes the bonus track "Handwriting on the Wall." The cover art for the album is rather eclectic. It displays the head of a woman with three arms growing from the head. The right arm is holding the earth. The middle arm is holding the wind, and the left arm is holding fire. This compilation was an indication of what was in store for Earth, Wind & Fire.

In an AllMusic review, Ron Wynn declares that once Earth, Wind & Fire became the top Black music band in the world, Warner Bros. realized the mistake they had made in not giving Maurice White complete creative freedom. They rushed out this anthology featuring the group's early music, hoping to piggyback off their huge Columbia hits.[67] *Another Time* reached #29 on the

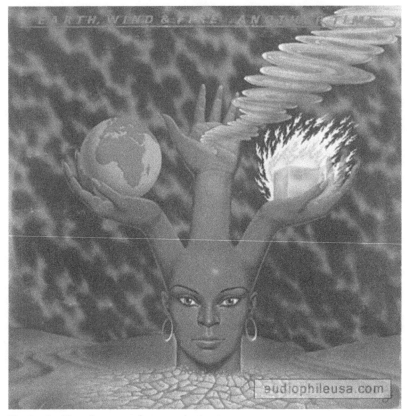

The *Another Time* album cover features eclectic art.

Billboard Top Soul Albums chart on October 5, 1974.[68] In the following year, EWF would release their most successful album to date: *That's the Way of the World*.

Shining Stars

The year 1975 was a good time for popular culture. *Saturday Night Live* debuted on NBC, and *The Jeffersons* debuted on CBS. The movie *Jaws*, considered the first blockbuster film, was released in theaters. Muhammad Ali defeated Joe Fraser in the "Thriller in Manila" match, and disco music reached mainstream. It would also be a great year for Earth, Wind & Fire. EWF started the year off right by releasing the inspirational song "Shining Star" on January 2. *That's the Way of the World* was released two months later, on March 15. The album is also the soundtrack for a movie of the same name. The movie is about the music business and record executives, and EWF portrayed a fictionalized version of themselves. "Shining Star" became an immediate hit.

THAT'S THE WAY OF THE WORLD

Richard Mack, director of R&B Promotion at CBS Records' Special Markets, and his staff were responsible for getting "Shining Star" immediate airplay when it was released. Within twenty-four hours, the song was being played on virtually every major R&B and rock radio station in the United States, including many secondary and tertiary markets. "Shining Star" has gone on to become a kind of anthem for millions of Earth, Wind & Fire fans, both Black and white.[1]

"Shining Star" was written by Philip Bailey, Larry Dunn, and Maurice White. The song came to White while he was taking a night-time walk outside the recording studio at Caribou Ranch in Nederland, Colorado, when the band was working on the album. Overwhelmed by the beautiful clarity of the night sky, White came up with the chorus "Shining star for you to see / What your life can truly be" and brought it to the other band members. They spent days perfecting the track, with White and Philip Bailey layering vocal upon vocal to create the stark a cappella at the end of the song.[2]

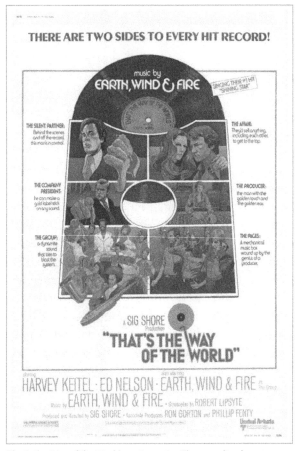

That's the Way of the World movie poster. The soundtrack was performed by EWF.

"Shining Star" begins with the distinctive electric guitar riffs before the pulsating horns let the audience know this is a special kind of groove. This song encourages listeners to search within to find the strength to achieve their hearts' desires. The song suggests that one must search within to find what abilities and talents he/she may possess. When those qualities are found, he/she can find success and happiness. He/she can "shine bright." In other words, he/she can stand out among others.[3]

> You're a shining star
> No matter who you are
> Shining bright to see
> What you could truly be (what you could truly be)[4]

This chorus sends a powerful message to listeners. It evokes humans' divine power. It suggests that all people are endowed with talents and gifts. There is a Kemetic proverb that states, "The kingdom of heaven is within you; and whosoever shall know himself shall find it." This indicates that ancient Egyptians believed in the divine essence of man. They believed in the concept "Know yourself."[5] "In "Shining Star," Earth, Wind & Fire delivers the same message of affirmation. The most important star to mankind is the sun.

The sun is the life force for all living things on this planet. It is the sun that gives energy and strength to organisms. "Shining Star" insinuates that people can stand alone and use the power within themselves: the power that was given to them by nature. At the end of the song, the vocalists chant "Shining star for you to see what your life can truly be" three times.

As the vocalists chant, the music fades out. Earth, Wind & Fire performs here not only the star's appearance, but the unveiling of a dominant ideology, a recognition that what makes up the norm—the music taken away—is something we could do without. What we hear every day is precisely that which prevents people from realizing what they could truly be.[6]

"Shining Star" is the epitome of Earth, Wind & Fire's idealism, infectious optimism, and incredible rhythmic mastery. This song has the pulsating throb and choppy guitars of classic James Brown funk, an extra sweet guitar line that gives a rock band feel, surges of spectacular horn breaks that challenged other funk bands, and furious hooks: "Shining star for you to see—what your life can truly be!"[7] "Shining Star" became a smash hit not only because of its dynamic sound, but also because of its uplifting message.

At the 2011 Soul Train Awards, actor Malcolm-Jamal Warner introduced the tribute to Earth, Wind & Fire. Warner declared that the first time he heard "Shining Star," he felt he could achieve anything he conceived in his mind. "Shining Star" rose to #1 on the *Billboard* Hot Soul Songs chart on March 22, 1975. It also rose to #1 on the *Billboard* Hot 100 chart on May 24.[8] The song would go on to win a Grammy for Best R&B Vocal Performance by a Duo, Group, or Chorus.[9] While "Shining Star" was climbing the charts, EWF released *That's the Way of the World* on March 15.

That's the Way of the World was produced by Maurice White and Charles Stepney. The album features eight tracks: "Shining Star," "That's the Way of the World," "Happy Feelin'," "All About Love," "Yearnin' Learnin'," "Reasons," "Africano," and "See the Light." The gatefold for this album displays the band members in different poses in black and white. The inner sleeve of the gatefold is a photo of the band with each member having a stern face.[10] The album was certified gold only weeks after its release, and it continued to sell at an incredible rate, sending sales over the three million units mark after

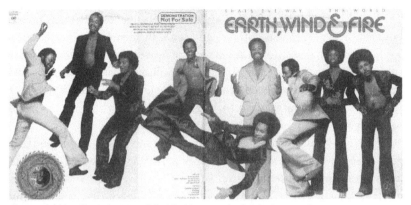

The gatefold for *That's the Way of the World* is a result of trick photography.

it had only been available for three months.[11] A second edition of *That's the Way of the World* was released in 1999. That edition is discussed in chapter 9. The second song released from the album is the title track: "That's the Way of the World."

"That's the Way of the World" was released on June 17, 1975. It was written by Charles Stepney, Maurice White, and Verdine White. This song is a masterpiece with flawless vocal arrangements, impressive horns, and a soothing bassline. "That's the Way of the World" encourages people to focus on the inner self, especially the heart. The opening verse reads:

> Hearts of fire creates love desire
> Take you higher and higher to the world you belong
> Hearts of fire creates love desire
> Higher and higher to your place on the throne[12]

This chorus speaks about fulfilling one's purpose in life. "The world you belong" and "your place on the throne" are metaphors for living one's destiny and finding true happiness. One must only follow his or her heart and follow the dreams God has placed inside his or her heart. The heart of a person has been considered a crucial dynamic in people through many cultures, particularly the ancient Egyptians. They believed one's heart represents a divine presence as a source of character and success.[13] In Kemetic spirituality, one important aspect in the judgment of a deceased soul is the weighing of the heart. This aspect is depicted in the judgment scene in the *Book of Coming Forth by Day*.

Independent Egyptologist/Kemetologist Anthony Browder explains that the *Book of Coming Forth by Day* (*Book of the Dead*) is a compilation of

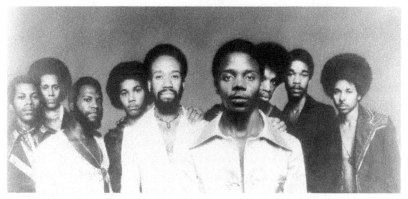

The inner sleeve for *That's the Way of the World* features all classic nine members.

texts that were inscribed on the walls of the tombs or papyrus scrolls in Egypt that were buried with the dead.[14] In the judgment scene, the heart of the deceased was weighed on the Grand Scale against the weight of Maat (goddess of justice, truth, and order), symbolized by the ostrich feather she wears in her headband. After reciting the forty-two negative confessions in chapter 125 of the *Book of Coming Forth by Day*, those whose good deeds caused their hearts to "measure up" to the goal of Maat were assured a blessed afterlife.[15] A blessed afterlife was rewarded to those whose hearts were "light as a feather." "That's the Way of the World" encourages people not to let their hearts be influenced by the evil deeds of others or the circumstances of their environment and to look into their hearts and souls for peace.[16] Some people have considered this song Earth, Wind & Fire's anthem because of its philosophical message.

"That's the Way of the World" reached #5 on the *Billboard* Hot Soul Songs chart on August 23, 1975, and #12 on the *Billboard* Hot 100 chart on September 20.[17] No other songs were released as singles from *That's the Way of the World*, but some of the other songs on the album have become fan favorites. One of those is "All About Love."

"All About Love" was written by Larry Dunn and Maurice White. Some may consider it a soulful, orchestrated jazz tune. The song begins with Maurice White speaking, then singing over piano chords and eventually turns into six minutes of pure bliss. Toward the end, Maurice White has a speaking part that lets listeners know that Earth, Wind & Fire was thought-provoking and philosophically profound. In this moment, White's religious preferences surface with as much frankness as they do in the many interviews he has given over the course of his career. The spoken interlude announces the band's, or at least Maurice White's, religious philosophy:[18]

> You know, for instance, we study all kinds of occult sciences
> and astrology and mysticism and world religion,
> And so forth, you dig?[19]

In this monologue, White also suggests that one must use his heart and mind (the inner self) as well as his physical body (the outer self) to appreciate beauty and create beauty. In other words, beauty is not only physical, it is also behavioral. People can see and appreciate the beauty in the natural environment, and they can also create beauty by the way they treat others. Treating others with love and respect is beauty that people are capable of creating. This concept is found in ancient Egyptian cosmology. Another classic song featured on *That's the Way of the World* that never charted is "Reasons."

"Reasons" was written by Philip Bailey, Charles Stepney, and Maurice White. The song was born out of a conversation between White and Bailey about the numerous women hanging around the band, desiring to hook up. For all the band's good intentions, "Reasons" was completely misunderstood.[20] Featuring the falsetto of Bailey, this popular R&B ballad is actually about a one-night stand: "I'm longing to love you just for one night."[21] People have used the songs at weddings as a musical expression of endless, undying love for one another, when in fact, it is a cautionary tune expressing the opposite.[22]

> Now, I'm craving your body, is this real
> Temperatures rising, I don't want to feel
> I'm in the wrong place to be real[23]

The singer declares he is having unwanted feelings and he is in the wrong place. This song is more about lust than love. "Reasons" is beautifully delivered in falsetto by Bailey.

Many people have tried and failed to reach the notes that Philip Bailey hits on "Reasons." The song is not only a karaoke classic, but also a sign of how the group had evolved from a visionary funk-rock band to a cosmopolitan ensemble that incorporated easy pop, jazz, and disco. As Maurice White explained to *Billboard* in 1975, "It was simply our goal to reach everybody."[24] "Reasons" is a crucial component to *That's the Way of the World.*

That's the Way of the World received high praise from music critics. *Billboard* described the album as "a very tightly produced and performed package" and stated that Earth, Wind & Fire has some of the finest musicians in any band and the compositions are all top-notch.[25] Robert Christgau stated that, on this album, EWF can do so many things and that this unit qualifies as the one-man band of Black music although it has nine members.[26] Alex

Henderson of AllMusic stated that there are no dull moments on *That's the Way of the World* and that it is one of the best albums of the 1970s and EWF's crowning achievement.[27]

That's the Way of the World resulted in Earth, Wind & Fire's move to larger stadiums. They packed Madison Square Garden in New York City and played medium-sized auditoriums for four and five nights at a time. Maurice White decided that the band needed a bigger live sound, which would require a horn section. He reached out to his old friends from Chicago: Louis "Lou" Satterfield and Don Myrick. With the addition of Michael Harris, they became known as the Phenix Horns: Lou Satterfield on trombone. Don Myrick on saxophones, and Michael Harris on trumpet and flugelhorn. Both Satterfield and Myrick were former members of the Pharaohs. The Pharaohs was a jazz and soul group born from the Affro-Arts Theater in Chicago. They had an Afrocentric point of view, which was inspiring to Maurice White.[28] Rahmlee Michael Davis later joined as a trumpet player and Elmer Brown played trumpet for the Phenix Horns briefly in 1979.[29]

With a new horn section, Earth, Wind & Fire came up with an unexpected, entirely new direction. Rather than incorporate the horns for emphasis or punctuation, as James Brown and the Stax Records bands had done, EWF wove them into the arrangements playing fluid secondary melodic lines, then unexpectedly leaping into the foreground. Along with the early recordings of such EWF contemporaries as Kool & the Gang and the Commodores, this sound would generate an entire school of horn-based soul and funk groups, including Slave and Brass Construction.[30]

With the Phenix Horns on board, Earth, Wind & Fire went on tour in Europe with Santana in September 1975. This is one of several major tours for the band. This particular tour helped the band win the foreign market. They did thirty-two shows in twenty-six cities. Although EWF had risen beyond being an opening act, they agreed to go on first, and they took no prisoners and captivated audiences.[31]

Earth, Wind & Fire's live set was smooth. Rather than just feature the band's most popular songs, it opted for a more balanced delivery, alternating lesser known ballads and seething instrumentals with standards like "Shining Star," "Reasons," and "That's the Way of the World." The choreography was slick, simple but effective. The special effects were mind-blowing, but at the same time, served to enhance the music instead of distracting the listener. Maurice White saw EWF's approach as a natural outgrowth of the African American experience: "We create fantasies for our audience to get the message across. For a time, Black people instilled pride by militancy; we want to instill pride by making people believe in themselves. I'm here to testify. I believe."[32]

With the success of *That's the Way of the World*, Earth, Wind & Fire became Columbia Records' top box office attraction. Largely ignored by the rock press, the band broke practically ever attendance and sales record in the book. *That's the Way of the World* went platinum three months after its release and sold over three million copies, and "Shining Star" broke the 1.5 million sales barrier. According to Columbia promotion numbers, Earth, Wind & Fire became the label's biggest artist, outdistancing household names like Chicago, Paul Simon, and Barbara Streisand.[33] *That's the Way of the World* also helped boost interest in the three previous EWF albums: *Open Our Eyes*, *Head to the Sky*, and *Last Days and Time*. By that time all but the latter had been declared gold, signifying sales in excess of one million.[34]

GRATITUDE

After the phenomenal success of *That's the Way of the World*, CBS/Columbia wanted another album quickly. Maurice White declared, "We didn't have time to do a whole new album so we started taping our shows. I sat down and listened to the tapes from everywhere. We cut four new songs in the studio and we had the double-album *Gratitude*."[35] This album was a response to years of requests for an Earth, Wind & Fire live album. In addition to the three sides of familiar material taken from live performances, Maurice White and co-producer Charles Stepney took the band into the studio to record all new songs for the fourth side. *Gratitude* is a broad-ranging portrait of the magical essence throughout the entire Black music tradition, and it quickly became the standard by which live bands were measured.[36]

Gratitude was released on November 11, 1975. The album features live songs from performances in Chicago, Los Angeles, St. Louis, Atlanta, Boston, and New York City, as well as the first cities that embraced Earth, Wind & Fire: Philadelphia and Washington, DC. Gratitude is the recording debut of the Phenix Horns, who excelled on the studio tracks as well as on the live material. The Phenix Horns soon became the strongest part of EWF's signature sound. The live recordings on *Gratitude* were produced by Maurice White and Joe Wissert, and the studio songs were produced by Maurice White and Charles Stepney. George Massenburg's mixing and engineering remained on board as well.[37] The gatefold for the album is simple. The front cover only displays the name of the band and title of the album surrounded by an embroidery design. The inner sleeve features photos of the band members in concert.

Gratitude features an introduction track and nine songs from the live performances. The tracks from the live performances are "Introduction by

The front cover of the album *Gratitude*.

Perry Jones," "Africano/Power," "Yearnin' Learnin'," "Devotion," "Sun God-dess," "Reasons," "Sing a Message to You," "Shining Star," "New World Sym-phony," and "Sunshine." The studio tracks include "Sing a Song," "Gratitude," "Celebrate," and "Can't Hide Love."[38] *Gratitude* was reissued in 1999; that edition is discussed in chapter 9. The first song, "Africano/Power," is a bass-, saxophone-, and percussion-driven instrumental Earth, Wind & Fire had been developing in the studio and on stage since 1971. "Africano/Power" incorporates jazz fusion, Afro-Cuban jazz, funk, and more power than fans had ever heard on an EWF record. The first single from *Gratitude* is "Sing a Song," which was released in November 1975.

"Sing a Song." Earth, Wind & Fire's second gold single, comes from the studio material. This is a high-spirited tune which features Maurice White on lead. Philip Bailey's background vocals and the signature horns give the song a pleasant vibe. "Sing a Song" implies there is a real purpose in music: it

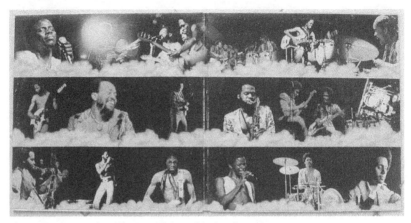

. The *Gratitude* inner sleeve features photos of the band members in concert.

helps people get through pressure and bad times. This tune is about positivity and was written by Maurice White and Al McKay. It is about the power of speech and uplifting one's state of mind.

"Sing a Song" plainly encourages listeners to change their mood by speaking positivity into the atmosphere.

> When you feel down and out
> Sing a song (it'll make your day)
> For you, here's the time to shout
> Sing a song (it'll make a way)[39]

Speech is the concrete expression of the Creator's thoughts. This reflects the absolute efficiency of the potency of speech. The heart conceives the idea of the universe and the tongue concretely makes the idea real by giving orders.[40] The tongue has the power to affect all change, all production, all generation. For example, sowing alone is not enough to make crops germinate and grow. Speech and song must be added. All the activities of men and all the movement in nature depend on the productive power of the word.[41] Maurice White believed that humans possess divine power, and he chose to express that in his music. That belief is exemplified in "Sing a Song."

"Sing a Song" rose to #1 on the *Billboard* Hot Soul Songs chart on January 10, 1976. It spent two weeks at that position. The song also rose to #5 on the *Billboard* Hot 100 Songs chart on February 7, 1976.[42] To cap off 1975 as a banner year for Earth, Wind & Fire, they were voted Favorite R&B Group at the American Music Awards.[43] The second single from *Gratitude* is "Can't Hide Love," which was released in March 1976.

"Can't Hide Love" was written by Skip Scarbrough, who had already written songs for Earth, Wind & Fire, including "I'd Rather Have You" on *Last Days and Time* and "The World's a Masquerade" on *Head to the Sky*. He would later write "Love's Holiday" on *All 'N All*. According to Maurice White, Scarbrough's songs contributed much to EWF's sound. A group named Creative Source had recorded "Can't Hide Love" in 1973, but Earth, Wind & Fire completely changed it, just as they did with all outside material. The original version had a Fifth Dimension kind of vocal sound. EWF slowed it down significantly and added a new vocal arrangement.[44] The song begins with aggressive horns. Then Maurice White draws the attention of the listener with his crooning tenor. Philip Bailey's background falsetto adds another ingredient, along with the humming vocals as the song fades out.

"Can't Hide Love" is about a girl who is denying her feelings for the singer, who tells her she can't hide the love she's feeling. The song is a concert favorite for Earth, Wind & Fire. It often involves some audience participation, especially during the long fadeout at the end of the song. Bass player Verdine White declared: "When we play for our audiences and they know the song, they do that end without us. We just put the mic up there. Our whole audience knows those whole chord changes."[45] "Can't Hide Love" reached #11 on the *Billboard* Hot Soul Songs chart on May 1, 1976. The song was also nominated for a Grammy Award for Best Vocal Arrangement.[46]

The live version of "Reasons" contains a churchy call and response between Philip Bailey's voice and Don Myrick's saxophone. It created a special moment in time. Bailey's line to the audience: "He plays so beautiful, don't you agree?"—became a part of pop culture, a shout-out that introduced Myrick to Earth, Wind & Fire fans. The live version of "Reasons" became more popular than the studio version, making Bailey an African American legend in his own right.[47] Another live recording featured on *Gratitude* is the instrumental "Sun Goddess."

"Sun Goddess" was written by Maurice White and Jon Lind. As stated previously, the song first appeared on Ramsey Lewis's studio album *Sun Goddess* in 1974. It should be noted that the title of the song is a Kemetic (ancient Egyptian) reference. There was a sun goddess in ancient Egypt named Hathor. Hathor was closely connected with the sun god Ra, whose disk she wears. She was also said to be the wife or daughter of Ra.[48] The title of this song supports White's passion for ancient Egypt.

The live recordings and the studio material helped *Gratitude* become another EWF success. *Gratitude* rose to #1 on the *Billboard* Hot Soul Albums chart on January 3, 1976; it stayed in this position for six weeks. The album also rose to #1 on the *Billboard* Hot 200 Albums chart on January 17, where

it stayed for three weeks.[49] The title track for the album was nominated for a Grammy in the category of Best R&B Performance by a Duo or Group with Vocals.[50] *Gratitude* was certified triple platinum in the United States on March 13, 2001, by the RIAA, which equates to at least three million units sold.[51] Later in 1976, Earth, Wind & Fire began working on their next studio album.

SPIRIT

In 1976, America celebrated its Bicentennial on July Fourth. But many African Americans did not perceive America as the "land of the free," nor had they realized the American dream. A series of inconceivable blows to the urban industrial economy caused the nation to collapse into a stagflation nightmare. Racial tension continued to erupt, as the long-fought battle for school desegregation through integrated busing sparked unjustifiable hostility and violence toward African Americans. White flight was on the rise, leaving devastated cities to fall into further decline and governmental neglect.[52] In response to the hostile conditions in American society, Earth, Wind & Fire released the first single from the forthcoming album titled "Getaway" shortly after Independence Day, on July 7.

"Getaway" was written by Bernard Taylor and Peter Cor Belenky, two songwriters who worked with Earth, Wind & Fire. Taylor recorded as a solo artist and composed other songs for EWF, including "Lady Sun" and "Spread Your Love." Belenky spoke about the special meaning of "Getaway": "We were on our own spiritual path and the concept came about as we were basically broke, living in a roach-infested apartment in WATTS! That will make you want to 'Getaway.'"[53] The lyrics to "Getaway" relate to transcendental meditation, practiced and extolled by the members of Earth, Wind & Fire: use the powers of your mind in meditation to get away from the hassles of life, to relax and find yourself.[54]

According to Verdine White, the band members were into meditation. They were also into healthy food, taking vitamins, and reading philosophical books.[55] Learning about different philosophies is what encouraged Earth, Wind & Fire to produce songs with deep, philosophical messages such as "Getaway," which offered Americans, especially African Americans, an escape from a chaotic society.

> So come, take me by the hand
> We'll leave this troubled land
> I know we can, I know we can, I know we can
> Getaway! Let's leave today![56]

The lyrics were revealing in their theme of escapism and implied that the conditions in the 1970s forced African Americans to desire to remove themselves from an oppressive white mainstream society.[57] The escape is not meant to be in the form of an exodus, but by way of the power of the mind by meditation.

Meditation has its origins in civilizations of ancient Africa, Japan, and India. In ancient Egypt, it was traditionally used for calming and regeneration. Basically, a person reaches a balance of the systems of the body and mind. The meditative state enables one to be in the middle of both or at a point of equilibrium and harmony. Meditation involves consciously controlling the rate of breathing, which will in turn decelerate the heartbeat and blood flow. As is the case with sleep, this state of slowness allows the mind and body time to rejuvenate.[58] "Getaway" suggests listeners can find peace and tranquility through the power of meditation. The music for "Getaway" is something special.

"Getaway" begins with a blazing, almost jazzy bebop intro with the Phenix Horns, and the horns are a major factor in the song. At first, Maurice White thought the intro was too long and wanted to get rid of it, but Charles Stepney convinced him to keep it. The song ushered in a new era of the Earth, Wind & Fire sound. From that point onward, the band would use that kind of driving force in their sound.[59] "Getaway" did very well on the music charts and in sales.

"Getaway" reached #1 on the *Billboard* Hot Soul Songs chart on August 7, 1976, and remained in that position for two weeks; it also reached #12 on the *Billboard* Hot 100 Songs chart on October 9.[60] The single sold more than one million copies and was certified gold on October 29 by the RIAA.[61] During the success and popularity of "Getaway," Earth, Wind & Fire released their seventh studio, *Spirit*, in September 1976.

Spirit is remembered as one of the band's best albums and sadly for also being the last project of producer Charles Stepney. Stepney died of a heart attack on May 17, 1976, in Chicago, Illinois, at the age of forty-five. The former Chess Records arranger, producer, instrumentalist, and songwriter had been Maurice White's main collaborator on Earth, Wind & Fire projects.[62] *Spirit* was produced by Maurice White and Charles Stepney to empower the minds of the weary, whose hope and faith were being tested by the burdens of the times. The album features nine tracks: "Getaway," "On Your Face," "Imagination," "Spirit," "Saturday Nite," "Earth, Wind & Fire," "Departure," "Biyo," and "Burnin' Bush."[63] This album was reissued in 1999 and 2014; the second and third editions are discussed in chapters 9 and 12, respectively. *Spirit* is also the first Earth, Wind & Fire album to display Kemetic symbols on the cover.

On the front cover of *Spirit*, the nine band members are standing in front of three white pyramids reminiscent of the pyramids at Giza, Egypt.

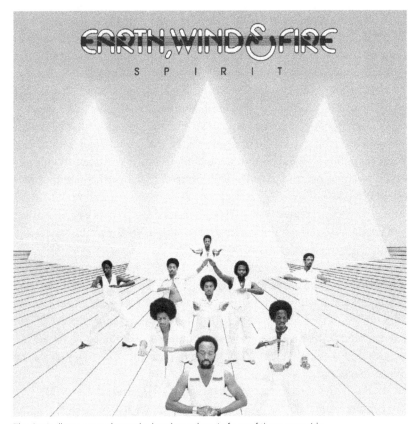

The *Spirit* album cover shows the band members in front of three pyramids.

The cover was designed by art designer and director Tom Steele.[64] Given the traumatic circumstances that arose during its creation, it was clear that Earth, Wind & Fire was mourning not only the passing of their dear mentor, Charles Stepney, but also the state of human affairs. The mood is clearly evident on the album cover, where the band, dressed in white attire, is shown in an African-styled meditative state. The spiritual energy was in full levitation and showed no sign of coming down. The production's fluid slickness was anchored by the band's sophisticated funk personality that White had been developing since its inception.[65] Some people wonder why the pyramids on the album cover don't resemble the Giza pyramids in their current state.

Today, the pyramids at Giza are not white or any other bright color, but rather light brown. But for the first 3,500 years of their history, they were encased in polished white limestone. This must have been an amazing sight in the Egyptian sun! The sun's rays would reflect from the pyramid and it

could shine bright from a far distance. Unfortunately, the limestone covering was stripped in medieval times to build palaces and mosques in Cairo. Now, only the rough building blocks of the pyramids can be seen.[66] The pyramids on the album cover are reminiscent of how the Giza pyramids looked for more than 3,500 years.

When asked about the significance of the pyramids on the *Spirit* cover, White responded, "Dedicated to Charles Stepney sending him on his way."[67] It has become a common belief that the pyramids were gateways to the afterlife for ancient Egyptian rulers. It was the ancient Egyptians' faith in a resurrection of the body for a material afterlife that led them to provide with such extreme care for the protection of the body.[68] Apparently, White believed Stepney was deserving of a great honor like the leaders of ancient Egypt.

The second single from *Spirit*, "Saturday Nite," written by Philip Bailey, Al McKay, and Maurice White, was released on November 13, 1976. It's a funky tune with a horn-laced intro, and the horns are featured throughout, but not to the extent of "Getaway." White chants the lead vocals and Bailey provides his falsetto for the background. This is a song about people going out for a good time while allowing worldly pursuits to distract them from their true selves.[69] "Saturday Nite" peaked at #4 on the *Billboard* Hot Soul Songs chart on January 15, 1977, and at #21 on the *Billboard* Hot 100 Songs chart on January 29.[70]

On April 6, 1977, Earth, Wind & Fire released "On Your Face," written by Philip Bailey, Charles Stepney, and Maurice White. This inspirational groove advises listeners to reach into the depths of their souls to bring optimism to their lives and others.[71]

> Sadness bears no remedy for the problems in your life
> While you run your race, keep a smiling face—
> Help you set your pace[72]

"On Your Face" implies that problems cannot be solved by worrying about them. Problems can only be solved through optimism, faith, and action. It has been said that in order to receive positivity, one must release positive energy. Having faith is what moves God to work on a person's behalf. Negativity and worrying does nothing to make a situation better. "On Your Face" peaked at #26 on the *Billboard* Hot Soul Songs chart on April 23, 1977.[73]

Another inspirational song from this album is the title track, "Spirit," written by Larry Dunn and Maurice White. This song reminds us that the body may die but the spirit lives forever. The music for "Spirit" had been written and recorded years earlier by Dunn. Right after he finished, the normally

gregarious musical director was depressed. He had a feeling something bad would happen but couldn't understand why. Dunn gave Maurice White the track and he shelved it for years. White finally unearthed the piece of music and wrote the lyrics and melody and titled it while he and Charles Stepney prepared for production of the *Spirit* album. It was going to be Stepney's signature song. Dunn recalled, "I got a phone call: Charles Stepney just passed away from a heart attack." His mind went three years back. Dunn stated, "That's why I was so discombobulated that night I wrote it. I made the connection right away."[74]

"Spirit" is dedicated to Charles Stepney. It is a song about immortality. "Spirit" supports the notion that man has a soul and the soul never dies. The ancient Egyptians were among the first people to believe in a soul and the afterlife. There is an ancient Egyptian proverb that states, "Body's sleep becomes the soul's awakening, and closing of the eyes—true vision, pregnant with good my silence, and the utterance of my word begetting good things.[75] The soul's awakening is discussed in the lyrics of "Spirit."

> We must make our brother see
> That the light is he shining on you and me
> And the land he gave, roads we must pave[76]

When the body dies, the soul becomes free and more potent with renewed life.

The people of Kemet (ancient Egypt) believed prayers played a major role in preparing the soul of the recently departed for its journey through the underworld and guarantee its safe passage to God in the next world.[77] This safe passage is called the "Coming Forth by Day," meaning that the soul, in its passage through the underworld, will rise again with renewed life, as the sun, after having set in the west, comes forth again in all its glory in the east.[78] The shining light mentioned in the song may refer to the renewed life acquired during the resurrection. "Spirit" is rightfully titled because both song and album provide spiritual energy for listeners.

An additional song from *Spirit* that speaks positive energy into people is "Earth, Wind & Fire," written by Maurice White and Skip Scarborough. This song alludes to the creation of man and his blessing to dwell on Earth. "Earth, Wind & Fire" has a special message for humanity.

> Born of the Earth, are nature's children
> Fed by the wind, the breath of life
> Judged by the fiery hands of God[79]

This song refers to three of the four elements ancient Egyptians believed composed all matter. Egyptians used the four simple phenomena earth, air (wind), fire, and water to describe the functional roles of the four elements necessary to matter.[80] Notice that water is missing from the elements listed in the song, as it is from the title of the band. This song is about the elements in the band's name. As stated previously, Maurice White purposely omitted water from the title of the band because it is not a part of his astrological sign, Sagittarius. "Earth, Wind & Fire" deals with the elements of matter and religious concepts:

- God molding man from clay (earth)
- God breathing the breath of life into man's nostrils (wind)
- Traditions of hell and hellfire (fire)[81]

"Earth, Wind & Fire" suggests that humans are nature's children. Near the end of the song, Maurice White professes that God's love will guide his children to utter fulfillment. Other songs help make *Spirit* a jewel.

Spirit features fan favorites "Imagination," which features Philip Bailey's incredible falsetto, and "Burnin' Bush," which is a hymn of hope for humanity. The two instrumental tracks, "Departure," arranged by Larry Dunn, and "Biyo," arranged by Maurice White and Al McKay, represent Earth, Wind & Fire's musical versatility and improvisational jazz impulse. With this album, Maurice White considers the burdens of humanity in the light of God's love for the world.[82] *Spirit* is considered a classic by many.

In a *Billboard* magazine album review, *Spirit's* "arrangements, songs, sweet floating vocal harmonies, and punching instrumental phrases are best described as faultless."[83] *Vibe* magazine called *Spirit* "one of the group's defining moments" and "soul for the ages."[84] The *New York Times* described *Spirit* as an album that crosses "any stylistic formats" of music.[85] It's no wonder the album did well on the music charts. *Spirit* rose to #2 on the *Billboard* 200 chart on October 2, 1976, and also to #2 on the *Billboard* Top Soul Albums chart on October 30.[86] The album was nominated for an American Music Award for Favorite Soul/R&B album.[87] *Spirit* was certified double platinum in the United States by the RIAA on October 26, 1984.[88] Earth, Wind & Fire developed a stage show to coincide with the album.

Maurice White admitted that he had gone down a dangerous path when it came to spending money for tours. He got some money for tours from Columbia Records, but it was not nearly enough for what he envisioned. That money was taken out of his royalties. Touring was a monetary problem and a mental strain for White, but he was willing to make the sacrifice to develop

an amazing show. White borrowed money from different sources without letting the other band members know. Only his manager, Bob Cavallo, was privy to the financial issues related to the tours.

For the Spirit Tour, Maurice White wanted an Egyptian-themed stage that reflected the album cover. He envisioned three huge white pyramids with hydraulic doors that opened up and revealed the band waiting inside. At the end of the show, the band would return to the pyramids and the doors would close. With the help of his production manager, Frank Scheidbach, White's desire came to fruition. White gave Scheidbach complete autonomy and financial freedom to make it happen. On the opening night of the tour, when the band came out of the pyramids, the crowd went wild with thunderous applause. The opening cheers helped White realize that the money he spent on the stage props was worth it. The Spirit Tour went to eighty-six cities and was the band's most successful tour to date.[89] Earth, Wind & Fire were soaring with the *Spirit* album and tour. But they were about to go to even higher heights in 1977 with their next album, *All 'N All*. They would also develop a tour that would be remembered for ages.

All 'N All

In 1977, several science fiction movies were produced, including *Close Encounters of the Third Kind* and *Star Wars*. When Maurice White first saw *Star Wars*, he was blown away. He told the members of Earth, Wind & Fire, "We gotta do something like that." According to Philip Bailey, that is why the band featured a pyramid spaceship onstage, combining it with a love of the metaphysics of Egyptology.[1] Maurice White's ongoing interest in many world religions and ideologies became the central themes for the album: holiness and mysticism, not politics. Maurice White was also inspired by a trip to Brazil. He recalled: "I went to Brazil for a vacation. When I came back, I was fresh and ready to start writing. I was affected by what I'd heard there. I think of that album as a turning point in in our maturity musically. That record got everyone's attention." Verdine White insisted, "That was one of the hardest records I ever worked on. We were all in there sweating ourselves into the ground. Maurice was singing, playing drums, producing. And it was one of the best albums we did."[2]

ALL 'N ALL

Al McKay came up with the title of the album. According to Philip Bailey, McKay asked Maurice White, "What are you going to call it?" White responded, "Hmm ... *All* ... something." McKay suggested, "How about *All in All*?" White looked at McKay, and his eyes widened. That look meant that it was a good idea.[3] *All 'N All* features eleven tracks: "Serpentine Fire," "Fantasy," "In the Marketplace (Interlude)," "Jupiter," "Love's Holiday," "Brazilian Rhyme (Beijo)," "I'll Write a Song for You," "Magic Mind," "Runnin'," "Brazilian Rhume (Ponta de Areia)," and "Be Ever Wonderful."[4] A second edition of *All 'N All* was issued in 1999; that edition is discussed in chapter 9.

The gatefold for *All 'N All* is in a class of its own, a visual representation of all that can be most easily expressed in music or painting: elements of

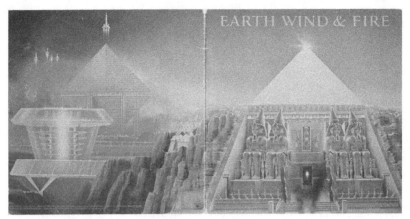

The *All 'N All* gatefold depicts Kemetic monuments on the front and spacecraft on the back.

changing times; symbols of those things that have most influenced human behavior, such as religion, arts, and sciences; and exciting visions of what the future holds for mankind.[5] The gatefold displays Kemetic symbols and the inner sleeve displays symbols from different world religions, such as Christianity, Judaism, Buddhism, as well as ancient Egyptian spirituality. White explained the use of those symbols: "For instance, on EWF's *All 'N All* album, I put a lot of symbols on there purposely to create some curiosity so that people would think and start to raise questions about what life is about, and think about all the symbols that they had been seeing all these years."[6] The cover and inside sleeve for *All 'N All* exemplify White's enthusiasm for Egyptology and metaphysics. *All 'N All* is the first of several Earth, Wind & Fire albums to feature cover art by Japanese artist Shusei Nagaoka.

Shusei Nagaoka's real name was Shuzo Nagaoka. He was born in 1936 in Nagasaki, Japan, and grew up in Iki, Japan. Nagaoka quit Musashino University before completing his studies and went on to establish his career as an illustrator. After moving to the United States in 1970, he based himself in Hollywood and produced album covers for popular artists, including the Carpenters, Electric Light Orchestra, and Earth, Wind & Fire. Nagaoka returned to Japan during the first decade of the twenty-first century and died in 2015.[7]

When Maurice White began working with Shusei Nagaoka, it was difficult to communicate because of the language barrier. White could not speak Japanese and Nagaoka did not speak English. White began their first meeting by showing him pictures in his Egyptian coffee table book as well as books on UFOs. White pointed to the pictures and nodded and Nagaoka began to draw. After that, White gathered bits of paper and drew religious

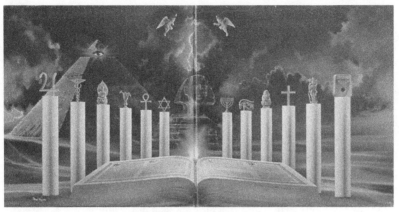

The *All 'N All* inner gatefold displays symbols of religion and enlightenment.

and other iconic symbols on them. White placed the symbols in a pattern on the paper, and Nagaoka started to draw them. Somehow, they communicated. The result was the outside cover and the gatefold for *All 'N All*. White was highly satisfied.[8] Nagaoka's skill led him to illustrate more album covers for Earth, Wind & Fire following *All 'N All*.

On the front of the *All 'N All* gatefold, there is a large pyramid with a bright light at its apex. The pyramid is set on top of the Great Temple at Abu Simbel, which is located in southern Egypt. Pharaoh Ramses II built the temple in the 1200s BCE. Four seated figures of Ramses II are shown at the temple's entrance.[9] Other smaller Kemetic symbols can be seen on the temple. The construction of the Great Temple at Abu Simbel was well-planned, and it is one of the architectural marvels of ancient Egypt. On the back of the *All 'N All* gatefold is a space ship in the shape of a pyramid. This suggests man's ability to travel through the cosmos, physically and spiritually. As stated previously, pyramids are considered by some as gateways to the spiritual realm.

The inside sleeve for the album is just as elaborate as the outside cover. In the background, a pyramid is shown with an eye upon it. This eye could represent the eye of Heru. There is also the Great Sphinx, a symbol of strength and mystery. The Great Sphinx is a large monolithic statue of a lion's body with a human head. It is the largest royal portrait ever made. The face is 13 feet 8 inches across. It is believed by many to portray Khafre, the king who built the second largest pyramid frequently pictured in the Great Sphinx's background. The Sphinx is over 200 feet long and over 60 feet in height.[10] Many scholars believe that mixed images such as the Sphinx symbolize mankind's domination over wild beasts, and over chaos itself.[11] Above the Sphinx

are two angels that may represent spiritual protection and guidance. In the foreground, there are twelve symbols, many of which pertain to world religions, such as Christianity, Judaism, Islam, and Kemetic spirituality.

From the left, the first symbol is the symbol of the planet Jupiter. This symbol resembles the number four. Maurice White's birthday is December 19, 1941. His zodiac sign is Sagittarius. Sagittarius is the archer and Jupiter is the planet of the archers, spreading positivity to them in right constellation. The next symbol is the sign of Paracelsus. It is frequently used as a medical symbol. Paracelsus was a Swiss doctor who pointed out the need of caring for natural life. The third symbol is the Buddha. The primary message for Buddhism is the taking away of personal needs and wishes by meditation to eliminate the personality and reaching a space of freedom.

The fourth symbol is a bird, which could represent the phoenix. The phoenix is a mythical bird that represents immortality or the rebirth of hope. It arose from the ashes of a funeral pyre to live through another lifetime. This bird could also be the Bennu bird or a Ba from Egyptian mythology. The Bennu bird was an imaginary bird resembling a heron. It has long feathers on the crest of its head and was often crowned with the Atef crown of Auser (Osiris) or with the disk of the sun. The Bennu was associated with the sun and represented the Ba or soul of the sun god, Ra.[12]

The next symbol is the ankh. The ankh is a prominent symbol of Kemetic spirituality. It is often seen in the visual art of Earth, Wind & Fire. Since the ankh has been the symbol of eternal life, in this world and in the afterlife, it is connected with tradition in modern times in that it was adopted as the cross of the Coptic Christians in Egypt.[13] The ankh represents not only life but also resurrection, because the ankh is put together by a T-shaped cross and an oval, which is supposed to symbolize reincarnation and is "the key to the gates of life and death."[14] The primary meaning for the ankh is "life."

Next to the ankh is the hexagram. The hexagram is the star of the Jewish people. It also represents other ideas. In the Nsibidi script used among ethnic groups in southern Nigeria, the symbol means passionate love. The hexagram is an old mystic symbol in many cultures and has various spiritual meanings.[15] To the right of the hexagram is a menorah, the candelabra of the Jewish religion. Candlesticks hold light, and many of Earth, Wind & Fire's songs give messages of enlightenment.

The eighth symbol is the Eye of Heru. Heru was an Egyptian sun god with the head shaped like a falcon. The eye of Heru is found frequently in ancient Egyptian art. It is also known as Egyptian eye or third eye. The sun and the moon were the eyes of Heru. The Heru eye embodied the eternally

returning restoration of universal harmony. According to myth, the envious Set tore the eye from his nephew Heru after he killed and dismembered his father, Auser. The moon god, Thoth, restored the eye and healed it. Heru then brought the eye to his father in order for him to give it new life. Since then, the Heru eye has been considered the prototype of the sacrifice ceremony. The left eye of Heru represents the moon and the past, and it received feminine forces. The right eye embodies masculine forces of the sun and the future. Together, the two eyes guarantee the power of omniscience. Therefore, it promises eternal life.[16]

The next symbol is a statue of William Shakespeare, is a symbol for the power of words and intellect. The tenth symbol is the popular Christian cross. This symbol is for the remembrance of Jesus sacrificing his life and the power of his resurrection. The next to last symbol is the Shiva, god of the Hindus. Shiva is the dancing god. His message is "Everything in this universe is a part of the big dance." In other words, everything is connected. All forms of matter are only aspects of one and the same thing, which is the "Eternal Dance."[17] The symbol on the far right is the kalimba, the African thumb piano, which Maurice White plays on several songs. Each symbol is set on top of a pedestal that resembles a candle. The symbols appear to be substitutes for flames, providing illumination. In front of the twelve aforementioned symbols placed beside each other is a Bible. The Bible represents God's word and instruction. All the symbols serve a purpose.

The religious symbols and others on the *All 'N All* gatefold signify man's quest to connect with the creator. When asked about the meaning of the cover for *All 'N All*, Maurice White answered, "Represents the one God."[18] White believed there is more than one way to connect with the one God: "Spiritually, we don't have to walk the same path. I'm not speaking in terms of any denominational religion. I'm talking about a more universal thing. But people should make sure that whatever path they walk is a positive one to instill good things in yourself and others."[19]

The front cover art for *All 'N All* is also displayed in a promotional clip (later known as a music video) for the first single from the album, "Serpentine Fire," which was released on October 15, 1977. "Serpentine Fire" is a mixture of African music, tango, and gospel blues with lyrics about yoga and creative energy. Maurice White declared that the gospel calls of "Oh yeah, oh yeah, oh yeah" made him feel southern and churchy. He believed "Serpentine Fire" is Earth, Wind & Fire's most ambitious single because it is so musically intellectual. It is the complete opposite of the disco music that was dominant during the late 1970s.[20] Of course, the complex horn arrangements help make

the song unique. The promotional clip for the song begins with a display of the front cover of *All 'N All*, which includes an image of the Great Temple at Abu Simbel with the pyramid on top. The camera zooms into the temple and the band performs the song. As the song ends, the camera zooms back to the front exterior of the temple.[21] The band's performance inside a temple may suggest that a spiritual ritual is taking place.

"Serpentine Fire" was written by Maurice White, Verdine White, and Reginald "Sonny" Burke. Burke was a keyboardist/producer who did some work with Earth, Wind & Fire. The serpentine fire is described as one's creative energy—the force that guides a person and makes him/her unique. The deeper explanation comes from Kundalini yoga, where spinal awareness can be achieved by envisioning the body as a serpent. Secretions in the spine can be stimulated to travel from the sex organs to the brain, creating vitality throughout the body—the serpentine fire.[22]

> I wanna see your face in the morning sun ignite my energy
> The cause and effect of you has brought new meaning in my life to me
> Gonna tell the story morning glory all about the serpentine fire[23]

After hearing the song, and even after reading the lyrics, one may still be confused about the song's meaning. An explanation by one of the songwriters is helpful. In order to clarify the meaning, Maurice White gave his own description of the serpentine fire:

> "The Kundalini principle has to do with the fluid in the spine. After 29 days, if used properly, it can be converted into a higher choice. It's called a serpent, because if you tipped the spine out of the body and looked at it, it would look like a serpent—and the fluid is the fire in the spine. Nobody knows what I'm talking about, but a lot of kids go out and look it up and immediately it expands their consciousness."[24]

White's primary goal was to raise people's consciousness. People's curiosity about "Serpentine Fire" let him know that his lyrics were intriguing. Philip Bailey declared, "Maurice is a student of all kinds of different cultures and spiritual philosophies. All the stuff he'd write about, like 'Serpentine Fire,' really separated us from the other bands. It gave us a specialness, an identity, and it raised the level of consciousness and awareness for what we were doing."[25] "Serpentine Fire" is a song about yoga. Verdine White is a yoga enthusiast and has a serious aptitude for it.[26] When most people think of yoga, they think of India, but yoga can be traced back to ancient Egypt.

Yoga principles have been discovered in the thirteen surviving chapters of the *Corpus Hermeticum*, a collection of essays attributed to the legendary Egyptian master Thoth, who was known as Hermes by the Greeks. To Thoth we may attribute writing, medicine, chemistry, law, rhetoric, the higher aspects of mathematics, astronomy and astrology, and the early Egyptian understanding of the intricate dynamics of universal order.[27] As African people migrated to India, the science of yoga was adopted and became a key component of the Hindu religion. Confusion about the religious aspects stops some people from getting involved with yoga. Krishna Kaur, a Los Angeles Kemetic yoga instructor, claims yoga should not conflict with Christian beliefs. She explains, "Yoga is not a religion, it is an art and a science. It is guided by the universal laws of nature." Kemetic yoga performs movements and postures that are depicted on the wall paintings and hieroglyphics found in ancient Egypt.[28] If there is any doubt if "Serpentine Fire" has a Kemetic theme, Verdine White confirmed that it does. When asked about songs with Kemetic themes, "Serpentine Fire" was the first song he mentioned. He proclaimed, "That's one that reflects that." He added, "'Serpentine Fire' obviously has Egyptology."[29]

"Serpentine Fire" was a commercial success. The song rose to #1 on the *Billboard* Hot Soul Songs chart on November 19, 1977, and remained there for seven weeks; it also rose to #13 on the *Billboard* Hot 100 Songs chart on February 11, 1978.[30] The next single, "Fantasy," was also confirmed by Verdine White to have Kemetic themes.[31]

"Fantasy" was released in January 1978. It was written by Maurice White, Verdine White, and Eddie del Barrio, a keyboardist/composer who worked with Earth, Wind & Fire.[32] Maurice White found inspiration from the movie *Close Encounters of the Third Kind*. He was caught up in the symbolism and stereotypical meanings. The aliens' implantation of a vision into the Richard Dreyfuss character and the mythic elements of communicating with a deity stirred his imagination. The movie's acknowledgment of a primal spiritual yearning in all of us resonated deeply with Maurice White. He had been reading about reincarnation and past lives, how we are born into the future through death. All those factors and others led to the gist of this Brazilian music–infused song.[33]

The vocals for "Fantasy" begin with Philip Bailey's falsetto reminding us that everyone has a fantasy in his/her heart and that it is possible for dreams to come true.[34] The listener is encouraged to focus on the heart and inner man. "Fantasy" informs the listener of how powerful thoughts are. Thoughts have the power to create action in the physical world. In other words, it is the spiritual realm that governs the physical realm. The chorus of the song invites listeners to a euphoric land called Fantasy:

Come to see victory
In a land called fantasy
Loving life, a new degree
Bring your mind to everlasting liberty[35]

This chorus is about escaping to a place of ecstasy. As in other Earth, Wind
& Fire songs, "Fantasy" encourages people to use their minds to find a place
of contentment to get away from life's troubles. The extraterrestrial themes
in "Fantasy" and contemporary popular music occur within the realm of
what cultural critic Mark Dery terms "Afro-futurism."

Afro-futurism refers to African American signification that uses images
of advanced technology (fantasii) and alien and or prosthetically enhanced
(other kind) features. Afro-futuristic art is usually concerned with Black
nationalism and empowerment and the creation of mythologies based on
the confrontation between historical prophetic imagination, such as Kemetic
(ancient Egyptian) themes of the afterlife, and modern alienated Black exis-
tence. As Mark Dery discerns, African Americans are, in a true sense, the
descendants of alien abductees (people stolen from Africa). Sociologist Paul
Gilroy claims that Afro-futurism deals with the history of dispersed peoples
(African descendants of slaves) and the space that results from the dispersal.
This dispersal is an interruption of time and space that governs modern Black
politics. Therefore, Africans dispersed in the Western Hemisphere seek to
return to a homeland that is out of reach. In some sense, that homeland is
an imaginary utopia that outer space metaphorically represents.[36] "Fantasy"
is the epitome of Afro-futurism. The song tells of a utopia that is far away.
Philip Bailey's falsetto helps figuratively send the listener to that utopia.

For Earth, Wind & Fire, rising to higher heights through falsetto is the
rule and not the exception. Earth, Wind & Fire consciously uses falsetto
throughout "Fantasy" to reach the heights of which they are singing. With
Philip Bailey singing in his signature falsetto, EWF invites you to "take a ride
/ in a ship called fantasii," and the song does exactly what it promises. The
song takes you for a ride and takes you to the skies. A mixture of bold escap-
ism and utopianism, the message is confirmed by its extravagant literalism.
Bailey's voice is higher than all the others, sailing over the words. It is clear
that his voice is already coming from the ship fantasii.[37]

It should be understood that this song is about leaving this world and
traveling through the cosmos to experience a better environment and exis-
tence. The lyrics make the message plain. It is clearly about escape. Maurice
White explained this in British music weekly *Melody Maker*:

The song "Fantasy" is motivated about escapism in the sense of living on a world that is untrue, a world that is unjust, a world that is very selfish and envious, there is a place that everyone can escape to which is their own fantasy. I had to write the song in the sense of sharing this place with people. It's an escape mechanism.[38]

The song mentions the soul being in ecstasy. This concept can be found in several religions.

Christians told Maurice White that if the word *fantasy* is replaced with *heaven*, they understand what the song is about. "Fantasy" is about heaven to Christians. It is about nirvana to Buddhists, and some Muslims believe it is about paradise.[39] As stated previously, the belief in an afterlife was found among the ancient Egyptians. They were among the first people to believe in a human soul and that it is immortal. The hope of eternal happiness (heaven) is what "Fantasy" is about.

This song did well on the music charts. "Fantasy" reached #12 on the *Billboard* Hot Soul Songs chart on March 25, 1978, and #32 on the *Billboard* Hot 100 Songs chart on April 22. In addition to its success on the music charts, "Fantasy" received a Grammy Award nomination for Best R&B Song.[40]

The third single from the album is "Jupiter," released in April 1978, and written by Maurice White, Verdine White, Philip Bailey, and Larry Dunn. This is one of the funkiest tracks by Earth, Wind & Fire, consisting of a strong bassline and polished horns. Maurice White wrote that "Jupiter" speaks to an ageless, ancient, and transcendental spiritual wisdom. He gave this description for other songs, including "Serpentine Fire," "Fantasy," and "In the Stone."[41] When thinking about songs dealing with Egyptology, Ralph Johnson stated, "The first song that comes to mind is 'Jupiter.'"[42] While listening to "Jupiter," one may think it is a song about science fiction. It features a character named Jupiter who travels to Earth from a distant planet.

> The name is Jupiter, from the galaxy
> I came to meet you, to make you free
> Deliver to you a flower from
> A distant planet, from where I come[43]

"Jupiter" deals with mystery and wisdom. The song speaks of a mysterious man with knowledge. The man coming from a distant planet can be a metaphor for a place in ancient times: Egypt. Ancient Egypt has been studied for its advanced knowledge and contributions to civilization. The song also

speaks of righteousness and love for one's fellow man. Love and good will are common themes in EWF songs and ancient Egyptian philosophy. If we are to become informed about the world around us, we can start with the sciences of ancient Egypt.

In ancient Egypt, centers of learning have been labeled "Mystery Schools." These schools, and the subjects taught therein, were a mystery only to those unfamiliar with that system of education. The purpose of education in ancient Egypt was to create a nation where people would understand the relationship which existed between themselves and the universe. These "Mystery Schools" were the first universities. They were called "Mystery Schools" by foreigners who came there seeking enlightenment.[44] "Jupiter" encourages the listener to become enlightened by keeping his/her eye on an extraordinary source: Jupiter. When Earth, Wind & Fire performed this song on their tour in 2017, images of flying pyramids were displayed on the large screen. This song has long intrigued Earth, Wind & Fire listeners.

Philip Bailey wrote about an encounter he had with a fan inquiring about the song. One day at a hotel in Atlanta, Earth, Wind & Fire encountered a horde of fans. One female fan ran up to Bailey in a seeming panic. She shouted "Jupiter! Jupiter! What is the answer?" To that woman, the song was compelling as if it held the key to the secrets of the universe. She was searching for meaning in her own life and believed Bailey could help her.[45] Her reaction is an indication of how EWF's music affected their listeners. "Jupiter" did not chart in the United States, but it rose to #41 on the UK singles chart on May 13, 1978.[46]

The fourth and final single released from *All 'N All*, "Magic Mind," was released in July. "Magic Mind" was written by Philip Bailey, Larry Dunn, Al McKay, Fred White, Maurice White, and Verdine White. According to Larry Dunn, it is a song about how people do stupid stuff. When Maurice White was writing the lyrics to the song, it actually started out with the title "Midget Mind." But Maurice White decided on "Magic Mind." Larry Dunn declared, "It was a brilliant move on his part because he didn't want to get caught up in that political incorrectness."[47] Maurice White was always conscious about what he presented to the world. "Magic Mind" did not make the music charts in America but reached #54 on the UK charts on July 29.[48]

Other songs from *All 'N All* not released as singles became favorites among EWF fans. "Brazilian Rhyme (Beijo)" is just a flighty eighty-second groove, but thanks to its falsetto disco call, "Beijo! Beijo! Ba da ba ba ba!," its impact on hip-hop would be monumental. DJs from New York's earliest days of the genre would spin the track for MCs to rhyme over. Southern

rap pioneer MC Shy D sampled it for his hard-rocking 1987 single "I've Got to Be Tough." A Tribe Called Quest used it to fill out their groundbreaking debut, *People's Instinctive Travels and the Paths of Rhythm* and Big Punisher couldn't resist copping it for his iconic 1998 Top 40 hit "Still Not a Player." Everyone from the Black Eyed Peas to MF Doom have joyfully borrowed its ecstatic hook. "Beijo" is, after all, Portuguese for "kiss."[49]

There are also popular ballads included on *All 'N All*. "Love's Holiday," "Be Ever Wonderful," and "I'll Write a Song for You" are ballads that have become classics among Earth, Wind & Fire fans. "Love's Holiday" and "Be Ever Wonderful features Maurice White on lead vocals, and "I'll Write a Song For You" features the surreal falsetto of Philip Bailey. Another song, "Runnin'," won a Grammy Award for Best R&B Instrumental.[50]

All 'N All won a Grammy Award for Best R&B Vocal Performance By A Duo, Group or Chorus.[51] The album was also nominated for an American Music Award in the category of Favorite Soul/R&B Album.[52] *All 'N All* spent nine weeks at the top of the *Billboard* Top Soul Albums chart beginning on December 17, 1977. The album also rose to #3 on the *Billboard* 200 chart on January 7, 1978.[53] *All 'N All* has sold over three million copies and was certified triple platinum on November 14, 1994, by the RIAA.[54]

The album also received good reports from critics. Monroe Anderson of the *Chicago Tribune* claimed that *All 'N All* is a rare blend of poetry, passion, and artistic progression.[55] Alex Henderson of AllMusic believes *All 'N All* is a highly rewarding addition to Earth, Wind & Fire's catalog, stating: "Because EWF had such a clean-cut image and fared so well with pop audiences, some people may have forgotten just how sweaty its funk could be." But "Jupiter" underscores the fact that the band delivered some of the most intense and gutsy funk of the 1970s.[56] To coincide with this great album, Earth, Wind & Fire developed a tour that would set them apart from their peers and make them one of the greatest live acts in the world.

By the mid-1970s, funk artists were developing colorful stage shows. George Clinton of Parliament adopted the "mothership" as a stage prop. Several funk-soul groups like the Sylvers, LaBelle, the Isley Brothers, and Commodores wore futuristic rubberized shoulder pads and mirrored jumpsuits with pride, transmitting hugely flared funk signals from another, better world. These were aspects of Afro-futurism. Earth, Wind & Fire used illusionists Doug Henning and David Copperfield to develop a stage show that rivaled the best of funk bands. On stage, the band conjured up links with Egyptology, African mysticism, and interplanetary travel to show how their horn-led (and by mid-decade hugely successful) brand of joyous jazz-funk-soul

recognized no barriers of time or place. EWF had already used pyramids in their concerts. These pyramids represented spaceships that were similar to a vehicle George Clinton used called the mothership.

In a particular manner of Afro-futurism, George Clinton and Parliament-Funkadelic drew heavily upon outer space and alien themes. Clinton assumed the alter ego of an alien named Starchild who was sent down from the mothership to bring funk music to earthlings. Starchild was a symbolic representation of freedom and positive energy. This alien and mothership represented an empowering and socially activist image of African American society during the 1970s.[57] The same can be said for the pyramids and alien characters Earth, Wind & Fire used.

In funk music, the "mothership" is the centerpiece of Afrocentricity and of escape. The original space traveler imagery had been created by jazz wizard Sun Ra. His indulgence in numerology, Egyptology, astrology, and a variety of cosmic insights introduced an intergalactic orientation to improvisational music.[58] This mixture of escapism and utopianism was all part of a cultural response to the crisis that enveloped the Black liberation movement. Historically, what was significant about these visions was that, by the early 1970s, it was only in outer space or in a parallel world conjured up by religious mysticism, magic, drugs, or through some romanticized vision of an African past, that it was really possible to envision interracial—or even Black—harmony.[59]

The link between Sun Ra and many funk groups of the 1970s is clear. His unique spiritual assortment surfaced in the costumes, stage props, and performance behavior of Earth, Wind & Fire.[60] Like Sun Ra, Maurice White saw himself as a spiritual leader with a divine mandate. White encouraged his band members to resist smoking and drinking, and he encouraged a healthy diet. Before each concert, White required twenty minutes of meditation in a prayer circle. In the November 8, 1976, issue of *People*, he stated, "This band has a very positive effect on people. . . . I feel we were elected to this by a higher force."[61] Like the *Spirit* Tour, EWF's affection for Egyptology was exemplified even more during the *All 'N All* Tour.

The *All 'N All* Tour began on November 2, 1977, in Cincinnati, Ohio. Appearing with Earth, Wind & Fire were Deniece Williams and Pockets.[62] For this tour Earth, Wind & Fire intensified their concerts. They used magic tricks and pyramids as stage props. The band members would climb inside the pyramids, and then the pyramids would explode and shatter, only to reveal the musicians safe and sound, standing among the audience.[63]

To perform the magic tricks, Maurice White recruited the famous magician, Doug Henning. Doug Henning was known all over the world for his magic tricks performed on television, Broadway, and in Las Vegas. Henning

was born on May 3, 1947, in Fort Garry, Manitoba, Canada. After graduating
with a degree in psychology from McMaster College in Hamilton, Ontario,
he won a grant from the Canadian government to study magic by convinc-
ing government officials that it could be considered an art form. Using the
$4,000 in grant money and raising thousands more, Henning developed a
successful stage show, *Spellbound*, which occurred in Toronto.

In May 1974, Doug Henning took his magic to Broadway with *The Magic
Show*; it ran for four and a half years. During this time, he also performed
at casinos in Las Vegas and Lake Tahoe. His success continued into the
mid-1980s until he retired. Then, he sold some of his most famous illusions
to another famous magician, David Copperfield, who began working with
Earth, Wind & Fire in 1979. Henning died in 2000 at the age of fifty-two after
a short battle with liver cancer. He is credited with singlehandedly reviving
the public's interest in magic after a long slump.[64]

Doug Henning created fantastic illusions for Earth, Wind & Fire. One
illusion consisted of hooded aliens with masks gradually joining the mem-
bers of the band. Then, one by one, the band members entered a metallic
pyramid, leaving the hooded aliens onstage. The pyramid took off skyward
then exploded. To the audience's amazement, the band members revealed
themselves as the hooded aliens, as if they had been transported from the
exploding pyramid to the stage.[65] It was definitely a unique experience for
those who attended the concerts on this tour.

Robert Palmer of the *New York Times* cited an air of mysticism in his
review of Earth, Wind & Fire's November 1977 concert at Madison Square
Garden:

> Men in spacesuits, their features hidden behind tinted glass visors,
> appear on the stage toward the end of Earth, Wind & Fire's new show,
> which was at Madison Square Garden on Thursday and Friday. They
> supervise the lowering of a pyramid-shaped space craft onto a raised
> platform and one by one the members of the band disappear into it.
> The thing takes off, hoisted smoothly up into the air, and then there is
> a puff of smoke and it bursts apart. It is empty. The men in the space
> suits turn to face the audience and remove their helmets. They are the
> same musicians who disappeared into the pyramid moments before.
> . . . This superior bit of parlor magic on a grand scale is just the sort
> of thing that makes Earth, Wind & Fire special. It is flashy, and the
> band is certainly that, with its brilliantly colored costumes, energetic
> showmanship, and espousal of various aspects of mysticism. But it is
> also magic, or illusion, to give it its proper name, of the very best kind

because it stretches the imaginations and conceptual boundaries of
its viewers.[66]

The pyramids were used as spaceships, signifying man's ability to travel
through the cosmos physically while the original pyramids of Giza signify
traveling spiritually, as they have been considered gateways to the afterlife.
 The largest of the pyramids at Giza, the pyramid of Khufu, which is also
called the Great Pyramid, provides the greatest riddle. Often characterized
as a book in stone, it can be shown that its shape and orientation toward
the north release a kind of energy, which provides maintenance of the life
forces and aids to preservation. It is suspected that the large pyramids of Giza
involve a kind of dedication center, in which the initiates are led through
various stages to enlightenment. On the path, the disciple passes through
the death process to the other side, then returns transformed to the world of
the living.[67] This ritual is similar to Earth, Wind & Fire's reappearance from
the pyramids on stage. When the band members are standing in front of the
audience, they are figuratively returning to the world of the living, which is
represented by the audience. This stage act is open to interpretation.
 Ronald Kisner, an observer of a concert from the *All 'N All* Tour, wrote
about his experience in a 1978 issue of *Jet*.

> The lights were dim and, as if on cue, a chorus of shrieks ring out in
> the dark and suddenly, the Los Angeles Forum has that spooky grave-
> yard feeling about it. Overhead spotlights crisscross against the glass
> cylinders as a siren shrills hauntingly in the background. A cloudy
> mist begins to encircle the base of the cylinders and the mind is now
> racing into imagination overdrive. Is something about to explode?
> You're watching closely and Presto! Imperceptibly the cylinders fill
> with nine caped men who look like refugees from a *Star Wars* space
> station than who they really are: Earth, Wind & Fire. Leaping from
> their tubes, the band members swirl their capes in the air like moon-
> age bull fighters as they position themselves behind instruments and
> stage mics prepping to explode into their opening number "Fantasy."[68]

The space themes used by funk and soul artists were a figurative alternative
for escape from oppression, because neither nonviolence nor militancy had
proven efficient. Therefore, the space vehicle signifies freedom and liberation
by creating a modern meeting site that travels to outer space as the social,
political, and economic conditions for many African Americans during the
1970s were not consistently improving.[69]

Wayne Vaughn, a musician and close friend of Maurice White, also gives insight about the extravagant Earth, Wind & Fire concerts. Vaughn is from Los Angeles, California, and attended Los Angeles City College and the University of California at Los Angeles, where he majored in music composition. He has worked with Quincy Jones and the Brothers Johnson. While on tour with the Brothers Johnson, he met his wife, Wanda Hutchinson, who is a member of female soul group the Emotions. Wanda introduced Wayne to Maurice White around 1978. Wayne Vaughn is a songwriter and composer who worked on Earth, Wind & Fire's hit songs "Let's Groove" and "Side by Side." Discussing the pyramids in the concerts, Vaughn stated:

> They were more or less going into the mystic, the illusion. But don't forget when they had Verdine levitate. It was just representing the fact that man, probably back in the pyramid days, had more mystical powers, had a third eye. How did they make the pyramids? They still can't make a pyramid today. There's a lot of unanswered questions. If you stretch your intellectual curiosity, things that you think you know, the smarter you get, you know that you don't know nothing. The more information you receive, the more questions you come up with. I think Maurice was trying to bring in a little curiosity, a little "you gone find out for yourself" kind of thing of things he was experimenting or discovering or questioning himself.[70]

The pyramid is basically a symbol of ancient mysticism. Today, people still wonder how the Great Pyramid and others were built. The pyramid is featured on some of the albums after *All 'N All*. After the success of the *All 'N All* album and tour, Earth, Wind & Fire was still flying high, and they would remain on a high for a while.

See the Light

In 1977, before the *All 'N All* tour had even begun, Maurice White was approached by the Bee Gees' manager, Robert Stigwood. Stigwood wanted Earth, Wind & Fire to appear as guests in a movie musical based on the Beatles album *Sgt. Pepper's Lonely Hearts Club Band*. The band was expected to do a cover of one of the Beatles' songs for the soundtrack. White agreed. But with EWF's busy schedule, after a few months, White had forgotten about it. When the project was brought to White's remembrance, he had only three weeks to complete the cover. By this time, many of the songs he was given to choose from were taken, but "Got to Get You into My Life" was available, and the band chose to cover it.[1]

Earth, Wind & Fire's cover version of "Got to Get You into My Life" was recorded in about forty-eight hours. To film the band's segment for the movie, they went to the MGM backlot in Culver City, California. There was no real planning for the scene. The band simply bought their road show to the stage. As soon as you hear the mesmerizing Phenix Horns in the intro, you know this song is a gem. The director of the film, Michael Schultz, was very impressed. Schultz stated to Maurice White, "You guys having those tubes coming down from the sky and all, I felt like I was at an Earth, Wind & Fire concert. All I had to do is point the cameras and say cut!" Unlike the other artists in the film, Maurice White decided to put their own spin to the cover. But there was an accurate prediction that the movie was going to flop.[2] After the filming, the *All 'N All* tour continued.

Also during the tour, EWF was asked to appear on *The Natalie Cole Special* in March 1978. Earth, Wind & Fire performed a medley of "Serpentine Fire," "Saturday Nite," "Can't Hide Love," "Reasons," and "That's the Way of the World." Natalie Cole sang along with the band on "That's the Way of the World." Maurice White believed this was the band's best television performance.[3] After this appearance, EWF continued the tour. They also had unfinished business with *Sgt. Pepper's Lonely Hearts Club Band*.

After the studio showed Earth, Wind & Fire a rough cut of *Sgt. Pepper's Lonely Hearts Club Band,* they knew it would be a loser from the start. Some of the other songs on the soundtrack sounded too similar to the original versions. The film was destined to be another EWF bomb at the box office like *That's the Way of the World.* But this time, the band did not cry. They had a plan. Columbia Records swiftly released "Got to Get You into My Life," and by the time the movie was released, the song was already a hit climbing the charts.[4]

THE BEST OF EARTH, WIND & FIRE, VOL. 1

"Got to Get You into My Life" was released on July 14, 1978. Earth, Wind & Fire's version of this song contains more energy and pomp. The song begins with an electrifying intro and moves into a soulful funk groove with punching horn riffs and smooth vocals. With "Got to Get You into My Life," Earth, Wind & Fire reached another milestone in their superb career by becoming the first Black group ever to enter *Record World's* Pop and R&B Charts as "Chartmaker of the Week." "Got to Get You into My Life" broke into the Pop charts at #48 with a bullet and into the R&B charts at #41 with a bullet.[5] The single eventually reached #9 on the *Billboard* Hot 100 Songs chart on September 16, 1978, and #1 on the *Billboard* Hot Soul Songs chart on September 23.[6] The band was praised for their rendition of this Beatles song.

Musician and former Beatles member Paul McCartney claimed that Earth, Wind & Fire's version of "Got to Get You into My Life" is his favorite Beatles cover.[7] Ed Hogan of AllMusic declared that EWF did a great remake of the song.[8] "Got to Get You into My Life" won a Grammy Award for Best Instrumental Arrangement Accompanying Vocalist(s).[9] The song was also Grammy nominated for Best Pop Performance by a Duo or Group with Vocals.[10] As stated previously, "Got to Get You into My Life" was featured on the soundtrack for *Sgt. Pepper's Lonely Hearts Club Band.* But this cover took on a life of its own, thanks largely to its prime placement on *The Best of Earth, Wind & Fire, Vol. 1,* ensuring that generations of fans love the easygoing EWF groove as much or more than the original version.

Before the next single was released, Maurice White started his own record label, the American Recording Company (ARC) in a deal worked out with Columbia Records. The label would be distributed through CBS. The initial artists on the roster were Earth, Wind & Fire, the Emotions, D. J. Rogers, Weather Report, Deniece Williams, Reggie Knighton, and Valerie Carter.[11] The insignia ARC would appear above the familiar red Columbia Records

logo on future EWF records. Fueled by money he acquired from Columbia Records to debut ARC, White built a lavish headquarters for ARC that was called the Complex. The Complex consisted of offices, a recording studio, and rehearsal rooms.[12] The first song released on the new label was "September" by Earth, Wind & Fire.

September" is also featured on *The Best of Earth, Wind & Fire, Vol. 1* and was released on November 18, 1978. It was written by Maurice White, Al McKay, and Allee Willis specifically for this greatest hits album. According to Maurice White, he got the idea for "September" from a hotel room in Washington, DC, while there was a protest going on below. White stated, "There's all these cats screaming and throwing things and going crazy and this tune just evolved."[13] "September" is the first song that legendary songwriter Allee Willis wrote with EWF.

Maurice White wanted Allee Willis and other collaborators with him to understand that nonconformity and curiosity always lead to heightened creativity. That is why he had her read certain books, including *The Greatest Salesman in the World*. White wanted to expose Willis to different things and take her out of the norms of conventional thinking. White believed that inhibitions kill imagination, and mysticism helps keep it alive. He also wanted to give her a language that would hip her to write lyrics in a philosophical manner, even love songs.[14]

According to Willis, she was reading books for a couple of months. Lyrics started being twenty-five to thirty pages long as she was trying to figure it all out. Willis stated, "Reading all those books changed me forever. He led me to a path I've stayed on." For Willis, "September" was exciting and thrilling. When she first heard the music, she knew it would be a hit.[15] The first words of this song have become a staple of pop culture.

> Do you remember the 21st night of September?
> Love was changing the minds of pretenders
> While chasing the clouds away[16]

Many people have wondered why the 21st was chosen for the date in the song. Willis declared that White always told her there was no real significance; it was just something that sang really well. Willis claimed that White taught her to never let a lyric get in the way of a groove. Ironically, the first song Willis wrote for Earth, Wind & Fire was not philosophical. It was simply a song about having a good time and being happy. In the beginning, the hook of the song was troubling for Willis.

Many people hear the first words in the chorus as "Party-on." It is actually "Ba-de-ya." Willis stated: "I actually could not deal with lyrics that were nonsensical, or lines that weren't complete sentences. And I'm exceedingly happy that I lost that attitude." She told Maurice White that he couldn't leave "ba-de-ya" in the chorus. She felt that it should mean something. White replied, "No, that feels great. That's what people are going to remember. We're leaving it."[17] White's idea worked. "September" became a smash hit.

"September" consists of faultless horn arrangements and gentle guitar riffs, along with Maurice White's smooth tenor on lead and Philip Bailey's falsetto in the chorus. This song represents White's talent for writing joyously optimistic soul anthems. At the song's center are the soaring Phenix Horns and Philip Bailey's falsetto vocalese closing the song by riffing, "Ba-de-ya-de-ya-de-ya." It was a throwback reference to the days of doo-wop, White told *Billboard* in 1979. "My principle for producing is to pay attention to the roots of America, which is doo-wop music."[18] A promotional clip was made for the song. In the clip, the band members are performing on stage in elaborate African-styled costumes.[19] This helped the song do extremely well on the music charts and in sales.

"September" rose to #1 on the *Billboard* Hot Soul Songs chart on January 13, 1979, and #9 on the *Billboard* Hot 100 Songs chart on February 10.[20] "September" was certified gold in the United States (before 1989, gold equaled one million sales) on January 23, 1979.[21] "September" has become a favorite for many people across the globe. It is one of EWF's most requested songs. Verdine White has spoken about the song's lasting influence. He declared, "People are now getting married on September 21st. The stock market goes up on September 21st. Every kid I know that is in their 20s, they always thank me because they were born on September 21st."[22]

The Best of Earth, Wind & Fire, Vol. 1, released in November 1978, features ten songs. The seven previously released tracks include "Fantasy," "Can't Hide Love," "Getaway," "That's the Way of the World," "Shining Star," "Reasons," and "Sing a Song." The three previously unreleased tracks include "Got to Get You into My Life," "Love Music," and "September."[23] This compilation was reissued in 1999; that edition is discussed in chapter 9. On the cover of this album is what appears to be a gold coin with the full image of the ancient Egyptian god Heru, also known as Horus.

"Horus" is the Greek name for Heru. Heru is depicted as a falcon with wings spread while holding a shen ring and an ankh in each of its talons. A shen ring is a circle with a line at a tangent to it, which was represented in hieroglyphics as a loop of a rope. It symbolized eternal protection.[24] As

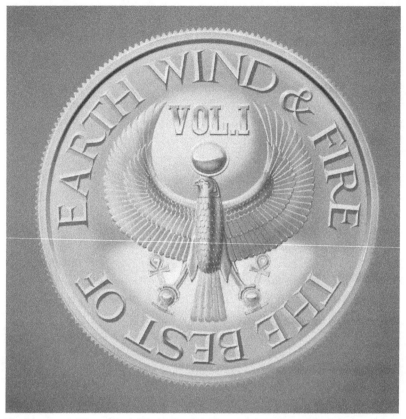

The front cover of *Best of Earth, Wind & Fire, Vol. 1* features the Kemetic deity Heru.

1. Shining Star
2. That's the Way of the World
3. September
4. Can't Hide Love
5. Got To Get You Into My Life
6. Sing a Song
7. Gratitude
8. Serpentine Fire
9. Fantasy
10. Kalimba Story
11. Mighty Mighty
12. Reasons
13. Saturday Night
14. Let's Groove
15. Boogie Wonderland
16. After The Love Has Gone
17. Getaway

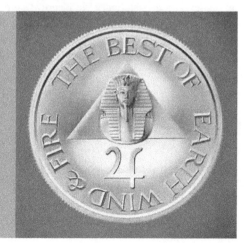

The back cover of *Best of Earth, Wind & Fire, Vol. 1* displays a pharaoh in front of a pyramid.

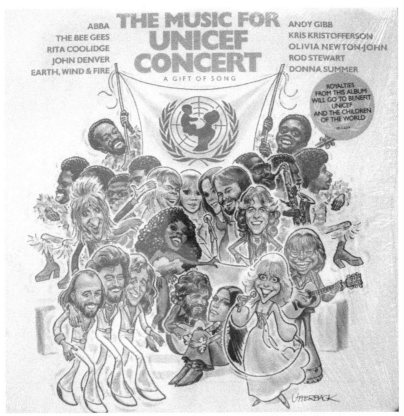

Album cover for *The Music for UNICEF Concert: A Gift of Song*. The EWF members are depicted at the top of the group of artists.

stated previously, the ankh also represents eternal life. By holding the shen rings and the ankhs, Heru appears to have control of life eternal. When Heru referred to himself, he stated, "I am Heru distant of place from people and gods."[25] The name of Heru exemplifies his greatness and supremacy. On the back of the album cover is what appears to be the opposite side of the gold coin. On the flip side of the coin is an image of an Egyptian Pharaoh wearing the royal headdress. Behind the head of the Pharaoh is a pyramid. The symbols on this cover may have drawn people to the album.

The Best of Earth, Wind & Fire, Vol. 1 rose to #3 on the *Billboard* Top Soul Albums chart on January 6, 1979, and to #6 on the *Billboard* 200 chart on January 27.[26] *The Best of Earth, Wind & Fire, Vol. 1* did remarkably well in sales. It was certified triple platinum in the United States by the RIAA on March 13, 2001. After the album's success, Earth, Wind & Fire were in great

This Tour of the World 1979 poster displays the Kemetic deity Heru.

demand. In early 1979, the band was asked to perform at a United Nations Children's Fund (UNICEF) concert.

The Music for UNICEF Concert: A Gift of Song was a televised special and benefits concert held at the General Assembly of the United Nations to raise money and awareness for UNICEF. It also kicked off UNICEF's International Year of the Child. For the concert, Earth, Wind & Fire prerecorded the track and sang the lead vocals live. They performed a medley of "September" and "That's the Way of the World." Famed artists who performed in the concert included Donna Summer, ABBA, the Bee Gees, Rod Stewart, and others.[27]

Also in early 1979, Earth, Wind & Fire began what they called the Tour of the World 1979. For this tour, Earth, Wind & Fire enlisted magician David

Copperfield. Copperfield had studied with Doug Henning but had branched out on his own. His illusions were executed very technically. He developed an astounding disappearing act for the band that boggled the mind. George Faison was once again on board to work the choreography for the band.[28] For Earth, Wind & Fire, a good portion of 1979 was spent overseas, headlining shows in Europe and Japan. It seemed as if the band could do no wrong. Philip Bailey declared, "When we sold out five nights at Wembley in London, that's when I knew we had transcended our US success."[29]

During the tour, Maurice White decided to take the band to an endearing place: Egypt. On March 19, 1979, Maurice White took everyone, band and crews, to Egypt for a few days of sightseeing and rest. They left Paris and arrived in Cairo on a clear sunny day. They went to all the great sights, including the pyramids, the Great Sphinx, and the Abu Simbel temples, which was the inspiration for the *All 'N All* cover. For White, his time in Egypt was a spiritual pilgrimage. Walking into the pyramids gave him a feeling of destiny. White declared, "I got a feeling that I was stepping into my heritage, my DNA, my ancestors' true greatness. It validated my inclination to link the public persons of Earth, Wind & Fire to the planet's ancestral home—Black folks' ancestral home, my ancestral home."[30] Back in America, the band was hot and about to get even hotter.

I AM

By mid-1979, disco music was at its peak. Earth, Wind & Fire's next song, "Boogie Wonderland," would be their contribution to the genre. The song was released on May 6, 1979. It was the first single released from their next album, *I Am.* "Boogie Wonderland" was written by Allie Willis and Jon Lind. The song was inspired by the movie *Looking for Mr. Goodbar*, which stars Diane Keaton as a troubled soul who goes to clubs every night to dance away her misery. Willis explained, "When I saw *Mr. Goodbar*, I got kind of fascinated with people who did go to clubs every night, whose life was kind of falling apart, but they lived for the night life, though it didn't seem to be advancing them as humans in the end."[31] The mood of "Boogie Wonderland" is different from that of "September," the previous EWF song co-written by Allie Willis.

When speaking about the mood of "Boogie Wonderland," Allie Willis declared: "It's not a happy song at all. It's really about someone on the brink of self-destruction who goes to these clubs to try and find more, but is at least aware of the fact that if there's something like true love, that is something that could kind of drag them out of the abyss."[32]

The mirror stares you in the face
And says, "Baby, uh, uh, it don't work"
You say your prayers though you don't care
You dance and shake the hurt[33]

For the writers of the song, Boogie Wonderland was a state of mind that one entered when one was around music and dance. Hopefully, it was an aware enough state of mind that one would want to feel as good during the day as at night. At first, Earth, Wind & Fire had reservations about recording the song.

Maurice White was unsure if "Boogie Wonderland" would be a good fit for Earth, Wind & Fire. In the studio, Larry Dunn and Verdine White convinced Maurice it would work if they recorded it in that special EWF way. Disco was ubiquitous and positive-sounding. The concern for Earth, Wind & Fire was to do it very distinctively. "Boogie Wonderland" is definitely a different kind of disco song. It's much more heavily orchestrated. The chord structures are different, and lyrically, it is certainly different.[34] The song is also different vocally. White felt the song needed more vocal power in the hook. White enlisted the Emotions, and their vocals gave the song punctuation.[35]

"Boogie Wonderland" is credited to Earth, Wind & Fire with the Emotions. The Emotions are a female vocal trio from Chicago, Illinois. The trio primarily consisted of three sisters: Wanda Hutchinson, Sheila Hutchinson, and Jeanette Hutchinson. In the trio's early years, family friend Theresa Davis replaced Jeannette for a while. In later years, Pamela Hutchinson substituted for Jeanette while she was away. Maurice White had previously worked with the Emotions and produced their 1977 #1 single "Best of My Love."[36] "Boogie Wonderland" became a hit record and a promotional clip was produced for the song. In the clip, both groups are dancing while performing on stage. The EWF members are dressed in Kemetic-styled costumes while the Emotions are wearing sexy, disco-inspired outfits. Everyone on stage is moving and smiling as if they are actually in a "Boogie Wonderland."[37]

According to Verdine White, making the promotional clip was a real laugh. He declared, "Sometimes, the 1970s get a bad rep when it comes to the clothes, but our outfits were designed by the late Bill Whitten and were exquisite. We never said no to anything: pink waistcoats, white boots, shiny green flares. It was the 70s, man![38] "Boogie Wonderland" became a favorite among EWF fans and disco music lovers.

"Boogie Wonderland" reached #2 on the *Billboard* Hot Soul Songs chart on June 16, 1979, and #6 on the *Billboard* Hot 100 Songs chart on July 14.[39] "Boogie Wonderland" eventually won a Grammy Award for Best R&B Instrumental Performance. The song was also nominated for Best Disco

The front cover of *I Am* displays temple columns below a fetus.

Recording.[40] While Earth, Wind & Fire was riding the waves of a hot disco tune, they released *I Am* in June 1979.

I Am was produced by Maurice White. The album features nine tracks: "In the Stone," "Can't Let Go," "After the Love Has Gone," "Let Your Feelings Show," "Boogie Wonderland," "Star," "Wait," "Rock That," and "You and I."[41] This album was reissued in 2004; the second edition is discussed in chapter 10. "I Am" is the name of the Hebrew God who revealed himself to Moses in the book of Exodus 3:14. The gatefold for *I Am* is another example of Maurice White's passion for Egyptology. But everyone's passion was not as strong as his. White declared, "Half the band loved it. Half of them hated it. Everyone didn't share the same beliefs. I was into metaphysics and everyone else wasn't so that caused somewhat of a separation within the core of the group."[42]

The front cover of *I Am* is simple but intriguing. It displays the columns of an ancient Egyptian temple underneath a bright sun with a fetus and man

The back cover of *I Am* depicts a Kemetic landscape.

inside. In Egyptian mythology, the celestial realm of the sky was supported above the earth on columns, which are often shown as a framing device at the sides of temple representations. The columns can be seen as cosmic pillars.[43] The pillars of the temple symbolize the pathway to heaven or God. The temple stood at the center of the three spheres of heaven, earth, and the underworld. It served as a kind of portal by which gods and men might pass from one realm to the other.[44] Therefore, this image represents man's connection to the spiritual realm, and even I Am, God himself.

On the back of the gatefold, also intriguing, is a drawing of an aerial view of a Kemetic landscape, featuring pyramids, other buildings, and pyramid-shaped space vehicles. For the inner sleeve, there is a majestic portrait of all nine members of the band, dressed in elaborate costumes underneath the Jupiter symbol. Surrounding the band are other figures, including mythical animals and Kemetic people.[45] Maurice White stated that his mission was to raise the consciousness of his audiences with spiritual messages, which

The *I Am* inner gatefold depicts the band members and intriguing symbols.

can be conveyed through images and symbolism. This elaborate artwork was employed by White to inspire his audience.

I Am consists of nothing but high-quality tracks, and the next single, "After the Love Has Gone," released on July 12, 1979, was a definite hit. It was written by David Foster, Jay Graydon, and Bill Champlin. The song was intended for Champlin's solo album, but Maurice White heard it and wanted to record it. "After the Love Has Gone" is about a relationship that has gone bad. The

singer struggles to understand how something that felt so right could suddenly be so wrong, and wonders if their love is lost forever. Musically, the song stands out because of its direct progression. As one may notice, it has a pre-chorus and a main chorus. Bill Champlin stated, "From letter B of 'After the Love Has Gone' to letter C, to the chorus, is unbelievable." According to Verdine White, "After the Love Has Gone" was one of the hardest songs to get right in the studio. He declared, "The track was based on a vibe. We cut it about six, seven times, and Maurice just said, "No, it's not right yet. We'll come back and get it tomorrow. It's not right yet." And then one day we nailed it, and it was right. The way it felt. It sounded like Earth, Wind & Fire."[46]

"After the Love Has Gone" reached #2 on the *Billboard* Hot Soul Songs chart on August 25, 1979; #2 on the *Billboard* Hot 100 Songs chart on September 15; and #3 on the *Billboard* Adult Contemporary chart on September 29.[47] The single sold over one million copies and was certified gold on November 19.[48] The song won two Grammy Awards: for Best R&B Vocal Performance by a Duo or Group;[49] and for Best R&B Song for David Foster, Jay Graydon, and Bill Champlin as its composers.[50] It also was nominated in the category of Record of the Year. "After the Love Has Gone" has become another of the many classics by Earth, Wind & Fire.

After this song, "In the Stone" was released as a single on October 14, 1979. Written by Maurice White, Allee Willis, and David Foster, this is a song about finding love, truth, and strength. Like many Earth, Wind & Fire songs, "In the Stone" is about looking beyond the obvious for a deeper meaning. According to Sheldon Reynolds, a guitarist and vocalist who worked with EWF and became close to Maurice White, the song is about searching for the truth in the past. Reynolds declared, "It was directing us to dig in and learn about our history. There are a lot of things that have been dug up in the last couple hundred years that are revealing intelligence from us, from our past."[51] In other words, Black people should embrace ancient Egypt because it reveals their potential to be great.

Maurice White called "In the Stone" Earth, Wind & Fire's mystical anthem because it exemplifies the primary message the band wanted to convey to their listeners: look beyond the physical realm and search within; focus on the spiritual. In a 1979 article for *High Fidelity*, White explained the mission of his music:

> We feel that we are being used as a tool to say certain things . . . Most black people walking around in the streets are very unhappy, very depressed. I truly feel myself that love is the better way, that when you can get inside and reacquaint yourself, you can make yourself a

better life. I try to make a better way for them so they can face each day with a better attitude. . . . Because we are living in this jive society, we tend to relate to the beautiful things—like the universe—in a very negative manner. So in the group we draw all of our forces from the universe, and from the Creator, and from the sky. Meditation is one way, though there's other ways too . . . The group is very heavily into Egyptology. We felt that there were many secrets from that era that have never been totally worked out. Also that some of our spirituality and ideas relate to Egyptology. . . . Our total concept is to create an illusionary effect in the public's mind. We're trying to reacquaint them with the Egyptian civilization so they can search and find new things about themselves.[52]

"In the Stone" is one of those that fits directly into White's mission. The song encourages people to make better lives for themselves. The message in the song exemplifies White's passion for raising the consciousness of his listeners:

> I found that love provides the key
> Unlocks the heart and souls of you and me
> Love will learn to sing your song
> Love is written in the stone[53]

This song declares that love comes from the inner man, in the heart and soul, things that are spiritual. It declares the same for truth and strength. The phrase "in the stone" can also be interpreted as a metaphor which refers to the hieroglyphics inscribed in stone on the monuments of ancient Egypt. The ancient Egyptians inscribed literature "in stone" because it contained important messages that needed to last for eternity. These writings "in the stone" were believed to hold the answers to questions about the universe.

"In the Stone" also suggests that we can find the answers to the universe if we just look deep within ourselves. This song reached #58 on the *Billboard* Hot 100 Songs chart on November 10, 1979, and #23 on the *Billboard* Hot Soul Songs chart on November 24.[54] "In the Stone" is one of Earth, Wind & Fire's most memorable songs and a favorite among marching bands because of its outstanding horn arrangements. It is featured in the 2002 film *Drumline*.

Two more singles were released from *I Am*. Released on early December 6, 1979, "Star" was written by Allee Willis, Eduardo del Barrio, and Maurice White and produced by White.[55] It is a horn-laced dance tune featuring Philip Bailey's falsetto on lead vocals. This track only reached #64 on the *Billboard* Hot 100 Songs chart on January 19, 1980. On that same date, it peaked at

#47 on the *Billboard* Hot Soul Songs chart.[56] The fifth single from the album, "Can't Let Go," was released on December 30, 1979. This is another upbeat song in which the horns stand out and features White on lead vocals. It is hard for the audience to sit still while listening to this song. "Can't Let Go" did not chart in the United States, but it did reach #46 on the UK Singles chart.[57] There are other songs on the album that many people feel should have been released as singles, such "Let Your Feelings Show," "Wait," and "You and I." *I Am* is considered one of EWF's finest albums.

Maurice White declared that, before *I Am* was finished, he knew it was a winner because of its musical diversity. It has Dixieland swing in "Star" and 1950s doowop in "Wait."[58] "Boogie Wonderland" is a disco tune, "After the Love Has Gone" a sultry ballad. In "In the Stone," there is the Afro/Cuban/funky/pop/percussive vibe only Earth, Wind & Fire could deliver. Before its release, both Quincy Jones and Prince told White that *I Am* was the band's finest record.[59]

The album was also praised by critics. Eric Sieger of the *Baltimore Sun* declared that *I Am* was faultlessly produced and enhanced Earth, Wind & Fire's position as America's top Black party band. He believed that "Rock That!," an instrumental that shows off the band's virtuosity, was the sharpest track, and described "Let Your Feelings Show" as faultless funk.[60] John Rockwell of the *New York Times* called *I Am* an interesting record from "this flashingly, theatrical, musically imaginative creation of Maurice White."[61] For this album, Maurice White was nominated for a Grammy Award in the category of Producer of the Year Non-Classical.[62]

I Am did extremely well on the charts and in sales; it shot to #1 on the *Billboard* Top Soul Albums chart and #3 on the *Billboard* 200 Albums chart on July 14, 1979.[63] The album was certified platinum after one million sales on June 7, 1979. *I Am* eventually sold more than two million copies and was certified double platinum in the United States by the RIAA on October 26, 1984. With the success of *I Am* and its predecessors, Earth, Wind & Fire solidified themselves as the top Black band/group of the 1970s, and they were ready to take on a new decade.

The Changing Times

The year 1980 was a pivotal time in history. The United States led a boycott of the Summer Olympics in Moscow, Russia; the Iran hostage crisis was going on; and former movie star Ronald Reagan was elected to his first term as president of the United States. In pop culture news, ex-Beatle John Lennon was assassinated, the Rubik's Cube went on sale, and millions tuned in to the soap opera *Dallas* to see who killed J. R. Ewing. Also in 1980, Earth, Wind & Fire traveled to the Caribbean island of Montserrat to record their tenth studio album, *Faces*.

After *Faces* was recorded, Maurice White signed on to a $500,000 television campaign in which Earth, Wind & Fire would endorse Panasonic Products, and Panasonic would promote *Faces*.[1] EWF would eventually appear in three television commercials and print ads advertising Panasonic Platinum line of portable stereos, also known as boom boxes. In all three TV commercials, EWF come to Earth from outer space or appear in some otherworldly context. Of course, this Afro-futuristic concept had been a part of EWF's visual art for a few years. Panasonic, a Japanese company whose futuristic slogan "Just slightly ahead of our time," fit nicely with EWF's futuristic angle.[2] After signing on with Panasonic, EWF released the first single from *Faces*: "Let Me Talk."

FACES

"Let Me Talk" is the first track on *Faces* and is a high-spirited song that sets the tone for the entire album. Released in August 1980, it was written by Philip Bailey, Larry Dunn, Ralph Johnson, Al McKay, Maurice White, and Verdine White.[3] Maurice White loved "Let Me Talk." He felt it was comparable to "Serpentine Fire" as Earth, Wind & Fire's most ambitious first single release from an album. Maurice White described the song as an EWF-meets-Peter

EWF's first advertisement for Panasonic.

Gabriel record because its percussive dominance put it so close to world music. However, it is still jazzy and soulful.[4]

"Let Me Talk" is a song about problems going on in the world at the beginning of the 1980s, such as inflation, nuclear weapons, and the struggle for oil, and encourages people to discuss solutions to the problems.[5] "Let Me Talk" would be the album's highest-charting single. This was encouraged by the music video (formerly known as promotional clip) that was produced for the song.

A music video not only spreads the music; it almost universally represents and circulates the performer. Although the image track may include narrative, graphic, or documentary visuals, it usually (even if sometimes briefly

or intermittently) shows the performer performing. The music thus gains narrative status and appears to come from the world the video depicts.[6] This is a good description for the "Let Me Talk" video, which features Earth, Wind & Fire performing in front of still and moving photography. The photography features various images and symbols from around the world. Some of those symbols include the Hebrew Star of David, the Christian cross, the planet Saturn, the Jupiter symbol, angels, Mesoamerican symbols, and symbols from the Far East. There are also several Kemetic (ancient Egyptian) symbols. According to Ralph Johnson, "It was about including all of it in all the media that we were producing at that time."[7] The Kemetic symbols shown in the video include the ankh, pyramids, the eye of Heru, the royal cartouche of Tutankhamun (also known as King Tut), King Tut's death mask, a beetle called a scarab, and the vulture goddess Nekhbet.[8]

Nekhbet was the great vulture goddess of ancient Egypt. She was the wisdom keeper and the alchemist who knows what needs to happen on Earth for the connection between heaven and heart to happen.[9] The cartouche depicts a loop formed by a double thickness of rope with the ends tied together. The loop is elongated and oval because of the length of most hieroglyphic names enclosed in it. It is likely that the purpose for the cartouche was to represent the king as ruler of all "that which is encircled by the sun."[10] The death mask was used to cover the face of the pharaoh's mummy and ensure that his spirit would be able to recognize the body.[11] The scarab is an artifact that represents the holy beetle in ancient Egypt. The beetle symbolizes the resurrection and immortality of God as represented by the sun. The scarab lays its eggs in a ball of dung, which it rolls across the ground in a direction that follows the sun. The sun warms the eggs inside the dung ball, which undergo a metamorphosis before emerging into the light of day as winged scarabs. The newly born scarab represents spiritual rebirth.[12] The symbols suggest we should seek knowledge from ancient civilizations to help us navigate through this modern world. All the symbols converge to help make an elaborate and intriguing music video.

The purpose of music videos and all forms of advertisement is to attract the attention of viewers and make them interested in a product. The "Let Me Talk" video is an attention grabber. No matter how people may respond to the video, it serves Maurice White's purpose: to stimulate curiosity. "Let Me Talk" reached #44 on the *Billboard* Hot 100 Songs chart on October 18, 1980, and #8 on the *Billboard* Hot Soul Songs chart on November 1.[13] Even with the Panasonic advertising, "Let Me Talk" did not do as well as anticipated.

A few weeks after this song was released, *Faces* was issued to the public in October 1980. A double album, it was produced by Maurice White and

The *Faces* front cover features the band members and several people around a pyramid.

features fifteen tracks: "Let Me Talk," "Turn It into Something Good," "Pride," "You," "Sparkle," "Back on the Road," "Song in My Heart," "You Went Away," "And Love Goes On," "Sailaway," "Take it to the Sky," "Win or Lose," "Share Your Love," "In Time," and "Faces."[14] The second edition of *Faces* was released in 2010; that edition is discussed in chapter 11. According to White, *Faces* is one of Earth, Wind & Fire's best albums, and many people would agree. White declared, "It has it all—the polyrhythms of *All 'N All*, the sonic quality of *I Am*, and the supreme musicianship of the EWF recording family."

The album cover for *Faces* is classic Earth, Wind & Fire. The gatefold displays faces of many people of various ethnicities. According to Maurice White, the faces were used to promote the family of man, the idea that we are all one.[15] On the front, the nine band members are standing around an ancient Egyptian-styled pyramid illuminated at its vortex in the mist of the various faces. In the liner notes, Maurice White wrote"

Poster included with *Faces* album.

In respect to these changing times, this offering of our creative efforts is presented to acquaint man with his many brothers and sisters around the world. We live so close, yet so far away.

We now live in a new age dawning upon technology, higher consciousness, higher elevation of space, and higher ideas. In this age the true essence of sharing should be acknowledged.

It is time for man to understand that we share the same sun, and we are all essentially the same with different names. All around the world the most enjoyed vibration is that of a smile. Through our smiles we touch the heart of our fellow man. Together, let's lift our planet to a higher vibration.[16]

White always wanted to use his music to spread a message of universal love. *Faces* is the third EWF album to display a pyramid on the front cover.

On *Spirit* and *All 'N All*, the pyramids signify gateways to heaven and the cosmos. On *Faces*, the pyramid signifies enlightenment and unity. The many faces around the pyramid may suggest what can be accomplished when many people come together for a common cause. The construction of the Great Pyramid of Egypt required thousands of laborers and long hours of work. It also required knowledge and skill. The builders of the pyramid relied on

cooperation and ambition. Cooperation, universal love, and making the world a better place are themes found in the philosophy of Earth, Wind & Fire, including the *Faces* album. A poster showing a portrait of the band members is included with the album.

The second single from *Faces*, "You," was written by David Foster, Brenda Russell and Maurice White and released in November 1980.[17] This ballad sounds similar to "After the Love Has Gone." It begins with soft piano notes and progresses to a saxophone solo by Don Myrick. Maurice White takes the lead on vocals. It definitely has the distinctive Earth, Wind & Fire sound with White's tenor voice on lead and the high backing vocals. "You" reached #48 on the *Billboard* Hot 100 Songs chart on December 20, 1980, and #30 on the *Billboard* Adult Contemporary Songs chart on December 27, 1980. The song also peaked at #10 on the *Billboard* Hot Soul Songs chart on January 10, 1981.[18]

After "You," the band released "Back on the Road" in late November 1980. "Back on the Road" was written by Al McKay and Maurice White. The beginning of the song surprises with a rock guitar rift by guest guitarist Steve Lukather of the rock band Toto.[19] The song quickly turns into a mid-tempo funk track that keeps the listener from sitting still. This song tells a story of someone who has to leave to continue with his life, and although he has shared a relationship with someone, it is not enough for him to stay. He explains to his companion that she shouldn't be sad. Instead, she should carry on and move on with her life. Unfortunately, "Back on the Road" did not make the *Billboard* charts.

The final single from *Faces*, "And Love Goes On," released in January 1981, was written by Larry Dunn, David Foster, Brenda Russell, Maurice White, and Verdine White.[20] The jazzy keyboards, the slick Phenix Horns, and the string arrangement makes this song a standard Earth, Wind & Fire tune from the classic period. "And Love Goes On" reached #59 on the *Billboard* Hot 100 Songs chart on February 28, 1981, and #15 on the *Billboard* Hot Soul Songs chart on March 21.[21]

This double album features other songs that fans wonder why they were not released as singles. "Turn It into Something Good" captures that late seventies/early eighties soul feel of which Earth, Wind & Fire were pioneers. The instrumentation on this song is so pure and polished that it has to be applauded for its production. Maurice White's voice is immaculate as the lyrics speak of being positive and riding through the bad times. "Pride" is quintessential EWF. The solid horns at the start and the tune they capture make this song pleasing to the ears. "Pride" lyrically follows "Turn It into Something Good" and sounds like a continuation of it with a theme of self-esteem and, of course, pride. "Song in My Heart" is a fun song, a positive and

happy track that is funky and has a hook that makes you feel good. "In Time" is one of the more creative songs on the album. It is more to the left when it comes to the brand of funk music the band was used to producing. The bridge is superb, and the song is slickly produced and sounds like perfection.[22] The title track and last song on the album, "Faces," is a seven-and-a-half-minute instrumental with a Latin-inspired groove. *Faces* is loaded with quality tracks and listening to this double album is definitely time well spent.

Faces received adequate reviews from critics. Dennis Hunt of the *Los Angeles Times* called *Faces* the R&B album of the year.[23] *Billboard* described Maurice White's production as detailed and crisp. *Billboard* also declared that Earth, Wind & Fire is supported by a huge orchestra consisting of violins, horns, strings, cellos, tubas, and harp, all of which gives the material a full-bodied, rich flavor and that White and Philip Bailey's vocals are rendered sincerely.[24] Chuck Pratt of the *Chicago Sun-Times* called the album a set of intricately produced, high-gloss funk.[25] *Faces* also did well on the charts, but commercially, it did not do as well as its predecessors.

Faces rose to #2 on the *Billboard* Top Soul Albums chart on November 29, 1980, and #10 on the *Billboard* 200 Albums chart on December 6. *Faces* sold more than 500,000 copies and was certified gold in the United States by the RIAA on January 7, 1981.[26] Although a gold record should be applauded, it was a disappointment for Earth, Wind & Fire. Their previous albums had reached multi-platinum status. *Faces* is a great album, but it seems in 1980, many people were not into buying double albums. This would also be the last album with Al McKay; he left the band shortly after the album was released. After this disappointment, EWF was hoping to bounce back with their next album, *Raise!* And they did.

RAISE!

In the spring of 1981, Maurice White began production on *Raise!* During this year, the band also did a second ad for Panasonic. Maurice White enlisted Roland Bautista to return to the band to replace Al McKay. The album was titled *Raise!* because the band sought to continue their mission of raising the consciousness of their listeners. Released in October 1981, it features nine tracks: "Let's Groove," "Lady Sun," "My Love," "Evolution Orange," "Kalimba Tree," "You're a Winner," "I've Had Enough," "Wanna Be with You," and "The Changing Times."[27] *Raise!* was reissued in 2011 and 2015; the second and third editions are discussed in chapters 11 and 12, respectively. The cover for the album displays Kemetic symbols.

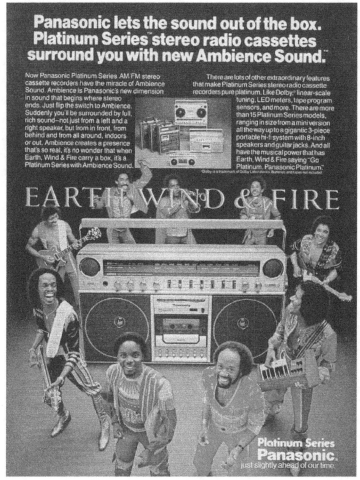

EWF's second advertisement for Panasonic.

The cover art for *Raise!* was designed by Roger Carpenter and illustrated by Shusei Nagaoka. This is the fourth album by Earth, Wind & Fire with cover art by Nagaoka. On the front of the gatefold is an image of an ancient Egyptian female figure, perhaps a goddess or a noble woman. The figure appears to represent two time periods. The left side looks futuristic while the right side looks ancient. The back of the gatefold is similar. It displays a female lying in a sarcophagus (ancient coffin). The left side of the sarcophagus is purple and the right side is blue. The sarcophagus appears to be futuristic.[28]

In ancient Egypt, a sarcophagus was one of the most important items purchased by royalty and other elites. The purpose of the sarcophagus was to protect the body, preserving it from deterioration or mutilation.

The back cover of *Raise!* depicts a Kemetic woman lying in a sarcophagus.

The back cover of *Raise!* depicts a Kemetic woman lying in a sarcophagus.

The inner gatefold of *Raise!* shows the earth and moon beneath a hand.

"Sarcophagus" is a Greek term. In the ancient Egyptian language, the coffin might be called *neb ankh* (possessor of life). The ancient Egyptians believed that from the sarcophagus the deceased will be reborn. The illustrations of the two-sided female figure on the front cover and the two-sided sarcophagus on the back cover signify a return to the ancient ideals the Egyptians valued. Maurice White believed modern people should study the philosophy of the ancients Egyptians. For White, Egypt is the place where it all started and where it will all end.[29] The inside cover displays an image of the Earth and moon from outer space. Above the two is a hand. This hand may represent the hand of God.

The first single released from *Raise!* is "Let's Groove." Released in September 1981, it was written by Wayne Vaughn and Maurice White. The song is about losing yourself in the music, which in the hands of Maurice White is a more spiritual message than one might think. The groove can take you to a place of positivity and presence, and you can find it right on the dance floor.[30] This song has three hooks. The first hook is the intro to the song with the voice over the robotic vocoder stating "We can boogie down." The second hook begins with "Let's groove tonight." The third hook begins with "Let this groove get you to move." The first three stanzas are all hooks. The first verse begins with the fourth stanza.[31] Maurice White declared that the multiple hooks over that one great groove gives the song an exciting yet simple approach. The horns are held back until the bridge, giving the song a 1940s big band swing sound. Bill Meyers's horn arrangement turned up the joyous vibe, which is why White believed "Let's Groove" feels so good.[32] Earth, Wind & Fire navigated the changing trends in the music of the early 1980s with this slick piece of synthesizer funk.

The robotic vocoder heard on the intro heralded the dawn of a new Earth, Wind & Fire for the new decade, mixing electronica with their live-brass past. White explained the transition to *New Musical Express* (*NME*) magazine. "It's really just knowing the feelings and fundamentals involved in producing a hit. Just like writing a story. It's not less honest than a piece of jazz. Take the new record, 'Let's Groove.' It's real honest. We just went in and done it—a natural giving thing. Just saying, Hey man, enjoy this with me. Share this with us." Many people did share it; "Let's Groove" sold over one million units.[33] A music video was produced to help promote and sell the song.

The music video became a popular advertising strategy for pop music artists in 1981 when Music Television (MTV) was created. However, at that time, MTV refused to play videos by Black music artists. Music videos by Black artists could be seen in other spaces, such as *Soul Train* and *Video Soul*, which aired on the Black Entertainment Television (BET) network. The music video for "Let's Groove" was actually the first to be played on *Video Soul*. This music video features the band performing and dancing in futuristic costumes with outer space in the background. A female dancer is also shown. The video also uses vintage electronic effects.[34] This marketing tool helped "Let's Groove" become one of Earth, Wind & Fire's biggest hits.

"Let's Groove" shot to #1 on the *Billboard* Hot Soul Songs chart on November 28, 1981, and in that position for eight weeks. The song also went to #3 on the *Billboard* Hot 100 Songs chart on December 19, 1981.[35] As stated previously, "Let's Groove" sold over one million copies and was certified gold by the RIAA on January 12, 1982.[36] It was also nominated for a Grammy Award in the category of Best R&B Vocal Performance by a Duo or Group.[37]

As "Let's Groove" became a hit, Earth, Wind & Fire began their *Raise!* Tour, their most expensive production to date, costing about $700,000 in production alone. Once the show was established, it cost $60,000 per concert. The tour consisted of a crew of about sixty people, fourteen tractor-trailers, buses, airfares, hotel bills, band salaries, and other expenses. However, EWF sold out just about every show in advance. Maurice White still came off the tour with a loss, but this loss was not as large as those from previous tours.[38]

During the tour, EWF released the second single from the album, "Wanna Be with You," in December 1981. Written by Wayne Vaughn and Maurice White,[39] "Wanna Be with You" features White's soothing tenor on lead and Philip Bailey's high notes on background. The voices blend well throughout the song. The horns help punctuate the groove. This is a love song about a man's desire to spend time with his significant other. It went to #51 on the *Billboard* Hot 100 Songs chart on February 13, 1982, and #15 on the *Billboard*

Hot Soul Songs chart on March, 13.[40] "Wanna Be with You" won a Grammy Award for Best Vocal Performance by a Duo or Group.[41]

"I've Had Enough" was released as a single in January 1982. It was written by Philip Bailey, Gregory Phillinganes, and Brenda Russell.[42] This is a mid-tempo party song about releasing one's frustration. The percussion and horns in the intro exemplify a fierce, feel-good EWF groove. Bailey's falsetto is one of the main ingredients. "I've Had Enough" peaked at #29 on the UK Singles chart.[43]

Another notable track on *Raise!* is "Lady Sun." It was not released as a single, but consists of the distinctive Earth, Wind & Fire sound, including the impeccable horns and harmonious vocals. This song was written by Bernard Taylor, the songwriter who co-wrote "Getaway." It may be interpreted as romantic love between a man and woman or the relationship between humans and the sun.

> I want you to know, you're my lady sun
> You're my reason for living, you light up my day
> You're my lady sun, you're my reason for living
> Don't you go away[44]

On the surface, this song may appear to be just another romantic love song, but it can be interpreted as the personification of the sun.

As stated previously, there is an ancient Egyptian sun goddess named Hathor. There is also a sun god named Ra. The Egyptians were among the first people to personify the sun and make it a deity. This song is about a lady and how important she is to a man's life. The sun is also important to life on earth. It provides life for all creatures on the planet. The song states that Lady Sun is the man's reason for being and she lights up the day. This implies that a woman makes the man's life worth living, and it could also refer to sunlight. In the last stanza, the song mentions trust. A good woman can be trusted. The sun can also be trusted to rise and set every day. "Lady Sun" signifies a love affair between a man and a woman and man's relationship with the sun, the life force. This song reminds us of the beauty of creation and encourages us to appreciate and live in harmony with nature.

The sun was one of the most important symbols in the Nile Valley. The people of Kemet (ancient Egypt) not only deified the sun, but they also considered its different aspects: its light, its heat, and its rays. Various deities were designed to represent the physical sun, the intellectual sun, the power of the sun, the sun in the heavens, and the sun in its resting place. The awesome force of the sun was recognized as the primary activator for life.[45] The

sun played an important role in nature. Due to Earth, Wind & Fire's unique messages, critics of the band have accused the band of being sinister and having ulterior motives.

According to former musical director Morris Pleasure, some people claimed that Earth, Wind & Fire worshipped the sun.[46] And because EWF employed Kemetic and other ancient symbols, they were perceived as devil worshippers by others. According to Maurice White, EWF, along with KISS, the Rolling Stones, and other rock acts, was accused of having demonic messages via backward masking on their recordings. White denounced it as completely false. People were trying to pass legislation in California to prove it.[47] Those accusations are based on ignorance and/or the preconceived notion that ancient Egypt was a wicked nation. While some people were accusing EWF of devil worship, music critics had nothing but positive things to say about them.

Ken Tucker of *Rolling Stone* describes *Raise!* as reflecting the wave of street-gritty Black pop occurring at that time. Tucker also claims that Maurice White's romanticism is tighter and more seductive.[48] Hugh Wyatt of the *New York Daily News* described the LP as "a real gem" with "superb" music.[49] Robert Christgau exclaimed that there is no reason why Earth, Wind & Fire can't turn their sparkling harmonies and powerful groove into a pure display of virtuosity.[50]

Raise! did extremely well on the charts and in sales. The album went to #1 on the *Billboard* Top Soul Albums chart on November 28, 1981, and remained in that position for eleven weeks. The album also peaked at #5 on the *Billboard* 200 Albums chart on the same date.[51] *Raise!* was certified platinum in the United States by the RIAA on December 30.[52] In the spring of 1982, Earth, Wind & Fire became the first Black group or band on CBS Records International to win the Crystal Globe Award for sales in excess of five million copies outside the United States. The band joined an elite list of only eleven past winners, including Simon & Garfunkel, Bob Dylan, and Neil Diamond. *Raise!* became EWF's biggest selling international release.[53] Because of the success of *Raise!*, one of their concerts was issued on video.

Earth, Wind & Fire: In Concert first aired on HBO in 1982. The concert was recorded in late December 1981 in Oakland, California. This film captures the excitement of Earth, Wind & Fire and is an opportunity to experience them during the peak of their career. The concert would later be released on VHS by Vestron Video. The film was reissued on DVD in 2008 by Eagle Rock Entertainment;[54] that DVD is discussed in chapter 11. After having a successful run with *Raise!*, the band began to work on their next studio album.

I've Had Enough

The year 1982 was a good one for Earth, Wind & Fire. In addition to being featured on HBO, *Raise!* passed the five million mark in sales globally. The band won another Grammy for "Wanna Be with You," and completed another successful tour. In other news, the futuristic theme park Epcot Center opened at Disney World, and the first compact discs (CD) were sold in Japan. "The Computer" was named *Time*'s Man of the Year. It was evident that technology was having a great impact on the world. In November 1982, Michael Jackson released his iconic album *Thriller*. During the same month, Earth, Wind & Fire was finishing production on their twelfth studio album, *Powerlight*, and its first single, "Fall in Love with Me," was released.

POWERLIGHT

"Fall in Love with Me" was written by Maurice White, Wayne Vaughn, and Wanda Vaughn. Wanda Vaughn is a member of the female singing group the Emotions, and Wayne Vaughn is her husband. This song features a mesmerizing horn intro, Maurice White on lead vocals, harmonious background vocals, and an energetic guitar solo by Roland Bautista. "Fall in Love with Me" is a song in which the singer tells his love interest what he would do if she falls in love with him.[1] A video was produced for "Fall in Love with Me." It displays White's affection for Egyptian imagery and symbolism. The video shows White and his love interest along with the other band members dancing in a Kemetic landscape. The video also features Kemetic symbols flashing throughout. Those symbols include the Great Pyramid, the Sphinx, Heru, a sarcophagus, and deities, such Amun, Anubis, and Auset (Isis).[2]

Amun is represented by ram-headed sphinxes, sometimes called criosphinxes. Amun was held to be a universal god who filled the cosmos and all it contained. He was sometimes revered as the *ba* or soul of all natural phenomena.[3] Anubis was concerned with the burial and afterlife of the dead

and became the patron god of embalmers.[4] The last deity shown is the well-known goddess Auset, who was called Isis by the Greeks. She appears as a double-sided image with her wings spread. Auset (Isis) had the power through her words to stop death and to bring the dead back to life.[5] The video for "Fall in Love with Me" is very colorful with special effects, showing strange objects floating in the air.[6] This short film helped the song become *Powerlight*'s biggest hit.

"Fall in Love with Me" reached #4 on the *Billboard* Hot R&B Songs chart on February 26, 1983, and #17 on the *Billboard* Hot 100 Songs chart on March 19.[7] "Fall in Love with Me" received a Grammy Award nomination for Best R&B Performance by a Duo or Group with Vocals.[8] While "Fall in Love with Me" was having a decent run on the charts, Earth, Wind & Fire released *Powerlight* in February 1983. After the album was released, Maurice White released the Phenix Horns. Don Myrick, Louis Satterfield, and Michael Harris were now free to record and tour with other artists, and they were quickly seized by Phil Collins and Genesis.[9]

Philip Bailey and Larry Dunn traveled across the United States to promote *Powerlight*. While in Atlanta, Georgia, to promote the album, Bailey stated, "We have built up a reputation of putting on a good road show. Our road show is very expensive because we use a lot of effects and illusions. Bailey declared that he enjoys traveling, especially in Europe where the crowds respect them more as artists. He added, "In Europe, you can perform more freely. They are more into the artist. You can take more liberty in playing what you want than over here—where the radio dictates what you play."

Dunn explained that promotion is talking to people and making yourself visual through television and radio. He declared, "We are promoting the album in all the major cities, such as Los Angeles, Washington, D.C., Chicago, New York, and Atlanta. We've visited five or six radio and TV stations a day. Promotion is getting no sleep in two days. Really, it's a blessing to travel for free." Dunn also talked about the outside projects for some of the band members. He stated, "Phil is working on his first solo album. Maurice is producing an album for Jennifer Holiday, and I am producing a new group from England called Level II."[10] These new projects indicated that the talent of the members could go beyond Earth, Wind & Fire. But at this time, *Powerlight* was the first priority.

Powerlight was produced by Maurice White. It features nine tracks: "Fall in Love with Me," "Spread Your Love," "Side by Side," "Straight from the Heart," "The Speed of Love," "Freedom of Choice," "Something Special," "Heart to Hearts," and "Miracles."[11] According to White, "Powerlight" refers to the chakras—the centers of the body that connect us with cosmic power. While

recording the album, Earth, Wind & Fire established a special connection that goes beyond explanation.

One night while White was mixing the album at The Complex studio, there was a loud boom. Then, the building shook, and everything went dark. A minute later, when the studio's power came back on, the manager of the studio called the power authority to find out what occurred. But the authorities were bewildered and swore the incident could not have happened. The studio's manager concluded that the cause of the power outage was a "cosmic short circuit."[12] It seems this incident influenced the title of the album and its cover art.

The front cover art for *Powerlight* was illustrated by Shusei Nagaoka and directed by Monte White and Roger Carpenter. The cover displays a man standing in front of the sun with his chakras illuminated.[13] It is a common belief that the notion of chakras began in India, but the ancient Egyptians also had a system of chakras. The term *chakra* means wheel. Chakras are believed to be spinning disks of energy that should stay open and aligned as they relate to bundles of nerves, organs, and areas that affect a person's emotional and physical health. The chakras in the man on the album cover could be receiving power from the sun. The sun is necessary for all life on Earth. No organism could survive without its light or energy. This album cover is unique, but the lyrical content of this album contains a familiar theme: love. Love is the focus of the second single released from the album, "Side by Side."

"Side by Side" was released in April 1983. It was written by Maurice White, Wayne Vaughn, and Wanda Vaughn. This is the same trio who wrote "Fall in Love with Me," and the Vaughns helped write two other songs on the album: "The Speed of Love" and "Something Special." "Side by Side" is a smooth, romantic song that begins with White crooning over soft notes, showcasing his vocal prowess. The song also features string arrangements and strong backing vocals which give a gospel vibe. "Side by Side" climbed to #15 on the *Billboard* Hot R&B Songs chart on May 21, 1983, and to #76 on the *Billboard* Hot 100 Songs chart on the same date.[14]

The third and final single released from *Powerlight* is "Spread Your Love," in June 1983. It was written by Maurice White, Beloyd Taylor, and Azar Lawrence. Of course, this is a song that encourages one to spread love to others. "Spread Your Love" is an electro-funk tune in which Maurice White chants over rhythm guitars. This song got to #57 on the *Billboard* Hot R&B Songs chart on August 27, 1983.[15] Other noteworthy tracks from *Powerlight* are "The Speed of Love" and "Something Special," both of which feature complex horn arrangements and soothing vocals that are reminiscent of the Earth, Wind & Fire hits from the 1970s.

The *Powerlight* cover displays a man in front of a heavenly body with his chakras illuminated.

Although there were no smash hits from *Powerlight*, the album received decent reviews. Christopher Connelly of *Rolling Stone* declared, "Maurice and company are still pumping out the same spiffy horn parts, bouncy bass lines and stacked-to-the-sky vocals that have made Earth, Wind & Fire a persistently platinum act.[16] *Billboard* magazine stated that EWF remains in a solid commercial groove, both lyrically and musically.[17] Craig Lytle of AllMusic claims that throughout the entire album, Maurice White's unifying message is fueled by the aggressive rhythms and relaxing melodies.[18]

Powerlight did well on the music charts but did not reach platinum status. It rose to #12 on the *Billboard* 200 Albums chart on March 26, 1983, and to #4 on the *Billboard* Top R&B Albums chart on April 9.[19] *Powerlight* sold more than 500,000 copies and was certified gold by the RIAA on April 11.[20] This was disheartening after *Raise!* had reached multi-platinum status.

EWF's third advertisement for Panasonic.

In addition to this album, Earth, Wind & Fire contributed to another movie soundtrack. In April 1983, the Canadian adult animated film *Rock & Rule* was released. However, it never saw wide release in North America. The plot revolves around a four-piece rock band whose songs are provided by Cheap Trick and Blondie. Most of the songs on the soundtrack are forgettable. The standout track is "Dance, Dance, Dance" by Earth, Wind & Fire, an electro-funk tune with the distinctive EWF vocal sound, with Maurice White on lead.[21] The song was finally released as a single in 2012 on the Kalimba Music label. In the spring of 1983, EWF presented their third advertisement for Panasonic, and by mid-1983, they began working on their next studio album, *Electric Universe*.

ELECTRIC UNIVERSE

Electric Universe was released in November 1983, and produced by Maurice White. *Electric Universe* features eight tracks: "Magnetic," "Touch," "Moonwalk," "Could It Be Right," "Spirit of a New World," "Sweet Sassy Lady," "We're Living in Our Own Time," and "Electric Nation."[22] *Electric Universe* was reissued in 2015; this second edition is discussed in chapter 12. For *Electric Universe*, White decided to try a different musical approach. He wanted to take EWF into a modern era and capture the new wave sound out of Europe.[23] Lyrically, the album was a commentary on the limits and pitfalls of technology, which was a core belief of White.[24]

This musical change is symbolized by the cover. The gatefold for *Electric Universe* features a pyramid on the front, but it is unique. *Electric Universe* is the fifth album by Earth, Wind & Fire to feature a pyramid on the cover. A

The front cover of *Electric Universe* displays a computerized image of a cone inside a pyramid.

The back cover of *Electric Universe* displays a computerized graphic of the sun and moon.

squared pyramid with a pyramid-like cone inside is displayed. Both figures are made of illuminated rings. The back of the gatefold displays a computerized image of the sun and the moon.[25] This was an indication of the change happening in the music industry and the futuristic sound of some of the songs on the album. The image on the back and the pyramid and cone on the front represent ancient knowledge and modern information and technology. The pyramid is the most common symbol used by EWF during their classic period. It is so common that many people believe the pyramid is the official symbol for EWF. But Verdine White has confirmed that there is no official symbol for the band.[26]

The inner sleeve for the *Electric Universe* displays a photo of the eight band members dressed in the latest 1980s fashion.[27] This fashion is much different from the costumes the band wore in previous years. These outfits suggest that the band was changing its style. The new style could be heard on the album and could be seen in the music video for the first single on the album.

The inner gatefold of *Electric Universe* shows the band members in eighties fashion.

The first single from *Electric Universe*, "Magnetic," exemplifies the new sound Maurice White was seeking. "Magnetic" was released in November 1983. It was written by Martin Page, who is from England. This is one of the few songs Earth, Wind & Fire had no part in writing. Page had written a song for his group Q-Feel called "Dancing in Heaven (Orbital Be-Bop)," which White liked. White asked for a song with a similar sound, and Page, who is a huge fan of the band, was happy to comply. Page explained, "I quickly ran down the road to a little electrical shop and bought a Fostex 8-track. I tried to emulate the groove of 'Dancing in Heaven' because I knew that appealed to him. And I wanted to create something that had a mysterious lyric to it but sounded very contemporary." Page believed EWF was special: "Earth, Wind & Fire had this magical sense of rhythmic vocals. You didn't have to know what they were singing about, you just had to feel where their syncopations happened."[28]

"Magnetic" is about a groove so attractive it pulls you toward it like a magnet.[29] A music video was produced for "Magnetic," and it expresses the message of the song. The post-apocalyptic video features futuristic gladiator battles that look like a cross between *RoboCop* and *Tron*. Although the video is exciting, like those by many Black artists, it was ignored by MTV. At this time, Michael Jackson was the only Black artist who was receiving heavy airplay on MTV.[30] Prince was the first Black artist to actually appear on MTV.

"Magnetic" turned out to be the biggest hit from *Electric Universe*, peaking at #57 on the *Billboard* Hot 100 Songs chart on December 3, 1983; #10 on the *Billboard* Hot R&B Songs chart on December 24; and #36 on the *Billboard* Dance Club Songs chart on January 7, 1984.[31] Robert Christgau of the *Village Voice* placed "Magnetic" at #20 on his dean's list of 1983.[32] Although

"Magnetic" did fairly well on the chart, it did not do as well as Earth, Wind & Fire had expected.

After "Magnetic" was released, an unexpected and unusual band meeting occurred. By the end of 1983, the music business had begun to take its toll on Maurice White. He had been working hard nonstop in the music industry since 1966, when he started with the Ramsey Lewis Trio. White was worn out physically, psychologically, and emotionally. So, he called a rare group meeting at The Complex in early 1984. When the band arrived for the meeting, everyone was cordial. They had not seen each other for a while and were anxious to find out what was in the band's near future. Without much pomp, White informed the band members that he was disbanding Earth, Wind & Fire.[33] He began by saying, "Guys, I've decided that I'm going to put Earth, Wind & Fire on the back burner. We're going to stop touring. You guys need to do whatever you want to do in the meantime. Columbia doesn't want an album from us. They want me to do my solo album." The breakup happened immediately, and the band members had no time to prepare.[34] White believed it was a good decision, but the other band members did not. The other members felt the band was coming to a halt at their peak. This was a sudden decision for White; he had first considered it on Christmas 1983. White later felt guilty about how he broke the news to the band.[35] They were caught totally off guard.

Each band member received a letter in their pay packets advising them to remove all personal items from the band's storage space or they would be sold. Earth, Wind & Fire had its own lights and sound equipment. This created a huge financial burden and tied up a lot of money. EWF also paid a quarter of a million dollars for wardrobes. The equipment and road cases were up for liquidation. Unfortunately, the cases containing those memorable EWF costumes went with the others. Most of them were not redeemed.[36] With the band on hiatus, the classic period of EWF came to an end. Although the band was on hiatus, two more singles were released from *Electric Universe*.

The second single from the album, "Touch," was released in January 1984. It was written by Jon Lind and Martin Page. "Touch" is an upbeat love song that has the distinctive feel-good sound for which Earth, Wind & Fire is known, with Maurice White on lead vocals and Philip Bailey's falsetto in the background.[37] It also features a drum machine and synthesizers. This song reached #23 on the *Billboard* Hot R&B Songs chart on March 3, 1984.[38]

The final single from *Electric Universe*, "Moonwalk," was released in April 1984. Written by David Porter and Desmond O'Connor, this is not a bad tune, but the vocals are the only aspects that actually sound like Earth, Wind & Fire.[39] "Moonwalk" only made it to #67 on the *Billboard* Hot R&B Songs chart

on May 12, 1984.[40] There are several decent tracks on *Electric Universe*, but EWF surprised their fans by experimenting with a new sound. One ballad, "Could It Be Right," has the familiar EWF sound, but the final track, "Electric Nation," is a far cry from traditional EWF, consisting of a bold electro style.

However, the album did well on the music charts. *Electric Universe* rose to #8 on the *Billboard* Top R&B Albums chart on December 17, 1983, and to #40 on the *Billboard* 200 Albums chart on January 7, 1984.[41] The album also received good reviews from critics. Robert Palmer of the *New York Times* declared that *Electric Universe* is full of rich vocal harmonies and skilled pop craftsmanship.[42] Gary Graff of the *Detroit Free Press* described the album as having a grittier, funkier approach.[43] *Cash Box* stated that Maurice White and company write soulful, tear-jerking ballads and upbeat funk-a-ramas that keep the listener humming along the hook for the rest of the day.[44] Although *Electric Universe* received high praise and did well on the charts, it did not sell well. Maybe this was a good time for the band to take a break.

Maurice White expressed his sentiments about the end of the classic period. He declared, "CBS wanted another 'Let's Groove.' Frankly, we did the album *Electric Universe* too early. And then, everything hit the fan. The album was a total bomb—didn't even make it to gold. Personally, I'd had it. I'd been making albums for twelve years, non-stop, with almost no breaks from touring." Philip Bailey also gave insight: "Those years, 1980 to 1983, were the most difficult. We were battling 'the giant.' We were trying viciously to outdo ourselves. The pressure was on more and more. We were expected to sell the volume and still be innovative. It got crazy and the band began to grow apart."[45] Bailey added, "It was time to stand on our own two feet and find out what the world was like without one another. I moved back to Colorado because I had just had enough of everything—L.A., ... the band. I wanted to get away from it. I go back to real neighbors and cutting my own grass and barbecuing on the weekends. I got revitalized."[46] Verdine White also found peace after the breakup. He stated, "The break gave me a chance to find out who I was as a person, to get with my family. I really needed it. I resigned myself to the fact that we might not get back together again."[47]

Some of the band members fell on hard times after the breakup. According to Bailey, some of the members of Earth, Wind & Fire lost their homes and fortunes. Some of them went into counseling after suffering nervous breakdowns. Maurice and Verdine White stopped speaking to each other for a while, and Freddie White just went on about his business. Some of the band members ventured into new projects. Verdine White became a music producer and directed music videos. For a while, Ralph Johnson wrote songs, and he coproduced The Temptations *Truly for You* with Al Mckay.[48] This album

features the hit song "Treat Her Like a Lady," which became the Temptations' biggest hit since 1975. Some of the band members who had written hit songs did better as time went on because they continued to receive royalties.[49]

The hiatus also gave Philip Bailey the opportunity to spread his wings. After the breakup, Bailey worked to build his solo career. Before *Electric Universe* was released, Bailey had scored a deal with Columbia Records. He recorded *Continuation* in late 1983 with George Duke as producer. The album was released after *Electric Universe*.[50] *Continuation* peaked at #19 on the *Billboard* Top R&B Albums chart on October 22, 1983.[51] This album served as a foundation for Bailey's solo career. In 1984, Bailey recorded a gospel album titled *The Wonders of His Love*. This album climbed to #13 on the *Billboard* Top Christian Albums chart on March 9, 1985, and to #17 on the *Billboard* Top Gospel Albums chart on April 20.[52] *The Wonders of His Love* received a Grammy nomination for Best Inspirational Performance.[53]

Bailey also released his third album in the fall of 1984. *Chinese Wall* includes the international hit "Easy Lover," featuring Phil Collins. This song reached #3 on the *Billboard* Hot R&B Songs chart on March 2, 1985,[54] and went to #1 in several countries. "Easy Lover" received a Grammy nomination for Best Pop Performance by a Duo or Group with Vocal.[55] Another hit song from this album is "Walking on the Chinese Wall." This song peaked at #56 on the *Billboard* Hot R&B Songs chart on June 8, 1985.[56] *Chinese Wall* peaked at #10 on the *Billboard* Top R&B Albums chart on March 16, 1985. It also reached #22 on the *Billboard* 200 Albums chart.[57] *Chinese Wall* received a Grammy nomination for Best R&B Vocal Performance, Male.[58] Philip Bailey would release ten solo albums during his career.

Maurice White also became a solo artist during the hiatus. In addition to producing records for pop artists Neil Diamond and Barbra Streisand, White released his solo album in 1985. The album is titled *Maurice White*. The first single from the album was "Stand by Me." There were a couple of reasons why he chose to record this song. For one reason, he loved the song, which was a Top Ten hit for Ben E. King in 1961. It was later recorded by Spyder Turner, John Lennon, and Mickey Gilley. For another, White thought it was important to keep classic songs from the sixties in the spotlight. He lamented, "A lot of kids now are unfamiliar with these songs. This was my way of trying to reacquaint them with their heritage."

And then, there was the voice that spoke to him. Maurice White says he heard a voice while riding along in his car one day. He was alone. The radio was off. All of a sudden, loud and clear, he heard the words "Stand by Me." White, who was open to mystical experiences, recalled, "It was like a voice speaking to me. I even looked in the back seat to see if there was anybody

back there. There wasn't, and I thought, 'What's going on?' Then, I thought, 'Oh, the song, "Stand by Me."' When I got home, I pulled out the old Ben E. King record and played it, and I was thrilled with what I heard. Then I went about recording it myself."[59] "Stand by Me" was released in the fall of 1985. It climbed to #6 on the *Billboard* Hot R&B Songs chart on November 2, 1985, and to #11 on the *Billboard* Adult Contemporary Songs chart on the same date.[60]

The release of "Stand by Me" sparked renewed speculation that Earth, Wind & Fire had passed into pop music history. In the liner notes of the album, Maurice White wrote of "a new beginning which I am now discovering." White explained, "But that new beginning refers simply to the fact he is launching a solo career—which doesn't mean that EWF has broken up. I haven't disbanded the group." He added, "Philip Bailey hasn't left the band. We are just in a state of mind now where we want to do solo projects. It's just evolution."[61] White also released a second single; "I Need You" peaked at #20 on the *Billboard* Adult Contemporary Songs chart on January 25, 1986, and #30 on the *Billboard* Hot R&B Songs chart on February 1.[62] No more songs were released from *Maurice White* and White believed Columbia could have promoted the album better. In the following year, Philip Bailey released two more albums.

In 1986, Philip Bailey released his second gospel album, *Triumph*, for which he won a Grammy Award for Best Male Gospel Performance.[63] Bailey also quietly released his third R&B album titled *Inside Out*. This album did not match the success of *Chinese Wall*.[64] At this time, Bailey began to think about his future in the music business. He wanted to do another Earth, Wind & Fire record, and he reached out to Maurice White for his opinion. Bailey and White began talking about getting Earth, Wind & Fire back together.[65] So, if there was going to be a reincarnation of Earth, Wind & Fire, who would make up the band, and how would they be received by the public? The next EWF album would answer those questions.

Back on the Road

In 1987, Reaganomics was in full effect, and the Cold War was waning. In popular music, hip hop was becoming mainstream, and the funk and soul bands who came of age during the seventies were becoming less popular. But Maurice White and Philip Bailey decided to give Earth, Wind & Fire another chance. They reached out to Al McKay and Larry Dunn to see if they were interested in rejoining the band; both declined. Without McKay and Dunn on board, White realized that the previous era of EWF was truly over.[1] However, White believed an EWF album could still be relevant. So, Maurice White, Verdine White, and Philip Bailey had a meeting to discuss the comeback.

The three musicians began to recruit other musicians for the band. They reached out to Ralph Johnson and Andrew Woolfolk; these two agreed to rejoin the band. Next, Sheldon Reynolds was hired to be the new guitarist.[2] Reynolds was born and grew up in Cincinnati, Ohio. He began playing music at an early age and played all the way up to the college level. He then left Cincinnati and moved to Los Angeles, California.[3] Before joining Earth, Wind & Fire he worked with the Commodores, and he is a great vocalist. Maurice White hired Reynolds to bring a new energy to the comeback album. He brought a youthful and creative spirit.[4] Reynolds would perform with EWF for fifteen years. Sonny Emory was hired as a drummer. A native Atlantan, Emory received his first drum set at the age of four. After graduating from Georgia State University with a bachelor's degree in Jazz Performance, he began his transition to becoming a professional drummer, playing with Joe Sample and the Crusaders.[5] Emory would remain with EWF for twelve years. Vance Taylor was hired as a keyboardist. Taylor is a native Atlantan who received his first piano at the age of thirteen and began practicing and perfecting his skills. In addition to the piano, he plays organ, keyboards, and synthesizers.[6] Taylor stayed with EWF until 1993. Dick Smith was also hired as a guitarist. As a composer, Smith has earned three Emmys for his work in documentary film. He has also recorded on numerous records for other artists.[7] Another musician, Mike McKnight was also hired as a keyboardist.

Mike McKnight is a music programmer and musical director. He is best known for his work on live tours with major artists such as Michael Jackson, Madonna, and TLC.[8] He remained a keyboardist for EWF until 1999. This lineup stayed the same until 1991, when Dick Smith left the band.

Maurice White also created a new horn section called the Earth, Wind & Fire Horns. Gary Bias was hired as saxophonist, Ray Brown as trumpet player, and Reggie Young as trombone player. Bias is a native of South Central Los Angeles and began playing saxophone at the age of eleven. While pursuing his music degree at California State University, Los Angeles, Bias was hired to tour with the Quincy Jones Orchestra. A few months before working with Earth, Wind & Fire, he earned a Grammy Award for R&B Song of the Year for Anita Baker's "Sweet Love," which he co-wrote.[9]

Ray Brown grew up in South Central Los Angeles. Bias and Brown have been friends since high school. In the early 1980s, Brown was a member of the soul group Madagascar, which was composed of session musicians. Madagascar recorded an album titled *Spirit of the Night* in 1981. In the mid-1980s, Brown was a member of the Pan Afrikan Peoples Arkestra (the Ark) of South Park, Los Angeles, along with Gary Bias and Reggie Young.[10] Reggie Young is also a native of Los Angeles. As a trombonist, he has worked with soul and jazz artists such as George Duke, Anita Baker, and John Stoddart.[11] During this comeback time, the leadership dynamic would be different for Earth, Wind & Fire.

The fate of Maurice White's and Philip Bailey's solo projects suggest that White could no longer rule the band with an iron hand. Bailey's *Chinese Wall* reached gold status and White's only solo album did not. Bailey acknowledged that the "control" issue is one of the factors that led to the hiatus. He recalled, "We were a little inhibited to say things for fear of bruising Maurice's ego. He was sensitive to the fact that we were growing up (musically) and that we were disenchanted about certain things. But he was still in the driver's seat to make decisions. It created a lot of tension." White acknowledged that although he would remain the group's leader, he was more open to input from the other musicians. He declared, "I was in a situation where I was like the godfather. I brought all of them into the industry. But now, everybody has a responsibility. There's more sharing. There's a lot more trust." Bailey agreed. He stated, "It's more comfortable. He's still in the driver's seat, but now, he's got a co-pilot."[12] White learned something about himself during the hiatus.

White noted that he had no burning desire to become a solo artist like his peers Lionel Richie, former lead singer of the Commodores, and Jeffrey Osborne, former lead singer of L.T.D. White declared, "Everyone's not a solo artist. Everyone does not have that kind of charisma. I don't look at myself

as a solo artist. I'm not an entertaining machine." White said that he prefers working in a group. He added that the hiatus made him realize Earth, Wind & Fire is more than the sum of its parts. White stated, "I didn't know that till I got away from it. I had to see that it was bigger than me, him [Philip Bailey], all of us. It's an entity within itself."[13] White, Bailey, and the revised band began working on the comeback album.

TOUCH THE WORLD

The first song Earth, Wind & Fire recorded for the new album was the title track "Touch the World," a gospel song written by Reverend Oliver Wells. Maurice White's good friends Edwin Hawkins and Walter Hawkins sang on the track with the band. He had been friends with the Hawkins brothers for over twenty years. White believed that recording session was anointed by God. Although it is a gospel song, people from all faiths can relate to it because it is about helping those in need and making the world a better place. "Touch the World" coincides with EWF's mission of spreading love and hope to humankind.

The first single to be released from *Touch the World*, in the fall of 1987, was "System of Survival." This song came to Earth, Wind & Fire in a peculiar way. Maurice White and Philip Bailey had been looking for a theme that touched something deep in their own experience, but they were having trouble finding it. One morning, when they left the apartment they were renting in Sausalito, California, to drive to the studio, they found a plastic bag taped to the side of the car. A note explained: "I've been told you all the songs you need for your LP. Please excuse the way I'm getting this to you." Bailey recalled, "In the pouch was a cassette. We put it in the car's tape deck and said, 'That's it!'" The song is about overcoming the forces that try to beat you down in life. White declared, "The songwriter [Skylark] had definitely gotten that song to us by using his survival systems."[14] The song suggests that dancing can be a coping mechanism. The singer states that dancing is his system of survival.[15] "System of Survival" was added at 113 radio stations its first week out of the box.[16] It became an immediate hit. The song had a vision, excellence, and a sweet sound that were unmistakable. With this single, Earth, Wind & Fire made a comeback.[17] "System of Survival" has an electronica sound with drum programming and synth notes accompanied by horns. A music video was produced to promote the song.

The video for "System of Survival" begins with troubling scenes of society. Suddenly, people are shown dancing. Earth, Wind & Fire is also seen

performing. In one scene, the band members are playing basketball. The video is uplifting because it encourages people to dance their troubles away. "System of Survival" rose to #1 on the *Billboard* Dance Club Songs chart on November 21, 1987, and #1 on the *Billboard* Hot R&B Songs chart on December 12, 1987. However, it only reached #60 on the *Billboard* Hot 100 Songs chart on December 19, 1987.[18] How could this song not do better on the pop chart? Philip Bailey gave insight about radio politics: "It's so screwed up. If you're Black, you're labeled R&B. But if you're white and play R&B, you're pop. It's not what your music says at all." Bailey claimed that record and radio industries hadn't kept up with the changes in listening habits in the past generation: "Before, [black and white] people's backgrounds were totally apart from one another. But now, kids grow up listening to all kinds of stuff. The musicians who are coming up now have many different kinds of expression, but they're still labeled and marketed based on the color of their skin."[19] Regardless of the politics, "System of Survival" proved that Earth, Wind & Fire was still hot. It was nominated for a Soul Train Award in the category of Best R&B Soul Single—Group, Band or Duo.[20]

A few weeks after the song came out, EWF released *Touch the World* in November 1987. Produced by Maurice White, the album features ten tracks: "System of Survival," "Evil Roy," "Thinking of You," "You and I," "Musical Interlude: New Horizons," "Money Tight," "Every Now and Then," "Touch the World," "Here Today and Gone Tomorrow," and "Victim of the Modern Heart." *Touch the World* deals with the negative social issues of the late eighties, such as inner-city crime, the Iran-Contra political scandal, prostitution, and teen pregnancy on songs like "System of Survival," "Touch the World," and "Evil Roy."[21] Unlike previous albums, the cover for *Touch the World* is not elaborate and distinctive. There is a photo of the band and other photos depicting American society, such as children playing basketball, a man skateboarding, and a mother and child.

Hoping to have another hit like "System of Survival," in January 1988 Earth, Wind & Fire released the second single from the album, "Thinking of You," written by Wanda Vaughn, Wayne Vaughn, and Maurice White.[22] This is a laid-back groove that features White on lead vocals. This song makes the listener want to sing along and move. A music video was produced for the song. In the video, the band members are performing in an East Asian environment and East Asian models are shown. The band members are wearing suits, not elaborate costumes for which they were known during the classic period. With this song, Earth, Wind & Fire scored another hit. "Thinking of You" only reached #67 on the *Billboard* Hot 100 Songs chart on March 12, 1988. However, it climbed to #3 on the *Billboard* Hot R&B Songs chart and

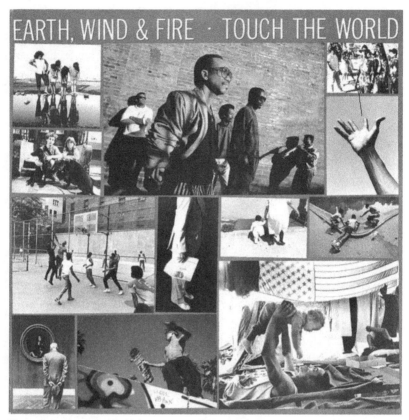

The cover for *Touch the World* shows scenes of American society.

to #1 on the *Billboard* Dance Club Songs chart on March 19, 1988.[23] With two new hit songs, the band would soon be on tour again.

Around the same time "Thinking of You" was released, Earth, Wind & Fire began their Touch the World Tour in St. Petersburg, Florida. The show the band unveiled was one of astonishing proportions. The spectacle took a crew of sixty 45,000 man-hours to put together and cost over a million dollars to produce. It drew on the talents of behind-the-scenes experts like Stig Edgren, designer and producer who conceived the Pope's visit to Dodger Stadium and the grand finale of the Los Angeles Olympics. It also employed Roy Bennett, lighting designer for Prince, and Michael Peters, who choreographed music videos for Michael Jackson, including the short film for "Thriller." Larry Hitchcock, who helped stage tours for Pink Floyd and the Rolling Stones, was also on board.[24] James Earl Jones was enlisted to record a Darth Vader–like dialogue for the introduction to the show. The band had planned a show that exemplified the standards established by Earth, Wind

& Fire during the seventies. But this was 1988, not 1978. They were not sell-ing out the big arenas as expected. After a month into the tour, EWF took a break for six weeks. They made the stage smaller and retooled for smaller venues. Once that was done, the tour did well.[25]

EWF released a third single from *Touch the World*, "Evil Roy," in March 1988. Written by Philip Bailey, Attala Zane Giles, and Allee Willis, this is a socially conscious song, but the music sounds nothing like Earth, Wind & Fire. "Evil Roy" is about a man forced to do evil things because of his dread-ful circumstances. The music video for this song shows the negative effects of drug use and encourages people to just say "No." "Evil Roy" peaked at #22 on the *Billboard* Hot R&B Songs chart on May 28, 1988, and at #38 on the *Billboard* Dance Club Songs chart on June 11, 1988.[26]

After this song, "You and I" was released as a single in July 1988. Not to be confused with the song on the *I Am* album with the same title, this bal-lad features Philip Bailey singing passionately on lead. "You and I" peaked at #29 on the *Billboard* Hot R&B Songs chart on September 3, 1988. This is the last song released as a single from the album, and no other tracks stand out.

Although *Touch the World* does not possess the type of quality most would expect from Earth, Wind & Fire, the album received positive feedback from music critics. Rob Hoerburger of *Rolling Stone* declared that Maurice White and Philip Bailey's groove hadn't lost its step, nor had their politics gone askew. He also claimed that White and Bailey complemented each other, whether they were singing about politics or love.[27] *People* stated that *Touch the World* could stand on its own merits.[28] *Cash Box* described the album as tasty, city-bred, spicy funk. It also claimed that White and Bailey were born to sing together and their sweet/sharp blend elevates the songs to beauty.[29]

Touch the World was also well received by the public. It reached #33 on the *Billboard* 200 Albums chart on December 19, 1987, and #3 on the *Billboard* Top R&B Albums chart on December 26.[30] *Touch the World* sold more than 500,000 copies and was certified gold in the United States by the RIAA on January 18, 1988.[31] The album was also nominated for a Soul Train Award in the category of Best R&B/Soul Album of the Year.

Because of the good reception to *Touch the World*, Earth, Wind & Fire was featured in another commercial, this time for Coca-Cola Classic. In the commercial, the band is dressed in futuristic fashion while dancing on stage with robots in front of pyrotechnics. EWF is singing about the product to the groove of "System of Survival." Maurice White chants "Can't beat the feeling," a slogan that was used by Coca-Cola. It was nice to see EWF regain their popularity in the late 1980s. This was a good time for the band to release another compilation album.

THE BEST OF EARTH, WIND & FIRE, VOL. 2

In the fall of 1988, Earth, Wind & Fire released *The Best of Earth, Wind & Fire, Vol. 2*. This album features eight tracks: "Turn On (The Beat Box)," "Let's Groove," "After the Love Has Gone," "Fantasy," "Devotion," "Serpentine Fire," "Love's Holiday," "Boogie Wonderland," "Saturday Nite," and "Mighty Mighty."[32] The 2000 reissue is discussed in chapter 10. The cover for this album shows a glimpse of the solar system, including planets Earth, Jupiter, and two others. The EWF logo is shown with what appears to be a comet soaring through it. This may signify that EWF's music has reached cosmic heights and its influence is universal.

The only single released from the album, in November 1988, was the previously unreleased "Turn On (The Beat Box)." Written by Rhett Lawrence, Martin Page, and Maurice White,[33] this is an electro dance song that was also featured on the *Caddy Shack II* soundtrack. "Turn On (The Beat Box)" rose

The cover for *Best of Earth, Wind & Fire, Vol. 2* displays the EWF moniker in outer space.

to #26 on the *Billboard* Hot R&B Songs chart on December 24, 1988.[34] On the same date, *The Best of Earth, Wind & Fire, Vol. 2* peaked at #74 on the *Billboard* Top R&B Albums chart and at #190 on the *Billboard* 200 Albums chart.[35] The album was certified gold in the United States by the RIAA on April 19, 1995.[36] In 1989, a few months after the song and album peaked, Earth, Wind & Fire began work on their next studio album.

HERITAGE

In February 1990, Earth, Wind & Fire released their fifteenth studio album, *Heritage*. This would be the band's last album on the Columbia label. Produced by Maurice White, this album features twelve songs and six interludes: "Interlude: Soweto," "Takin' Chances," "Heritage (featuring The Boys)," "Good Time (featuring Sly Stone)," "Interlude: Body Wrap," "Anything You Want," "Interlude: Bird," "Wanna Be the Man (featuring MC Hammer)," "Interlude: Close to Home," "Daydreamin'," "King of Groove," "I'm in Love," "For the Love of You (featuring MC Hammer)," "Gotta Find Out," "Motor," "Interlude: Faith," "Welcome," "Soweto (Reprise)."[37]

The art for the album cover displays unique symbols with the colors red, gold, black, and green. These colors are often used to signify Pan-Africanism. Pan-Africanism is an ideal that encourages all people of African descent to unite and cooperate. Red, black, and green were chosen by Marcus Garvey, founder of the Universal Negro Improvement Association. Red symbolizes the noble blood that unites all people of African descent. Black represents the rich, dark skin of African people. Green represents the fertile land of Africa. Over time, gold has often been added to the other three colors, representing the precious metal and the richness of the African continent. The cover signifies the importance of culture and heritage.

The first single released from this album is the title track. "Heritage (featuring The Boys)," released in February 1990, was written by Frankie Blue, Lestley R. Pierce, and Maurice White. The vocals of White and Philip Bailey are the indicators that this is an Earth, Wind & Fire song. The groove is not typical EWF, and the rap contribution from The Boys is unnecessary. A powerhouse like EWF shouldn't have to appeal to hip hop. "Heritage" encourages people, especially Black people, to take pride in the land from which they come and their cultural heritage.[38] Ever since Earth, Wind & Fire was created, Maurice White wanted Black people to have racial pride. The band was formed during the Black Arts Movement and White was heavily influenced by it. A music video was produced to accompany "Heritage." In

The cover for *Heritage* features West African symbols in the colors of Pan-Africanism.

the video, Earth, Wind & Fire is rehearsing on stage while The Boys sneak around and eventually join the band on stage. During the performance, multiple TV screens show scenes of Black culture and images of important people in history. "Heritage" peaked at #5 on the *Billboard* Hot R&B songs chart on March 17, 1990.[39]

The follow-up single was released in May 1990. "For the Love of You (featuring MC Hammer)" was written by Robert Brookins, MC Hammer, Stephanie Mills, and Maurice White.[40] It peaked at #19 on the *Billboard* Hot R&B Songs chart on June 30, 1990.[41] The next single, "Wanna Be the Man (featuring MC Hammer)," was written by MC Hammer, K. L. Patterson, Sheldon Reynolds, Maurice White, and Verdine White, and released in August 1990.[42] The song peaked at #46 on the *Billboard* Hot R&B Songs chart on September 1, 1990.[43] Both of the aforementioned songs caught Earth, Wind & Fans off guard. Neither of the tracks present the typical EWF sound. They both made the band look desperate to stay relevant by collaborating with a

popular rapper. The *Heritage* album did rather well on the R&B chart but not so well on the pop music chart. *Heritage* only reached #70 on the *Billboard* 200 Albums chart on March 3, 1990, but peaked at #19 on the *Billboard* Top R&B Albums chart on March 24.[44]

The album also received favorable reviews. John Milward of *Rolling Stone* described *Heritage* as having plenty of soul in the grooves.[45] *People* declared that *Heritage* restores Earth, Wind & Fire's reputation, with a full dose of energy and creativity.[46] Don Palmer of *Spin* argued that EWF delivered bright, cheery harmonies set in crisp call-and-response patterns laced together with dreamy musical interludes.[47]

Maurice White liked the music on the album but he did have second thoughts. He stated that he liked the tracks on *Heritage* and also liked the two young guest artists, The Boys and MC Hammer. But White explained, "When you're an adult artist who has had a bunch of hits, like Earth, Wind & Fire, it looks like you're trying too hard when you put younger people on your record *for the sake of having younger people on your record*. That makes it not about music, or a new sound; it makes it about marketing." White was willing to embrace change. But he believed when the change appears forced, it's over before it begins.[48] By the time *Heritage* was released, the music industry had definitely changed.

The 1980s had not been very kind to funk and soul bands. Rhythm machines replaced drummers. Synthesizers substituted for horns. And rappers found that the easiest way to make a hit was by sampling old R&B songs.[49] At the beginning of the 1990s, large bands with expensive horn sections and gangs of percussionists had become an endangered species. Philip Bailey believed this had a negative impact on Earth, Wind & Fire. He stated that *Heritage* is filled with annoying drum machines and inboard studio effects. He argues that MC Hammer, The Boys, and Sly Stone couldn't rescue the insincere studio sound of the album. Bailey believes *Heritage* is EWF's most disappointing record.[50] After the run of *Heritage*, Maurice White received some devastating news.

In the spring of 1991, Maurice White was experiencing severe tremors in his hand. The tremors had actually begun in 1986, but they started lightly. White decided to seek help from experts in alternative medicine. Some of them were herbalists and some dealt in mind-body. Other attempts to treat the tremors were more difficult. But by 1991, the tremors had become worse, and White knew he could no longer solely depend on alternative medicine. A neurologist at USC, Dr. Mark Lew, diagnosed White with Parkinson's disease.[51] Parkinson's is a degenerative disorder of the nervous system. The early symptoms include shaking of the limbs, cramped joints, and slow

movement of the body. There is no cure for Parkinson's, but its symptoms can be controlled with medication.[52] Maurice White did not tell anyone about his diagnosis. He did not want to claim the identity of a man with Parkinson's, and he did not want to make it the focus of his life. Instead, he chose to remain positive.[53] In the following year, more changes occurred in White's life, personal and business.

On February 14, 1992, Maurice White's third child, Eden, was born. Around that same time, Bob Cavallo briefly came back into his business life. After the creative interference on *Heritage*, White wanted to get out of his deal with Columbia Records. White and Cavallo met with Warner Brothers Records, and the president, Mo Ostin, agreed to sign Earth, Wind & Fire. Ostin was known as an executive who encouraged creativity. He had signed Joni Mitchell, James Taylor, and Prince.[54] Warner Brothers is the same label that launched the original Earth, Wind & Fire back in 1971. With the next studio album, instead of chasing the latest trends, EWF would try a back-to-basics approach. They brought in songwriters who worked well for them, including Allee Willis, Roxanne Seeman, and Jon Lind.[55] Production for the album on Warner Brothers began in late 1992. Before Earth, Wind & Fire worked on their next studio album, they released their most extensive compilation project to date.

THE ETERNAL DANCE

In the early 1980s, several recording artists had begun releasing box sets of their musical anthologies. By this time, Earth, Wind & Fire had an extensive catalogue of hit songs; a box set for EWF would be a great idea. On September 8, 1992, EWF released a box set titled *The Eternal Dance*, consisting of three CDs of the band's best music. It also includes a booklet with commentary by Alan Light of *Rolling Stone* and David Nathan of *Billboard*. The booklet also has words of expression by Maurice White, Ramsey Lewis, and El DeBarge, and contains photos of the band members. The cover art for *The Eternal Dance* exemplifies the band's passion for Egyptology. It displays three Kemetic-styled faces, two facing forward and one facing the side. It also displays the third eye and the ankh, the symbol that represents life, rebirth, and eternal life.

There are fifty-five tracks featured in this compilation. The first volume contains songs from 1971 to 1975; the second, from 1975 to 1977; the third, from 1978 to 1989. The track listing is detailed as follows. Volume one contains eighteen tracks:

The front of *The Eternal Dance* box set features a Kemetic nobleman and symbols.

1. "Fan the Fire"
2. "Love Is Life"
3. "I Think about Lovin' You"
4. "Interlude"
5. "Time Is on Your Side"
6. "Where Have All the Flowers Gone"
7. "Power"
8. "Keep Your Head to the Sky"
9. "Evil"
10. "Mighty Mighty"
11. "Feelin' Blue"
12. "Hey Girl (Interlude)"
13. "Open Our Eyes"
14. "Shining Star (alternate version)"
15. "Happy Feelin'"
16. "Reasons"
17. "Shining Star (original version)"
18. "That's the Way of the World"

Volume two also contains eighteen tracks:

1. "Kalimba Story/Sing A Message to You (live)"
2. "Head to the Sky/Devotion (live)"
3. "Sun Goddess"
4. "Mighty Mighty"
5. "Interlude"
6. "Can't Hide Love"
7. "Sing a Song"
8. "Sunshine"
9. "Getaway"
10. "Saturday Nite"
11. "Spirit"
12. "Ponta de Areia—B. R. (Interlude)"
13. "Fantasy"
14. "Serpentine Fire"
15. "I'll Write a Song for You"
16. "Be Ever Wonderful"
17. "Beijo (Interlude)"
18. "Got to Get You into My Life"

Volume three contains nineteen tracks:

1. "September"
2. "Boogie Wonderland"
3. "After the Love Has Gone"
4. "In the Stone"
5. "Dirty (Interlude)"
6. "Let Me Talk"
7. "And Love Goes On"
8. "Pride"
9. "Demo"
10. "Let's Groove"
11. "Wanna Be With You"
12. "Little Girl (Interlude)"
13. "Night Dreamin'"
14. "Fall in Love With Me"
15. "Magnetic"
16. "System of Survival"
17. "Thinking of You"
18. "Gotta Find Out"
19. "That's the Way of the World (live)"[56]

This box set is definitely a collector's item for EWF fans. *The Eternal Dance* contains almost four hours of music. The classy "Night Dreamin'" is the only song not heard before. This compilation also has several good-to-excellent interludes that aren't anywhere else, including the extended version of "Brazilian Rhyme." A great component to this compilation is the live version of "That's the Way of the World" from a 1982 concert in Houston, Texas. It's hard to do justice to great music like the original, but this version meets the challenge.[57]

A couple of months after releasing *The Eternal Dance*, Earth, Wind & Fire released a compilation of short films. On November 24, 1992, Earth, Wind & Fire released *The Eternal Vision* on VHS. This is a compilation of music videos and live performances. This project includes performances of twelve songs: "Serpentine Fire," "September," "Boogie Wonderland," "After the Love Has Gone (Live)," "Let Me Talk," "Let's Groove," "Reasons (Live)," "Fantasy (Live)," "System of Survival," "Thinking of You," "Evil Roy," "Wanna Be the

Man." The cover for this cassette is the same as the cover for *The Eternal Dance*.[58] By the time this compilation was released, EWF had begun working on their next studio album, *Millennium*.

Can't Let Go

In 1993, Bill Clinton was inaugurated as the 42nd President of the United States; and apartheid finally ended in South Africa. The world population was almost 5.5 billion and Earth, Wind & Fire released their sixteenth studio album, *Millennium*, which was supposed to be their last. Maurice White saw it as symbolic that EWF's career would end where it started, at Warner Brothers. White wanted to conclude Earth, Wind & Fire's recording career in a manner that was respectful to their musical legacy. Mo Ostin, the president at Warner Brothers, gave White complete creative freedom. The whole idea was to return to the classic EWF sound. Maurice White believed he achieved some of that on *Millenium*.[1] Before the album was released, the band received some devastating news.

On July 30, 1993, Maurice White's close friend, Phenix Horns saxophonist Don Myrick, was shot to death in a case of mistaken identity by the Los Angeles Police. Myrick answered the door with a butane lighter in his hands, which the police mistook for a weapon and fatally shot him. At Myrick's funeral, there was a lot of sadness and racial frustration. His death was senseless and should not have occurred.[2]

MILLENNIUM

Shortly after Myrick's death, Earth, Wind & Fire released a new single in August 1993, "Sunday Morning," written by Sheldon Reynolds, Maurice White, and Allee Willis.[3] Maurice White stated, "We always seem to get back to the basics." He was talking about the kind of music that sold millions of Earth, Wind & Fire albums in the seventies and early eighties: luscious melodies, heartbreaking ballads, and of course, the horns. The Earth, Wind & Fire Horns still consisted of Gary Bias on saxophones and Ray Brown on trumpet, while the trombone duties went to Reggie Young.

"Sunday Morning" was the first piece of evidence that proved EWF was guilty of getting back to the basics. The listener recognizes the horn blasts in the beginning of the song, and Maurice White's voice is just as distinctive. This song makes the listener appreciate the sound of real horns. Synthesizers just don't compare.[4] A video was made to accompany the song. The video shows the band performing and shows scenes of a beautiful woman who appears to be the singer's love interest.

"Sunday Morning" did well on various charts, peaking at #53 on the *Billboard* Hot 100 Songs chart on September 25, 1993, and #35 on the *Billboard* Adult Contemporary Songs and #10 on the *Billboard* Adult R&B Songs chart on October 2. It climbed to #20 on the *Billboard* Hot R&B Songs chart on October 9.[5] "Sunday Morning" was also nominated for a Grammy in the category of Best R&B Vocal Performance by a Duo or Group.[6]

A month after that single was released, Earth, Wind & Fire released *Millennium* on September 14, 1993. *Millennium* was produced by Maurice White and contains sixteen tracks: "Even If You Wonder," "Sunday Morning," "Blood Brothers," "Kalimba Interlude," "Spend the Night," "Divine," "Two Hearts," "Honor the Magic," "Love Is the Greatest Story," "The 'L' Word," "Just Another Lonely Night," "Super Hero," "Wouldn't Change a Thing About You," "Love Across the Wire," "Chicago (Chi-Town) Blues," and "Kalimba Blues." The cover art was designed by Todanori Yokoo. It features intriguing symbols of history, such as the Great Pyramid, the Great Sphinx, ships for exploration, spacecraft, and others.[7] One month after the album's release, former Earth, Wind & Fire vocalist Wade Flemons died from cancer in Battle Creek, Michigan, at the age of fifty-three.

Later that year, the second single from *Millennium* was released. "Spend the Night" was released in December 1993. It was written by Dawn Thomas.[8] This is a ballad that features Maurice White on lead vocals. The video for this song shows White and the other band members singing while a man and woman travel through the city to meet each other. "Spend the Night" reached #36 on the *Billboard* Adult R&B Songs chart on January 1, 1994, and #42 on the *Billboard* Hot R&B Songs chart on January 29.[9]

The third and final single from *Millennium* is "Two Hearts," released around March 1994. Written by Burt Bacharach, Philip Bailey, and Maurice White, this is a soulful jazz ballad with Bailey on lead vocals. The track features two familiar guest musicians: Burt Bacharach on keyboards and Gerald Albright on saxophone.[10] "Two Hearts" peaked at #88 on the *Billboard* Hot R&B Songs chart on April 16, 1994.[11]

Other songs on *Millennium* add quality to the album. "Super Hero" features Bailey on lead vocals, but this song doesn't get back to the basics. It goes

The cover for *Millennium* exhibits iconic historic symbols.

in the opposite direction. "Super Hero" was written by Prince and features him on background vocals. This is one of Prince's most political songs since "Annie Christian" or "Ronnie Talk to Russia." This song is about the exploitation of Black talent. Another good tune is "Chicago (Chi-Town Blues)." This tune is about Maurice White's early career in Chicago. The lyric "Ba Da Bop Ba Dee-Ah Ba-Dee-Ah" sounds like a hook from the 1970s. *Millennium* definitely includes some of the soulful sounds that helped make Earth, Wind & Fire popular in the 1970s.[12]

Music critics approved of this album's content. M. R. Martinez of *Cash Box* called *Millennium* a fine return. He also stated that the opening three to five tracks could have been selected from Earth, Wind & Fire's early years.[13] Tom Sinclair of *Vibe* declared that EWF still had the knack for constructing sweet-sounding R&B on the visionary/romantic tip.[14] Alex Henderson of AllMusic called *Millennium* a decent offering that finds the crew being true to itself.[15]

The album also did well on the music charts. *Millennium* rose to #8 on the *Billboard* Top R&B Albums chart and #39 on the *Billboard* 200 Albums chart on October 2, 1993.[16] The album was eventually nominated for a Soul Train Music Award in the category of Best R&B/Soul Album—Group, Band or Duo.[17] To promote the album, EWF made television appearances.

Before promotion of the album, four musicians had joined the EWF family: David Romero, Freddie Ravel, Morris Pleasure, and Carl Carwell. David Romero is a percussionist whose various styles of playing include pop, jazz, R&B, African, Brazilian, and Latin music. Whether playing with jazz trios, bands, or symphony orchestras, Romero's personality and great sense of humor add to his creative and rhythmic performance.[18] Romero was a mainstay until 1999. Freddie Ravel is a Los Angeles native. He is of South American and Eastern European descent. Ravel began accordion lessons at age seven and dabbled in drums and guitar before playing the piano. He pursued jazz and classical studies and earned a bachelor's degree at California State Northridge. Ravel also served as the musical director for a while.[19] Instrumentalist Morris Pleasure, also known as Mo Pleasure, was born in Hartford, Connecticut, on July 12, 1962. He began playing the piano at four years old and developed his music skills at Guilford High School in Guilford, Connecticut. Pleasure also learned to play trumpet, violin, drums, and other instruments. After receiving a bachelor's degree in music from the University of Connecticut, Pleasure began his professional music career. He was suggested to Philip Bailey by the late musician George Duke, with whom he had toured. A suggestion also came about singer Carl Carwell, who is from Denver, Colorado. Carwell joined the band as a supporting vocalist and stayed for less than two years. Pleasure would eventually become the musical director for EWF, and he kept that role until his departure in 2001. His first performance with the band was on *The Arsenio Hall Show*.[20]

On October 14, 1993, Earth, Wind & Fire performed "Sunday Morning" on *The Arsenio Hall Show*. Later in the month, they taped a segment for *The American Music Awards 20th Anniversary Special*.[21] For this special, the band performed a medley of "Sunday Morning," "Fantasy," and "September." These were good performances for EWF, but viewers noticed something different about Maurice White. He appeared to be ill. There were rumors stating that White had cancer, AIDS, or multiple sclerosis. He made a public statement that he was not sick but that he was retiring from touring.[22] This left a huge void for EWF. In addition to this, *Millennium* did not sell as well as expected, and the band was dropped from the label.[23] Some people wondered if this was really the final studio album for Earth, Wind & Fire and if the group would be disbanded. . . . again. The following year would be a pivotal time for EWF.

Although the band was on pause, in the beginning of 1994, Earth, Wind & Fire was inducted into the NAACP Hall of Fame.[24] They were inducted by the host of BET's *Video Soul*, Donnie Simpson. A musical tribute to the band was given by Howard Hewett, the Emotions, Siedah Garrett, and Shai. Their work and time in the music business would garner them several more awards for years to come.

Later in the year, an interesting turn of events would occur. In the spring of 1994, Philip Bailey began performing solo gigs that included Earth, Wind & Fire songs in his set. Ross Freeman and David Benoit invited Bailey to be the special guest singer for "After the Love Has Gone" at a Memorial Day weekend concert for San Diego's smooth jazz radio station KIFM. Freeman and Benoit had recorded a cover of the song with vocalists Vesta Williams and Phil Perry. Bailey agreed to do the guest slot, and he wondered, "What if Verdine came too?" Bailey asked Verdine White to do the show with him and White agreed. At the concert, they jumped onstage, feeling nervous and uncertain about how the crowd would react. Bailey added a few snippets of Earth, Wind & Fire hits, and then Verdine launched into a singing version of "Sun Goddess." At that moment, the crowd went wild. After the concert, people were flocking to Bailey and White. After signing a few autographs, they came to the same conclusion: "Maybe we can do this without Maurice."

Soon after that performance, Philip Bailey and Verdine White had a meeting with Maurice White to discuss using the Earth, Wind & Fire name to tour. They later met with former EWF manager Bob Cavallo, who had been getting calls from an agent named Jeff Frasco. Frasco wanted to get Earth, Wind & Fire to tour again.[25] Bob Cavallo and Art Macnow, an accountant who had worked with EWF, had a meeting with Maurice White. Macnow wanted to prove how lucrative a tour would be for Maurice and the band. At first, White was reluctant. He initially wanted to retire the Earth, Wind & Fire name and leave it as a performing act to the memory of the fans. After a month of pondering, Maurice White eventually gave in to the idea.[26]

The band members negotiated a licensing agreement with Maurice White so they could legally use the name Earth, Wind & Fire. It was official: Earth, Wind & Fire would go back on the road without their founder Maurice White. They had a full musical ensemble with guitars, keyboards, drums, bass, and the Earth, Wind & Fire Horns.[27] Musician Keith Robinson was hired as a supporting vocalist. Robinson is a guitarist who has also worked with Keith Sweat, Johnny Gill, Babyface, and others. He toured with EWF for a year.[28]

EWF added a new element to their live performances: attractive, graceful dancers who would enhance their stage shows for several years. The first two dancers to perform with the band were Daryl Richardson and Dee Dee

Weathers. Later, it was Dee Dee Weathers with Kyausha Simpson. Next, it was Kyausha Simpson with Sybil Azur. The final set of dancers included Kyausha Simpson, Joanna Collins, and Ayesha Orange.[29] These dancers encouraged audiences to groove along to the rhythmic sounds of the legendary pop band.

Earth, Wind & Fire developed a set filled with classic hits and performed at smaller venues.[30] The name Earth, Wind & Fire had overcome many challenges and would prove it could stand the test of time for many years to come. By now, the band had amassed fans of different generations, and with their string of hit records, they would remain a bona fide musical act for many years to come. In the spring of the following year, EWF released a new album.

LIVE IN VELFARRE

In April 1995, Earth, Wind & Fire released a live music album titled *Live in Velfarre*. It was released on the now defunct Japanese label called Avex Trax before Rhino Records licensed it. In Europe, this album was titled *Plugged In and Live*. It was recorded at the world-famous disco in the Roppongi District of Tokyo, Japan. *Live in Velfarre* includes eighteen tracks: "In the Stone," "September," "Let Your Feelings Show," "Let's Groove," "Sun Goddess," "Can't Hide Love," "Boogie Wonderland," "Fantasy," "Reasons," "That's the Way of the World," "Africano," "I'll Write a Song for You," "Be Ever Wonderful," "After the Love Has Gone," "Shining Star," "System of Survival," "Sing a Song," and "Devotion." The cover for this album is plain. It simply states the name of the album and the only image is the "EWF" moniker written twice in the shape of a cross.[31] This album would also be released the following year under a different name: *Greatest Hits Live*. A second edition of *Live in Velfarre* was released in 2010; that edition is discussed in chapter 11.

Also in 1995, an exciting drummer and vocalist joined the band. B. David Whitworth, from East Orange, New Jersey, began singing at an early age. His first professional gig was on his fourteenth birthday, playing trumpet with friends in a pop band at a wedding reception. Whitworth played in marching bands and sang in choruses throughout high school and acquired work touring with Broadway artist Stephanie Mills. He was suggested to join Earth, Wind & Fire by a friend named Scott Mayo, who worked with the band. Whitworth quickly accepted the offer and has been an active member of EWF ever since.[32]

Later in the year, the band received a special honor. On September 15, 1995, Earth, Wind & Fire was honored with a star on the Hollywood Walk of Fame. Maurice White attributed EWF's success to the support of their fans. "It's been quite a trip for us to stay together for over twenty years," White stated

The cover for *Live in Velfarre* features a cross with the EWF moniker imprinted.

to the crowd, which included comedian Sinbad and former radio host Tom Joyner. He added, "When we first started on this scene, we didn't know if we were going to make it. But I want to thank you all for sharing the dream with us." The star is located at exactly 7800 Hollywood Boulevard (South), at the corner of La Brea Avenue.[33]

The band also worked with Bill Meyers on a song for his 1996 album. Meyers is an accomplished musician who formed a valuable relationship with Maurice White in the 1970s. Meyers has produced, arranged, and played on a few Earth, Wind & Fire albums, including, *I Am*, *Powerlight*, *Touch the World*, and *Heritage*.[34] On his 1996 album *All Things In Time*, EWF is featured on the song "Sky," produced by Bill Meyers and Maurice White.[35] "Sky" sounds like a classic EWF tune. It has a groove similar to "Sunday Morning" and vocal chants similar to "way-yo" of "Sun Goddess" and "ba-de-ya" of "September." This song serves as a reminder that Earth, Wind & Fire could still produce that unique sound after so many years.

ELEMENTS OF LOVE: THE BALLADS

Before their next studio album was released, a unique compilation album was issued. On June 11, 1996, *Elements of Love: The Ballads* was released on Columbia Records. This compilation features fourteen of Earth, Wind & Fire's most soothing tracks: "Open Our Eyes," "Keep Your Head to the Sky," "Devotion," "Love's Holiday," "Ponta de Areia (Brazilian Rhyme) (Interlude)," "Be Ever Wonderful," "All About Love," "Can't Hide Love," "I'll Write a Song for You," "After the Love Has Gone," "Imagination," "Side by Side," "Spirit," and "Reasons." The cover for this album features the Kemetic deity Heru above the clouds with a pyramid in the background.[36]

Elements of Love: The Ballads became a priority for EWF fans. Andrew Hamilton of AllMusic described this softer side of Maurice White's creation as sparkling.[37] J. D. Considine of the *Baltimore Sun* claims *Elements of Love: The Ballads* suggests Earth, Wind & Fire provided a useful model for soul harmony acts.[38] A month after this compilation was released, EWF released new material.

The cover for *Elements of Love: The Ballads* displays the Kemetic deity Heru.

AVATAR

In July 1996, Earth, Wind & Fire released *Avatar* only in Japan. It was their first studio album in two and a half years. This album features thirteen tracks: "Keep it Real," "The Right Time," "Feel U Up," "Avatar (Interlude)," "Cruising," "Revolution (Just Evolution)," "Round and Round," "Change Your Mind," "Love Is Life," "In the Name of Love," "Take You to Heaven," "Rock It," and "Bahia (Interlude)." The cover for this album is simple. It displays the title and that familiar Kemetic symbol, the ankh.[39] The US version of this album, titled *In the Name of Love. In the Name of Love*, would be released in 1997.

Shortly after *Avatar* was released, Maurice White started his own record label. In August 1996, he opened the doors of Kalimba Records. With this label, White hoped to sign artists in all genres of music. He served as president and chief executive officer. Earth, Wind & Fire co-manager Art Macnow served as head of the label's business affairs. Named for the African thumb piano featured in many EWF songs, the Kalimba offices featured a state-of-the-art recording studio at the Santa Monica, California, headquarters. The initial plan was to issue three or four albums per year, some of which would be produced or co-produced by Maurice White.

The cover for *Avatar* displays the familiar ankh.

Maurice White co-produced the debut release of keyboardist Freddie Ravel, the first artist signed to Kalimba. At the time, Ravel's *Sol to Soul* was in the top half of the contemporary jazz charts. Contemporary jazz/hip hop artist Hypnofunk was another project produced by White. White expressed, "Now that I am no longer touring with Earth, Wind & Fire, I'm focused on the next phase of my career. With the record label, I'm charged about finding and developing new talent and helping true artists realize their potential." He added, "Throughout my career, I've had the good fortune to work with some of the industry's greatest record executives. Those experiences helped prepare me to run a successful label."[40]

GREATEST HITS LIVE

A couple months later, on October 29, 1996, EWF released *Greatest Hits Live*. As stated previously, *Greatest Hits Live* is the reissue of *Live in Velfarre*. The only difference in the issues is the album cover. For *Greatest Hits Live*, the color of the album cover is different. The EWF moniker is brown, the color of ancient stone. In the background appears what looks like a snapshot of an ancient Egyptian temple wall with hieroglyphs.[41] This is another example of Kemetic symbolism. Earth, Wind & Fire has always sounded just as good live, if not better, as they did on their studio recordings. Leo Stanley of All-Music stated that the band sounds professional on this fun performance for dedicated fans.[42] *Greatest Hits Live* peaked at #75 on the *Billboard* Top R&B Albums chart on November 16, 1996.[43] Earth, Wind & Fire's live collection of hits is superb.

Because of this, nearly a year later, the band performed at the Montreux Jazz Festival. The Montreux Jazz Festival occurs every summer in July for two weeks. It takes place in Switzerland, on the shores of Lake Geneva. It was created in 1967 by Claude Nobs and over the years has become an essential event, generating fantastic stories and legendary performances. With nearly 250,000 spectators, the Montreux Jazz Festival is one of the largest music festivals in the world.[44]

For Earth, Wind & Fire's performance, there was certainly no shortage of energy. Proving that there was no need for elaborate costumes for a good party, the band trotted out a couple of female dancers along with some of their most-beloved radio hits, such as "Saturday Night," "September," the funky "Let's Groove," and even their hit ballad, "After the Love is Gone," which did not have the effect of lowering the energy level. Phillip Bailey's vocals were still on point, hitting high notes that seem impossible. The band was

The cover for *Greatest Hits Live* displays a cross with hieroglyphics in the background.

tight overall, laying down silky seventies grooves that never seem to age.[45] This performance was recorded on film and would be released on DVD in 2004, which is discussed in the next chapter. During the same month of the festival, EWF issued a release of *Avatar* under a different name: *In the Name of Love.*

IN THE NAME OF LOVE

In the Name of Love was released on July 22, 1997. Unlike *Avatar*, instead of having thirteen tracks, *In the Name of Love* features eleven tracks. The two interludes "Avatar" and "Bahia" and the song "Change Your Mind" are not included on *In the Name of Love*. A new song, "When Love Goes Wrong," was added to *In the Name of Love*. The album cover is also different; it features

The cover for *In the Name of Love* shows a large ankh on a desert landscape.

a building in the shape of the ankh on a desert landscape, perhaps Egypt.[46] This album was reissued in 2006; that edition is discussed in chapter 11.

The first single, "Revolution (Just Evolution)," was released around the same time as the album. This song was written by Sir James Bailey, Sonny Emory, Morris Pleasure, and Maurice White.[47] Sir James Bailey is the son of lead singer Philip Bailey. This is a funky track with a strong bassline accompanied by horn riffs. This is a treat for Earth, Wind & Fire fans who love their distinctive sound. Sir James Bailey has a rap vocal on this track that fits well with the groove. "Revolution (Just Evolution)" encourages humanity to unite, love one another, and do what is right.[48] These ideals have always been a part of the mission of Earth, Wind & Fire. "Revolution" reached #89 on the *Billboard* Hot R&B Songs chart on August 8, 1997.[49]

On Friday, September 12, 1997, Earth, Wind & Fire appeared on the *Today* show. Their stage was set outdoors in the middle of the street. Philip Bailey,

Verdine White, and Ralph Johnson discussed *In the Name of Love* and Maurice White's absence from performing. The band performed their latest single "Revolution (Just Evolution)" with Sheldon Reynolds on lead vocals, and they performed the classic "Fantasy," showing the world that Philip Bailey's falsetto was still intact.[50] Soon after, in the fall of 1997, EWF released the second single from *In the Name of Love*, "When Love Goes Wrong."

On "When Love Goes Wrong," written by Philip Bailey, Alan Glass, and Andrew Klippel,[51] Bailey delivers his falsetto over a neo-soul groove. "When Love Goes Wrong" suggests that one's love life can affect everything around him. This song peaked at #33 on the *Billboard* Adult R&B Songs chart on November 1, 1997.[52] In one form or another, the other tracks on *In the Name of Love* showcase elements of what fans have come to love about Earth, Wind & Fire: powerful lyrics, harmonious vocals, punching horn riffs, and funky basslines. *In the Name of Love* peaked at #50 on the *Billboard* Top R&B Albums chart on September 13, 1997.

According to critics, this album is great because it exemplifies a return to the classic Earth, Wind & Fire sound. Chuck Eddy of *Entertainment Weekly* declared that on *In the Name of Love*, Earth, Wind & Fire's fluid blend of percussion, horns, and soul harmonies is impressive.[53] Omoronke Idowu of *Vibe* declared that "Revolution," "Rock It," and the title track are certainly dance floor anthems, while "Fill You Up" and "Love Is Life" are brilliantly orchestrated indicators of romantic love. Idowu adds that the ballads "When Love Goes Wrong," "Cruising," and "Right Time" are among the band's finest work.[54] Alex Henderson of AllMusic declared that *In the Name of Love* was EWF's most live-sounding, least high-tech album since *Powerlight*. Henderson adds that live horns and real instruments abound, and the album is unapologetically retro.[55] After twenty-seven years, EWF proved they were still relevant, and another experienced musician soon joined the band.

Robert Brookins joined Earth, Wind & Fire in 1998. Brookins was a respected singer, songwriter, and producer born in San Francisco, California. He began singing at the age of four, by age five was playing drums, and began playing keyboards at the age of nine. Brookins eventually learned to play bass, guitars, and various horn instruments. He worked with several artists, including George Duke, Stephanie Mills, and Roy Ayers.[56] Brookins had an impressive résumé, and he became musical director of EWF in 2001. It was always Maurice White's goal to have the best musicians in his band. In July 1998, EWF were given the unusual honor to performed at the Montreux Jazz Festival in Switzerland for the second consecutive year.[57]

A month later, the band went on tour with two other soul music legends. The Sweet Sounds of Soul Tour linked Earth, Wind & Fire with the O'Jays and

the Isley Brothers. It was the first time the soul titans had toured together. The tour was sponsored by Honey Nut Cheerios, and EWF appeared on Honey Nut Cheerios boxes with an offer for a CD-sampler containing songs from all three groups. The tour began in August 1998 and continued through October 1998 with stops in New York, Los Angeles, and major cities in between.[58] With Honey Nut Cheerios as the sponsor, the tour attracted a diverse crowd. Ralph Johnson declared, "It's a totally different demographic. More families, more racially balanced." And of course, the audiences were bigger. Between the three groups, they amassed more than 180 hit songs, mostly from the 1970s.[59] Verdine White reiterated Johnson's statement: "All of the bands really sound great. The audiences are really loving it. People seem to be talking about it. There are young people, old people. White people, Black people. It's a very mixed audience."[60]

GREATEST HITS

In November 1998, Earth, Wind & Fire released *Greatest Hits*, featuring seventeen tracks from the classic period: "Shining Star," "That's the Way of the World," "September," "Can't Hide Love," "Got to Get You Into My Life," "Sing a Song," "Gratitude," "Serpentine Fire," "Fantasy," "Kalimba Story," "Mighty Mighty," "Reasons," "Saturday Nite," "Let's Groove," "Boogie Wonderland," "After the Love Has Gone," and "Getaway." All but one of the ten songs from *The Best of Earth, Wind & Fire, Vol. 1* are included. Six of the ten songs from *The Best of Earth, Wind & Fire, Vol. 2* are included. It is a sheer delight to have all these hit songs on one superb disc.[61] The cover for this album looks like a return to the 1970s. It features many of the symbols seen on the inside sleeve of *All 'N All*, such as the ankh, the cross, the Star of David, the eye of Heru, and others. A return to the seventies for EWF was showcased in 1999.

In 1999, the world began to prepare for the new millennium. Prince's hit song "1999" was played over the airwaves constantly. Many people wondered how they would celebrate the turn of the millennium. While Earth, Wind & Fire and the rest of the world were contemplating the future, the band also looked to the past. In July 1999, EWF reissued four albums from the classic period, particularly albums from the 1970s.

A second edition of the 1975 breakout album *That's the Way of the World*, which includes the smash hit "Shining Star" and the anthemic title track, was reissued. This edition of *That's the Way of the World* features five bonus tracks: "Shining Star (Future Star) [Original Sketches]," "All About Love (First Impression) [Original Sketches]," "Happy Feelin' (Anatomy of a Groove)

The cover for *Greatest Hits* displays symbols of religion and enlightenment.

[Original Sketches]," "Caribou Chaser (Jazzy Jam) [Original Sketches]," and "That's the Way of the World (Latin Expedition) [Original Sketches]."[62]

The second album reissued is *Gratitude*, the follow-up album to *That's the Way of the World* and also released in 1975. Like *That's the Way of the World*, this album rose to #1 on both the *Billboard* 200 and Top Soul Albums charts. *Gratitude* is a double album that consists of mostly live material. The 1999 edition of *Gratitude* features three bonus tracks: "Musical Interlude #1," "Musical Interlude #2," and "Live Bonus Medley: Serpentine Fire/Saturday Nite/Can't Hide Love/Reasons."[63]

In addition, *All 'N All* was reissued, originally released in 1977. This album may always be remembered as the one with the most elaborate gatefold and the extravagant tour that accompanied it. *All 'N All* spent nine weeks at the top of the *Billboard* Top Soul Albums chart and features the hit songs "Fantasy" and "Serpentine Fire," which was in the #1 position for seven weeks on the

Billboard Hot Soul Songs chart. The 1999 reissue of *All 'N All* features three bonus tracks: "Would You Mind (Demo Version of 'Love's Holiday')," "Runnin' (Original Hollywood Mix)," and "Brazilian Rhyme (Beijo) (Recorded Live)."[64]

The fourth reissue of 1999 is *The Best of Earth, Wind & Fire, Vol. 1*, first released in 1978. It has been certified quintuple platinum by the RIAA. This compilation album features the signature classic "September" and other Earth, Wind & Fire standards. The second edition of *The Best of Earth, Wind & Fire, Vol. 1* features two bonus tracks: "Megamix 2000," and "Megamix (Radio Edit)."[65] This second edition has a different back cover. In addition to the pyramid and the pharaoh with the royal headdress, it also displays Heru, the ankh, the Jupiter symbol, and the sign of Paracelsus. These four albums were produced when the band was at its height. The reissue of these albums helped the younger generation fall in love with them more.

THE ULTIMATE COLLECTION

The Ultimate Collection was issued by Columbia Records in the United Kingdom in July 1999. On the cover is a picture of the classic nine members wearing afros and African-styled costumes. This compilation features nineteen tracks from the classic period: "Boogie Wonderland," "Shining Star," "That's the Way of the World," "September," "Can't Hide Love," "After the Love Has Gone," "Got to Get You into My Life," "Sing a Song," "Gratitude," "Serpentine Fire," "Fantasy," "In the Stone," "Reasons," "Saturday Nite," "Let's Groove," "Getaway," "September 99 (Phats and Small Remix)," "Let's Groove (Merchant of Menace Remix)," and "Boogie Wonderland (Stretch/Vern Remix)."[66]

The only single from the album was "September 99," released in July 1999. The song was remixed by English dance music duo Phats and Small. "September 99" climbed to #25 on the UK Singles chart on July 25, 1999,[67] and to #4 on the UK Dance Singles chart on the same date.[68] The song reached #1 on the Canadian magazine *RPM* Dance Songs chart on December 6, 1999.[69] The success of this single exemplifies the staying power of this classic EWF song. *The Ultimate Collection* peaked at #34 on the UK Albums Chart July 8, 1999.[70]

In the same year, a new drummer joined the band. Earth, Wind & Fire hired Gorden Campbell as the new drummer. Campbell grew up in Newburgh, New York. He began playing drums at the age of five in his grandfather's church. Campbell earned a bachelor's degree in music with a major in jazz studies from Howard University. Before joining EWF, he toured with the R&B group Shai. Campbell stayed with EWF for two years and later became the musical director for R&B singer Ne-Yo.[71]

The cover for *The Ultimate Collection* features a vintage photo of the classic nine band members.

During the summer of 1999, EWF went on tour with Barry White. AMFM, formerly known as Chancellor Media, launched the first of its concert tour packages by pairing Earth, Wind & Fire with Barry White. The tour began on August 4 in San Francisco, California, and was scheduled for sixteen shows in fourteen cities.[72] While on tour in Nashville, Tennessee, Barry White was hospitalized for a blood pressure problem. He suffered from exhaustion. The shows in Nashville, New Orleans, Dallas, and Detroit were cancelled.[73] One observer noted that Earth, Wind & Fire's sound was so good that it made her wonder if any electronic cheating was going on, especially since the music sounded so much better than Barry White's.[74] After so many years, EWF could still deliver.

By this time, Earth, Wind & Fire had been in the music business for more than twenty-nine years. Their thirty-year anniversary was on the horizon. They had endured challenges in their career. They survived a hiatus. Maurice

White was no longer touring, and several personnel changes had occurred. The music landscape had changed dramatically from when the band started, but they were still a significant act in the music business. Thirty years is a special milestone for musicians, but how long would EWF last? Would they retire at the new millennium? Other questions came with the turn of the millennium. Many people wondered if the world would come to an end while people all over the globe were preparing for a possible catastrophic computer and internet crash called Y2K.

Millennium

As the year 1999 came to a close, global citizens began preparing for extravagant celebrations for the new millennium. Also, Prince's 1982 hit song "1999" was being played on the airwaves and at social events. While many people were excited about the turn of the millennium, others were worried about the Y2K hysteria. Y2K is short for year 2000, and the problem was with computers. Computer programmers had long been rendering years with the last two digits only. For example, "71" was used in place of 1971. It was a way of saving bits on the computer. So, what would happen when 1999 clicked over into 2000? Would computers think we were moving back in time to 1900? Then, anything electronic might go crazy! There could be massive power failures. Financial records could disappear. Planes might fall from the sky, and missiles could be launched by mistake.[1] So, what exactly would the new millennium bring? Would the computer systems crash? Those questions were soon answered.

On December 31, 1999, people around the world were celebrating to bring in the new year, the new decade, the new century, and the new millennium. In their specific time zones, citizens of the world counted down Five . . . Four . . . Three . . . Two . . . One . . . Happy New Year! Happy New Century! Happy New Millennium! There were no catastrophes. Any Y2K problems that occurred were minor.[2] The world kept spinning and life went on. Earth, Wind & Fire began the new millennium by appearing on the popular sketch comedy series *Mad TV*, which aired on the Fox Network.

On the *Mad TV* episode that aired on February 19, 2000, Earth, Wind & Fire performed during a parody featuring the Blaxploitation character Dolemite. In the parody, Dolemite has to fight the rock monster, the flame monster, and the wind monster. Dolemite realizes he needs some help. He declares, "To beat earth, wind, and fire, we must use Earth, Wind & Fire." EWF then performs their classic hit "Shining Star." This performance on *Mad TV* proved the band was still a strong entity in popular culture after thirty years in the music business.

This thirty-year milestone rendered EWF another huge accomplishment. After being on the nominee list for seven years, Earth, Wind & Fire was inducted into the Rock & Roll Hall of Fame. The announcement of the band's induction came in December 1999. At first, Maurice White was reluctant to attend the induction ceremony. He did not want to deal with Parkinson's disease at such a high-profile event. He received a lot of pressure from Art Macnow and Verdine White to attend the ceremony, and he gave in. Maurice White knew he had to tell the public about his health. One week before the ceremony, White declared to the Associated Press that he had been suffering from Parkinson's disease. He was being asked many questions about his situation, and he felt the band's special moment was being overshadowed by the revelation. This did not sit well with White. However, the good thing about this occasion is it was the first time that EWF band members from the classic period had been together in twenty years.[3]

On March 6, 2000, the sixteenth annual induction ceremony for the Rock and Roll Hall of Fame was held at the Waldorf Astoria Hotel in New York City. Earth, Wind & Fire was inducted by Lil' Kim. Other inductees that year included Bonnie Raitt, Eric Clapton, Billie Holiday, The Moonglows, Nat "King" Cole, and others.[4] At the ceremony, the band performed "Shining Star" and "That's the Way of the World." The award was a fitting gesture for a band who had been in the music business for thirty years.

On May 30, 2000, the second edition of *The Best of Earth, Wind & Fire, Vol. II* was released. The first edition of this album was released in 1988 and contains the hit song "Turn On (The Beat Box)." The second edition of *The Best of Earth, Wind & Fire, Vol II* contains two bonus tracks: "Keep Your Head to the Sky," and "I'll Write a Song for You."[5]

By this time in their career, EWF had solidified their legendary status in the music business, and they would receive more accolades and perform for world leaders. On June 20, 2000, Earth, Wind & Fire performed on the South Lawn of the White House for His Majesty Mohammed VI, King of Morocco, and Her Royal Highness Princess Lalla Meryem. The band was specially invited by President Bill Clinton. White House social secretary Capricia Marshal described the king, stating, "He likes race car driving. He's a skier. He enjoys Earth, Wind & Fire."[6] This was an indication of the influence EWF's music has had on people around the world. Their music has had a positive effect on people from various cultures and religions.

Earth, Wind & Fire was also featured on Wyclef Jean's album *The Ecleftic: 2 Sides II a Book*, which was released in late August 2000. For Wyclef Jean's album, Earth, Wind & Fire is featured on the track "Runaway." In this song, EWF chants the famous chorus from the fan favorite "Brazilian Rhyme

(Beijo)," which is featured on the 1977 album *All 'N All*. During the chorus, Jean declares, "Ain't no sample; this original, baby."[7] EWF's appearance on this track is another example of the love and admiration they have received from younger artists.

On February 13, 2001, a concert DVD titled *Earth, Wind & Fire: Live* was issued. The performance was recorded during a 1994 concert in Japan. The DVD would eventually sell more than 50,000 units and was certified gold on October 25, 2005.[8] In April 2001, Earth, Wind & Fire reissued two more albums from the classic period: *Open Our Eyes* and *Spirit*. *Open Our Eyes* was originally released in 1974 and features the breakout hit "Mighty Mighty" and the inspirational tune "Devotion." The second edition of *Open Our Eyes* features four bonus tracks: "Ain't No Harm to Moan (Slave Song)," "Fair But So Uncool (Walkin' in N'Awlins Mix)," "Step's Tune," and "Dreams."[9] *Spirit* is the 1976 album that features "Getaway" and "Saturday Nite." The second edition of *Spirit* features five bonus tracks: "Saturday Nite (Alternate Mix)," "Seraphim," "Imagination (Angels Mix)," "Departure (The Traveler)," and "African Symphony."[10] Both of these albums were released only a few years after EWF's first album *Earth, Wind & Fire*.

In 2001, Earth, Wind & Fire hired four musicians. Guitarist Bobby Gonzales would only be with the band for a year. EWF also hired John Paris to replace Gorden Campbell. Paris is a drummer, saxophonist, arranger, singer, songwriter, and electric guitarist, and has been the drummer for EWF ever since. Paris currently plays and endorses Drum Workshop drums, Remo drumheads, Vic Firth drumsticks, and Sabian cymbals.[11] Daniel de los Reyes was hired as a percussionist. He was born in New York City and raised in Puerto Rico and Las Vegas. Daniel de los Reyes is of Cuban and Puerto Rican descent and a third-generation musician. He received his early drum instruction from his father, Walfredo Reyes II. His grandfather, Walfredo de los Reyes Sr., was one of the founding members of the Cuban orchestra Casino de la Playa.[12] This percussionist performed with EWF for three years.

The fourth musician hired, Myron McKinley, is a pianist, producer, songwriter, programmer, and film score composer for large box-office films and television shows. Born and raised in Los Angeles and a USC alumnus, McKinley began studying jazz and classical piano at the tender age of three. Known for his contagious energy that captivates the audience in amazement, McKinley has a long list of working with the best in the music industry, including Whitney Houston and Chaka Khan.[13] He became the musical director for EWF in 2004 and continues to work with the band.

The year 2001 also marked the thirtieth anniversary of the release of *Earth, Wind & Fire*. To celebrate, *Billboard* published a commemorative issue

in July 2001. This issue features four articles written about the band. In the first articled, titled "Grooving to 30 Years of Earth, Wind & Fire," Don Waller gives a short discussion of the band's creation and its rise to superstardom. He describes EWF's concerts as a heady brew of racial pride, African consciousness, spiritual unity, and industrial-strength light and magic.[14] Waller also lists ten of EWF's hit songs during its classic period. The second article discusses the band's continued success in the twenty-first century.

In "In the Works," Rhonda Baraka discusses the release of Earth, Wind & Fire's documentary, *Shining Stars*, which traces the band's history. Baraka mentions the recording of *That's the Way of the World: Alive in '75*, which was due for release in 2002, and touring commercials that were in the works. Baraka notes that although the music industry was changing, EWF's songs still focused on spirituality and life. She also gives commentary by musicians David Foster and Wyclef Jean.[15]

Baraka wrote another article for this *Billboard* issue. Her second article in this commemorative issue is titled "A Conversation with Verdine White, Philip Bailey and Ralph Johnson." Baraka begins by exclaiming that Earth, Wind & Fire's music has been as essential to raising our collective consciousness and quenching our spiritual thirst as the elements (earth, wind, fire) themselves are to our very existence.[16] The article is basically an interview with White, Bailey, and Johnson. These three musicians have been with Earth, Wind & Fire since its classic period and have remained the core of the band since Maurice White stopped touring. In this conversation, they discuss their enlightenment, the band's transition, and the challenge of Maurice White's decision to stop touring. The last article in this special issue is an interview with Maurice White.

The last article, simply titled "Maurice White," was written by Gail Mitchell. In this interview, White reflects on Earth, Wind & Fire's longevity and reveals what makes the band's sound so successful. At the end of the article, commentary is given by music executives Clive Davis and Bob Cavallo and musician India Arie. Arie states, "The spirituality in their music and the symbolism of their album covers are so moving. The chakras, the colors and the pyramids. I love them all for that!"[17]

In August 2001, Eagle Rock Entertainment released *Shining Stars: The Official Story of Earth, Wind & Fire*. This documentary contains rarely seen historic video footage. It features in-depth interviews with band members from the classic period. Snippets of previously unreleased live music are also shown. The celebration of this legendary band would continue throughout the twenty-first century. Starting early in the following year, EWF continued to perform, release music, and receive more honors.

On February 24, 2002, Earth, Wind & Fire performed at the closing cer-emonies of the 2002 Winter Olympics held in Salt Lake City, Utah.[18] The band performed "September," a snippet of "Let's Groove," and "Shining Star."

THAT'S THE WAY OF THE WORLD: ALIVE IN '75

A couple of months later, in April 2002, Earth, Wind & Fire released a phe-nomenal live music album titled *That's the Way of the World: Alive in '75* featuring eleven tracks: "Overture," "Shining Star," "Happy Feelin'," "Yearnin' Learnin'," "Sun Goddess," "Interlude," "Evil," "Kalimba Story," "Reasons," "Mighty Mighty," and "That's the Way of the World."[19] All of the tracks selected by Maurice White are highlights from Earth, Wind & Fire's breakout 1975 tour. Stephen Thomas Erlewine of AllMusic describes the album as a fun record, something EWF fans, especially those who love the band's early peak years, will surely enjoy.[20] Mark Anthony Neal declared that this album

The cover for *That's the Way of the World: Alive in '75.*

catches EWF at their artistic peak, shortly before they are transformed into a pop phenomenon. Neal believes for that reason alone, it is a worthwhile investment.[21]

EWF also hired a female vocalist for the first time in nearly three decades. Kimberley Brewer was hired to tour with Earth, Wind & Fire as a backup vocalist in 2002 and 2004. Brewer began her singing career in the 1980s and became known for her longtime collaboration with Stevie Wonder. She has also contributed vocals to several other superstars including Whitney Houston, Kristen Vigard, Teena Marie, Rick James, K. D. Lang, Will Downing, Boney James, and Vanessa Williams.[22] EWF also hired guitarist John Johnson to replace Bobby Gonzales. Johnson performed with the band until 2004. In June 2002, EWF received two more awards.

On June 17, 2002, the American Society of Composers, Authors and Publishers (ASCAP) presented the ASCAP Rhythm & Soul Heritage Award to Earth, Wind & Fire. The award was presented at the 15th Annual ASCAP Rhythm & Soul Music Awards Dinner. The event was held at Beverly Hilton Hotel in Los Angeles, California. ASCAP is the world's largest performing rights organization, with over 135,000 composer, lyricist, and music publisher members. ASCAP is committed to protecting the rights of members by licensing and collecting royalties for public performances of their copyrighted works, and then distributing those fees to the society's members based on performances.

A little more than two weeks later, EWF received another award. On June 25, 2002, Earth, Wind & Fire received a Lifetime Achievement Award at the Second Annual BET Awards.[23] The band was presented the award by Steve Harvey. A musical tribute to EWF was performed by Chaka Khan, Gerald Levert, and Tweet. After the tribute, Philip Bailey, Ralph Johnson, and Verdine White took the stage to perform "Reasons" and "Let's Groove." While the band was singing "Let's Groove," Maurice White joined them and sang. The four core members of EWF and Larry Dunn gave words of expression after their performance as they received their awards.

THE ESSENTIAL EARTH, WIND & FIRE

In July 2002 Columbia Records released *The Essential Earth, Wind & Fire*, a two-disc compilation of some of Earth, Wind & Fire's greatest hit records. All the songs on this compilation come from Earth, Wind & Fire's classic period (1973–83). *The Essential* was reissued in 2014, that edition is mentioned in chapter 12. The two discs featuring seventeen tracks each.

The cover for *The Essential* compilation shows a familiar photo of the band from the classic period.

Disc 1:

1. "Mighty Mighty"
2. "Evil"
3. "Devotion"
4. "Keep Your Head to the Sky"
5. "Kalimba Story"
6. "Shining Star"
7. "That's the Way of the World"
8. "Yearnin' Learnin'"
9. "All About Love"
10. "Reasons
11. "Sing a Song"
12. "Can't Hide Love"
13. "Getaway"
14. "Saturday Nite"
15. "Ponta de Areia (Brazilian Rhyme)/Be Ever Wonderful"
16. "Open Our Eyes"
17. "Got to Get You into My Life"

Disc 2:

1. "September"
2. "Serpentine Fire"
10. "You and I"
11. "Let Me Talk"

3. "Fantasy"

4. "I'll Write a Song for You"

5. "Drum Song"

6. "In the Stone"

7. "Can't Let Go"

8. "After the Love Has Gone"

9. "Wait"

12. "And Love Goes On"

13. "You"

14. "Let's Groove"

15. "Fall in Love with Me"

16. "Side by Side"

17. "Boogie Wonderland"

The cover for *The Essential* is a photo of the band from the classic period. The band members are dressed in African-styled costumes.[24] *The Essential* reached #91 on the *Billboard* Top R&B on August 17, 2002,[25] and was certified gold by the RIAA on February 5, 2005.[26] The gold status of *The Essential* is an indication of how EWF maintained their popularity in the new millennium although popular music has constantly changed.

LIVE IN RIO

In November 2002, Earth, Wind & Fire released *Live in Rio* on Maurice White's Kalimba label. This album was recorded during the band's 1980 performance in Rio de Janeiro, Brazil. It features fifteen tracks: "Dialog," "Rock That," "In the Stone," "Serpentine Fire," "Fantasy," "Can't Let Go," "Getaway," "Brazilian Rhyme (Beijo)," "Magic Mind," "Runnin'," "After the Love Has Gone," "Rio After Dark," "Got to Get You into My Life," "Boogie Wonderland," and "September." The cover displays band members performing on stage.[27] Like their other live albums, *Live in Rio* makes listeners feel as if they are at an EWF concert. *Billboard* described this trip down memory lane as a colorful, smile-generating showcase of live performances.[28]

THE PROMISE

After publishing albums consisting of classic songs, new studio material was due. In May 2003, Earth, Wind & Fire released their eighteenth studio album, *The Promise*. This is the second album released on Maurice White's Kalimba label. It was executive produced by Maurice White. *The Promise* features seventeen tracks: "All in the Way featuring The Emotions," "Betcha," "Wiggle," "Why?" "Wonderland (featuring Angie Stone)," "Where Do We Go from Here?," "Freedom," "Hold Me," "Never," "Prelude," "All About Love," "Suppose You Like Me," "The Promise," "She Waits," "The Promise (Continued),"

The cover for *Live in Rio* shows concert scenes.

"Let Me Love You," and "Dirty." The Japanese edition of this album features two bonus tracks: "Soul" and "So Lucky." The cover for this album is reminiscent of some of the album covers from the classic period.

The cover for this album, reminiscent of some of the album covers from the classic period, displays a man with his arms raised to the sky. On the back of his robe is the ankh. In the sky, there is the sun and planets. There are also familiar symbols seen on other albums, including the Jupiter symbol, Heru, the eye of Heru, and the sign of Paracelsus. A Kemetic statue is also displayed.[29] Even in the twenty-first century, Earth, Wind & Fire continue to saturate their album covers with the rich visual symbolism and spirituality that has become synonymous with their legacy. *The Promise* was reissued six years later in 2009, and a third edition was released in 2014; those editions are discussed in chapters 11 and 12, respectively. Earth, Wind & Fire planned a shed-and-theater tour in support of the album for the summer. The outing kicked off May 23, 2003, in Boca Raton, Florida, and hit twenty-four dates

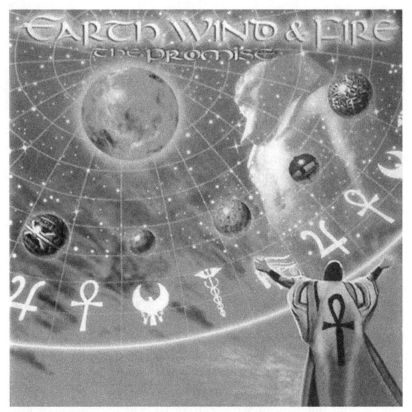

The cover for *The Promise* shows familiar symbols used by Earth, Wind & Fire.

in major US markets through July 3.[30] The first single, "All in the Way," was released in May.

"All in the Way" was written by Wayne Vaughn, Wanda Vaughn, and Maurice White.[31] This same trio wrote the hits "Fall in Love with Me" and "Side by Side," as well as other songs from the *Powerlight* album. These three musicians have good chemistry for creating a good song. "All in the Way" features Maurice on lead vocals, with backing vocals provided by The Emotions. The kalimba can also be heard on this song, which sounds like it was recorded in the late 1970s. "All in the Way" is about two people happily in love.[32]

This song had a decent run on the music charts. "All in the Way" peaked at #77 on the *Billboard* Hot R&B Songs chart on June 21, 2003, and #13 on the *Billboard* Adult R&B Songs chart on July 5. This song also went to #25 on the *Billboard* Adult Contemporary chart on July 6.[33]

On the following day, Earth, Wind & Fire received a prestigious award. On July 7, 2003, Earth, Wind & Fire was inducted into the RockWalk Hall of

Fame. The induction was held in front of Guitar Center Hollywood, home of the RockWalk, on Sunset Boulevard in Hollywood, California. The ceremony was attended by the four core members of the band: Philip Bailey, Ralph Johnson, Maurice White, and Verdine White.[34]

Over a week later, the band gave an outdoor performance in New York City. On July 16, 2003, Earth, Wind & Fire performed on *The Early Show*. For this event, Maurice White performed with the band. He had stopped performing in the mid-1990s due to Parkinson's disease. The fans were elated to see him on stage again. The band performed "All in the Way," "September," and "Boogie Wonderland." They also gave an interview for Hannah Storm.[35]

In August EWF released their second single from *The Promise*. "Hold Me" was written by Tim Kelley and Bob Robinson.[36] This is a neo-soul groove about romantic intimacy, featuring Maurice White on lead vocals. "Hold Me" made it to #28 on the *Billboard* Adult R&B Songs chart on December 6, 2003.[37] It was nominated for a Grammy Award in the category of Best Traditional R&B Performance.[38] In September, EWF was inducted into the Vocal Group Hall of Fame.[39] Two more singles from *The Promise* were released in the following decade. "Never" was released in 2014, and "Why?" was released in 2015. Both songs are discussed in chapter 12.

The songs on *The Promise* provide listeners with feel-good music that has become associated with Earth, Wind & Fire. In the liner notes, Maurice White writes: "This collection of songs continues the promise of committed effort to bring you music from the heart. We try in our own way to encircle our planet with love and light—that's our promise."[40] When speaking about the music of Earth, Wind & Fire, White said, "Throughout the years, music has changed quite a bit. We've changed a bit too, but we've never sacrificed our credibility. Everything we've done has always been positive. All we want to do is uplift people through music."[41] In a press statement, percussionist Ralph Johnson described how much thought was given to the production of each song. Johnson declared, "It starts with the song. We've always begun by making sure that we have great songs for each new CD; otherwise, you're wasting your time and money in the studio."[42] On this album, Philip Bailey and Maurice White sound just as good as ever. Despite his battle with Parkinson's disease, Maurice White's baritone is in firm control on the majestic jams "All in the Way" and "Why?"

There are also guest musicians on this album. Angie Stone shares lead vocals with Maurice White and Philip Bailey on the neo-soul tune "Wonderland." In addition to "All in the Way," The Emotions also provide backing vocals on "All About Love." "Dirty" and "Where Do We Go From Here" are hot tracks that were actually recorded in 1978 during the *I Am* recording

sessions.[43] *The Promise* is evidence that EWF were still able to produce their classic sound in the new millennium.

That is what some critics believe. Rob Theakston of AllMusic declared: "A certain reverence needs to be paid to a group that can manage to still produce interesting, soulful music well into a third decade. Earth, Wind & Fire has endured practically everything a music group can experience and still remain true to the very essence of what made it popular."[44] Chairman Mao of *Blender* wrote that *The Promise* maintains their trademark liveliness on a classic collection of mid-tempo numbers and sweeping ballads reminiscent of their heyday.[45] *People* magazine declared that the creative fire has been rekindled on a musically rich seventeen-track set "that blows away most of today's R&B."[46]

The Promise did well on the *Billboard* album charts; it peaked at #19 on the *Billboard* Top R&B Albums chart on June 7, 2003, and #5 on the *Billboard* Top Independent Albums chart on the same date.[47] Many longtime Earth, Wind & Fire fans believe *The Promise* is one of the band's more underrated albums. They cherish this album because it signified a return to EWF's classic sound.

In the following year, the band continued to work and to receive more awards. On January 14, 2004, the Recording Academy announced the newest additions to its Grammy Hall of Fame, adding thirty-three recordings to a list of timeless classics that already included 639 titles. "That's the Way of the World" was inducted into the Grammy Hall of Fame in 2004. The organization honors recordings of lasting qualitative or historical significance that are at least twenty-five years old. Winners are selected annually by a special committee of eminent and knowledgeable professionals from all branches of the recording arts.[48]

The 2004 Grammy Awards occurred on February 8. Fatefully, Earth, Wind & Fire performed at the ceremony. The Grammy Awards ceremony featured a tribute to funk music. For the tribute, Earth, Wind & Fire performed "Shining Star." After performing the song, they remained on stage to join OutKast in singing "The Way You Move." Then, both groups remained on stage as George Clinton and Parliament-Funkadelic and several other musicians sang "Give Up the Funk." It was fitting for Earth, Wind & Fire to take the stage first because they are certainly the most celebrated and decorated of all the funk bands.

In the same month, a second edition of *I Am* was released. *I Am* is the 1979 double platinum album that features the hit songs "Boogie Wonderland" and "After the Love Has Gone." The second edition features three new tracks: "Diana," "Dirty (Interlude)," and "Dirty (Junior's Juke)."[49] This was a strategic move for the band. Because of a resurgence in their popularity, new fans of EWF were inclined to listen to music from their classic period. Even more

people would experience the music from the classic period when EWF went on tour during the summer.

Before going on tour, new musicians were hired. In March 2004, trumpeter Robert Bobby Burns Jr. was asked to join the Earth, Wind & Fire Horns after recording an overdub for EWF for the Grammy Awards program. He was hired to replace trumpeter Ray Brown. Burns studied music at Indiana University. After graduating, he moved to Los Angeles to pursue a music career. Burns has worked with several artists, including the Temptations, Boyz II Men, Tony Bennett, and Snoop Dogg.[50] In addition to Burns, two guitarists were hired: Vadim Zilberstein as lead guitarist and Greg "G-Mo" Moore as rhythm guitarist. Zilberstein is a Russian guitarist who played on "Caught in the Act" from Chaka Khan's 1984 classic album *I Feel for You*.[51] He performed with EWF for four years. Greg Moore began faithfully practicing the guitar after his mother bought him one when he was young. After perfecting his craft, he gained enough confidence to move to Los Angeles to further his music career. Moore found himself working with musicians and celebrities he admired. At the age of eighteen, he was offered his first professional gig. He has worked with Anita Baker, Vanessa Williams, and Stevie Wonder. Moore's guitar can be heard on the opening credits of *The Steve Harvey Show* and *The Bernie Mac Show*.[52] He worked with EWF for eight years.

Earth, Wind & Fire also hired two sisters as backing vocalists: Kim Johnson and Krystal Johnson Bailey. Krystal Johnson Bailey was married to Philip Bailey. The Johnson sisters grew up in Los Angeles. With their other sister, Kandy, they began singing gospel music in church as youngsters. They were afforded the opportunity to sing alongside such popular gospel artists as Andre Crouch and Shirley Caesar. The group began to pick up steam after appearing on television shows, including *The Oprah Winfrey Show* and *Ally McBeal*. They called themselves "JS" which stands for Johnson Sisters. When the sisters met singer Ron Isley, he became their manager. Krystal Johnson left the group in 2002 when she married Philip Bailey. JS released an album in 2003 with a hit single titled "Ice Cream."[53] Krystal Johnson Bailey sang with EWF for less than a year, but Kim Johnson remained with the band until 2012. Having new personnel, EWF was prepared for their summer tour with rock band Chicago.

Before the tour, the band was honored by the Recording Academy. On June 8, 2004, the Los Angeles chapter of the Recording Academy presented Earth, Wind & Fire with the prestigious Governor's Award in recognition of their creative and artistic talents and their service to the Recording Academy. The event was held at the Beverly Hills Hotel. Other honorees were Elmer Bernstein and Jimmy "Jam" Harris & Terry Lewis.[54]

Three days later, EWF began their summer tour with Chicago. The tour started on June 11, 2004, in Dallas, Texas, and ended on August 15 in Seattle, Washington. It consisted of twenty-four dates with stops in major US cities, including Atlanta, Chicago, and Los Angeles. Fans had the opportunity to listen to three hours of hits during the concerts. Each concert began and ended with both bands playing onstage together. The middle sections featured full sets from each band. On this tour, fans were amazed by the amount of hit songs performed.[55]

After the tour, new music was released. In September, Earth, Wind & Fire released a new single, "Show Me the Way (Featuring Raphael Saadiq)." This song was written by Raphael Saadiq and Taura Jackson and produced by Raphael Saadiq.[56] It is featured on EWF's 2005 album *Illumination*. Saadiq was a founding member of R&B group Tony! Toni! Tone! and was also a founder of the neo-soul group Lucy Pearl. "Show Me the Way" is a nearly eight-minute-long track with Saadiq and Maurice White on lead vocals. Horns are featured along with Philip Bailey's falsetto in the background. The combination reminds listeners of the 1975 classic "Reasons." "Show Me the Way" climbed to #4 on the *Billboard* Hot 100 Songs chart on January 4, 2005, and #16 on the *Billboard* Adult R&B Songs chart on April 2.[57] "Show Me the Way" received a Grammy Award nomination in the category of Best R&B Performance by a Duo or Group with Vocals.[58] Not long after "Show Me the Way" was released, Louis Satterfield, former Phenix Horns member, died on September 27, 2004, at the age of sixty-seven.

On November 16, 2004, Earth, Wind & Fire released a concert DVD titled *Live at the Montreux 1990*. This DVD eventually reached gold status on February 16, 2010. Gold status for a long video equates to at least 50,000 units sold.[59] Shortly after the release of this DVD, Earth, Wind & Fire, along with jazz saxophonist Kenny G, issued a cover of OutKast's "The Way You Move." The song is featured on Kenny G's album titled *At Last . . . The Duets Album* and EWF's *Illumination*. "The Way You Move" peaked at #12 on the *Billboard* Adult Contemporary chart on February 19, 2005.[60] With two more hit songs in their collection, Earth, Wind & Fire proved they were still viable and still popular among the younger generation, as well as the older.

Because of their popularity, Earth, Wind & Fire were invited to perform with the Black Eyed Peas at the Super Bowl XXXIX Pregame Show on February 6, 2005, at the Alltel Stadium in Jacksonville, Florida. During this year, Damien Smith of Azoff Music Management became the manager of Earth, Wind & Fire.

On May 16, 2005, Maurice White was celebrated as the first recipient of the Cultural Achievement Award of Excellence at Los Angeles Valley College.



While accepting his award, White told the audience, "I want to thank you for your support throughout the years. The group and I have been around for thirty years and I can't believe we're still ticking." The event was organized by the Black Student Union (BSU) and drew a crowd of about 100 excited audience members who clapped and sang as Earth, Wind & Fire's music played in the background. BSU advisor David Mitchell declared that it was important to honor such a significant African American figure. Mitchell stated, "White is Earth, Wind & Fire. We are honoring him because his music has transcended so many cultures and reached so many people. He has such a positive impact on everyone." Valley College president Tyree Wieder was enthusiastic when speaking about the music icon, proclaiming May 16 "Maurice White Day": "I spent many hours listening and dancing to Earth, Wind & Fire. His mission is definitely well accomplished."

There were several speakers at the event, all of whom highlighted the impact White's music had on their lives. Tommy Burns of Valley College's football team shared an emotional story of how he heard "That's the Way of the World" on the day his mother died. After that, every time he heard the song it made him sad, but as he grew up, it became warmly nostalgic for him, reminding him of his mother and how he was when he was younger. Tommy Burns claimed, "I went from gang-banging to become a better person. I wish my mom was here to see my accomplishments." Custodian Leon Hardin stated, "I am here to witness the award and to be a part of it. I am a big fan of Earth, Wind & Fire, and I wanted to be here to see the man in person and shake his hand."[61] The ceremony demonstrated the impact Maurice White and Earth, Wind & Fire have had on people.

On June 8, 2005, a DVD of a concert featuring Chicago and Earth, Wind & Fire that was recorded in 2004 at Los Angeles's Greek Theatre was issued. Simply titled *Chicago & Earth, Wind & Fire—Live at the Greek Theatre*, it was certified platinum on August 5, 2005. Platinum status for a long video equates to at least 100,000 units sold.[62] One could suggest that the DVD may have helped boost concert ticket sales for the 2005 tour.

Due to the overwhelming popularity of the 2004 summer tour, Earth, Wind & Fire teamed up once again with legendary rock band Chicago to deliver another spectacular run of shows. Lauded as one of the most successful and creative tours of 2004, the 2005 summer run of Earth, Wind & Fire/Chicago shows promised to be even more electrifying. Fans could once again expect to hear more than three hours of hits including a full-length set from each band, with two incredible jam sessions at the opening and closing of the show, with both bands playing on stage together. The tour kicked off in Chicago on June 24, 2005, and ended on September 10 in Irvine, California.[63]

ILLUMINATION

Ten days after the tour ended, EWF released *Illumination* on September 20, 2005. The nineteenth studio album by Earth, Wind & Fire, *Illumination* features fourteen tracks: "Lovely People (Featuring will.i.am)," "Pure Gold," "A Talking Voice (Interlude)," "Love's Dance," "Show Me the Way (Featuring Raphael Saadiq)," "This is How I Feel (Featuring Big Boi, Kelly Rowland, and Sleepy Brown)," "Work It Out," "Pass You By," "The One," "Elevated (Featuring Floetry)," "Liberation," "To You (Featuring Brian McKnight)," "Love Together," and "The Way You Move (Featuring Kenny G)."[64] The cover features a depiction of the four core members, Philip Bailey, Ralph Johnson, Maurice White, and Verdine White, above the earth, in the midst of wind and fire. A second edition of this album was released in 2020, that edition is discussed in chapter 12. The song "Pure Gold" is featured on the *Roll Bounce* soundtrack. Before

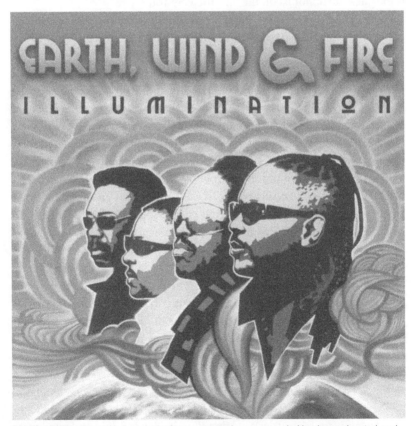

The cover for *Illumination* depicts the four core members surrounded by the earth, wind, and fire. Courtesy BMG Rights Management (UK) Limited.

the album was released, two other songs had already appeared in films: the Jimmy Jam/Terry Lewis–produced "Love Dance" in *Robots* and the Big Boi/Sleepy Brown/Kelly Rowland collaboration "This Is How I Feel" in *Hitch*.[65]

According to longtime member Ralph Johnson, Earth, Wind & Fire decided to try something different with this production, which many fans consider to be one of EWF's best: "We wanted to take a totally different approach, which is exactly what we did. We allowed writers and producers from the outside who were connected to our sound to produce us." Philip Bailey added: "They've given back to us what we've given to them. At the same time, it's fresh, and it's still very much us." Among the fresh talent featured on *Illumination* is Raphael Saadiq, who is considered an honorary member of EWF by the band members.[66] Production duo Jimmy Jam and Terry Lewis produced two songs on the album. Will.i.am, Floetry, Big Boi, Kelly Rowland, and Brian McKnight are featured as vocalists, and Kenny G is the guest saxophonist on the hit "The Way You Move."

"Pure Gold" is the third single from *Illumination* and it was released around the same time as the album. It was written by Jimmy Jam, Terry Lewis, Tony L. Tolbert, Bobby Ross Avila, and Issiah J. Avila and produced by the aforementioned musicians except Tony L. Tolbert. "Pure Gold" is a dreamy, mellow tune with lead vocals by Philip Bailey and Maurice White. It has the nostalgic Earth, Wind & Fire vibe.[67] This song reached #23 on the *Billboard* Adult Contemporary chart on September 24, 2005, and #15 on the *Billboard* Adult R&B Songs chart on October 8.[68] "Pure Gold" was nominated for a Grammy Award in the category of Producer of the Year, Non-Classical.[69]

The single that followed "Pure Gold" is "To You (Featuring Brian McKnight)," released in December 2005. It was written and produced by Brian McKnight, who also performs the lead vocals. Some EWF fans believe "To You" is similar to "Love's Holiday" and "Be Ever Wonderful," two classic songs from *All 'N All*. "To You" peaked at #16 on the *Billboard* Adult R&B Songs chart on February 25, 2006. According to Philip Bailey, Earth, Wind & Fire collaborating with the neo-soul movement made sense because the thrust of their music is still about playing instruments and utilizing vintage sounds.[70]

Illumination is loaded with quality tracks of feel-good music. The first track is "Lovely People (Featuring will.i.am)." The tune sets the tone for the entire album. "Lovely People" is the type of song that can be played at most social gatherings, including cookouts, family reunions, weddings, or house parties. It is an indication of the uplifting, high-spirited music on this album.

The hard work put into this album did not go unnoticed. Raymond Fiore of *Entertainment Weekly* declared that *Illumination* is a fluid, unforced marriage of modern beats and retro, horn-lined soul.[71] In *People*, Steve Jones

noted that *Illumination* is a case of the pupil bringing out the best in the master, and claimed that Earth, Wind & Fire were as vibrant as ever.[72] *People* proclaimed that Earth, Wind & Fire were R&B/funk pioneers who were still shining stars after thirty-five years.[73]

Illumination did well on the *Billboard* music charts, rising to #8 on the *Billboard* Top R&B Albums chart on October 8, 2005, and #32 on the *Billboard* 200 Albums chart on the same date.[74] *Illumination* was also nominated for a Grammy Award in the category of Best R&B Album[75] and an NAACP Image Award nomination for Best Duo or Group.[76] *Illumination* is another solid piece in Earth, Wind & Fire's body of work, proving why they are one of the greatest bands in pop music.

Earth, Wind & Fire attributed their success and longevity in the music business to hardcore fans who had been with them from eight-tracks to iPods, and to the hard work the band has endured over the years in staying visible. Ralph Johnson stated, "You have to make a conscious effort to want to stay in the hearts and minds and the sight of the people. We made a conscious effort to be visible, but we could have very easily faded."[77]

On December 17, 2005, NBC televised *Earth, Wind & Fire Tribute on Ice*. Earth, Wind & Fire began the program with their first #1 song, "Shining Star," as all the athletes skated on the ice. After that, the athletes performed alone or with partners as the band performed several of the classic songs, including "Boogie Wonderland," "Serpentine Fire," "Fantasy," "Let's Groove," and others. EWF closed the program with their signature classic "That's the Way of the World."[78] This tribute to ice skaters exemplifies the band's mass crossover appeal. At this point in their career, Earth, Wind & Fire showed no signs of disappearing, thanks to their dedication and the loyalty of their listeners. They continued to showcase their legendary catalogue on various occasions.

Be Ever Wonderful

In 2006, Earth, Wind & Fire turned 36 years old. This was another busy year for the pop music legends. On February 8, 2006, Earth, Wind & Fire performed at the Official Grammy After Party. Other artists who performed were will.i.am, Kelly Rowland, and Floetry. On March 1, 2006, EWF and Brian McKnight appeared on ABC's *Live with Regis and Kathie Lee*. A few days later, the classic smash hit "September" was certified gold for a minimum of 500,000 digital sales.[1] In the same month, a play in which Maurice White was involved was presented to the public.

In 2005, Maurice White had been approached by dancer/choreographer Maurice Hines to do a Broadway show based on the music of Earth, Wind & Fire. *Hot Feet* would be the result. White and Bill Meyers worked on the music for about a year. The script for the play was based on Hans Christian Andersen's fairy tale "The Red Shoes."[2] The story was written by Heru Ptah. It is about a beautiful young dancer named Kalimba whose ambition is to be a dancer. The music and lyrics were provided by Maurice White, and the play was directed and choreographed by Maurice Hines. *Hot Feet* had its pre-Broadway run at the Washington, DC, National Theatre from March 18 through April 9, 2006. The show opened on Broadway on April 30, 2006.[3] The play did not do as well as expected. Maurice White believed the story line was not strong enough.[4]

A day before *Hot Feet* opened on Broadway, EWF took their talents to church. On April 29, 2006, Earth, Wind & Fire performed at Maranatha Community Church's 26th Anniversary Celebration in Los Angeles, where Philip Bailey is a charter member. This was the band's first performance in a church. Other popular artists who performed at the service were Tony Terry and J. Moss. EWF played several of their hits. Nobody in the audience was more than fifty feet from the stage. It was truly an intimate performance.[5] EWF's performance in a church serves as a testament of the spirituality featured in their music. The message in EWF's music has always been described as spiritual, inspirational, and uplifting. Churches have long been destinations

The cover for the second edition of *In the Name of Love*.

of inspiration and community uplift. Later that year, EWF joined jazz artist Chris Botti's summer tour.

Chris Botti's 2006 summer tour began in June. Earth, Wind & Fire co-headlined a series of concerts of the tour beginning on July 18, 2006, in Boston. EWF toured with Botti for nineteen dates. They performed in major and minor American cities, including Cleveland, Ohio, Dallas, Texas, Holmdel, New Jersey, and Wallingford, Connecticut. EWF's work on the tour concluded on September 4, 2006, in West Palm Beach, Florida.[6]

On October 3, 2006, Earth, Wind & Fire released a second edition of *In the Name of Love*. This album was originally released in 1997. The 2006 edition features three bonus tracks: "The Right Time," "Take You to Heaven," and "Bahia." The two editions differ by the order of track listings. The second edition also has a much simpler cover. On the 2006 cover, only the name of the band and title of the album is shown.[7] There are no images or symbols.

From the second edition, "Change Your Mind" was released as a single in the fall of 2006. Written by Bill Meyers, Brenda Russell, and Maurice White and produced by Maurice White, this is a song about encouraging someone to find love again. Philip Bailey's lead vocals sound confident and convincing. The saxophone runs add jazz to the melody. "Change Your Mind" reached #26 on the *Billboard* Adult R&B Songs chart on October 7, 2006.[8]

On February 11, 2007, EWF performed at the 49th Grammy Awards at the Staples Center in Los Angeles. In this digital-cable universe of hundreds of channels, few awards shows attract the hoopla and ratings they used to, and the Grammys have fallen more than most. They once hit a high of 51.6 million (in 1984), but even in the first decade of the new millennium, they reliably drew audiences in the mid–20 million range. Executives of the National Academy of Recording Arts and Sciences, best known as the Recording Academy, were hoping that a little bit of the old razzle-dazzle would reverse this trend. The Police opened the show with a blistering rendition of "Roxanne." Earth, Wind & Fire joined Mary J. Blige and Ludacris for a performance of "Runaway Love."[9] At this time, "Shining Star" became the second song by EWF to be inducted into the Grammy Hall of Fame. A week later, on February 19, 2007, Verdine White appeared on *Everybody Hates Chris*.

Everybody Hates Chris is a sitcom that aired on the CW network. This sitcom is loosely based on comedian Chris Rock's childhood, set in the 1980s. In the "cutting school" episode, Chris and his best friend Greg cut school to go see *Ghostbusters*. While they are gone, a student introduces Earth, Wind & Fire to perform. Later in the day, Verdine White appears on the local news, stating that the band performed at Chris's school, but the only Black kid (Chris) was not there. EWF's inclusion in this episode is proof that the band has always been a driving force in pop culture.

A month later, the world would witness chemistry between Maurice White and younger artists. In March 2007, the revived Stax label issued a compilation album by various artists titled *Interpretation: Celebrating the Music of Earth, Wind & Fire*. This album was produced by Maurice White. It features ten tracks performed by different artists: "Shining Star" (Chaka Khan), "Be Ever Wonderful" (Angie Stone), "September" (Kirk Franklin), "Devotion" (Ledisi), "Can't Hide Love" (The Randy Watson Experience), "Love's Holiday" (Lalah Hathaway), "That's the Way of the World" (Dwele), "After the Love Has Gone" (Mint Condition), "Reasons" (Musiq Soulchild), and "Fantasy" (Me'Shell Ndegeocello).[10] The album reached #28 on the *Billboard* Hot 100 Albums chart on April 14, 2007.[11] A few of the songs from the album also did well.

Dwele's cover of "That's the Way of the World" was nominated for a Grammy Award in the category of Best Urban/Alternative Performance.[12]

Meshell Ndegeocello's cover of "Fantasy" was also nominated for a Grammy in the same category.[13] Kirk Franklin's rendition of "September" reached #17 on the *Billboard* Hot 100 Songs chart on April 28.[14] The songs on this album helped introduce Earth, Wind & Fire to a younger generation of fans, and the band continued to perform at special events that catered to people of different generations.

On April 25, 2007, Earth, Wind & Fire performed on an episode of *American Idol* titled "American Idol Gives Back." The purpose of the episode was to raise money for children in America and Africa. "American Idol Gives Back" was a striking emotional roller-coaster inside the Disney Concert Hall, where performances were staged in between filmed segments of the impoverished and the ill. As often as we have seen these images, "Idol's" producers superbly paced and alternated between information and entertainment, allowing the message to stand out with the music.[15] Earth, Wind & Fire was the opening act, performing a medley of "Boogie Wonderland," "Shining Star," and "September."

Earth, Wind & Fire performed at several concerts. In the spring of 2007, they played concerts in the Caribbean, such as the Plymouth Jazz Festival in Tobago, the Cove Atlantis Grand Opening on Paradise Island in the Bahamas, and the Bermuda Music Festival. EWF also played at music festivals in the United States, including the Riverbend Festival in Chattanooga, Tennessee, the City Stages Music Festival in Birmingham, Alabama, and the Jazz Aspen Snowmass in Aspen, Colorado. By this time in their career, it was not unusual to see EWF performing at high-profile events.

On December 11, 2007, Earth, Wind & Fire performed at the Nobel Peace Prize Concert in Oslo, Norway.[16] On February 3, 2008, the band performed at the Super Bowl XLII "Touchdown Club" event held at the Jobing.com Arena in Glendale, Arizona. After the game, they played at the New England Patriots' Super Bowl XLII post-game party. Later in February 2008, the band began touring overseas. EWF toured South America with stops in Brazil, Uruguay, and Chile. At the Festival De Vina Del Mar in Chile, the band received the Gaviota De Plata (The Silver Seagull), which is the highest award presented to an artist at the festival.

A few weeks later, a new lead guitarist was hired. In March, Morris James O'Connor was hired to replace Vadim Zilberstein. O'Connor grew up in Chicago and began playing guitar around the age of eight. He moved to move to Los Angeles at the age of nineteen to pursue his musical career and graduated from the Musician's Institute. He has played with several artists, including Jody Watley, Teena Marie, The Gap Band, and Stevie Wonder. O'Connor's move into the band was smooth one because he was already

friends with three of the musicians. He has known John Paris, Greg Moore, and Myron McKinley from his many years of working in the music industry before joining for Earth, Wind & Fire.[17] He is a good fit for the band. During the same month, the band toured Germany and the Netherlands.[18] In the spring of that year, EWF released a concert DVD.

In May 2008, Earth, Wind & Fire released *Earth, Wind & Fire: In Concert* on DVD by Eagle Rock Entertainment. This DVD features a concert recorded in Oakland, California, in December 1981.[19] The concert was shown on HBO in 1982 and later released on VHS by Vestron Video in 1984. This DVD rose to #40 on the *Billboard* Top Video Music Sales chart on May 10, 2008.[20]

Also on May 10, Berklee College of Music held its spring commencement at the Agganis Arena at Boston University. Honorary Doctor of Music degrees were presented by President Roger H. Brown to Philip Bailey and Maurice White. British rock pioneer Steve Winwood, composer and Berklee alumnus Howard Shore, and Brazilian singer/songwriter Rosa Passos also received honorary degrees. Bailey delivered the commencement address. The commencement concert took place the evening before graduation, also at Agganis Arena.

At the concert, some of the college's most accomplished students presented a musical tribute to the honorees. Bailey and the other honorees were so moved that they took to the stage to perform alongside the students. Bailey's soaring vocals brought the house down with "Fantasy." Other songs were performed by the students, including Earth, Wind & Fire's "September."[21]

Over a week later, more honorary degrees were awarded to the EWF members. On May 18, Columbia College Chicago awarded honorary doctorates to Philip Bailey, Ralph Johnson, Maurice White, and Verdine White. Columbia College Chicago provides degree programs in the visual, performing, media, and communication arts. At the 2008 commencement, Ralph Johnson and Verdine White gave acceptance speeches on behalf of Earth, Wind & Fire. Verdine White spoke about the history of the group and the mutual respect and support they have shared over the years. Ralph Johnson spoke about the critical importance of arts education in the schools noting, "I am a direct result of what can happen when there are artistic options presented to young students." After the acceptance speeches, student vocal and instrumental ensembles began a tribute for the honorees.

The students performed a rendition of "Shining Star." Philip Bailey, Ralph Johnson, and Verdine White thrilled the audience by grabbing a microphone and joining in the song. Verdine White then borrowed an electric bass from a student musician and played as everyone in the capacity crowd at the UIC Pavilion clapped, stomped, and sang along.[22] Verdine White has expressed

his sentiments about being honored with a doctorate. He exclaimed, "They could call me 'Dr. White' if they like, but my friends call me 'Doc.' It's a great honor." White added, "What's happening with us now, you know, is people are associating our work in a lot of different areas. We've always had songs in the movies . . . but now we're getting honored in music schools and places like that. It's really great."[23]

In the latter half of 2008, Earth, Wind & Fire performed at several venues in the United States. The band was featured at three music festivals: the 2008 Summerfest in Milwaukee, Wisconsin, the Macy's Music Festival in Cincinnati, Ohio, and Musikfest 2008 in Bethlehem, Pennsylvania. Earth, Wind & Fire also performed at sport events. They performed at the opening night of the 2008 US Open and at the home opener for the NBA Portland Trailblazers. In September 2008, Earth, Wind & Fire teamed up with Michael McDonald for the Earth, Wind & Fire/Michael McDonald Summer/Fall Tour 2008.[24] Michael McDonald is the former lead singer for the Doobie Brothers who began his solo career in the early 1980s. The tour began on September 11 in New Hampshire and consisted of eleven dates during that month.[25] Also, in September of that year, Raymond Brown, former trumpeter for the Earth, Wind & Fire Horns, became the band's road manager. At the end of 2008, EWF and the rest of the world watched as history was made in American politics.

On November 4, 2008, America elected its first African American president. Democrat Barack Obama defeated Republican John McCain by a landslide. Obama won the popular vote by nearly ten million, and he received 365 electoral votes while McCain received 173. With this election, a Black man became the most powerful person in the world. Like many people who enjoy good music, Barack Obama is a fan of Earth, Wind & Fire. This was confirmed shortly after Obama was inaugurated.

Barack Obama was inaugurated for his first term on January 20, 2009. The inauguration ceremony set a record attendance for any event held in Washington, DC. A month later, the Governors' Dinner was held at the White House on February 22, 2009. It was the first social function since Barack Obama had been inaugurated. EWF was invited to perform. The band got the invitation from Desiree Rogers, the White House social secretary. She informed them that President Obama requested them for the event. They answered the call without hesitation. President Obama confessed to Philip Bailey, "I used to sing 'Reasons' in college, but I lost my falsetto." Bailey declared that he knew an African American president had been elected when he saw Barack Obama lift his hands in the air while dancing to one of the songs and air and shout, "That's my jam."[26] Earth, Wind & Fire is one of Obama's favorite music artists.

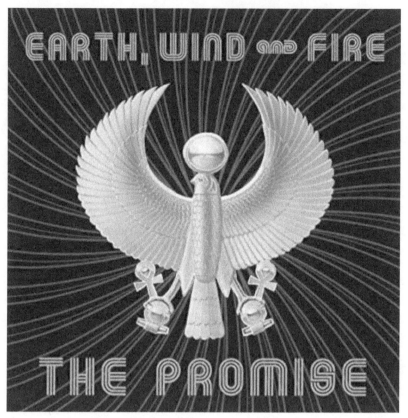

The cover for second edition of *The Promise* features the familiar image of the Kemetic deity Heru.

He declared, "I have pretty eclectic tastes. I grew up in the Seventies, so a lot of Seventies rhythm and blues and pop were staples for me: Stevie Wonder, Earth, Wind & Fire, Elton John, Rolling Stones."[27]

By the end of February 2009, Earth, Wind & Fire issued a second edition of *The Promise*, originally released in 2003. The second edition features the same track listing as the original; the only difference in the two editions are the album covers. The cover for the second edition features an image of the ancient Egyptian deity Heru.[28] It is the same image featured on *The Best of Earth, Wind & Fire, Vol. 1.*

Unfortunately, a few weeks later, a member of the EWF family passed away. On April 15, 2009, keyboardist and former musical director Robert Brookins died of a heart attack in Elk Grove, California. He is survived by a son. Writing for AllMusic, Andrew Hamilton stated, "The often over-used term multi-talented is true to its definition when referring to Robert F.

Brookins." Since his death an annual tribute event in Sacramento, California, has been held in his honor.[29] Two months after his death, Earth, Wind & Fire launched a third tour with Chicago.

The tour began June 5, 2009, in Orange Beach, Alabama, and ended August 1 in Lake Tahoe, Nevada. Like the previous tours, each band performed a full show before joining for a final set with both bands on stage together. The Tour was presented by AEG Live.[30] The two bands worked to aid food banks. In exchange for cans of food or a donation, fans were able to download new songs. Earth, Wind & Fire covered Chicago's "Wishing You Were Here," and both bands recorded a new original song written by EWF titled "You." Both songs were available during the 2009 summer tour.

From September 9–13, 2009, the 15th Annual Temecula Valley International Film & Music Festival (TVIFF) was held in Temecula, California. The festival screened more than 150 films and showcased twenty music artists from all across the United States and around the world. This event was presented by Cinema Entertainment Alliance, a non-profit arts and education organization dedicated to celebrating world cinema and music. On the final day of the festival, the Daniel L. Stephenson Humanitarian Award for Lifetime Achievement in Music and Extraordinary Impact on American Culture through the Performing Arts was presented to Earth, Wind & Fire. This award is based on the notion that EWF is simply one of the most important, innovative, and celebrated contemporary Pop/R&B acts of the twentieth century.[31] EWF also remained a viable force in the twenty-first century. That would be solidified with the band's next recording.

In November 2009, Earth, Wind & Fire and the cast from Fox's animated series *The Cleveland Show* released a holiday single titled "Get Your Hump on This Christmas." Both the song and the video for it were made available on iTunes.[32] This collaboration proved that Earth, Wind & Fire was still a significant artist in the music industry and closely connected to the American public. In the following year, the band continued to release music, perform around the world, and spread their message of love and unity. In 2010, a devastating event occurred that affected many artists in the music industry.

On January 12, 2010, Haiti suffered an earthquake with a magnitude of 7.0. The earthquake was so cataclysmic that the Haitian government reported the death toll to have reached 230,000. This catastrophe prompted dozens of musical artists to record "We Are the World—25 for Haiti." The lyrics and music are an updated version of "We Are the World," a song that raised at least $30 million for African humanitarian programs in 1985. Lionel Richie and Quincy Jones gathered a diverse group of contemporary superstar artists at the same studio used for the 1985 recording session. Earth, Wind & Fire

musicians Philip Bailey, Ralph Johnson, and Verdine White were included among the artists. The song, along with the video, was premiered during the opening ceremony of the Winter Olympics on Friday, February 12, 2010.[33]

EWF then continued their routine of entertaining audiences throughout the United States and abroad. In the spring of 2010, Earth, Wind & Fire performed at the Beale Street Music Festival in Memphis, Tennessee, and at the Sonoma Jazz Festival in Sonoma, California. The band once again teamed up with *The Cleveland Show*. On May 23, 2010, the season finale of *The Cleveland Show* featured a special musical number by Earth, Wind & Fire. Additionally, in mid-2010, Earth, Wind & Fire toured Europe with stops in France, The Netherlands, Ireland, Italy, Germany, and England.

After the tour, a new musician was hired. In June 2010, Philip Doron Bailey joined Earth, Wind & Fire. He is the son of longtime member Philip Bailey. Like his father, Philip Bailey Jr. has always been musically inclined. He graduated from the Berklee College of Music in Boston, Massachusetts. After graduation, he stayed in Boston for a few years, playing with local bands to master his craft. After the son had worked with other people, his father invited him to join Earth, Wind & Fire. This gave Philip Bailey Jr. a chance to see what his father was doing while he was growing up. It also gave them the opportunity to bond while working. It's a natural fit.[34]

In the same month, some of the members and past members of the band were inducted into another hall of fame.[35] On June 17, core members Maurice White, Philip Bailey, and Verdine White were inducted into the Songwriters Hall of Fame, along with past members Larry Dunn and Al McKay. Other 2010 inductees included Leonard Cohen, Jackie DeShannon, Johnny Mandel, and David Foster, who co-wrote "After the Love Has Gone." The Songwriters Hall of Fame is dedicated to recognizing the work and lives of those composers and lyricists who create popular music around the world.[36]

On July 20, 2010, Earth, Wind & Fire released another edition of *Live in Velfarre*. This album was originally released in 1995. The second edition is titled *Live at Velfarre*. The track listing for this edition is the same as the original. The cover image is also the same as the original release; the only difference is the color.[37]

On September 3–4, 2010, Earth, Wind & Fire was presented in concert at the Hollywood Bowl with a full orchestra. The Hollywood Bowl Orchestra was led by Thomas Wilkins. To complement the lineup, the Hollywood Bowl Orchestra performed music by Duke Ellington to open both halves of the concert. Both evenings were capped by a spectacular fireworks display.[38] For these concerts, EWF induced the initial expense of hiring someone to write orchestral arrangements of their songs. That gave the band the opportunity

The cover for second edition of *Live in Velfarre* shows the EWF moniker on a cross against a green background.

to visit other cities with symphony orchestras. Both concerts were sold out and were among the highest grossing events at the venue in years. EWF recorded and filmed the concerts for their own edification.[39]

On September 21, 2010, Earth, Wind & Fire reissued *Faces*, the double album that was originally released in 1980. The second edition of this album features three bonus tracks: "Let Me Talk (12" Long Version)," "You (Alternative Mix)," and "And Love Goes On (7" Remix)."[40] By reissuing older albums, younger fans of EWF could discover music to which they had not been exposed. Following the reissue of *Faces*, EWF continued to work on the road and within a few months, another classic album was reissued.

In March 2011, the multiplatinum *Raise!* was reissued. *Raise!* was originally released in 1981. It features the smash hit "Let's Groove" and the Grammy Award–winning "Wanna Be With You." This second edition of *Raise!* features three bonus tracks: "Let's Groove (Special Remixed Holiday Version)," "Kalimba Tree (12" Long Version)," and "Let's Groove (Instrumental)."[41]

A few months later, Earth, Wind & Fire embarked on a new business venture. On June 17, 2011, Monster Cable helped Earth, Wind & Fire develop their own brand of in-ear headphones called Gratitude. The headphones present EWF's music the way it was intended to be heard. By applying new technology, Monster brings out the clarity in the sound of EWF's detailed layers of music.[42] The Gratitude has a distinct gold aesthetic and comes with twelve different eartips of varying size and type. The headphones have a ControlTalk in-line microphone and seamless volume controls. When the listener is done tuning out the outside world, the headphones can be tucked away in one of the included carrying pouches. The headphones also come with a one-year warranty.[43]

In September 2011, Sony Legacy released *The Columbia Masters*, the biggest product of Earth, Wind & Fire's career. This project features fifteen newly mastered CDs encompassing Earth, Wind & Fire's astonishing recording career on Columbia Records. It also features a bonus disc of rarities, instrumentals, and unreleased tracks supervised by Maurice White. The discs included are *Last Days and Time, Head to the Sky, Open Our Eyes, That's the Way of the World, Gratitude, Spirit, All 'N All, The Best of Earth, Wind & Fire, Vol. 1, I Am, Faces, Raise, Powerlight, Electric Universe, Touch the World, Heritage,* and *Constellations.* The cover art for this product resembles the front cover of *All 'N All.*[44] Each CD is packaged in a sleeve that duplicates the original cover art. This product also contains a forty-page booklet with photos and commentary by Maurice White.

On November 17, 2011, Earth, Wind & Fire received the Soul Train Legend Award. The other Legend Award recipient was Gladys Knight. Philip Bailey, Ralph Johnson, and Verdine White accepted the award on behalf of the band. The 2011 Soul Train Music Awards ceremony was held at the Fox Theatre in Atlanta, Georgia.[45]

Earth, Wind & Fire released a new single titled "Guiding Lights" in late November 2011. "Guiding Lights" was co-written by Philip Bailey Jr. along with Daniel McClain, Austin Jacobs, and Darrin Simpson. It is one of six songs on *Now, Then & Forever* co-written by Philip Bailey Jr.[46] "Guiding Lights" was written and arranged in the classic mold of an EWF mid-tempo groove. This song is for the listener with that "Get Grown" sensibility. "Guiding Lights" was meant to be the lead single for an album that was initially due for release on January 31, 2012.[47] The song is described by Elias Leight in *PopMatters* as a break-beat-driven falsetto that stretches the drama out past six minutes and includes a scream at the 4:18 mark that shouldn't be humanly possible for any man above the age of thirty. When the song was recorded, Philip Bailey was twice that age.[48] "Guiding Lights" did well on the music charts.

The cover for *The Columbia Masters* box set presents an image of the front of the Abu Simbel temple complex.

"Guiding Lights" reached #30 on the *Billboard* Adult R&B Songs chart on March 24, 2012, and #16 on the *Billboard* Smooth Jazz Songs chart on June 2.[49] The album that was scheduled to be released in January 2012 was not released at that time. It would take nearly two years for the album to be complete.

However, Earth, Wind & Fire did receive another prestigious award in that month. In January 2012, Earth, Wind & Fire received a Trumpet Lifetime Achievement Award at the 20th Annual Trumpet Awards held at the Cobb Energy Performing Arts Center in Atlanta, Georgia. The Trumpet Awards were created by Xernona Clayton to celebrate African American achievers and those who celebrate the African American experience.[50] In the following month, on February 29, former guitarist Roland Bautista died of natural causes at the age of sixty. Later in the year, a new guitarist, Serg Dimitrijevic, joined the band.

Serg Dimitrijevic is originally from Sydney, Australia, and he began play-
ing the guitar at the age of eleven. While in high school, Dimitrijevic attended
weekly private lessons with leading guitarists in Australia. He later attended
the University of Wollongong to study music full-time. Dimitrijevic carved
out an impressive résumé of artists he worked for while living in Australia.
He made his way to the United States and started doing session work before
hooking up with Earth, Wind & Fire. Dimitrijevic has also toured with Aretha
Franklin, Ariana Grande, and Sugar Ray.[51]

Throughout 2012, EWF continued to received honors for their achieve-
ments. On June 20, Earth, Wind & Fire received the Horizon Award dur-
ing the Congressional Award Gold Medal ceremony in Washington, DC.
The band was acknowledged for its positive influence on America's youth.
On August 16, EWF was inducted into Goldmine Magazine's Hall of Fame.
On August 18, EWF received the Major League Baseball Beacon of Change
Award during the MLB's 2012 Delta Civil Rights Game Weekend in Atlanta,
Georgia. This award is given to those who impact society through words
and action. In September, the band was voted into Soulmusic.com's Hall of
Fame.[52] As the year 2012 was coming to a close, EWF was well into produc-
tion of their next studio album.

Now, Then & Forever

On January 20, 2013, President Barack Obama began his second term as the first African American president of the United States. He was sworn into office in the Blue Room of the White House. The next day, President Obama gave his second inaugural address. A few days later, Earth, Wind & Fire began what would be a busy year for them. On January 25, EWF performed at the Celebrating Yamaha's 125th Anniversary concert at the Hyperion Theatre in Anaheim, California. Several musical celebrities performed, including Elton John, David Foster, Chaka Khan, Amy Grant, Michael McDonald, and others.[1] In the second week of April, EWF took part in the Tom Joyner Foundation Fantastic Voyage Cruise, and two weeks after that, the band performed at the New Orleans Heritage & Jazz Festival.[2] EWF soon published their next studio album, which had been in production for quite some time.

NOW, THEN & FOREVER

In June 2013, Earth, Wind & Fire released the single "My Promise" from their forthcoming album *Now, Then & Forever*. This song was written by Siedah Garrett, Austin Jacobs, and Darrin Simpson.[3] With the intro horn riffs, "My Promise" sounds like the EWF from the 1970s. Philip Bailey sings the lead in his tenor, and the background vocals are sung in falsetto. His tenor proves to be as strong as his falsetto. "My Promise" reached #28 on the *Billboard* Adult R&B Songs chart on August 24, 2013, and #30 on the *Billboard* Adult Contemporary chart on the same date.[4]

Three months after the release of "My Promise," EWF released their twentieth studio album *Now, Then & Forever* on September 10. *Now, Then & Forever* was the band's first studio album in eight years, since *Illumination* in 2005. Former band member Larry Dunn is featured as a keyboardist on the album. *Now, Then & Forever* contains ten tracks: "Sign On," "Love Is Law," "My Promise," "Guiding Lights," "Got to Be Love," "Belo Horizonte,"

The cover for *Now, Then & Forever* shows Heru with his wings spread wide.

"Dance Floor," "Splashes," "Night of My Life," and "The Rush." Philip Bailey and Verdine White served as executive producers.[5]

The cover for this album displays a familiar symbol. On the front of *Now, Then & Forever*, the ancient Egyptian god Heru is displayed as the falcon with his wings spread wide. Heru is displayed on previous album covers, including *The Best of Earth, Wind & Fire, Vol. 1* and *The Promise*. On those two earlier covers, the symbols are virtually the same. On the cover of *Now, Then & Forever*, the falcon appears to have longer wings that are stretched wider. Maurice White gave a statement in the album's liner notes that may explain Heru's appearance on the cover. He declared, "As we see today's technology uniting the world wide web, sometimes it seems that the hearts of men are growing more distant from each other. It is my hope that this music will continue to tie past to future, reminding us of the love that united us to our ancestors, and to our descendants, and to each other. Peace!"[6] Heru

represents universal spiritual truths and ancient knowledge White hoped modern people would embrace.

Like several other EWF albums, *Now, Then & Forever* explores various genres of music, including the classic EWF sounds that fans appreciate. According to Philip Bailey, recording of the album was a two-year process that all hinged on "Guiding Lights." Bailey told *Billboard* in an August 2013 issue that Earth, Wind & Fire started recording *Now, Then & Forever* "a little over two years ago, then about a year ago we actually thought perhaps we were finished. That was before the band laid down 'Guiding Lights.'"[7] Bailey is especially proud of this song because it was co-written by his son, Philip Doron Bailey. "Guiding Lights" is appropriately titled, as it acted as a guiding light to the *Now, Then & Forever* album. Bailey told *Billboard*:

> When we got finished with that song, someone mentioned to me that it sounded like a great Earth, Wind & Fire that people had missed all these years. Then I started listening to the music we had done to that point, and the "Guiding Lights" song made me rethink the music we had and I said, "We've got to go back to the drawing board to make these other songs more classic sounding" and just changed the whole course of the album.[8]

This was EWF's first album without the input of Maurice White.

Maurice White left the musical affairs of Earth, Wind & Fire in the hands of Philip Bailey, Ralph Johnson, and Verdine White, but he remained a guiding force in whatever the band did. Bailey explained, "He's the architect. He's the conceptualizer. The ingredients we use for it to sound like Earth, Wind & Fire means it sounds the way Maurice has always intended for it to sound. So, we've made a record that he's not necessarily a part of, physically, but is a part of from a morale standpoint." Maurice White's intent, philosophically and musically, is something the members tried to make sure was a thread in *Now, Then & Forever*.[9] This is one of the strongest albums the band produced.

Now, Then & Forever features vibrant, energetic songs that are synonymous with Earth, Wind & Fire. Philip Bailey's falsetto does not disappoint, and his tenor vocals are a good substitute for Maurice White. On this album there is the stellar horn section, the energetic Verdine White laying down the basslines, the fierce drummer Ralph Johnson, and former keyboardist Larry Dunn, presenting his flawless synthesizer work. The only familiar sound missing from the album is Maurice White, but EWF definitely fills that void.

Music critics applauded this album for its classic EWF sound. Andy Kellman of AllMusic declared that *Now, Then & Forever* demonstrates the lasting

value of Earth, Wind & Fire's classic sound.[10] Elias Leight of PopMatters stated that EWF still has the thick, fluttering funk that made them such a power in the seventies. He added, "They haven't lost a step. *Now, Then & Forever* has all the old colors and grooves, an impeccable rhythm section, prominent guitars, and indomitable horns that trace and re-trace motifs, dancing rings around everything."[11] Chuck Arnold of *People* stated that it's good to hear their lush musicality again. He claimed that EWF is indeed the rare R&B group that is timeless.[12] The album did extremely well on the *Billboard* music charts.

Now, Then & Forever climbed to #11 on the *Billboard* 200 Albums chart on September 28, 2013, and to #6 on the *Billboard* Top R&B Albums chart on the same date.[13] *Now, Then & Forever* marked Earth, Wind & Fire's highest album chart presence in over thirty years.[14] More than twenty versions of *Now, Then & Forever* were released around the world with various bonus tracks.[15] The many versions of this album are an indication of the strong impact Earth, Wind & Fire has had on popular music.

On Friday, September 13, 2013, Earth, Wind & Fire appeared on *The Ellen DeGeneres Show*. EWF was the house band for the episode. DeGeneres comically declared herself a member of the band and performed with them for the classic "September." From September 13 to September 15, EWF performed three sold-out shows at the Hollywood Bowl. Also, on September 15, Philip Bailey, Ralph Johnson, and Verdine White were featured on CBS's *Sunday Morning*. On September 18, EWF performed on the season finale of *America's Got Talent*. They performed "September" and "My Promise."[16]

Later that year, Earth, Wind & Fire provided support for charity. The song "Sign On" from *Now, Then & Forever* appeared on *Songs for the Philippines*. Released in November 2013, this CD supported the typhoon relief effort in the Philippines.[17] "Sign On" is another song co-written by Philip Doron Bailey, along with Sharlotte Gibson, Austin Jacobs, Daniel McClain, Neal H. Pogue, and Darrin Simpson. It encourages people to "sign on" for being proactive in making the world a better place.[18] "Sign On" is an inspirational dance song that fits into Earth, Wind & Fire's mission of universal love and enlightenment.

In the following year, EWF continued to perform and release music. On February 16, 2014, the band performed with other artists during halftime of the 2014 NBA All-Star Game in New Orleans, Louisiana. On March 25, 2014, a second edition of *The Essential Earth, Wind & Fire* was released. This compilation was originally released in 2002. There are seven songs featured on the second edition that were not on the first: "Magnetic," "Dance Dance Dance," "System of Survival," "Sunday Morning (Radio Mix)," "Pure Gold," "The Way You Move," and "My Promise."[19]

The cover for the third edition of *The Promise* displays Heru against a blue background.

Less than three weeks later, an anticipated autobiography was published. Philip Bailey's autobiography, *Shining Star: Braving the Elements of Earth, Wind & Fire*, came out on April 15, 2014. Bailey details his career with Earth, Wind & Fire and discusses the ups and downs of the music industry, as well as his personal life. This book is conducive for all EWF fans and anyone who loves to read.

Two days later, another EWF album was reissued. On April 17, Earth, Wind & Fire reissued *The Promise*. This third edition features one bonus track "Never (2014 Remix)." The cover for this album has the same image as the second edition released in 2009. The only difference is the color of the background, which is blue.[20] About two weeks after this edition was released, on May 2, former lead vocalist Jessica Cleaves died of complications from a stroke in a Los Angeles hospital at the age of sixty-five.[21]

On June 2, 2014, a third edition of *Spirit* was released. This edition features comprehensive liner notes by Christian John Wikane, drawn from

interviews with Maurice White, Larry Dunn, and Philip Bailey. There are nine bonus tracks added to the 1976 original, the five bonus tracks from Columbia/Legacy's 2001 US reissue and four new tracks: the twelve-inch mix and instrumental versions of "Getaway" and the single edits of "Saturday Nite" and "Departure."[22]

The band also released a new single. In the summer of 2014, Earth, Wind & Fire released the single "Never." This song is featured on *The Promise*, which had just been reissued in the spring of that year. "Never" is a Latin-inspired tune, featuring Philip Bailey on lead vocals. The song expresses a man's desire to never live without his significant other.[23] "Never" reached #17 on the *Billboard* Smooth Jazz Songs chart on August 23, 2014, and spent twelve weeks on the chart.[24]

ULTIMATE COLLECTION

On September 8, 2014, Sony Music issued *Ultimate Collection* in the United Kingdom. This album should not be confused with *The Ultimate Collection* that was released in 1999. The cover for *Ultimate Collection* is a replica of the front cover of *The Best of Earth, Wind & Fire, Vol. 1*. The album cover displays a gold coin with the Kemetic deity Heru on it against a red background. The only difference is the printed album title. This cover is a reminder that Maurice White's goal was to raise the consciousness of his listeners and for them to become enlightened. *Ultimate Collection* features twenty tracks: "September," "Let's Groove," "Boogie Wonderland," "Fantasy," "After the Love Has Gone," "Shining Star," "Saturday Nite," "Star," "I've Had Enough," "Let Me Talk," "Sing a Song," "Can't Let Go," "Serpentine Fire," "That's the Way of the World," "Reasons," "Got to Get You into My Life," "Getaway," "In the Stone," "Sign On," and "My Promise."[25] *Ultimate Collection* is one of several compilation albums that demonstrate ongoing demand for EWF's uplifting music.

HOLIDAY

EWF released their first Christmas album on October 21, 2014. *Holiday* was produced by Philip Bailey and Earth, Wind & Fire's music director, Myron McKinley, with assistance from Philip Bailey Jr.[26] This album consists of thirteen tracks, traditional Christmas songs and others: "Joy to the World," "Happy Seasons," "O Come, All Ye Faithful," "Winter Wonderland," "What Child Is This," "Away in a Manger," "The Little Drummer Boy," "Every Day

The cover for *Ultimate Collection* compilation displays a coin with the familiar Heru image.

Is Like Christmas," "The First Noel," "Sleigh Ride," "Snow," "Jingle Bell Rock," and "December."[27] "December" is a Christmas version of the classic "September" and "Happy Seasons" was originally "Happy Feelin'" from *That's the Way of the World*. The *Holiday* cover simply displays the Earth, Wind & Fire moniker and the album title in gold surrounded by a gold border against a red background.[28] A second edition of this album was released the following year and is discussed later in this chapter.

When describing *Holiday*, Philip Bailey declared, "We stretched the envelope a bit on several songs, changing the harmonic structures and rhythms—kind of what we did with the Beatles' 'Got to Get You into My Life.' It's Christmas songs but still EWF-esque." Verdine White added, "It's our special twist. We never thought about doing a holiday album before. But Legacy/Sony asked and so have our fans, so we hope the audience likes it." Earth, Wind & Fire fans did love it and so did music critics.

The cover for *Holiday*.

Sarah Rodman of the *Boston Globe* declared that Earth, Wind & Fire brings the joy on a horn-flecked collection of familiar tunes.[29] Brett Milano of *OffBeat* claimed that *Holiday* gets seasonally festive without departing a bit from EWF's classic formula.[30] *Holiday* peaked at #8 on the *Billboard* Top Holiday Albums chart on November 8, 2014, and #26 on the *Billboard* Top R&B Albums chart on December 20.[31]

During the 2014 Christmas season, EWF performed on various television programs. Earth, Wind & Fire performed for TNT's *Christmas in Washington*, which occurred at the National Building Museum in Washington, DC. This program aired on December 19. On the same date, the band could be seen on CBS's *A Home for the Holidays*. EWF performed songs from *Holiday* on ABC's *Live With Kelly & Michael*, which aired on Christmas Eve. On December 30, the 37th Kennedy Center Honors ceremony aired on CBS.[32] Earth, Wind & Fire paid tribute to Al Green by performing his classic "Love

and Happiness." The band appeared on other television programs in the following month, including *The Ellen DeGeneres Show* and *Jimmy Kimmel Live*.

In early summer 2015, Earth, Wind & Fire released the single "Why?" from *The Promise*. As stated previously, a third edition of *The Promise* was released in 2014. "Why?" is a mellow jazz tune, featuring Maurice White on lead vocals. This song reached #19 on the *Billboard* Smooth Jazz Songs chart on August 22, 2015, and spent nine weeks on the chart.[33] It peaked almost exactly one year after "Never" peaked on the same *Billboard* chart.

In July 2015, Earth, Wind & Fire teamed up with Chicago for their fourth tour together. This tour was called the Heart & Soul Tour 2015. It was promoted by Live Nation and consisted of twenty-five dates in major cities, such as Dallas, Atlanta, Detroit, and others. The Heart & Soul Tour 2015 began July 15 in Concord, California, and ended September 6 in Atlantic City, New Jersey.[34]

A few weeks after the tour ended, three EWF albums were reissued. On October 2, 2015, Earth, Wind & Fire released a third edition of *Raise!* This edition features four more bonus tracks than on the second edition that was released in 2011: "Wanna Be With You (7" Version)," "Let's Groove (7" Version)," "I've Had Enough (7" Version)," and "The Changing Times (7" Version)."[35]

A second edition of *Electric Universe* was also released on this date. Originally released in 1983, it contains the hit song "Magnetic." This edition of *Electric Universe* features eight bonus tracks: "Magnetic (Extended Dance Remix)," "Magnetic (Instrumental)," "Magnetic (7" Version)," "Spirit of a New World (Demo Version)," "El Solitario (We're Living in Our Time) (Demo Version)," "Here's to Love (Instrumental)," "Club Foot," and "Milky Way."[36]

The third album reissued on this day is *Holiday*, only a year after its original release. The second edition is titled *The Classic Christmas Album* and contains five bonus tracks: "Gather Round," "Get Your Hump on This Christmas," "I Asked for a Miracle (God Gave Me You) (Philip Bailey with Full Force)," "Open Your Heart to Love," and "One World." The cover for this album is different from the original. The front cover shows what appears to be a present wrapped in paper with symbols of the Kemetic deity Heru with a gold bow on it.[37] *The Classic Christmas Album* reached #18 on the *Billboard* Top R&B Albums chart on December 26, 2015.[38]

Earth, Wind & Fire closed out 2015 and brought in 2016 by appearing on *Pitbull's New Year's Revolution Special* on the Fox network. The beginning of the new year brought some good news for Earth, Wind & Fire. In January 2016, it was announced that EWF would receive a Grammy Lifetime Achievement Award in April. This is another one of several lifetime achievement awards. However, in the following month, the world and especially lovers of EWF received the most devastating news possible.

The cover for *The Classic Christmas Album* resembles a wrapped Christmas gift.

On February 4, 2016, Maurice White, the founder and visionary of Earth, Wind & Fire, died in his sleep after his long battle with Parkinson's disease. He was seventy-four years old.[39] White left behind three children and a host of relatives, friends, and loved ones. With the Grammy Awards less than two weeks away, a tribute to the founder of one of the greatest bands in popular music was necessary for the program.

The 2016 Grammy Awards were held on February 15, 2016. At the ceremony, Stevie Wonder and a cappella group Pentatonix paid tribute to Maurice White by giving words of expression and performing an emotional rendition of "That's the Way of the World." As they sang, audience members clapped along while photos of the music icon rotated on the giant screens at the venue.[40]

The memorial service for Maurice White took place on February 22, 2016, at 11:00 a.m. It was held at the Agape International Spiritual Center in Culver

City, California. Pastor Michael Beckwith officiated the program, which was planned by Verdine White and his wife Mashelle "Shelly" Clark White. According to Verdine White, attendees could feel Maurice White's spirit from the moment they entered. The family and attendees entered while the hit song "Sun Goddess" was playing. The edifice was filled to capacity. A letter of condolence from President Barack Obama and First Lady Michelle Obama was read aloud. A nineteen-minute video tribute was played, consisting of rare interviews, photos, and performance clips. Several musicians gave words of expression, including Ramsey Lewis, David Foster, Larry Dunn, Philip Bailey, Ralph Johnson, and Stevie Wonder. Others who spoke were managers Bob Cavallo, Damien Smith, and Irving Azoff. After the spoken tributes, Earth, Wind & Fire performed a medley of songs with the choir. After the medley, Pastor Beckwith gave a eulogy and benediction. The ceremony closed while "September" was playing.[41] The current members of EWF vowed to keep the legacy of Maurice White alive, and they soon went on another tour.

Due to popular demand, in March 2016, Earth, Wind & Fire and Chicago embarked on a fifth tour together, titled Heart And Soul Tour 2.0. The tour began on March 23 in Jacksonville, Florida, and concluded on April 18 at New York's Madison Square Garden. Philip Bailey declared, "There's a saying that goes, 'if it's not broken, there is no need to change it.' Indeed. The powerful magic of Chicago and Earth, Wind & Fire works for both bands and fans alike. Here we go again!" Lee Loughnane of Chicago stated, "Both bands are playing great and when we play together, the show rises to another level."[42]

Less than a week after that tour ended, EWF received one of their most prestigious awards. On April 23, Earth, Wind & Fire received their Grammy Lifetime Achievement Award during the 2016 "Grammy Salute to Music Legends" awards ceremony and tribute concert at the Dolby Theatre in Los Angeles, California. Other honorees included Ruth Brown, Celia Cruz, Herbie Hancock, Jefferson Airplane, Linda Ronstadt, and Run-D.M.C. The show was televised on PBS's *Great Performances* on October 14.[43]

On June 24, 2016, Earth, Wind & Fire began a European tour in Paris. The tour consisted of thirteen dates with stops in France, the UK, The Netherlands, Ireland, Italy, Switzerland, and Norway. The tour also ended in France in the city of Les Pins on July 15.[44]

Later in the summer, the autobiography that EWF fans had long anticipated was released. On September 13, Maurice White's autobiography titled *My Life with Earth, Wind & Fire* was published. It was co-written by Herb Powell. The book features an introduction by media mogul Steve Harvey, a foreword by musician and music executive David Foster, and an afterword by Herb Powell. This autobiography is suitable for everyone who has been

inspired by Maurice White and Earth, Wind & Fire. In the same week, the band embarked on a tour of Asia with stops in Japan and Hong Kong.

After the Asia tour, EWF conducted another tour in North America. For this North American tour, Earth, Wind & Fire teamed up with Chicago for a sixth tour together. This tour was titled Heart And Soul 3.0. and consisted of a fifteen-city trek. It began on October 19 in Rochester, New York, and concluded on November 13 in Billings, Montana. In addition to US cities, this tour made an extensive run through Canada, visiting cities such as Montreal, Winnipeg, and Vancouver.[45]

On December 1, 2016, Earth, Wind & Fire received another lifetime achievement award during the Ebony Power 100 gala at the Beverly Hilton Hotel in Los Angeles. The ceremony was hosted by Cedric the Entertainer, and Jimmy "Jam" Harris presented Earth, Wind & Fire their lifetime achievement award. The other lifetime achievement award was presented to Cicely Tyson by Regina King, and Nile Rodgers was honored with the Icon Award. During the gala, *Ebony* editor-in-chief Kyra Kyles addressed the significance of the magazine's Power 100. She declared, "We are not helpless. We are not hapless. We've got the power. Now what we do with it, that's up to each one of us."[46] EWF has always used the power of love to spread hope and joy to their listeners. That message of love is displayed in Maurice White's biography. On December 13, it was announced that *My Life with Earth, Wind & Fire* was nominated for an NAACP Image Award Outstanding Literary Work—Biography/Autobiography.[47]

In 2017, Earth, Wind & Fire appeared on various talk shows. They performed on ABC's *Good Morning America*, CBS's *The Talk*, and TBS's *Conan*. EWF also performed at the Country Music Awards with Lady Antebellum. The band could also be seen on tour with Nile Rodgers and Chic during July and August. That tour, titled 2054: The Tour, featured twenty-one dates. It began on July 12 in Oakland, California, and concluded on August 19 in Atlanta. Philip Bailey was complimentary of his tour mates, saying, "Nile Rodgers and Chic are legendary for their iconic style, song, sound, and groove. Get ready for a nonstop 2054 party!" Rodgers was equally flattering, stating, "There was a time when we could only dream of seeing Earth, Wind & Fire live. Now we get the honor of sharing the stage together. Get your feet ready for a deluge of hits!"[48] This was one of the most popular and successful tours of 2017.

On October 27, 2017, Maurice White was inducted into the Memphis Music Hall of Fame at the Cannon Center for Performing Arts. White was born and grew up in Memphis. The Smithsonian Institution–developed Memphis Rock 'n' Soul Museum had launched the Hall of Fame in 2012.

Three years later, the museum opened a Hall of Fame Museum at 126 Beale Street.[49] Beale Street is not far from where White grew up and has become a Memphis landmark.

As Earth, Wind & Fire approached their golden anniversary, the band would acquire more long overdue awards, and they would cover a new territory. On January 1, 2018, Earth, Wind & Fire rode and performed on The Forum float at the Rose Bowl Parade. Four months later, on May 2, Earth, Wind & Fire started their limited Las Vegas residency to a sold out-crowd at the Venetian Theatre inside the Venetian Resort Las Vegas. The engagement included a total of six shows over eleven days.[50]

On March 20, 2019, due to popular demand, Earth, Wind & Fire started their second residency at the Venetian Theatre inside the Venetian Resort Las Vegas. Like the first, this second residency featured six shows over eleven days.[51]

On the same date as the first show, EWF's classic hit "September" was added to the National Recording Registry.[52] The list of recordings in the National Recording Registry are preserved at the Library of Congress. Since 2002, the National Recording Preservation Board (NRPB) and members of the public have nominated recordings to the National Recording Registry annually. Each year, the National Recording Registry at the Library of Congress chooses twenty-five recordings showcasing the range and diversity of American recorded sound heritage in order to increase preservation awareness.[53]

Later in the year, two solo albums were released. In May 2019, Philip Bailey released his tenth solo album, *Love Will Find a Way*. This is a jazz album that features ten songs, including covers of two songs by Curtis Mayfield: "Billy Jack" and "We're a Winner."[54] Earth, Wind & Fire has long worked to instill hope and racial pride in African Americans. "Billy Jack" is a critique of US society, and "We're a Winner" is a 1968 civil rights anthem. Bailey is concerned about the blatant police brutality and injustice against African Americans in recent years. He declared, "They're killing black men in the United States like flies on the streets. 'Billy Jack' was one of those songs that sounds like it was written today." "We're a Winner" is also relevant today. According to Bailey, it was a song that resonated hope in turbulent times. He stated, "Curtis's messages speak more directly to the African American community, saying live, have hope, be strong, we're going to make it." The album also features cameos and productions by contemporary jazz artists.[55] *Love Will Find a Way* reached #1 on the *Billboard* Contemporary Jazz Albums and Top Jazz Albums charts on July 6, 2019.[56]

A posthumous solo album by Maurice White, *Manifestation*, was released on July 16. During his years of work with Earth, Wind & Fire, Maurice White also did solo work. For nearly thirty years, he frequently collaborated with

legendary songwriter and producer Preston Glass, with the partnership resulting in more than forty songs, many of which were never released. Preston Glass and Soul Music Records writer David Nathan collected twelve of these "lost" songs and issued them on *Manifestation*, eleven songs and one interlude.[57] The songs on this album do not have the typical EWF sound. However, they sound like the R&B of the 1980s and 1990s.[58] This album is definitely worth the listener's time.

A couple months after *Manifestation* was released, EWF was honored in an exclusive manner. In the age of social media, many Earth, Wind & Fire fans on Facebook, Twitter, and Instagram have declared September 21 as "Earth, Wind & Fire Day." This refers to the famous line "Do you remember the 21st night of September?" from the 1978 hit "September." Consequently, on September 10, 2019, the city of Los Angeles, California, held a ceremony at city hall officially designating September 21 as Earth, Wind & Fire Day. During the ceremony, Philip Bailey grabbed a microphone near the DJ who was spinning "September." To the delight of a few hundred city workers, some of whom were wearing t-shirts that read "DO YOU REMEMBER?," Bailey began to sing a few lyrics of the song. It was almost enough to make the crowd forget they were in the spot where city officials congregate.[59] This tribute was most endearing for Ralph Johnson. He stated, "I'm from Los Angeles, born and raised. I'm a product of the L.A. United School District. This is a very special moment for me."[60]

But that was not the last honor for the band in 2019. On November 17, the Smithsonian's National Portrait Gallery held its biannual American Portrait Gala. Earth, Wind & Fire received the Portrait of a Nation Prize. The honorees included luminaries in business, fashion, science, and entertainment: Frances Arnold, Jeff Bezos, Lin-Manuel Miranda, Indra Nooyi, Anna Wintour, and of course, Earth, Wind & Fire. National Portrait Gallery director Kim Sajet stated, "We wanted to make a direct connection with what we have up and how we talk about American achievement, people who have made a major contribution to history and culture." Speaking of EWF specifically, Sajet said, "What's not to love? They've been one of the longest-serving bands, won many Grammys and all sorts of amazing awards. They've just got lots of flair and excitement." The prize was presented to EWF by music mogul Clive Davis. The band even gave a special performance.[61] The portrait in the gallery features the classic nine members of Earth, Wind & Fire.

The next award the band received solidified their legendary status. On December 8, 2019, Earth, Wind & Fire was inducted into the Kennedy Center Honors. The Kennedy Center celebrates icons in the performing arts for their lifetime of contributions to American culture. EWF is the first R&B

group/band to receive the honor after three rock groups: The Who (2008), Led Zeppelin (2012), and Eagles (2016). David Rubenstein, Kennedy Center chairman, declared: "Earth, Wind & Fire's hooks and grooves are the foundation of a seminal style that continues to shape our musical landscape."[62] Other honorees included Linda Ronstadt, Sally Field, Michael Tilson Thomas, and *Sesame Street.*

For the tribute to Earth, Wind & Fire, musician David Foster introduced the band with a biographical video. John Legend sang "Can't Hide Love" and David Copperfield gave remarks. Cynthia Erivo sang "Fantasy" and "Reasons." Ne-Yo sang "Shining Star" and the Jonas Brothers sang "Boogie Wonderland." To close the tribute and the ceremony, the artists came together onstage to sing "September." The celebration of Earth, Wind & Fire was the highlight of the program. Many people felt this honor was long overdue. EWF closed the year on a high, but no one could expect what the year 2020 would bring.

The year 2020 got off to a sinister start. During the first week of January, tensions escalated in the Persian Gulf crisis. On January 11, Puerto Rico was hit by several earthquakes. The impeachment trial of President Donald Trump began on January 16. On January 21, the first case of Covid-19 in the United States was confirmed by the CDC. On January 26, basketball superstar Kobe Bryant and his daughter Gianni Bryant were killed in a helicopter crash in Calabasas, California, along with seven others.

The 62nd Annual Grammy Awards ceremony was held at the Los Angeles Staples Center on January 26, 2020. After the ceremony, a special concert was held to pay tribute to the multitalented pop music icon Prince, who passed away on April 21, 2016. Sheila E. and Jimmy "Jam" Harris and Terry Lewis served as musical directors for the two-hour program. Tributes were performed by Morris Day and the Time, the Revolution, Common, and several others, including Earth, Wind & Fire. EWF thrilled the crowd with their performance of "Adore" with Philip Bailey on lead vocals. Sheila E. declared, "The tribute brings so many musicians, artists, and people that have worked with Prince or were inspired by him."[63] EWF inspired Prince and worked with him on the *Millennium* album. The tribute concert would air April 21, 2020, the four-year anniversary of Prince's death.

On February 7, a second edition of *Illumination* was released. First released in 2005, the album contains the singles "The Way You Move," "Pure Gold," and the Grammy-nominated "Show Me the Way." This second edition features two bonus tracks: "Lovely People (instrumental)," and "Elevated (instrumental)."[64]

On February 25, Earth, Wind & Fire announced they would join Santana for a North American tour during the summer, titled Miraculous Supernatural 2020. This would be the first time the two bands performed together in

North America. The two bands toured Europe together in 1975. The 2020 tour was scheduled to begin in Chula Vista, California, on June 19 and to end in Tampa, Florida, on August 29. Carlos Santana stated, "It is a great joy and honor to co-share music with the magnificent elements of Earth, Wind & Fire. We look forward to delight, joy and ecstasy!" Philip Bailey added, "We are excited to rock the USA alongside our friend Carlos Santana and his band with their off-the-chart musicianship and high energy show."[65] But in a couple of weeks, the world would see more chaos due to the coronavirus.

On March 11, 2020, the World Health Organization (WHO) declared the Coronavirus disease, Covid-19, a global pandemic. Because of this, many countries around the world ordered their citizens to shelter in place and wear masks. In the United States, millions of people became unemployed as many businesses shut down, and thousands of people died. Schools switched to online learning, churches closed, and sports, conventions, and concerts were cancelled. This pandemic would affect the anticipated Miraculous Supernatural 2020 tour and Earth, Wind & Fire's fiftieth anniversary year.

It was in the first week of April 1970 when Maurice White moved his band to Los Angeles, to rename it and develop the concept of Earth, Wind & Fire. But in April 2020, the world was dealing with a pandemic. Because of this pandemic, the decision was made to reschedule the Miraculous Supernatural 2020 tour for 2021. Ticket holders were asked to retain their tickets and they would be honored at the rescheduled show dates. Refunds would also be available for those who sought them. On their website, EWF encouraged people to "stay well, stay safe, and stay tuned."[66]

Naturally, fans were disappointed about not being able to see Earth, Wind & Fire and Santana in concert during the summer. Instead, they were inspired to listen to EWF's music more frequently during this troublesome time. EWF's music has always been inspiring and uplifting. It puts the listener in a good mood, no matter what is happening in his/her environment.

To commemorate the band's fiftieth anniversary, Sony Music released a special compilation of their music. In August, *Earth, Wind & Fire and Friends—50 Years Anniversary Album* was released by Sony Music from the Netherlands. This is a five-CD compilation with a total of ninety-two songs. The first CD consists of eighteen hit songs from EWF's classic period. The second CD contains seventeen more songs, including some from the classic period and two hit songs recorded by Philip Bailey and two recorded by Maurice White. The third CD features eighteen songs recorded after the 1987 comeback. The fourth CD includes nineteen more songs from the classic period. The fifth CD provides twenty songs by friends of EWF, artists who have worked with the band and artists whose songs were produced by

The cover for *Earth, Wind & Fire and Friends—50 Years Anniversary Album* box set features several Kemetic symbols.

Maurice White or another band member. Those friends include The Emotions, Deniece Williams, Ramsey Lewis, and others. The Christmas song "December" is also included on the fifth CD. The cover art for this project is a significant tribute to EWF, featuring several Kemetic (ancient Egyptian) symbols.[67] This album should be in the collection of all EWF fans and all lovers of good music.

In the following month, EWF fans also found another way to honor the band. For a few years, September 21 had been recognized as Earth, Wind & Fire day. In September 2020, fans declared the entire month of September as Earth, Wind & Fire month. During the month, fans would share hit songs from the band on their social media pages. Of course, fans all over the world paid tribute to EWF on September 21. Less than a week before the 21st of September 2020, Earth, Wind & Fire released a remix of "September" along with an updated version of the music video for the song. The song was remixed by Eric Kupper. Philip Bailey declared, "When I first heard the mastered final mix of 'September' at our private listening party back in the day, I would never have guessed that such a simple catchy song as it is, and

was, would become an all-time global favorite for generations."[68] The remix helped "September" reach a milestone during the quarantine.

For the third straight year, according to Nielsen Music/MRC Data, "September" had a tremendous spike in on-demand audio streams and digital download sales on September 21. On-demand audio streams of the song rose from 340,000 on September 20 to 1,187,000 on September 21, a gain of 249 percent. In 2019, on September 21, "September" experienced a rise from 383,000 to 1,017,000, a gain of 265 percent. In 2018, the song had a larger gain of 279% from 292,000 to 1,107,000. In 2020, "September" also jumped a whopping 622% in day-to-day sales, from a meager amount on September 20 to 2,000 on September 21. The full-week sales spike caused "September" to re-enter *Billboard*'s Digital Song Sales chart at #19 for the chart dated October 3. This was a new achievement for the song that originally peaked at #3 on the *Billboard* Hot 100 Songs chart in February 1979.[69]

To celebrate the 21st night of September during the quarantine year of 2020, Earth, Wind & Fire's YouTube channel held a three-hour virtual party hosted by DJ Spinna. During the livestream, Philip Bailey, Ralph Johnson, and Verdine White popped in as special guests.[70] This party gave EWF fans a reprieve during the quarantine year, but other scheduled events were cancelled.

Because of their acclaimed Las Vegas residency in 2019, Earth, Wind & Fire were scheduled for another limited residency in November 2020 at the Palms Casino Resort. But the three concerts scheduled for November 18, 20, and 21 were cancelled due to the pandemic.[71] Although fans could not see EWF live in concert, they made it a priority to keep the band's music in their playlists and to keep those playlists rotating. EWF finished their fiftieth anniversary year with some Christmas music.

Earth, Wind & Fire is featured on Meghan Trainor's single "Holidays," which is on her Christmas album *A Very Trainor Christmas*. The song embodies EWF's classic sound, with pulsating horns and a funky bassline. Trainor stated that collaborating with one of her family's favorite groups felt like the best early Christmas present.[72] Trainor and the band performed the track on *The Tonight Show Starring Jimmy Fallon* on December 9. "Holidays" is another track in the EWF catalogue that consists of songs that lift peoples' spirits and help them get through troubled times. During the band's fiftieth anniversary year, it is safe to say that their music was in heavy rotation on stereos, computers, smart phones, and iPods.

In fifty years, Earth, Wind & Fire has become a pop music icon. The band's music has had a positive influence on listeners. Keyboardist Larry Dunn once stated, "One brother said, 'Because of you, I got off heroin.'"[73] EWF's music

has also impacted people from various demographics. Some people claim EWF concerts are among the most integrated concerts they have attended. This is the impact Maurice White hoped his band would have on the world. This impact began during EWF's classic period when the band was able to cross over and reach a global audience.

Today, there are three musicians who have been with Earth, Wind & Fire since the classic period: Philip Bailey, Ralph Johnson, and Verdine White. These gentlemen are the core members of the band, and some people believe the Earth, Wind & Fire moniker fits them well. Johnson is the Earth because of his down-to-earth persona and his percussion is the beat of the Earth. Bailey is the Wind because of his amazing vocal ability. Verdine White is the Fire because of his high energy on stage. He is the only original member of Earth, Wind & Fire who is still with the band. These three legends are joined by other musicians who are highly qualified to carry on the EWF legacy.

Philip Bailey is the current leader of Earth, Wind & Fire. In recent years, his children have joined him on his musical journey. His daughter, Trinity Bailey, serves as his personal assistant. Bailey's son, Creed Bailey, helps archive the latest EWF images, and Philip Bailey Jr. is a percussionist and singer with the band.[74] With all the talented people who have been and are a part of EWF, the art of this legendary band is sure to continue to enhance the lives of global citizens for many years to come. It has been stated that the purpose of life is not to live forever but to create something that will. That is what Maurice White did when he created Earth, Wind & Fire.

Earth, Wind & Fire Forever!

Afterword

Maurice White created Earth, Wind & Fire with a primary vision: to raise the consciousness of people around the world. During the 1970s, Earth, Wind & Fire became one of the most celebrated pop music bands in the world. They stood out from other artists with their unique sound and captivated audiences with their live performances. EWF inspired people with their spiritual messages. Their songs contain messages about self-love, spiritual guidance, man's soul, escape from life's troubles, man's relationship with nature, romantic love, and universal love. One of the main themes found in EWF's lyrics is metaphysics, which is searching for the meaning by looking beyond the physical world. EWF also intrigued people with their elaborate album covers and other visual art, mostly inspired by ancient Egypt.

The Kemetic symbols in Earth, Wind & Fire's visual art represent man's connection to the Supreme God, man's divine nature, and his quest for enlightenment. White's mission was to lead people to the one Supreme God and EWF encouraged people to seek ways to become better individuals so that we may live in a better world. The pyramid, deities, and other Kemetic symbols helped shape EWF's image and mysticism. The deities represent attributes of the Supreme God, such as wisdom, truth, righteousness, and immortality.

Maurice White wanted to share his spirituality with all people, not only with Christians. He understood the importance of inclusion, and chose to explore all faiths, especially ancient Egyptian cosmology. Although Maurice White encouraged people to seek different spiritual paths, he did not forget about his own Baptist upbringing. Herb Powell stated that he and White often talked about Christ consciousness during many of their late-night conversations.[1] Guitarist Sheldon Reynolds declared that in the last conversation he had with Maurice White, White told him, "By the way, keep Jesus with you."[2] Evidently, Maurice White did not reject Christianity. He understood there is positivity in all faiths.

Earth, Wind & Fire's message is positive. It is also intimate because the band has never been afraid to give and display all their energy. As they grew,

musically and spiritually, we were inclined to listen because their virtuoso musicianship makes it so easy. EWF cultivated rhythms that are the heartbeat of humanity. The instruments were mastered by each member. The will of each musician, operating within the framework of EWF's ultimate destiny, evolves into a greater will. That will is to spread the message of love, devotion, reason, and thought to all of us. Work and dedication for and to the natural order of things has made Earth, Wind & Fire what they are, and listening to their music has hopefully influenced each of us to realize the potential within ourselves.[3]

Maurice White wanted his audience to be able to enjoy life. He was actually a funny guy. Keyboardist Morris Pleasure stated, "You could not even be in that band if you did not have a sense of humor."[4] Maurice White wanted audiences to take a higher path. He wanted them to reach the divine, and they did, because, according to music and culture writer Ericka Blount Danois, reaching the divine requires transcending time.[5] White encouraged audiences to transcend time by using pyramids as spaceships in concerts. He encouraged fans to elevate their minds by employing ancient Egyptian imagery in the visual art. And he encouraged listeners to transcend space by fantasizing ("Fantasy") and meditating ("Getaway").

White reflected, "I wanted to create a library of music that would stand the test of time. 'Cosmic Consciousness' is the key component of our work. Expanding awareness and uplifting spirits is so important in this day. People are looking for more. I hope our music can give them some encouragement and peace."[6] Earth, Wind & Fire gave African Americans a new sense of racial pride and gave all people the hope for universal love.

Earth, Wind & Fire's music has been used several times over by other musicians. Their songs have been covered by many artists, including Norman Connors, Dionne Warwick, Black Box, Maysa, Taylor Swift, and others. Their music has been sampled by many hip hop and R&B artists, including Big Pun, TLC, Crystal Waters, Yo-Yo, Naughty by Nature, Raheem DeVaughn, and many more. According to Whosampled.com, Earth, Wind & Fire's songs have been covered 247 times, and their music has been sampled 677 times.[7] This music is the gift that keeps on giving.

Earth, Wind & Fire's hit songs can be found on compilation albums with various artists. Those songs can also be found on Earth, Wind & Fire compilation albums, in addition to those discussed in this narrative. Many of these compilation albums were released by various record companies usually found in foreign markets, such as France and the UK. EWF's music has no boundaries, and we are thankful to Maurice White for his amazing contribution to our world: music that will stand the test of time.

Notes

INTRODUCTION

1. "Remembering 2010 SHOF Inductee Maurice White," Songwriters Hall of Fame News, accessed April 14, 2017. https://www.songhall.org/news/view/remembering_2010 _shof_inductee_maurice_white.

2. "Shining Star by Earth, Wind & Fire," Songfacts, accessed December 10, 2016. http://www.songfacts.com/detail.php?id=20700.

3. Michael Ray, *Disco, Punk, New Wave, Heavy Metal, and More: Music in the 1970s and 1980s* (New York: Rosen Education Service, 2012), 123.

4. Brian Ward, *Just My Soul Responding: Rhythm and Blues, Black Consciousness, and Race Relations* (Berkeley: University of California Press, 1998), 408.

5. Larry Neal, "The Black Arts Movement," *Drama Review: TDR* 12, no. 4 (Summer 1968): 29.

6. Floyd B. Barbour, ed., *The Black Seventies* (Boston: Porter Sargent, 1970), 87.

7. Clovis E. Semmes, "The Dialectics of Cultural Survival and the Community Artist: Phil Cohran and the Affro-Arts Theater," *Journal of Black Studies* 24, no. 4 (June 1994): 451.

8. Teresa Reed, *The Holy Profane: Religion in Black Popular Music* (Lexington: University Press of Kentucky, 2003), 140–41.

9. Reed, *The Holy Profane*, 138–40.

10. Semmes, 452.

11. Semmes, 457–58.

12. Rickey Vincent, *Funk: The Music, the People, and the Rhythm of the One* (New York: Macmillan, 1996), 4–5.

13. Howard C. Harris and William Fielder, *Complete Book of Composition/ Improvisation and Funk Techniques* (Houston: De Mos Music Publications, 1982), 114.

14. Reed, 138.

15. Vincent, 15.

16. Kesha M. Morant, "Language in Action: Funk Music as the Critical Voice of a Post–Civil Right Movement Counterculture," *Journal of Black Studies* 42, no. 1 (January 2011): 74.

17. Vincent, 78.

18. Morant, 74–75.

19. Maurice White and Herb Powell, *My Life with Earth, Wind & Fire* (New York: HarperCollins, 2016), 147.

20. White and Powell, 148.

21. Donald Matthews, "Proposal for an Afro-Centric Curriculum," *Journal of the American Academy of Religion* 62, no. 3 (Autumn 1994): 885–92.

CHAPTER 1: IMAGINATION

1. Philip Bailey, *Shining Star: Braving the Elements of Earth, Wind & Fire* (New York: Penguin Group, 2014), 50.

2. Maurice White and Herb Powell, *My Life with Earth, Wind & Fire* (New York: HarperCollins, 2016), 14–15.

3. David Nathan, "The Eternal Dance of Earth, Wind & Fire," liner notes for *The Eternal Dance* (CD box set Sony Music Entertainment, 1992).

4. Nathan, 17–18.

5. Nathan.

6. Nathan, 19–20.

7. Nathan, 24–25.

8. "Biography," Earth, Wind & Fire, last modified 2019. http://earthwindandfire.com/history/biography/.

9. Ericka Blount Danois, "Cosmic Heights," *Wax Poetics* (July/August 2011): 73.

10. "Biography," Earth, Wind & Fire.

11. Nathan.

12. Danois, 73.

13. White and Powell, 66.

14. Nathan.

15. Danois, 73.

16. Bailey, 87.

17. Maurice White, Interview in 2009, accessed October 10, 2016. https://www.youtube.com/watch?v=uMf83ofyFUk&t=699s.

18. Bailey, 1.

19. Danois, 73.

20. White and Powell, 78.

21. Danois, 73.

22. Bailey, 57.

23. Nathan.

24. "About Verdine," Verdine White, last modified 2014, accessed May 15, 2015, http://www.verdinewhite.com/bio.htm.

25. White and Powell, 91.

26. "Earth, Wind & Fire," *Chicago Defender (Big Weekend Edition)*, April 27, 1974, accessed June 30, 2015. http://search.proquest.com.ezproxy.auctr.edu:2051/news/results/.

27. "Earth, Wind and Fire at Arie Crown," *Chicago Defender (Daily Edition)*, May 1, 1975, accessed June 30, 2015. http://search.proquest.com.ezproxy.auctr.edu:2051/news/results/.

28. Anthony T. Browder, *The Nile Valley Contributions to Civilization* (Washington, DC: Institute of Karmic Guidance, 1992), 78.

29. Danois, 74.

30. Bailey, 60.

31. Danois, 74.

32. Teresa L. Reed, *The Holy Profane: Religion in Black Popular Music* (Lexington: University Press of Kentucky, 2003), 127.

33. White and Powell, 94.

34. Bailey, 61.

35. White and Powell, 78.

36. "Love Is Life," *Billboard*, accessed June 2, 2019, https://www.billboard.com/music/earth-wind-fire/chart-history/r-b-hip-hop-songs/song/578960.

37. "Earth, Wind & Fire Explains the Kalimba," *Chicago Metro News*, August 10, 1974, accessed June 16, 2015. http://infoweb.newsbank.ezproxy.auctr.edu:2051/iw-search/we/histArchive?p_action=search.

38. Semmes, 458.

39. Nathan.

40. Alan Light, "Kalimba Story," liner notes for *The Eternal Dance* (CD box set, Sony Music Entertainment, 1992).

41. "Earth, Wind & Fire," *Billboard*, accessed June 2, 2019, https://www.billboard.com/music/earth-wind-fire/chart-history/r-b-hip-hop-albums/song/820657.

42. Lester Bangs, "Earth, Wind & Fire," *Rolling Stone*, June 24, 1971, https://www.rollingstone.com/music/music-album-reviews/earth-wind-fire-246411/

43. John Bush, "Earth, Wind & Fire: Earth, Wind & Fire," last modified 2019, https://www.allmusic.com/album/earth-wind-and-fire-mw0000095039.

44. Bailey, 61.

45. Danois, 74.

46. Mossi Reeves, Jason Heller, et al., "Earth, Wind & Fire: 12 Essential Songs," *Rolling Stone*, February 5, 2016. https://www.rollingstone.com/music/music-lists/earth-wind-fire-12-essential-songs-26670/.

47. Danois, 74.

48. Reeves et al.

49. White and Powell, 99.

50. "I Think about Lovin' You," Earth, Wind & Fire, *The Need of Love* (Warner Brothers, 1971).

51. White and Powell, 99.

52. "Think about Lovin' You," *Billboard*, last modified 2019. https://www.billboard.com/music/earth-wind-fire/chart-history/r-b-hip-hop-songs/song/578960.

53. John Bush, "*The Need of Love*, Earth, Wind & Fire," last modified 2019, https://www.allmusic.com/album/earth-wind-and-fire-mw0000095039.

54. "Album Reviews," *Billboard*, December 4, 1971, 46.

55. Nathan.

56. Bailey, 19.

57. Nathan.

58. Bailey, 29–30.

59. Bailey, 39.

60. Nathan.

61. White and Powell, 106.

62. Bailey, 70–80.

63. Bailey, 31.

64. "Bio: Larry Dunn," Larry Dunn Music, last modified 2020, accessed January 24, 2020. https://www.larrydunnmusic.com/bio-larry-dunn/.

65. Ralph Johnson, Interview with the author, March 16, 2017.

66. Danois, 77.

67. White and Powell, 107.

68. White and Powell, 115.
69. Bailey, 83.
70. White and Powell, 107.
71. Nathan.
72. White and Powell, 101.
73. Nathan.
74. White and Powell, 116–17.
75. Bailey, 109.
76. Earth, Wind & Fire, *Last Days and Time* (Columbia, 1972).
77. "Week Ending March 10, 1973." *Cash Box* R&B Top 65. http://cashboxmagazine.com/archives-r/70s_files/19730310R.html.
78. "Earth, Wind & Fire Enjoy Phenomenal Success," *Tri-State Defender*, May 18, 1974. http://search.proquest.com.ezproxy.auctr.edu:2051/news/docview/.
79. William Ruhlmann, "Last Days and Time," Earth, Wind & Fire, last modified 2020. https://www.allmusic.com/album/last-days-and-time-mw0000318254.
80. "Album Reviews," *Billboard*, November 8, 1972, 24.
81. "Last Days and Time," Earth, Wind & Fire, *Billboard*. https://www.billboard.com/music/earth-wind-fire/chart-history/r-b-hip-hop-albums/song/827027.
82. Nathan.
83. Bailey, 115.
84. "Andrew Woolfolk," Jaye Purple Wolf Dot Com, accessed August 28, 2019. http://www.jayepurplewolf.com/EARTHWINDFIRE/andrewwoolfolk.html.
85. Bailey, 115.
86. "Johnny Graham," Jay Purple Wolf Dot Com, accessed May 15, 2015. www.jayepurplewolf.com/EARTHWINDFIRE/johnnygraham.html.
87. "Al's Bio," Al McKay, accessed January 21, 2020. http://www.almckay.com/bio.php.
88. Danois, 77.

CHAPTER 2: MOMENT OF TRUTH

1. William C. Banfield, *Makings of a Black Music Philosophy: An Interpretive History from Spirituals to Hip Hop* (Lanham, MD: Scarecrow Press, 2010), 33.
2. Rickey Vincent, *Funk: The Music, the People, and the Rhythm of the One* (New York: St. Martin's Griffin, 1996), 5.
3. Teresa L. Reed, *The Holy Profane: Religion in Black Popular Music* (Lexington: University Press of Kentucky, 2003), 5.
4. Maurice White and Herb Powell, *My Life with Earth, Wind & Fire* (New York: HarperCollins, 2016), 148.
5. White and Powell, 147–48.
6. Maurice White, Interview in 2009, accessed October 10, 2016. https://www.youtube.com/watch?v=uMf83ofyFUk&t=699s.
7. David Nathan, "The Eternal Dance of Earth, Wind & Fire," liner notes for *The Eternal Dance* (CD box set, Sony Music Entertainment, 1992).
8. Denise Martin, "Maat and Order in African Cosmology: A Conceptual Tool for Understanding Indigenous Knowledge," *Journal of Black Studies* 38, no. 6 (July 2008): 951.
9. Maulana Karenga, *Maat: The Moral Ideal in Ancient Egypt* (New York: Routledge, 2004), 10.
10. Ralph Johnson, Interview with the author, Atlanta, Georgia, March 16, 2017.

11. "Earth, Wind & Fire," *The Skanner*, December 8, 1977, accessed June 30, 2015/ http://search.proquest.com.ezproxy.auctr.edu:2015/news/results.

12. Craig Werner, *A Change Is Gonna Come: Music, Race & the Soul of America* (Ann Arbor: University of Michigan Press, 2006), 178.

13. Werner, 187.

14. White and Powell, 81.

15. Earth, Wind & Fire, *Head to the Sky* (Columbia, 1973).

16. White and Powell, 129.

17. Philip Bailey, *Shining Star: Braving the Elements of Earth, Wind & Fire* (Viking Adult, 2014), 118.

18. White and Powell, 133.

19. "Earth, Wind & Fire Appeals to All Tastes," *Milwaukee Star*, August 2, 1973. https://infoweb-newsbank-com.ezproxy.auctr.edu:2050/apps/readex/doc?p=.

20. "Evil," Earth, Wind & Fire, *Billboard*, accessed August 14, 2019. https://www.billboard.com/music/earth-wind-fire/chart-history/adult-contemporary/song/338741.

21. "Following a Series of Sold-out Appearances," *Chicago Metro News*, October 13, 1973. https://infoweb-newsbank-com.ezproxy.auctr.edu:2050/apps/readex/doc?p=.

22. James B. Stewart, "Message in the Music: Political Commentary in Black Popular Music from Rhythm and Blues to Early Hip Hop," *Journal of African American History* 90, no. 3 (Summer 2005): 215.

23. White and Powell, 129–30.

24. Earth, Wind & Fire, "Keep Your Head to the Sky," *Head to the Sky* (Columbia, 1973).

25. White and Powell, 349.

26. Karenga, 199.

27. "Keep Your Head to the Sky," Earth, Wind & Fire, *Billboard*, accessed August 14, 2019. https://www.billboard.com/music/earth-wind-fire/chart-history/r-b-hip-hop-songs/song/338991.

28. Vince Aletti, "Head to the Sky," *Rolling Stone*, August 17, 1973. https://www.rollingstone.com/music/music-album-reviews/head-to-the-sky-189912/.

29. "Top Album Picks," *Billboard*, May 26, 1973, 52.

30. "Head to the Sky," Earth, Wind & Fire, *Billboard*. https://www.billboard.com/music/earth-wind-fire/chart-history/r-b-hip-hop-albums/song/825365.

31. "Head to the Sky," Earth, Wind & Fire. RIAA. https://www.riaa.com/gold-platinum/?tab_active=default-award&se=Earth%2C+Wind+%26+Fire+Head#search_section.

32. Danois, 77.

33. Bailey, 124–25.

34. Earth, Wind & Fire, *Open Our Eyes* (Columbia, 1974).

35. Bailey, 129–30.

36. "Mighty Mighty," Earth, Wind & Fire, Songfacts.com, accessed August 20, 2019. https://www.songfacts.com/facts/earth-wind-fire/mighty-mighty.

37. White and Powell, 148.

38. Earth, Wind & Fire, "Mighty Mighty," *Open Our Eyes* (Columbia, 1974).

39. White and Powell, 148.

40. White and Powell, 148.

41. "Mighty Mighty," Earth, Wind & Fire. Billboard.com. https://www.billboard.com/music/earth-wind-fire/chart-history/r-b-hip-hop-songs/song/338286.

42. Nathan.

43. Earth, Wind & Fire," *Chicago Defender (Big Weekend Edition)*, April 27, 1974. http://search.proquest.com.ezproxy.auctr.edu:2015/news/results/.

44. "Earth, Wind & Fire Explains the Kalimba," *Chicago Metro News*, August 10, 1974, accessed June 16, 2015. http://infoweb.newsbank.ezproxy.auctr.edu:2051/iw-search/we/histArchive?p_action=search.

45. "Kalimba Story," Earth, Wind & Fire, *Open Our Eyes* (Columbia, 1974).

46. "Kalimba Story," Earth, Wind & Fire, Billboard.com. https://www.billboard.com/music/earth-wind-fire/chart-history/r-b-hip-hop-songs/song/338461.

47. Danois, 78.

48. "Hot Dawgit," Ramsey Lewis and Earth, Wind & Fire, Billboard.com. https://www.billboard.com/music/earth-wind-fire/chart-history/BSI/song/580871.

49. Bailey, 127.

50. White and Powell, 140.

51. Mossi Reeves, Jason Heller, et al., "Earth, Wind & Fire: 12 Essential Songs," *Rolling Stone*, February 5, 2016. https://www.rollingstone.com/music/music-lists/earth-wind-fire-12-essential-songs-26670/.

52. "Devotion," Earth, Wind & Fire, *Open Our Eyes* (Columbia, 1974).

53. "Devotion," Earth, Wind & Fire, Billboard.com. https://www.billboard.com/music/earth-wind-fire/chart-history/r-b-hip-hop-songs/song/399469.

54. Reed, 145–46.

55. Reed, 141.

56. White and Powell, 9.

57. "Earth, Wind & Fire Creates Euphoria with Dynamic Sound," *Milwaukee Star*, April 25, 1974. http://search.proquest.com.ezproxy.auctr.edu:2015/news/results/.

58. Edmund Lewis, "Remembering Maurice," *Louisiana Weekly*, February 29, 2016, accessed October 30, 2016. http://www.louisianaweekly.com/remembering-maurice/.

59. "Open Our Eyes," Earth, Wind & Fire, *Open Our Eyes* (Columbia, 1974).

60. Ken Emerson, "Open Our Eyes," *Rolling Stone*, May 9, 1974. https://www.rollingstone.com/music/music-album-reviews/open-our-eyes-104019/.

61. Robert Christgau, "Open Our Eyes." https://www.robertchristgau.com/get_album.php?id=1111.

62. *Open Our Eyes*, Earth, Wind & Fire, Billboard.com. https://www.billboard.com/music/earth-wind-fire/chart-history/r-b-hip-hop-albums/song/827529.

63. *Open Our Eyes*, Earth, Wind & Fire, RIAA. https://www.riaa.com/gold-platinum/?tab_active=default-award&se=Earth%2C+Wind+%26+Fire+Open+Our+Eyes#search_section.

64. Bailey, 133.

65. "Freddie White," Earth, Wind & Fire, Jay Purple Wolf Dot Com, accessed September 8, 2019. www.jayepurplewolf.com/EARTHWINDFIRE/freddiewhite2.html.

66. Bailey, 133.

67. Ron Wynn, *Another Time*, Earth, Wind & Fire, AllMusic. https://www.allmusic.com/album/mw0000839159.

68. "Another Time," Earth, Wind & Fire, Billboard.com. https://www.billboard.com/music/earth-wind-fire/chart-history/r-b-hip-hop-albums/song/826804.

CHAPTER 3: SHINING STARS

1. "Exhilarating: Hottest Group on Set Gets Hotter," *Milwaukee Star*, June 19, 1975, 12. http://search.proquest.com.ezproxy.auctr.edu:2015/news/results/.

2. Mark Savage, "Earth, Wind & Fire: How Maurice White Made a Force for Positivity," *BBC News*, February 5, 2016. https://www.bbc.com/news/entertainment-arts-35500894.

3. "Shining Star," Earth, Wind & Fire, *That's the Way of the World* (Columbia, 1975).

4. "Shining Star."

5. "Ancient Egyptian Proverbs," Ancient Egyptian Facts, accessed October 30, 2016. http://www.ancientegyptianfacts.com/ancient-egyptian-proverbs.html.

6. Anne-Lise Francois, "Fakin' It/Makin' It: Falsetto's Bid for Transcendence in 1970s Disco Highs," *Perspectives of New Music* 33 (Winter-Summer 1995): 448.

7. Rickey Vincent, *Funk: The Music, the People, and the Rhythm of the One* (St. Martin's Press, 1996), 187.

8. "Shining Star," Earth, Wind & Fire. Billboard.com. https://www.billboard.com/music/earth-wind-fire/chart-history/r-b-hip-hop-songs/song/346432.

9. "Shining Star," Earth, Wind & Fire. Grammy.com. https://www.grammy.com/grammys/artists/earth-wind-fire.

10. Earth, Wind & Fire, *That's the Way of the World* (Columbia, 1975).

11. "Exhilarating: Hottest Group on Set Gets Hotter," *Milwaukee Star*, June 19, 1975, 12. http://search.proquest.com.ezproxy.auctr.edu:2015/news/results/.

12. Earth, Wind & Fire, "That's the Way of the World," *That's the Way of the World* (Columbia, 1975).

13. Maulana Karenga, *Maat: The Moral Ideal in Ancient Egypt* (New York: Routledge), 85.

14. Anthony T. Browder, *Nile Valley Contributions to Civilization* (Washington: Institute of Karmic Guidance), 87.

15. Carole R. Fontaine, "A Look at Ancient Wisdom: The Instruction of Ptahhotep Revisited," *Biblical Archaeologist* 42, no. 3 (Summer 1981): 156.

16. "That's the Way of the World," Earth, Wind & Fire, *That's the Way of the World* (Columbia, 1975).

17. "That's the Way of the World," Earth, Wind & Fire, Billboard.com. https://www.billboard.com/music/earth-wind-fire/chart-history/hot-100/song/345901.

18. Teresa L. Reed, *The Holy Profane: Religion in Black Popular Music* (Lexington: University Press of Kentucky, 2003), 146.

19. "All about Love," Earth, Wind & Fire, *That's the Way of the World* (Columbia, 1975).

20. White and Powell, 168–69.

21. "Reasons," Earth, Wind & Fire, Songfacts. https://www.songfacts.com/facts/earth-wind-fire/reasons.

22. White and Powell, 169.

23. "Reasons," Earth, Wind & Fire, *That's the Way of the World* (Columbia, 1975).

24. Mossi Reeves, Jason Heller, et al., "Earth, Wind & Fire: 12 Essential Songs," *Rolling Stone*, February 5, 2016. https://www.rollingstone.com/music/music-lists/earth-wind-fire-12-essential-songs-26670/.

25. "Album Reviews," *Billboard*, March 8, 1975, 84.

26. Robert Christgau, "*That's the Way of the World*," Earth, Wind & Fire. https://www.robertchristgau.com/get_album.php?id=1112.

27. Alex Henderson, "That's the Way of the World," Earth, Wind & Fire, AllMusic. https://www.allmusic.com/album/thats-the-way-of-the-world-mw0000650107.

28. White and Powell, 181–82.

29. "The Phenix Horns," Jay Purple Wolf Dot Com. http://www.jayepurplewolf.com/EARTHWINDFIRE/thephenixhorns.html.

30. Alan Light, "Kalimba Story," liner notes for *The Eternal Dance* (CD box set, Sony Music Entertainment, 1992).

31. White and Powell, 184.

32. "Earth, Wind & Fire in Concert," *Common Bond*, October 1, 1976, 9. http://search .proquest.com.ezproxy.auctr.edu:2015/news/results/.

33. "Earth, Wind & Fire in Concert," *Common Bond*.

34. "Exhilarating: Hottest Group on Set Gets Hotter," 12.

35. Nathan.

36. White and Powell, 187.

37. Bailey, 163–64.

38. Earth, Wind & Fire, *Gratitude* (Columbia, 1975).

39. "Sing a Song," Earth, Wind & Fire, *Gratitude* (Columbia, 1975).

40. Theophile Obenga, "African Philosophy of the Pharaonic Period," in *Egypt Revisited*, ed. Ivan Van Sertima (New Brunswick, NJ: Transaction Publishers, 1999), 315.

41. Janheinz Jahn, *Muntu: African Culture and the Western World* (New York: Grove Press, 1961), 125–26.

42. "Shining Star," Earth, Wind & Fire, *Billboard*. https://www.billboard.com/music/ earth-wind-fire/chart-history/hot-100/song/337723.

43. "Earth, Wind & Fire," *The Skanner*.

44. White and Powell, 193.

45. "Can't Hide Love," Earth, Wind & Fire, Songfacts. https://www.songfacts.com/facts/ earth-wind-fire/cant-hide-love.

46. "Can't Hide Love," Earth, Wind & Fire, Grammy Awards. https://www.grammy.com/ grammys/artists/earth-wind-fire.

47. White and Powell, 191–92.

48. Richard Wilkinson, *The Complete Gods and Goddesses of Ancient Egypt* (New York: Thames & Hudson, 2003), 140.

49. "*Gratitude*," Earth, Wind & Fire, *Billboard*. https://www.billboard.com/music/ earth-wind-fire/chart-history/r-b-hip-hop-albums/song/317059.

50. "*Gratitude*," Earth, Wind & Fire, Grammy Awards. https://www.grammy.com/grammys/ artists/earth-wind-fire.

51. "*Gratitude*," Earth, Wind & Fire. RIAA. https://www.riaa.com/gold-platinum/?tab _active=default-award&se=Earth%2C+Wind+%26+Fire+Gratitude#search_section.

52. Brandon Ousley, "Revisiting the Black Pop Liberation of Stevie Wonder and Earth, Wind & Fire, 40 Years Later," *Albumism*, September 26, 2016. https://www.albumism.com/ features/revisiting-the-black-pop-liberation-of-stevie-wonder-and-earth-wind-and-fire.

53. "Getaway by Earth, Wind & Fire," Songfacts, accessed January 30, 2017. http://www .songfacts.com/detail.php?id=35073.

54. "Earth, Wind & Fire," *The Skanner*.

55. Kory Grow, "Maurice White and Powell, Earth, Wind & Fire Singer and Co-founder, Dead at 74," *Rolling Stone*, February 4, 2016, accessed December 20, 2016. www.rollingstone .com.

56. "Getaway," Earth, Wind & Fire, *Spirit* (Columbia, 1976).

57. Travis K. Lacy, "Funk Is Its Own Reward: An Analysis of Selected Lyrics in Popular Funk Music of the 1970s" (master's thesis, Clark Atlanta University, 2008), 95–96.

58. Naadu Blankson, "Breath of Life," *Essence*, July 1993, 22.

59. White and Powell, 200.

60. "Getaway," Earth, Wind & Fire, *Billboard*. https://www.billboard.com/music/ earth-wind-fire/chart-history/hot-100/song/337306.

61. "Getaway," Earth, Wind & Fire, RIAA. https://www.riaa.com/gold-platinum/?tab_active=default-award&ar=EARTH%2C+WIND+%26amp%3B+FIRE&ti=GETAWAY.

62. "Biography," EarthWindandFire.com, last modified 2017, accessed April 22, 2017. http://www.earthwindandfire.com/history/biography.

63. Earth, Wind & Fire, *Spirit* (Columbia, 1976).

64. Earth, Wind & Fire, *Spirit*.

65. Ousley.

66. J. Donald Fernie, "Astronomy and the Great Pyramid," *American Scientist* 92, no. 5 (September-October 2004): 406.

67. Davi, Interview with Maurice White, 2005, accessed June 10, 2016. www.okayafrica.com/culture-2/maurice-white-earth-wind-and-fire-african-ness-interview/.

68. Richard A. Proctor, "The Pyramid of Cheops," *North American Review* 136, no. 316 (March 1883): 262.

69. Ousley.

70. "Saturday Nite," Earth, Wind & Fire, Billboard.com. https://www.billboard.com/music/earth-wind-fire/chart-history/hot-100/song/337481.

71. Ousley.

72. White and Powell, 209.

73. "On Your Face," Earth, Wind & Fire, Billboard.com. https://www.billboard.com/music/earth-wind-fire/chart-history/HSI/song/336869.

74. Danois, 81.

75. Muata Abhaya Ashby, *Egyptian Proverbs: Mystical Wisdom Teachings and Meditations* (Miami: Cruzian Mystic Books, 1997), no page number listed.

76. "Spirit," Earth, Wind & Fire, *Spirit* (Columbia, 1976).

77. Browder, 87.

78. Paul Carus, "The Conception of the Soul and the Belief in Resurrection among the Egyptians," *The Monist* 15, no. 3 (July 1905): 411–12.

79. "Earth, Wind & Fire," Earth, Wind & Fire, *Spirit* (Columbia, 1976).

80. Gadalla, 49.

81. Browder, 88.

82. Ousley.

83. "*Billboard*'s Top Album Picks," *Billboard*, October 9, 1976.

84. Craig Warner, "Earth, Wind & Fire: *Open Our Eyes, Spirit*," *Vibe*, March 2001, 200.

85. "The Pop Life," *New York Times*, October 22, 1976.

86. "Spirit," Earth, Wind & Fire, *Billboard*. https://www.billboard.com/music/earth-wind-fire/chart-history/r-b-hip-hop-albums/song/316009.

87. "Bio-Awards," Earthwindandfire.com. https://web.archive.org/web/20090307013150/http://www.earthwindandfire.com/bio_awards.html.

88. "Spirit," Earth, Wind & Fire, RIAA. https://www.riaa.com/gold-platinum/?tab_active=default-award&se=Earth%2C+Wind+%26+Fire+Spirit#search_section.

89. White and Powell, 212–14.

CHAPTER 4: ALL 'N ALL

1. Philip Bailey, *Shining Star: Braving the Elements of Earth, Wind & Fire* (New York: Viking Adult, 2014), 179.

2. Nathan.

3. Bailey, 178.

4. Earth, Wind & Fire, *All 'N All* (Columbia, 1977).

5. "Earth, Wind & Fire," *The Skanner*.

6. Lynn, Van Matre, "Who Told Maurice White to Record 'Stand by Me'? It Was . . . A Voice," *Chicago Tribune*, December 1, 1985, accessed June 30, 2015. http://search.proquest .com.ezproxy.auctr.edu:2051/news/results/.

7. Kyodo, "Nagaoka, Illustrator for Earth, Wind & Fire, Other bands, Dies at 78," *Japan Times*, June 27, 2015, accessed November 10, 2016. http://www.japantimes.co.jp/news/2015/06/27/ national/nagaoka-illustrator-for-earth-wind-fire-other-bands-dies-at-78/#.WBjBV9IrKUk.

8. Maurice White and Herb Powell, *My Life with Earth, Wind & Fire* (New York: HarperCollins, 2016), 229.

9. "Abu Simbel, Temples of," Reference Center, World Book, accessed November 1, 2016. http://www.worldbookonline.com/pl/referencecenter/printarticle?id=ar006180.

10. Martha G. Morrow, "Thousands of Sphinxes," *Science News-Letter* 61, no. 12 (March 22, 1952): 186.

11. "The Meaning of the Great Sphinx of Giza" Feature Stories, accessed July 20, 2016. http://www.touregypt.net/featurestories/sphinx4.htm.

12. "The Symbols," The EWF Experience, Homdrum.net. http://www.homdrum.net/ewf/ symbols.html.

13. Heike Owusu, *Egyptian Symbols* (New York: Sterling, 2008), 167.

14. "The Symbols," The EWF Experience.

15. "The Symbols," The EWF Experience.

16. Owusu, 139.

17. "The Symbols," The EWF Experience.

18. Davi, Interview with Maurice White, 2005.

19. Van Matre.

20. White and Powell, 228.

21. Earth, Wind & Fire, "Serpentine Fire (Official Video)" (Sony Music Entertainment, 1978, accessed June 15, 2016. https://www.youtube.com/watch?v=XoI1XPqXQ90.

22. "Serpentine Fire by Earth, Wind & Fire," Songfacts, accessed December 10, 2016. http:// www.songfacts.com/detail.php?id=26012.

23. "Serpentine Fire," Earth, Wind & Fire, *All 'N All* (Columbia, 1977).

24. "Serpentine Fire," Songfacts.

25. Dan Epstein, "Earth, Wind and Fire Groove into Hall," *Rolling Stone*, March 2, 2000, accessed April 20, 2017. http://www.rollingstone.com/music/news/earth-wind-and-fire-groove -into-hall-20000302.

26. Morris Pleasure, Interview with the author, Atlanta, Georgia, March 18, 2017.

27. Wayne B. Chandler, "Of Gods and Men: Egypt's Old Kingdom," in *Egypt Revisited*, ed. Evan Van Sertima (New Brunswick, NJ: Transaction Publishers, 1999), 131–32.

28. Bobbi Roquemore, "The Yoga Craze," *Ebony* 56, no. 10 (August 2001), 122–26.

29. Verdine White, Interview with the author. Atlanta, Georgia, March 16, 2017.

30. "Serpentine Fire," Earth, Wind & Fire, Billboard.com. https://www.billboard.com/ music/earth-wind-fire/chart-history/hot-100/song/336411.

31. Verdine White Interview.

32. "Fantasy," Earth, Wind & Fire, *All 'N All* (Columbia, 1977).

33. White and Powell, 226.

34. "Fantasy," Earth, Wind & Fire.

35. "Fantasy," Earth, Wind & Fire.

36. Ken McLeod, "Space Oddities: Aliens, Futurism and Meaning in Popular Music," *Popular Music* 22, no. 3 (October 2003): 341–42.

37. Anne-Lise Francois, "Fakin' It/Makin' It: Falsetto's Bid for Transcendence in 1970s Disco Highs," *Perspectives of New Music* 33, no. 1/2 (Winter-Summer 1995): 448.

38. "Fantasy by Earth, Wind & Fire," Songfacts, accessed February 5, 2017. http://www.songfacts.com/detail.php?id=26013.

39. White and Powell, 227.

40. "Maurice White," Grammy Awards. https://www.grammy.com/grammys/artists/maurice-white.

41. White and Powell, 349.

42. Ralph Johnson, Interview with the author, Atlanta, Georgia, March 16, 2017.

43. "Jupiter," Earth, Wind & Fire, *All 'N All* (Columbia, 1977.

44. Browder, 124.

45. Philip Bailey, *Shining Star: Braving the Elements of Earth, Wind & Fire* (New York: Viking Adult, 2014), 152.

46. "Jupiter," Earth, Wind & Fire, Official Charts. https://www.officialcharts.com/artist/16058/earth,-wind-and-fire/.

47. Chris Williams, "That Groove Was Undeniable," *The Atlantic*, November 21, 2012. https://www.theatlantic.com/entertainment/archive/2012/11/that-groove-was-undeniable-making-earth-wind-fires-all-n-all/265323/.

48. "Magic Mind," Earth, Wind & Fire. Official Charts. https://www.officialcharts.com/search/singles/magic%20mind/.

49. Mossi Reeves, Jason Heller, et al., "Earth, Wind & Fire: 12 Essential Songs," *Rolling Stone*, February 5, 2016. https://www.rollingstone.com/music/music-lists/earth-wind-fire-12-essential-songs-26670/.

50. "Earth, Wind & Fire," Grammy Awards. https://www.grammy.com/grammys/artists/earth-wind-fire.

51. "Earth, Wind & Fire," Grammy Awards.

52. "Past Winners Database," *Los Angeles Times*—The Envelope, Archive.ph. https://archive.ph/20061031061437/http://theenvelope.latimes.com/extras/lostmind/year/1979/1979ama.htm.

53. "*All 'N All*," Earth, Wind & Fire, Billboard.com. https://www.billboard.com/music/earth-wind-fire/chart-history/TLP/song/315901.

54. "*All 'N All*," Earth, Wind & Fire, RIAA. https://www.riaa.com/gold-platinum/?tab_active=default-award&ar=Earth%2C+Wind+%26+Fire&ti=ALL+%27N+ALL&lab=&genre=&format=&date_option=release&from=&to=&award=&type=&category=&adv=SEARCH#search_section.

55. Monroe Anderson, "Earth, Wind & Fire," *Chicago Tribune*, December 11, 1977.

56. Alex Henderson, "Earth, Wind & Fire, *All 'N All*," AllMusic. https://www.allmusic.com/album/all-n-all-mw0000105072.

57. McLeod, 343.

58. Vincent, 138.

59. Ward, 357.

60. Reed, 141.

61. Reed, 144.

62. "Earth, Wind & Fire Launches '77 Tour," *Chicago Metro News*, November 5, 1977.

63. Bailey, 171.

64. "Doug Henning," *People*, accessed November 10, 2016. http://www.biography.com/people/doug-henning-9542367.

65. White and Powell, 235.

66. Reed, 142.

67. Heike Owusu, *Egyptian Symbols* (New York: Sterling Publishing, 2000), 21.

68. Ronald Kisner, "Earth, Wind & Fire: New Music, New Magic," *Jet*, February 16, 1978, 14.

69. Horace J. Maxile Jr., "Extensions on a Black Musical Tropology: From Trains to the Mothership (and Beyond)," *Journal of Black Studies* 42, no. 4 (May 2011): 602.

70. Wayne Vaughn, Interview with the author. Atlanta, Georgia, March 15, 2017.

CHAPTER 5: SEE THE LIGHT

1. Maurice White and Herb Powell, *My Life with Earth, Wind & Fire* (New York: HarperCollins Publishers), 237

2. White and Powell, 238–39.

3. White and Powell, 240.

4. Philip Bailey, *Shining Star: Braving the Elements of Earth, Wind & Fire* (New York: Viking Adult), 182–83.

5. "Earth, Wind & Fire Milestone," *Chicago Metro News*, August 12, 1978.

6. "Got to Get You into My Life," Earth, Wind & Fire, Billboard.com. https://www.billboard.com/music/earth-wind-fire/chart-history/HSI/song/335965.

7. White and Powell, 239.

8. Ed Hogan, "Earth, Wind & Fire, 'Got to Get You into My Life,'" AllMusic. https://www.allmusic.com/song/got-to-get-you-into-my-life-mt0002790588.

9. "Maurice White," Grammy Awards. https://www.grammy.com/grammys/artists/maurice-white.

10. "Earth, Wind & Fire," Grammy Awards. https://www.grammy.com/grammys/artists/earth-wind-fire.

11. White and Powell, 245.

12. Bailey, 184.

13. "September," Earth, Wind & Fire, Songfacts. https://www.songfacts.com/facts/earth-wind-fire/september.

14. White and Powell, 247.

15. "September," Earth, Wind & Fire, Songfacts.

16. "September," Earth, Wind & Fire, *The Best of Earth, Wind & Fire, Vol. 1* (ARC/Columbia, 1978).

17. "September," Earth, Wind & Fire, Songfacts.

18. Mossi Reeves, Jason Heller, et al., "Earth, Wind & Fire: 12 Essential Songs," *Rolling Stone*, February 5, 2016. https://www.rollingstone.com/music/music-lists/earth-wind-fire-12-essential-songs-26670/.

19. Earth, Wind & Fire, "September (Official Video)," Sony Music Entertainment, 1978. https://www.youtube.com/watch?v=Gs069dndIYk.

20. "September," Earth, Wind & Fire, Billboard.com. https://www.billboard.com/artist/earth-wind-fire/chart-history/bsi/.

21. "September," Earth, Wind & Fire. RIAA. https://www.riaa.com/gold-platinum/?tab_active=default-award&ar=EARTH%2C+WIND+%26amp%3B+FIRE&ti=SEPTEMBER.

22. "September," Earth, Wind & Fire. Songfacts.

23. Earth, Wind & Fire, *The Best of Earth, Wind & Fire, Vol. 1* (Columbia, 1978).

24. Owusu, 167.

25. Mordechai Gilula, "An Egyptian Etymology of the Name of Horus?" *Journal of Egyptian Archaeology* 68 (1982): 259.

26. "*The Best of Earth, Wind & Fire, Vol. 1*," Earth, Wind & Fire, Billboard.com. https://www.billboard.com/music/earth-wind-fire/chart-history/TLP/song/180706.

27. White and Powell, 261.

28. White and Powell, 263.

29. Nathan.

30. White and Powell, 266.

31. "Boogie Wonderland," Earth, Wind & Fire, Songfacts. https://www.songfacts.com/facts/earth-wind-fire/boogie-wonderland.

32. "Boogie Wonderland," Earth, Wind & Fire, Songfacts.

33. "Boogie Wonderland," Earth, Wind & Fire, *I Am* (ARC/Columbia, 1979).

34. "Boogie Wonderland," Earth, Wind & Fire. Songfacts.

35. White and Powell, 259.

36. "Boogie Wonderland," Earth, Wind & Fire, Songfacts.

37. Earth, Wind & Fire, "Boogie Wonderland (Official Video)," Sony Music Entertainment. https://www.youtube.com/watch?v=god7hAPv8fo.

38. Dave Simpson, "How We Made Boogie Wonderland," *The Guardian*, October 7, 2013. https://www.theguardian.com/music/2013/oct/07/how-we-made-boogie-wonderland.

39. "Boogie Wonderland," Earth, Wind & Fire, Billboard.com. https://www.billboard.com/artist/earth-wind-fire/chart-history/bsi/.

40. "Earth, Wind & Fire," Grammy Awards.

41. Earth, Wind & Fire, *I Am* (Columbia, 1979).

42. Nathan.

43. Richard H. Wilkinson, *The Complete Temples of Ancient Egypt* (New York: Thames & Hudson, 2000), 65.

44. Wilkinson, 79.

45. Earth, Wind & Fire, *I Am* (Columbia, 1979).

46. "After the Love Has Gone," Earth, Wind & Fire, Songfacts. https://www.songfacts.com/facts/earth-wind-fire/after-the-love-has-gone.

47. "After the Love Has Gone," Earth, Wind & Fire, Billboard.com. https://www.billboard.com/music/earth-wind-fire/chart-history/ASI/song/335650.

48. "After the Love Has Gone," Earth, Wind & Fire, RIAA. https://www.riaa.com/gold-platinum/?tab_active=default-award&ar=EARTH%2C+WIND+%26amp%3B+FIRE&ti=AFTER+THE+LOVE+HAS+GONE.

49. "Earth, Wind & Fire," Grammy Awards.

50. "David Foster," Grammy Awards. https://www.grammy.com/grammys/artists/david-foster.

51. Sheldon Reynolds, interview by author, Atlanta, Georgia, February 11, 2017.

52. Reed, 144.

53. "In the Stone," Earth, Wind & Fire, *I Am* (ARC/Columbia, 1979).

54. "In the Stone," Earth, Wind & Fire, Billboard.com. https://www.billboard.com/music/earth-wind-fire/chart-history/BSI/song/335789.

55. "Star," Earth, Wind & Fire, *I Am* (ARC/Columbia, 1979).

56. "Star," Earth, Wind & Fire, Billboard.com. https://www.billboard.com/music/earth-wind-fire/chart-history/BSI/song/335874.

57. "Can't Let Go," Earth, Wind & Fire, Official Charts. https://www.officialcharts.com/search/singles/can't-let-go/.

58. White and Powell, 260.

59. White and Powell, 260.

60. Eric Sieger, "Six Major Groups in Area This Week," *Baltimore Sun*, September 23, 1979.

61. John Rockwell, "The Pop Life," *New York Times*, June 8, 1979.

62. "Maurice White," Grammy Awards. https://www.grammy.com/grammys/artists/maurice-white.

63. "*I Am*," Earth, Wind & Fire, Billboard. https://www.billboard.com/music/earth-wind-fire/chart-history/TLP/song/315181.

CHAPTER 6: THE CHANGING TIMES

1. Maurice White and Herb Powell, *My Life with Earth, Wind & Fire* (New York: HarperCollins, 2016), 278.

2. "Earth, Wind & Fire Panasonic Boombox Commercials, 1980–1983," We Are the Mutants, June 6, 2017. https://wearethemutants.com/2017/06/06/earth-wind-fire-panasonic-boombox-commercials-1980-1983/.

3. "Let Me Talk," Earth, Wind & Fire, *Faces* (ARC/Columbia, 1980).

4. White and Powell, 279.

5. White and Powell, 279.

6. Blaine Allan, "Musical Cinema, Music Video, Music Television," *Film Quarterly* 43, no. 3 (Spring 1990): 4.

7. Ralph Johnson, Interview with the author. Atlanta, Georgia, March 16, 2017.

8. Earth, Wind & Fire, "Let Me Talk (Official Video)," Sony Music Entertainment, 1980, accessed June 15, 2016. https://www.youtube.com/watch?v=4uQQm5xtMtU.

9. Linda Star Wolf and Ruby Falconer, *Shamanic Egyptian Astrology: Your Planetary Relationship to the Gods* (Rochester, VT: Bear & Company, 2010), 110–11.

10. Alan Henderson Gardiner, *Egyptian Grammar* (London: Griffin Institute, 1996), 74.

11. "Description of the King Tut Mask," History Embalmed, accessed July 5, 2016. www.historyembalmed.org/tomb-of-king-tut/king-tut-mask.htm.

12. Anthony Browder, *Nile Valley Contributions to Civilization* (Washington, DC: Institute of Karmic Guidance, 1992), 83.

13. "Let Me Talk," Earth, Wind & Fire, Billboard.com. https://www.billboard.com/music/earth-wind-fire/chart-history/HSI/song/335452.

14. Earth, Wind & Fire, *Faces* (Columbia, 1980).

15. White and Powell, 276.

16. Earth, Wind & Fire, *Faces* (Columbia, 1980).

17. "You," Earth, Wind & Fire, *Faces* (ARC/Columbia, 1980).

18. "You," Earth, Wind & Fire," Billboard.com. https://www.billboard.com/music/earth-wind-fire/chart-history/r-b-hip-hop-songs/3.

19. "Back on the Road," Earth, Wind & Fire, *Faces* (ARC/Columbia, 1980).

20. "And Love Goes On," Earth, Wind & Fire, *Faces* (ARC/Columbia, 1980).

21. "And Love Goes On," Earth, Wind & Fire, Billboard.com. https://www.billboard.com/music/earth-wind-fire/chart-history/HSI/song/334824.

22. "Faces—Earth, Wind & Fire (1980)," Lets Face the Music. https://letsfacethemusicblog.com/2016/02/12/faces-earth-wind-fire-1980/.

23. Dennis Hunt, "Earth, Wind & Fire Faces the Music," *Los Angeles Times*, November 30, 1980.

24. "Spotlight," *Billboard*, November 8, 1980.

25. Chuck Pratt, "Earth, Wind & Fire: Faces," *Chicago Sun-Times*, January 29, 1981.

26. "*Faces*," Earth, Wind & Fire, RIAA. https://www.riaa.com/gold-platinum/?tab_active=default-award&se=Earth%2C+Wind+%26+Fire++Faces#search_section.

27. Earth, Wind & Fire, *Raise!* (ARC/Columbia, 1981).

28. Earth, Wind & Fire, *Raise!*

29. "The Symbols," The Earth, Wind & Fire Experience. http://www.homdrum.net/ewf/symbols.html.

30. "Let's Groove," Earth, Wind & Fire, Songfacts. https://www.songfacts.com/facts/earth-wind-fire/lets-groove.

31. "Let's Groove," Earth, Wind & Fire, *Raise!* (ARC/Columbia, 1981).

32. White and Powell, 287.

33. Mossi Reeves, Jason Heller, et al., "Earth, Wind & Fire: 12 Essential Songs," *Rolling Stone*, February 5, 2016. https://www.rollingstone.com/music/music-lists/earth-wind-fire-12-essential-songs-26670/.

34. Earth, Wind & Fire, "Let's Groove (Official Video)," Sony Music Entertainment, 1981. https://www.youtube.com/watch?v=4uQQm5xtMtU.

35. "Let's Groove," Earth, Wind & Fire, Billboard.com. https://www.billboard.com/music/earth-wind-fire/chart-history/HSI/song/372052.

36. "Let's Groove," Earth, Wind & Fire, RIAA. https://www.riaa.com/gold-platinum/?tab_active=default-award&ar=EARTH%2C+WIND+%26amp%3B+FIRE&ti=LET%27S+GROOVE.

37. "Earth, Wind & Fire," Grammy Awards. https://www.grammy.com/grammys/artists/earth-wind-fire.

38. White and Powell, 288.

39. "Wanna Be With You," Earth, Wind & Fire, *Raise!* (ARC/Columbia, 1981).

40. "Wanna Be with You," Earth, Wind & Fire, Billboard.com. https://www.billboard.com/music/earth-wind-fire/chart-history/HSI/song/372198.

41. "Earth, Wind & Fire," Grammy Awards.

42. "I've Had Enough," Earth, Wind & Fire, *Raise!* (ARC/Columbia, 1981).

43. "I've Had Enough," Earth, Wind & Fire, Official Charts. https://www.officialcharts.com/artist/16058/earth,-wind-and-fire/.

44. "Lady Sun," Earth, Wind & Fire, *Raise!* (ARC/Columbia, 1981).

45. Browder, 85.

46. Morris Pleasure, Interview with the author, Grayson, Georgia, March 18, 2017.

47. White and Powell, 297.

48. Ken Tucker, "Raise!," *Rolling Stone*, February 4, 1982. https://www.rollingstone.com/music/music-album-reviews/raise-247324/.

49. Hugh Wyatt, "Earth, Wind & Fire: Raise!," *New York Daily News*, December 13, 1981. https://www.newspapers.com/newspage/486109355/.

50. Robert Christgau, "Earth, Wind & Fire: *Raise!*" http://www.robertchristgau.com/get_album.php?id=4714.

51. "Raise!," Earth, Wind & Fire, *Billboard*. https://www.billboard.com/music/earth-wind-fire/chart-history/TLP/song/313432.

52. "Raise!," Earth, Wind & Fire, RIAA. https://www.riaa.com/gold-platinum/?tab_active=default-award&se=Earth%2C+Wind+%26+Fire%3A+Raise%21#search_section.

53. "EWF Chosen for the Crystal Globe Award," *Chicago Metro News*, May 1, 1982.

54. Richard Marcus, "Music DVD Review: *Earth, Wind & Fire: In Concert*," Blogcritics. https://blogcritics.org/music-dvd-review-earth-wind-fire/?amp.

CHAPTER 7: I'VE HAD ENOUGH

1. "Fall in Love with Me," Earth, Wind & Fire, *Powerlight* (Columbia, 1983).

2. Earth, Wind & Fire, "Fall in Love with Me (Official Video)," Sony BMG Music Entertainment, 1983, accessed June 15, 2016. https://www.youtube.com/watch?v=GfLwdu8Arps.

3. Richard H. Wilkinson, *The Complete Gods and Goddesses of Ancient Egypt* (New York: Thames & Hudson, 2003), 94.

4. Wilkinson, 187, 190.

5. Miriam Ma'At-Ka-Re Mongues, "Reflections on the Role of Female Deities and Queens in Ancient Kemet," *Journal of Black Studies* 23, no. 4 (June 1993): 564.

6. Earth, Wind & Fire, "Fall in Love with Me (Official Video)."

7. "Fall in Love with Me," Earth, Wind & Fire, Billboard.com. https://www.billboard.com/music/earth-wind-fire/chart-history/HSI/song/334174.

8. "Earth, Wind & Fire," Grammy Awards.

9. Philip Bailey, *Shining Star: Braving the Elements of Earth, Wind & Fire* (New York: Viking Adult, 2014), 204.

10. William Byrd, "EWF's Bailey, Dunn Promote New LP," *Atlanta Daily World*, March 3, 1983, 7.

11. Earth, Wind & Fire, *Powerlight* (Columbia, 1983).

12. "Exec Offers to Save Statue of John Lennon," Talent & Venues, *Billboard*, February 5, 1983, 50.

13. Earth, Wind & Fire, *Powerlight*.

14. "Side by Side," Earth, Wind & Fire, Billboard.com. https://www.billboard.com/music/earth-wind-fire/chart-history/BSI/song/334295.

15. "Spread Your Love," Earth, Wind & Fire, Billboard.com. https://www.billboard.com/music/earth-wind-fire/chart-history/BSI/song/371388.

16. Christopher Connelly, "Powerlight," *Rolling Stone*, March 17, 1983. https://www.rollingstone.com/music/music-album-reviews/powerlight-251290/.

17. "Album Reviews," Billboard.com, February 26, 1983. https://books.google.tt/books?id=EyQEAAAAMBAJ&dq=billboard&q=POwerlight#v=snippet&q=Powerlight&f=false.

18. Craig Lytle, "Earth, Wind & Fire: Powerlight," AllMusic. https://www.allmusic.com/album/powerlight-mw0000189887.

19. "Powerlight," Earth, Wind & Fire, Billboard.com. https://www.billboard.com/music/earth-wind-fire/chart-history/TLP/song/312479.

20. "Powerlight," Earth, Wind & Fire, RIAA. https://www.riaa.com/gold-platinum/?tab_active=default-award&se=Earth%2C+Wind+%26+Fire+#search_section.

21. Sean J. O'Connell, "Rock & Rule Blu-Ray Release: Debbie Harry and Cheap Trick Vs. Cartoon Guitar Mutants (And Lou Reed)," *LA Weekly*, November 10, 2010. https://www.laweekly.com/rock-rule-blu-ray-release-debbie-harry-and-cheap-trick-vs-cartoon-guitar-mutants-and-lou-reed/.

22. Earth, Wind & Fire, *Electric Universe* (Columbia, 1983).

23. White and Powell, 302.

24. White and Powell, 303.

25. Earth, Wind & Fire, *Electric Universe*.

26. Verdine White, Interview with the author, Atlanta, Georgia, March 16, 2017.

27. Earth, Wind & Fire, *Electric Universe*.

28. "Magnetic," Earth, Wind & Fire, Songfacts. https://www.songfacts.com/facts/earth-wind-fire/magnetic.

29. "Magnetic," Earth, Wind & Fire, *Electric Universe* (Columbia, 1983).

30. "Magnetic," Earth, Wind & Fire, Songfacts.

31. "Magnetic," Earth, Wind & Fire, Billboard.com. https://www.billboard.com/music/earth-wind-fire/chart-history/HSI/song/333919.

32. Robert Christgau, "Dean's List (1983)," *Village Voice*, February 28, 1984. http://robertchristgau.com/xg/pnj/deans83.php.

33. White and Powell, 307.

34. Bailey, 205.

35. White and Powell, 307–8.

36. Bailey, 205.

37. "Touch," Earth, Wind & Fire, *Electric Universe* (Columbia, 1983).

38. "Touch," Earth, Wind & Fire, Billboard.com. https://www.billboard.com/music/earth
-wind-fire/chart-history/BSI/song/370865.

39. "Moonwalk," Earth, Wind & Fire, *Electric Universe* (Columbia, 1983).

40. "Moonwalk," Earth, Wind & Fire, *Billboard*. https://www.billboard.com/music/
earth-wind-fire/chart-history/BSI/song/896511.

41. "Electric Universe," Earth, Wind & Fire, Billboard.com. https://www.billboard.com/
music/earth-wind-fire/chart-history/TLP/song/312149.

42. Robert Palmer, "The Pop Life," *New York Times*, December 7, 1983. https://www.nytimes
.com/1983/12/07/arts/the-pop-life-093298.html.

43. Gary Graff, "Earth, Wind & Fire: Electric Universe," *Detroit Free Press*, December 4,
1983. https://www.newspapers.com/newspage/99166582/.

44. "Feature Picks: Albums," *Cash Box*, November 26, 1983. https://archive.org/details/
cashbox45unse_24/page/26?q.

45. David Nathan, "The Eternal Dance of Earth, Wind & Fire," liner notes for *The Eternal
Dance* (CD box set, Sony Music Entertainment, 1992).

46. Paul Grein, "Earth, Wind & Fire: Up from the Ashes," *Los Angeles Times*, December 6,
1987. https://www.latimes.com/archives/la-xpm-1987-12-06-ca-26679-story.html.

47. Nathan.

48. Bailey, 208.

49. White and Powell, 312.

50. Bailey, 208.

51. "Continuation," Philip Bailey, *Billboard*. https://www.billboard.com/music/Philip
-Bailey/chart-history/BLP.

52. "The Wonders of His Love," Philip Bailey, Billboard.com. https://www.billboard.com/
music/philip-bailey/chart-history/SLL.

53. "Philip Bailey," Grammy Awards. https://www.grammy.com/grammys/artists/philip
-bailey.

54. "Easy Lover," Philip Bailey, Billboard.com. https://www.billboard.com/music/philip
-bailey/chart-history/BSI.

55. "Philip Bailey," Grammy Awards.

56. "Walking on the Chinese Wall," Philip Bailey, *Billboard*. https://www.billboard.com/
music/philip-bailey/chart-history/BSI.

57. "Chinese Wall," Philip Bailey, Billboard.com. https://www.billboard.com/music/
philip-bailey/chart-history/TLP.

58. "Philip Bailey," Grammy Awards.

59. Lynn Van Matre, "Who Told Maurice White to Record 'Stand by Me'? It Was . . .
A Voice," *Chicago Tribune*, December 1, 1985. http://search.proquest.com.ezproxy.auctr
.edu:2051/news/results/.

60. "Stand by Me," Maurice White, Billboard.com. https://www.billboard.com/music/
maurice-white/chart-history/ASI.

61. Van Matre.

62. "I Need You," Maurice White, Billboard.com. https://www.billboard.com/music/
maurice-white/chart-history/BSI.

63. "Philip Bailey," Grammy Awards.

64. Bailey, 213.

65. Bailey, 215.

CHAPTER 8: BACK ON THE ROAD

1. Maurice White and Herb Powell, *My Life with Earth, Wind & Fire* (New York: HarperCollins Publishers, 2016), 320.

2. Philip Bailey, *Shining Star: Braving the Elements of Earth, Wind & Fire* (New York: Viking Adult, 2014), 216.

3. Sheldon Reynolds, Interview with the author, Atlanta, Georgia. February 17, 2017.

4. White and Powell, 321.

5. "Sonny Emory," Top 500 Drummers, Drummerworld.com, accessed December 18, 2019. https://www.drummerworld.com/drummers/Sonny_Emory.html.

6. "Vance Taylor," Discogs. https://www.discogs.com/artist/318868-Vance-Taylor.

7. "Dick Smith," Alchetron. https://alchetron.com/Dick-Smith-(musician).

8. "MOTU Artist Spotlight: Mike McKnight," MOTU. https://motu.com/en-us/news/motu-artist-spotlight-mike-mcknight/.

9. "Gary Bias," Smooth-Jazz.de. http://www.smooth-jazz.de/Artists2/Bias.htm.

10. "Raymond Lee Brown," People Pill. http://peoplepill.com/people/raymond-lee-brown.

11. "Reggie Young," LA Studio Musicians. https://lastudiomusicians.org/reggie-young.

12. Paul Grein, "Earth, Wind & Fire—Up from the Ashes," *Los Angeles Times*, December 6, 1987. https://www.latimes.com/archives/la-xpm-1987-12-06-ca-26679-story.html.

13. Grein.

14. "The First Single," *Chicago Metro News*, November 14, 1987. http://search.proquest.com.ezproxy.auctr.edu:2015/news/results/.

15. "System of Survival," Earth, Wind & Fire, *Touch the World* (Columbia, 1987).

16. "Earth, Wind & Fire to Release New LP," *Chicago Metro News*, October 31, 1987. http://search.proquest.com.ezproxy.auctr.edu:2015/news/results/.

17. "Earth, Wind & Fire Cometh," *Tri-State Defender*, April 6, 1988, accessed June 30, 2015. http://search.proquest.com.ezproxy.auctr.edu:2015/news/results/.

18. "System of Survival," Earth, Wind & Fire, Billboard.com. https://www.billboard.com/music/earth-wind-fire/chart-history/HSI/song/332249.

19. Grein, 96.

20. "1988 Soul Train Music Awards," Award & Winners. http://awardsandwinners.com/category/soul-train-music-awards/1988/.

21. Bailey, 216.

22. "Thinking of You," Earth, Wind & Fire, *Touch the World* (Columbia, 1987).

23. "Thinking of You," Earth, Wind & Fire, Billboard.com. https://www.billboard.com/music/earth-wind-fire/chart-history/DSI/song/332249.

24. "EW&F's Touch the World Has Gone Gold," *Chicago Metro News*, January 16, 1988. http://search.proquest.com.ezproxy.auctr.edu:2015/news/results/.

25. White and Powell, 323.

26. "Evil Roy," Earth, Wind & Fire, Billboard.com. https://www.billboard.com/music/earth-wind-fire/chart-history/DSI/song/332249.

27. Rob Hoerburger, "Touch the World," *Rolling Stone*, January 14, 1988. https://www.rollingstone.com/music/music-album-reviews/touch-the-world-104495/.

28. People Staff, "Picks and Pans Review: Touch the World," *People*, January 11, 1988. https://people.com/archive/picks-and-pans-review-touch-the-world-vol-29-no-1/.

29. "Album Releases," *Cash Box*, November 7, 1987. https://archive.org/details/cashbox 51unse_18/page/11?q=.

30. "Touch the World," Earth, Wind & Fire, Billboard.com. https://www.billboard.com/music/earth-wind-fire/chart-history/TLP/song/310288.

31. "Touch the World," Earth, Wind & Fire, RIAA. https://www.riaa.com/gold-platinum/?tab_active=default-award&se=Earth%2C+Wind+%26+Fire++Touch+The+World#search_section.

32. Earth, Wind & Fire, *The Best of Earth, Wind & Fire, Vol. 2* (Columbia, 1988).

33. "Turn on (The Beat Box)," Earth, Wind & Fire, *The Best of Earth, Wind & Fire, Vol. 2* (Columbia, 1988).

34. "Turn on (The Beat Box)," Earth, Wind & Fire, Billboard.com. https://www.billboard.com/music/earth-wind-fire/chart-history/BSI/song/368517.

35. "The Best of Earth, Wind & Fire, Vol. 2," Earth, Wind & Fire, Billboard.com. https://www.billboard.com/music/earth-wind-fire/chart-history/TLP/song/310049.

36. "The Best of Earth, Wind & Fire, Vol. 2," Earth, Wind & Fire, RIAA. https://www.riaa.com/gold-platinum/?tab_active=default-award&ar=Earth%2C+Wind+%26+Fire&ti=Best& lab=&genre=&format=Album&date_option=release&from=1978-01-01&to=1978-12-31&aw ard=&type=&category=&adv=SEARCH#search_section.

37. Earth, Wind & Fire, *Heritage* (Columbia, 1990).

38. "Heritage," Earth, Wind & Fire, *Heritage* (Columbia, 1990).

39. "Heritage," Earth, Wind & Fire, Billboard.com. https://www.billboard.com/music/earth-wind-fire/chart-history/BSI/song/367645.

40. "For the Love of You," Earth, Wind & Fire, *Heritage* (Columbia, 1990).

41. "For the Love of You," Earth, Wind & Fire, Billboard.com. https://www.billboard.com/music/earth-wind-fire/chart-history/BSI/song/367765.

42. "Wanna Be the Man," Earth, Wind & Fire, *Heritage* (Columbia, 1990).

43. "Wanna Be the Man," Earth, Wind & Fire, Billboard.com. https://www.billboard.com/music/earth-wind-fire/chart-history/BSI/song/367865.

44. "Heritage," Earth, Wind & Fire, Billboard.com.

45. John Milward, "Heritage," *Rolling Stone*, March 22, 1990. https://www.rollingstone.com/music/music-album-reviews/heritage-2-248903/.

46. People Staff, "Picks and Pans Review: Heritage," *People*, February 19, 1990. https://people.com/archive/picks-and-pans-review-heritage-vol-33-no-7/amp/.

47. Don Palmer, "Earth, Wind & Fire: Heritage, Columbia," *Spin*, April 1990.

48. White and Powell, 331.

49. John Milward, "Heritage," *Rolling Stone*, March 22, 1990. https://www.rollingstone.com/music/music-album-reviews/heritage-2-248903/.

50. Bailey, 220.

51. White and Powell, 324.

52. Bailey, 219.

53. White and Powell, 325.

54. White and Powell, 336–37.

55. Bailey, 220.

56. Earth, Wind & Fire, *The Eternal Dance* (Columbia, 1992).

57. "The Eternal Dance," The Earth, Wind & Fire Experience, Homdrum.net. http://www.homdrum.net/ewf/reviews/eternal.html.

58. Earth, Wind & Fire, *The Eternal Vision* (Sony Music, 1992).

CHAPTER 9: CAN'T LET GO

1. Maurice White and Herb Powell, *My Life with Earth, Wind & Fire* (New York: HarperCollins Publishers, 2016), 337.

2. White and Powell, 338.

3. "Sunday Morning," Earth, Wind & Fire, *Millennium* (Warner Brothers, 1993).

4. Brian Humek, "Earth, Wind & Fire," *Afro-American Gazette*, May 2, 1994. http://search .proquest.com.ezproxy.auctr.edu:2015/news/results/.

5. "Sunday Morning," Earth, Wind & Fire, Billboard.com. https://www.billboard.com/ music/earth-wind-fire/chart-history/HSI/song/21762.

6. "Earth, Wind & Fire," Grammy Awards. https://www.grammy.com/grammys/artists/ earth-wind-fire.

7. Earth, Wind & Fire, *Millennium* (Warner Brothers, 1993).

8. "Spend the Night," Earth, Wind & Fire, *Millennium* (Warner Brothers, 1993).

9. "Spend the Night," Earth, Wind & Fire, Billboard.com. https://www.billboard.com/ music/earth-wind-fire/chart-history/BSI/song/22464.

10. "Two Hearts," Earth, Wind & Fire, *Millennium* (Warner Brothers, 1993).

11. "Two Hearts," Earth, Wind & Fire, Billboard.com. https://www.billboard.com/music/ earth-wind-fire/chart-history/BSI/song/22469.

12. Humek.

13. M. R. Martinez, "Pick of the Week," *Cash Box*, September 25, 1993. https://archive.org/ details/cashbox57unse_1/page/12?q.

14. Tom Sinclair, "Earth, Wind & Fire," *Vibe*, September 1993.

15. Alex Henderson, "Earth, Wind & Fire: Millennium," *AllMusic*. https://www.allmusic .com/album/millennium-mw0000620865.

16. "Millennium," Earth, Wind & Fire, Billboard.com. https://www.billboard.com/music/ earth-wind-fire/chart-history/TLP/song/177354.

17. "Soul Train Music Award for Best R&B Album—Group, Band or Duo," 1994 Soul Train Music Awards, Awardsandwinners.com. http://awardsandwinners.com/category/ soul-train-music-awards/1994/.

18. "David Romero," Drum Solo Artist. http://www.drumsoloartist.com/Site/Drummers2/ David_Romero.html.

19. Benjamin Epstein, "Pianist Ravel Runs Gamut—From 'Sol to Soul,'" *Las Angeles Times*, May 18, 1996. https://www.latimes.com/archives/la-xpm-1996-05-18-ca-6386-story.html.

20. Morris Pleasure, Interview by the author, Grayson, Georgia, March 18, 2017.

21. White and Powell, 338.

22. White and Powell, 339.

23. Bailey, 220.

24. "NAACP Image Award—Hall of Fame Award," 1994 NAACP Image Award, Awards & Winners. http://awardsandwinners.com/category/naacp-image-award/1994/.

25. Bailey, 221–22.

26. White and Powell, 340–41.

27. Bailey, 223.

28. "Keith Robinson," Smooth-jazz.de. http://www.smooth-jazz.de/Artists1/Robinson.html.

29. Kyausha Simpson, Conversation with the author, June 12, 2021.

30. Bailey, 223.

31. Earth, Wind & Fire, *Live in Velfarre* (Rhino, 1995).

32. "David Whitworth—Earth, Wind & Fire," Aston Microphones. https://www.astonmics .com/EN/artist-details/David-Whitworth-Earth-Wind-and-Fire.

33. "Hollywood's Walk of Fame," Awards & Nominations, The Earth, Wind & Fire Experience. http://www.homdrum.net/ewf/index.html.

34. "Bio," Bill Meyers Music. http://billmeyersmusic.com/bio/.

35. "Sky," Bill Meyers, featuring Earth, Wind & Fire, Munyungo Jackson, and Sonny Emory, *All Things in Time* (Weberworks, 1996).

36. Earth, Wind & Fire, *Elements of Love: The Ballads* (Columbia, 1996).

37. Andrew Hamilton, "Elements of Love: Ballads," Earth, Wind & Fire, AllMusic. https://www.allmusic.com/album/mw0000183679.

38. J.D. Considine, "Funk is flying high, 20 years later Roots: The slippery synths, fatback drums, and heavy bass are as hip now as they were in the 1970s, when they were considered revolutionary," *Baltimore Sun*, June 23, 1996. https://www.baltimoresun.com/news/bs-xpm-1996-06-23-1996175170-story,amp.html.

39. Earth, Wind & Fire, *Avatar* (Avex Trax, 1996).

40. Peter Miro, "The Rhythm," *Cash Box*, August 17, 1996. https://archive.org/details/cashbox59unse_43/page/8.

41. Earth, Wind & Fire, *Greatest Hits Live* (Rhino, 1997).

42. Leo Stanley, "Greatest Hits Live," Earth, Wind & Fire, AllMusic. https://www.allmusic.com/album/greatest-hits-live-mw0000080523.

43. "Greatest Hits Live," Earth, Wind & Fire, Billboard.com. https://www.billboard.com/music/earth-wind-fire/chart-history/BLP/3.

44. "About Montreux Jazz Festival," Montreux Jazz Festival. https://www.montreuxjazzfestival.com/en/festival/about-montreux-jazz-festival/.

45. Brandon A. DuHamel, "Earth, Wind & Fire: Live at Montreux 1997 Blu-ray Review," Big Picture Big Sound, November 24, 2009. https://www.bigpicturebigsound.com/Earth-Wind-Fire-Live-at-Montreux-1997-Blu-ray.shtml.

46. Earth, Wind & Fire, *In the Name of Love* (Rhino, 1997).

47. "Revolution (Just Evolution)," Earth, Wind & Fire, *In the Name of Love* (Rhino, 1997).

48. "Revolution (Just Evolution)," Earth, Wind & Fire.

49. "Revolution (Just Evolution)," Earth, Wind & Fire, Billboard.com. https://www.billboard.com/music/earth-wind-fire/chart-history/BSI/song/51438.

50. Moses Torres, "The Today Show-NBC-September 12th 1997," Appearances, The EWF Experience. http://www.homdrum.net/ewf/rep_nbc.html.

51. "When Love Goes Wrong," Earth, Wind & Fire, *In the Name of Love* (Rhino, 1997).

52. "When Love Goes Wrong," Earth, Wind & Fire, Billboard.com. https://www.billboard.com/music/earth-wind-fire/chart-history/RBA/song/52633.

53. Chuck Eddy, "In the Name of Love," *Entertainment Weekly*, August 1, 1997. https://ew.com/article/1997/08/01/name-love/.

54. Omoronke Idowu, "Earth, Wind & Fire: In the Name of Love," *Vibe*, October 1997, 162.

55. Alex Henderson, "Earth, Wind & Fire: In the Name of Love, AllMusic. https://www.allmusic.com/album/in-the-name-of-love-mw0000025282.

56. "Robert Brookins," Soul Walking. http://www.soulwalking.co.uk/Robert%20Brookins.html.

57. DuHamel, "Earth, Wind & Fire: Live at Montreux 1997 Blu-ray Review."

58. "Earth, Wind & Fire Headlines Sizzling Summer Tour," *Jet*, September 7, 1998, 61.

59. Sam McDonald, "Earth, Wind & Fire and a Whole Lot of Soul," *Daily Press*, August 21, 1998. https://www.dailypress.com/news/dp-xpm-19980821-1998-08-21-9808210191-story.html.

60. "Earth, Wind & Fire Headlines Sizzling Summer Tour."

61. Stephen Thomas Erlewine, "Earth, Wind & Fire: Greatest Hits," AllMusic. https://www.allmusic.com/album/greatest-hits-legacy-mw0000045386.

62. Earth, Wind & Fire, *That's the Way of the World* (Legacy, 1999).

63. Earth, Wind & Fire, *Gratitude* (Legacy, 1999).

64. Earth, Wind & Fire, *All 'N All* (Legacy, 1999).

65. Earth, Wind & Fire, *The Best of Earth, Wind & Fire, Vol. 1* (Legacy, 1999).

66. Earth, Wind & Fire, *The Ultimate Collection* (Columbia, 1999).

67. "September 99," Earth, Wind & Fire, Singles, Official Charts. https://www.officialcharts .com/charts/singles-chart/19990725/7501/.

68. "September 99," Earth, Wind & Fire, Dance Singles, Official Charts. https://www .officialcharts.com/charts/dance-singles-chart/19990725/104/.

69. "September 99," Earth, Wind & Fire, *RPM* Top 30 Dance Chart, Library and Archives Canada. https://www.bac-lac.gc.ca/eng/discover/films-videos-sound-recordings/rpm/Pages/ item.aspx?IdNumber=9156&.

70. "The Ultimate Collection," Earth, Wind & Fire, Albums, Official Charts. https://www .officialcharts.com/artist/16058/earth,-wind-and-fire/.

71. "Gorden Campbell," Drummerworld. https://www.drummerworld.com/drummers/ Gorden_Campbell.html.

72. "Newsline," *Billboard*, July 24, 1999, 76.

73. "Queen Mums 99th A Family Affair," *South Florida Sun-Sentinel*, August 4, 1999. https:// www.sun-sentinel.com/news/fl-xpm-1999-08-04-9908040260-story.html.

74. Joya Wesley, "Barry White, Elements Deliver Soul-Stirring Show," *News & Record*, Greensboro.com, September 19, 1999. https://greensboro.com/barry-white-elements-deliver -soul-stirring-show/article_f5b223c5-3127-5ee4-9024-fb2c8b52222b.html.

CHAPTER 10: MILLENNIUM

1. John R. Schmidt, "The Panic of New Year's Eve 1999," WBEZ Blogs, December 31, 2012. https://www.wbez.org/shows/wbez-blogs/the-panic-of-new-years-eve-1999/1bdbe88d -5562-446d-a833-ee765feb1880.

2. Schmidt, "The Panic of New Year's Eve 1999."

3. Maurice White and Herb Powell, *My Life with Earth, Wind & Fire* (New York: HarperCollins, 2016), 348.

4. "Earth, Wind & Fire," Rock & Roll Hall of Fame. https://www.rockhall.com/inductees/ earth-wind-and-fire.

5. "The Best of Earth, Wind & Fire, Vol. II," Earth, Wind & Fire, Discogs. https://www .discogs.com/release/9951927-Earth-Wind-Fire-The-Best-Of-Earth-Wind-Fire-Vol-II.

6. Shannon McCaffrey, "Largest State Dinner at White House," AP News, June 20, 2000. https://apnews.com/article/8fa38c79578fadbc27e9b793d71051cb.

7. "Runaway," Wyclef Jean, Earth, Wind & Fire and The Product G&B, *The Ecleftic: 2 Sides II a Book* (Columbia, 2000).

8. "Earth, Wind & Fire: Live," Earth, Wind & Fire, RIAA. https://www.riaa.com/ gold-platinum/?tab_active=default-award&se=Earth%2C+Wind+%26+Fire#search_section.

9. Earth, Wind & Fire, *Open Our Eyes* (Columbia, 1974/2001).

10. Earth, Wind & Fire, *Spirit* (Columbia, 1976/2001).

11. "John Paris," Alchetron. https://alchetron.com/John-Paris.

12. "Daniel de los Reyes," Remo. https://remo.com/team/member/daniel-reyes-de-los/bio/.

13. "Myron McKinley," Vibrato Grill Jazz. http://www.vibratogrilljazz.com/events/2020/ 02/20/myron-mckinley.

14. Don Waller, "Grooving to 30 Years of Earth, Wind & Fire," *Billboard*, July 14, 2001, 30, 45.

15. Rhonda Baraka, "In the Works," *Billboard*, July 14, 2001, 38, 40.

16. Rhonda Baraka, "A Conversation with Verdine White, Philip Bailey and Ralph Johnson," *Billboard*, July 14, 2001, 32.

17. Gail Mitchell, "Maurice White," *Billboard*, July 14, 2001, 36.

18. Mike Wise, "Olympics: Closing Ceremony; Games End with a Mixture of Rowdy Relief and Joy," *New York Times*, February 25, 2002. https://www.nytimes.com/2002/02/25/sports/olympics-closing-ceremony-games-end-with-a-mixture-of-rowdy-relief-and-joy.html.

19. Earth, Wind & Fire, *That's the Way of the World: Alive in '75* (Columbia/Legacy, 2002).

20. Stephen Erlewine, "Earth, Wind & Fire: That's the Way of the World: Alive in '75," AllMusic. https://www.allmusic.com/album/thats-the-way-of-the-world-alive-in-75-mw0000658299.

21. Mark Anthony Neal, "Earth, Wind & Fire: That's the Way of the World: Alive in '75," *PopMatters*, May 2, 2002. https://www.popmatters.com/earthwindandfire-thats-2495888774.html.

22. Justin Brodsky, "Tag Archives: Kimberly Brewer," Artist Reach. https://artistreachofficial.com/tag/kimberly-brewer/.

23. "Earth, Wind & Fire to Receive ASCAP Rhythm & Soul Heritage Award," Awards, The Earth, Wind & Fire Experience. http://www.homdrum.net/ewf/awards.html.

24. Earth, Wind & Fire, *The Essential* (Columbia, 2002).

25. "The Essential," Earth, Wind & Fire, Billboard.com. https://www.billboard.com/music/earth-wind-fire/chart-history/BLP/3.

26. "The Essential," Earth, Wind & Fire, RIAA. https://www.riaa.com/gold-platinum/?tab_active=default-award&ar=EARTH%2C+WIND+%26amp%3B+FIRE&ti=THE+ESSENTIAL+EARTH%2C+WIND+%26amp%3B+FIRE.

27. Earth, Wind & Fire, *Live in Rio* (Kalimba, 2002).

28. "Live in Rio," News, *Billboard*, January 11, 2003. https://www.billboard.com/articles/news/72992/live-in-rio.

29. Earth, Wind & Fire, *The Promise* (Kalimba, 2003).

30. "Earth, Wind & Fire 'Promise' New Album, Tour," News, *Billboard*, April 21, 2003. https://www.billboard.com/articles/news/71433/earth-wind-fire-promise-new-album-tour.

31. "All in the Way," Earth, Wind & Fire, *The Promise* (Kalimba, 2003).

32. "All in the Way," Earth, Wind & Fire.

33. "All in the Way," Earth, Wind & Fire, Billboard.com. https://www.billboard.com/music/earth-wind-fire/chart-history/BSI/song/332249.

34. "Awards," The Earth, Wind & Fire Experience. http://www.homdrum.net/ewf/awards.html.

35. "Earth, Wind & Fire 2003 Summer Concert," YouTube. https://www.youtube.com/watch?v=M5CLKEEYxlo.

36. "Hold Me," Earth, Wind & Fire, *The Promise* (Kalimba, 2003).

37. "Hold Me," Earth, Wind & Fire, Billboard.com. https://www.billboard.com/music/earth-wind-fire/chart-history/RBA/song/441804.

38. "Hold Me," Earth, Wind & Fire, Grammy Awards. https://www.grammy.com/grammys/artists/earth-wind-fire.

39. Philip Bailey, *Braving the Elements of Earth, Wind & Fire* (New York: Viking Adult, 2014). 228.

40. Earth, Wind & Fire, *The Promise*.

41. "Earth, Wind & Fire 'Promise' New Album, Tour."

42. "The Promise," Album Reviews, The Earth, Wind & Fire Experience. http://www.homdrum.net/ewf/reviews/promise.html.

43. "The Promise," Album Reviews, The Earth, Wind & Fire Experience.

44. Rob Theakson, "Earth, Wind & Fire: *The Promise*," AllMusic. https://www.allmusic .com/album/the-promise-mw0000030242.

45. Chairman Mao, "Earth, Wind & Fire: The Promise," *Blender*. https://archive.li/ 20090510055802/http://www.blender.com/guide/new/52937/promise.html.

46. People Staff, "Picks and Pans Main: Song," *People*, May 26, 2003. https://people.com/ archive/picks-and-pans-main-song-vol-59-no-20/.

47. "The Promise," Earth, Wind & Fire, Billboard.com. https://www.billboard.com/music/ earth-wind-fire/chart-history/BLP/song/436207.

48. "2004 Grammy Hall of Fame Inductees Announced," Business Wire. https://www .businesswire.com/news/home/20040114005168/en/2004-GRAMMY-Hall-Fame-Inductees -Announced-Selections.

49. Earth, Wind & Fire, *I Am* (Columbia, 1979/2004).

50. "Bobby Burns Jr.," Torpedo Bags. https://torpedobags.com/artists/bobby-burns-jr/.

51. "Vadim Zilberstein—Earth, Wind & Fire, Chaka Khan," Guitarist News, September 13, 2007. https://www.guitaristnews.com/best/219-vadim-zilberstein.

52. "Egnater Artist: Gregory 'G-Moe' Moore," Egnater Amplification. http://www.egnater amps.com/artists/GMoe.html.

53. "JS," Biography, AllMusic. https://www.allmusic.com/artist/js-mn0000119887/bio graphy.

54. "The Los Angeles Chapter of the Recording Academy," *Billboard*, May 29, 2004, 21.

55. "Chicago and Earth, Wind & Fire: 3 Hour Extravaganza Brings Together Two of Popular Music's Greatest Hit Makers," Business Wire, March 25, 2004. https://www.businesswire.com/ news/home/20040325005516/en/Chicago-Earth-Wind-Fire-3-Hour-Extravaganza.

56. "Show Me the Way," Earth, Wind & Fire, *Illumination* (Sanctuary, 2005).

57. "Show Me the Way," Raphael Saadiq, Billboard.com. https://www.billboard.com/music/ raphael-saadiq/chart-history/HSI.

58. "Earth, Wind & Fire," Grammy Awards. https://www.grammy.com/grammys/artists/ earth-wind-fire.

59. "Earth, Wind & Fire—Live at the Montreux 1990," Earth, Wind & Fire, RIAA. https:// www.riaa.com/gold-platinum/?tab_active=default-award&ar=EARTH%2C+WIND+%26a mp%3B+FIRE&ti=LIVE+AT+THE+MONTREUX+1990.

60. "The Way You Move," Earth, Wind & Fire, Billboard.com. https://www.billboard.com/ music/earth-wind-fire/chart-history/ASI/song/469883.

61. Dan Villasenor, "Honoring White," *Valley Star*, May 18, 2005. https://web.archive.org/ web/20090601180533/http://www.lavalleystar.com/media/paper295/news/2005/05/18/News/ Maurice.White.Honored-953130.shtml.

62. "Chicago & Earth, Wind & Fire—Live at the Greek Theatre," Earth, Wind & Fire, RIAA. https://www.riaa.com/gold-platinum/?tab_active=default-award&ar=CHICAGO+%26amp %3B+EARTH%2C+WIND+%26amp%3B+FIRE&ti=LIVE+AT+THE+GREEK+THEATRE.

63. "Chicago and Earth, Wind & Fire Summer Tour 2005, Chicago and Earth, Wind & Fire Return for a Summer of 2005 Tour," West Coast Music, May 19, 2005. https://noted .blogs.com/westcoastmusic/2005/03/chicago_and_ear.html.

64. Earth, Wind & Fire, *Illumination* (Sanctuary, 2005).

65. "EWF Lights Up New Album With Big Boi, Will.I.Am," *Billboard*, June 9, 2005. https:// www.billboard.com/articles/news/62637/ewf-lights-up-new-album-with-big-boi-wiliam.

66. Marti Parham, "The Timeless Appeal of Earth, Wind & Fire," *Jet*, March 13, 2006, 54–60.

67. "Pure Gold," Earth, Wind & Fire, *Illumination* (Sanctuary, 2005).

68. "Pure Gold," Earth, Wind & Fire, Billboard.com. https://www.billboard.com/music/earth-wind-fire/chart-history/RBA/song/481839.

69. "The Complete List of Grammy Nominations," *New York Times*, December 8, 2005. https://www.nytimes.com/2005/12/08/arts/the-complete-list-of-grammy-nominations.html.

70. "EWF Lights Up New Album With Big Boi, Will.I.Am."

71. Raymond Fiore, "Illumination," *Entertainment Weekly*, September 16, 2005. https://ew.com/article/2005/09/16/illumination/.

72. Steve Jones, "'Angel': Synth Pop a la Mode," *USA Today*, October 17, 2005. https://usatoday30.usatoday.com/life/music/reviews/2005-10-17-listen-up_x.htm.

73. People Staff, "Picks and Pans Review: Earth, Wind & Fire," *People*, December 19, 2005. https://people.com/archive/picks-and-pans-review-earth-wind-fire-vol-64-no-25/amp/.

74. "Illumination," Earth, Wind & Fire, Billboard.com. https://www.billboard.com/music/earth-wind-fire/chart-history/BLP/song/486962.

75. "Earth, Wind & Fire," Grammy Awards.

76. Farham, 54.

77. Farham, 60.

78. "Earth, Wind & Fire—Live '05 Tribute On Ice Concert," YouTube. https://www.youtube.com/watch?v=UWJmGDu6Soc.

CHAPTER 11: BE EVER WONDERFUL

1. "September," Earth, Wind & Fire, RIAA. https://www.riaa.com/gold-platinum/?tab_active=default-award&se=Earth%2C+Wind+%26+Fire#search_section.

2. Maurice White and Herb Powell, *My Life with Earth, Wind & Fire* (New York: HarperCollins, 2016), 352.

3. "Hot Feet to Open on Broadway," New York Theatre Guide, November 13, 2005. https://www.newyorktheatreguide.com/news-features/hot-feet-to-open-on-broadway-in-april-2006.

4. White and Powell, 352.

5. "Earth, Wind & Fire—Maranatha 26th Anniversary," Top40-Charts. https://top40-charts.com/news.php?nid=23274&cat=.

6. "Grammy-Winning Jazz Trumpeter Chris Botti Tour to Include Dates with Mythic American Funk Band Earth, Wind & Fire," Top40-Charts. https://top40-charts.com/news.php?nid=24609&cat=.

7. Earth, Wind & Fire, *In the Name of Love* (Kalimba, 2006).

8. "Change Your Mind," Earth, Wind & Fire, Billboard.com. https://www.billboard.com/music/earth-wind-fire/chart-history/RBA/song/506601.

9. Jeff Leeds and Lorne Manly, "Defiant Dixie Chicks are Big Winners at the Grammys," *New York Times*, February 12, 2007. https://www.nytimes.com/2007/02/12/arts/music/12gram.html.

10. Various artists, *Interpretations: Celebrating the Music of Earth, Wind & Fire* (Stax, 2007).

11. "Interpretations: Celebrating the Music of Earth, Wind & Fire," various artists, Billboard.com. https://www.billboard.com/music/various-artists/chart-history/r-b-hip-hop-albums/song/525333.

12. "Dwele," Grammy Awards. https://www.grammy.com/grammys/artists/dwele.

13. "Me'Shell Ndegeocello," Grammy Awards. https://www.grammy.com/grammys/artists/meshell-ndegeocello.

14. "September," Kirk Franklin, *Billboard*. https://www.billboard.com/music/kirk-franklin/chart-history/gospel-songs/song/517279.

15. Phil Gallo, "American Idol: Idol Gives Back," *Variety*, April 26, 2007. https://variety
.com/2007/music/markets-festivals/american-idol-idol-gives-back-1200559880/.

16. "Etheridge to Play Nobel Peace Prize Concert," Today, October 18, 2007. https://www
.today.com/popculture/etheridge-play-nobel-peace-prize-concert-wbna21369494.

17. Morris O'Connor, Interview with the author Atlanta, Georgia, February 24, 2017.

18. "2008 News," EWF Fans. https://www.ewffans.com/news/index_2007.html.

19. Richard Marcus, "Music DVD: *Earth, Wind & Fire: In Concert*," Blogcritics. https://
blogcritics.org/music-dvd-review-earth-wind-fire/?amp.

20. "In Concert," Earth, Wind & Fire, Billboard.com. https://www.billboard.com/music/
earth-wind-fire/chart-history/music-video-sales/song/567850.

21. "Philip Bailey Delivers Commencement Address," Berklee School of Music. https://
www.berklee.edu/commencement/2008.

22. "Earth, Wind & Fire Members Receive Honorary Doctorates," UrbanMecca,
May 21, 2008. http://urbanmecca.net/news/2008/05/21/earth-wind-and-fire-members
-receive-honorary-doctorates/.

23. John Berger, "Doctor Is In," *Star Bulletin*, May 23, 2008. http://archives.starbulletin
.com/2008/05/23/features/story01.html.

24. "2008 News," EWF Fans. https://www.ewffans.com/news/index_2008.html.

25. Tracy Rasmussen, "Hitmakers Earth, Wind & Fire and Michael McDonald Co-headline
Reading Concert," *Reading Eagle*, September 11, 2008. http://www2.readingeagle.com/article
.aspx?id=105467.

26. Philip Bailey, *Shining Star: Braving the Elements of Earth, Wind & Fire* (New York:
Viking Adult, 2014), 233–34.

27. Daniel Kreps, "Stevie Wonder, Earth, Wind & Fire to Rock the House," *Rolling Stone*,
February 20, 2009. https://www.rollingstone.com/politics/politics-news/stevie-wonder
-earth-wind-and-fire-to-rock-the-white-house-97203/.

28. Earth, Wind & Fire, *The Promise* (Kalimba, 2009).

29. "Robert Brookins," People Pill. https://peoplepill.com/people/robert-brookins/.

30. David J. Prince, "Chicago and Earth, Wind & Fire Reunite for Summer Tour,"
Billboard.com, March 9, 2009. https://www.billboard.com/articles/news/269252/chicago
-and-earth-wind-fire-reunite-for-summer-tour.

31. "Music Icons Earth, Wind & Fire Lead Stellar List to Be Honored at the 15th Annual
Temecula Valley International Film and Music Festival's Awards Gala," mi2n. http://www
.mi2n.com/print.php3?id=122695.

32. "2009 News," EWF Fans. https://www.ewffans.com/news/index_2009.html.

33. Alan Duke, "Stars Gather for 'We Are the World' Recording," CNN. http://www.cnn
.com/2010/SHOWBIZ/Music/02/01/haiti.we.are.the.world/index.html.

34. Brooke Radke, "Q&A: Philip Bailey," *Las Vegas Magazine*, March 15, 2019. https://
lasvegasmagazine.com/interviews/qa/2019/mar/15/philip-bailey-earth-wind-fire-venetian
-music/.

35. "2010 News," EWF Fans. https://www.ewffans.com/news/index_2010.html.

36. "Songwriters Hall of Fame 2010 Inductee Announcement," PR Newswire, February 16,
2010. https://www.prnewswire.com/news-releases/songwriters-hall-of-fame-2010-inductee
-announcement-84474202.html.

37. Earth, Wind & Fire, *Live in Velfarre* (Rhino, 2010).

38. "Legendary Group Earth, Wind & Fire Perform With the Hollywood Bowl Orchestra
for Two Evenings at the Hollywood Bowl," LA Phil, September 3, 2010. https://www.laphil
.com/press/releases/1089.

39. Bailey, 231.

40. Earth, Wind & Fire, *Faces* (BBR Records, 2010).

41. Earth, Wind & Fire, *Raise!* (IconoClassic, 2011).

42. "2011 News," EWF Fans. https://www.ewffans.com/news/index_2011.html.

43. Mark Raby, "Monster Gratitude Earbuds are Endorsed by Earth, Wind & Fire," Slash Gear, February 5, 2012. https://www.slashgear.com/monster-gratitude-earbuds-are -endorsed-by-earth-wind-fire-05212119/.

44. "The Columbia Masters," Earth, Wind & Fire. http://www.earthwindandfire.com/ music/the-columbia-masters-2011/.

45. "Soul Train Legend Award 2011," Awards & Nominations, The Earth, Wind & Fire Experience. http://www.homdrum.net/ewf/awards.html.

46. Bailey, 232–33.

47. "Earth, Wind & Fire—"Guiding Lights,"" Grown Folks Music, January 3, 2012. https:// grownfolksmusic.com/earth-wind-fire-guiding-lights/.

48. Elias Leight, "Earth, Wind & Fire: Now, Then & Forever," PopMatters, September 22, 2013. https://www.popmatters.com/earth-wind-fire-now-then-forever-2495723844.html.

49. "Guiding Lights," Earth, Wind & Fire, *Billboard*. https://www.billboard.com/music/ earth-wind-fire/chart-history/JSI/song/725913.

50. Melissa Ruggieri, "Trumpet Awards to Honor Media Stars, Humanitarians and Leaders," *Atlanta Journal-Constitution*, January 6, 2012. https://web.archive.org/web/20120511015820/ http://www.accessatlanta.com/atlanta-events/trumpet-awards-to-honor-1292222.html.

51. John Rancke, "Earth, Wind & Fire—The White Guy," Coach4ADay, June 12, 2012. https:// coach4aday.wordpress.com/2018/06/12/earthwindfire-sergguitar-june-12/.

52. "2012 News," EWF Fans. https://www.ewffans.com/news/index_2012.html.

CHAPTER 12: NOW, THEN & FOREVER

1. "Yamaha's 125th Anniversary Concert," Blog, Earth, Wind & Fire, last modified 2020. http://www.earthwindandfire.com/2013/02/yamahas-125th-anniversary-concert/.

2. "2013 News," EWF Fans. https://www.ewffans.com/news/index_2013.html.

3. "My Promise," Earth, Wind & Fire, *Now, Then & Forever* (Legacy, 2013).

4. "My Promise," Earth, Wind & Fire, *Billboard*. https://www.billboard.com/music/ earth-wind-fire/chart-history/ASI/song/786770.

5. Earth, Wind & Fire, *Now, Then & Forever* (Legacy, 2013).

6. Earth, Wind & Fire, *Now, Then & Forever*.

7. Randee St. Nicholas, "Earth, Wind & Fire, 'Sign On': Exclusive Song Premiere," *Billboard*, August 12, 2013. https://www.billboard.com/articles/news/5645769/earth-wind-fire -sign-on-exclusive-song-premiere.

8. St. Nicholas, "Earth, Wind & Fire, 'Sign On.'"

9. St. Nicholas, "Earth, Wind & Fire, 'Sign On.'"

10. Andy Kellman, "Now, Then & Forever," Earth, Wind & Fire, AllMusic. https://www .allmusic.com/album/now-then-forever-mw0002288011.

11. Leight.

12. Chuck Arnold, "Picks and Pans Review: Quick Cuts," *People*, October 7, 2013. https:// people.com/archive/picks-and-pans-review-quick-cuts-vol-80-no-15/amp/.

13. "Now, Then & Forever," Earth, Wind & Fire, Billboard.com. https://www.billboard .com/music/earth-wind-fire/chart-history/BLP.

14. Philip Bailey, *Shining Star: Braving the Elements of Earth, Wind & Fire* (New York: Viking Adult, 2014), 232.

15. "Now, Then & Forever," Earth, Wind & Fire, Discogs. https://www.discogs.com/release/4965222-Earth-Wind-Fire-Now-Then-Forever.

16. "2013 News," EWF Fans. https://www.ewffans.com/news/index_2013.html.

17. "2013 News," EWF Fans.

18. Sign On," Earth, Wind & Fire, *Now, Then & Forever* (Legacy, 2013).

19. Earth, Wind & Fire, *The Essential* (Columbia/Legacy, 2002/2014).

20. Earth, Wind & Fire, *The Promise* (Kalimba Music, 2003/2009/2014).

21. Andrea Seikaly, "Soul Singer Jessica Cleaves Dies at 65," *Variety*, May 7, 2014. https://variety.com/2014/music/people-news/soul-singer-jessica-cleaves-dies-at-65-1201174485/.

22. Joe Marchese, "Don't Stop the Music: A Big Break Bounty, Part Two," The Second Disc, August 27, 2014. https://theseconddisc.com/2014/08/27/dont-stop-the-music-a-big-break-bounty-part-two/.

23. "Never," Earth, Wind & Fire, *The Promise* (Kalimba Music, 2014).

24. "Never," Earth, Wind & Fire, Billboard.com. https://www.billboard.com/music/earth-wind-fire/chart-history/JSI/song/436133.

25. Earth, Wind & Fire, *Ultimate Collection* (Sony Music, 2014).

26. Gail Mitchell, "Exclusive: Earth, Wind & Fire to Release First Holiday Album," *Billboard*, October 1, 2014. https://www.billboard.com/articles/news/6266751/earth-wind-fire-holiday-album-release-date.

27. Earth, Wind & Fire, *Holiday* (Legacy, 2014).

28. Earth, Wind & Fire, *Holiday*.

29. James Reed, Sarah Rodman, and Jeffrey Gantz, "Music Gift Guide: Holiday Albums," *Boston Globe*, November 26, 2014. https://www.bostonglobe.com/arts/music/2014/11/26/holiday-gift-guide-holiday-cds/TFiN1pCHWeeeluVypWMy4L/story.html.

30. Brett Milano, "Earth, Wind & Fire, Holiday (CBS)," *OffBeat*, November 24, 2014. https://www.offbeat.com/music/earth-wind-fire-holiday-cbs/.

31. "Holiday," Earth, Wind & Fire, *Billboard*. https://www.billboard.com/music/earth-wind-fire/chart-history/BLP.

32. "2014 News," EWF Fans. https://www.ewffans.com/news/index_2014.html.

33. "Why?" Earth, Wind & Fire, Billboard.com. https://www.billboard.com/music/earth-wind-fire/chart-history/JSI/song/917090.

34. "Legendary Bands Earth, Wind & Fire and Chicago Announce North American Co-Headlining Summer Tour," PR Newswire, March 4, 2015. https://www.prnewswire.com/news-releases/legendary-bands-earth-wind-fire-and-chicago-announce-north-american-co-headlining-summer-tour-300045156.html.

35. Earth, Wind & Fire, *Raise!* (FTG Records, 2015).

36. Earth, Wind & Fire, *Electric Universe* (FTG Records, 2015).

37. Earth, Wind & Fire, *The Classic Holiday Album* (Legacy, 2015).

38. "The Classic Holiday Album," Earth, Wind & Fire, Billboard.com. https://www.billboard.com/music/earth-wind-fire/chart-history/RBL.

39. Kory Grow, "Maurice White, Earth, Wind & Fire Singer and Co-Founder, Dead at 74," *Rolling Stone*, February 4, 2016. https://www.rollingstone.com/music/music-news/maurice-white-earth-wind-fire-singer-and-co-founder-dead-at-74-99968/.

40. Matt Medved, "Stevie Wonder & Pentatonix Perform 'That's the Way of the World' Tribute to Maurice White at the 2016 Grammys," *Billboard*, February 15, 2016. https://www.billboard.com/articles/news/grammys/6875306/stevie-wonder-pentatonix-thats-the-way-of-the-world-grammys-2016.

41. Verdine White, "Verdine White—Maurice White, A Celebration of Life." https://www.youtube.com/watch?v=xhU-T8Be1k4.

42. "Legendary Bands Earth, Wind & Fire & Chicago Announce 2016 Tour," Music Existence. https://musicexistence.com/blog/2015/11/12/legendary-bands-earth-wind-fire -and-chicago-announce-2016-tour/.

43. "2016 News," EWF Fans. https://www.ewffans.com/news/index_2016.html.

44. "Legendary Band Earth, Wind & Fire Sets European Tour Dates," BackStage360. https://www.backstage360.com/legendary-band-earth-wind-fire-sets-europe-tour-dates/.

45. "Heart & Soul Tour 3.0," Earth, Wind & Fire. https://www.earthwindandfire.com/2016/ 06/heart-soul-tour-3-0/.

46. Gail Mitchell, "Earth, Wind & Fire and Nile Rodgers Accept Top Honors at Ebony Power 100 Gala," *Billboard*, December 2, 2016. https://www.billboard.com/articles/columns/ hip-hop/7597324/earth-wind-fire-nile-rodgers-ebony-power-100.

47. "NAACP Image Award Nominations Announced," NAACP, December 13, 2016. https:// www.naacp.org/latest/naacp-image-award-nominations-announced/.

48. B. Cakes, "Earth, Wind & Fire Teams with Nile Rodgers & Chic to Bring Us '2054: The Tour,'" SoulBounce, April 25, 2017. http://www.soulbounce.com/2017/04/earth-wind -fire-nile-rodgers-chic-2054-the-tour-dates/.

49. Elle Perry, "Memphis Music Hall of Fame Announces 2017 Inductees," *Memphis Business Journal*, August 22, 2017. https://www.bizjournals.com/memphis/news/2017/08/22/ memphis-music-hall-of-fame-announces-2017.html.

50. Rebecca Lewis, "Earth, Wind & Fire Kick Off Las Vegas Residency to Sold-Out Crowd," News 3 Las Vegas, May 3, 2018. https://news3lv.com/news/local/earth-wind-fire -kick-off-las-vegas-residency-to-sold-out-crowd.

51. "Earth, Wind & Fire to Play The Venetian Las Vegas in March 2019," Travel Agent Central. https://www.travelagentcentral.com/hotels/earth-wind-fire-to-play-venetian-march-2019.

52. Jon Blistein, "Jay-Z, Cyndi Lauper, Curtis Mayfield Added to National Recording Registry," *Billboard*, March 20, 2019. https://www.rollingstone.com/music/music-news/ jay-z-cyndi-lauper-national-recording-registry-library-of-congress-810566/.

53. "About This Program," National Recording Preservation Board, Library of Congress. https://www.loc.gov/programs/national-recording-preservation-board/about-this-program/ ?dates=2002-2099.

54. Philip Bailey, *Love Will Find a Way* (Verve, 2019).

55. Charles Waring, "'Love Will Find a Way': 'It's Come Full Circle' Says EW&F's Philip Bailey," Udiscovermusic, June 22, 2019. https://www.udiscovermusic.com/stories/ philip-bailey-love-will-find-a-way-album/.

56. "Love Will Find a Way," Philip Bailey, Billboard.com. https://www.billboard.com/ music/philip-bailey/chart-history/JCR/song/1149845.

57. "World Premiere: Long Lost Maurice White Music Pulled from the Vault," Soul Tracks. https://www.soultracks.com/first-listen-maurice-white-couldnt-be-me.

58. Maurice White, *Manifestation*, Soul Music, 2019.

59. Mikael Wood, "In Praise of Earth, Wind & Fire, Purveyor of Black Excellence for a Half-Century," *Los Angeles Times*, September 12, 2019. https://www.latimes.com/entertainment-arts/ music/story/2019-09-12/earth-wind-and-fire-september-hollywood-bowl.

60. Rob Hayes, "LA City Council Declares Sept. 21 'Earth, Wind & Fire Day,'" ABC7, September 11, 2019. https://abc7.com/society/la-city-council-declares-sept-21-earth -wind-and-fire-day/5529896/.

61. Jason Fraley, "National Portrait Gallery Honors Bezos, Miranda, Earth, Wind & Fire," WTOP News, November 18, 2019. https://wtop.com/gallery/entertainment/national -portrait-gallery-honors-bezos-miranda-earth-wind-fire/.

62. "Earth, Wind & Fire Makes History by Becoming the First Black Group Inducted into Kennedy Honors," NewsOne. https://newsone.com/3896681/earth-wind-fire-kennedy-honors/.

63. Ross Raihala, "CBS to Air Tribute Concert Tuesday Night with Performances from Beck, Usher and John Legend," *Grand Forks Herald*, April 17, 2020. https://www.grandforksherald .com/entertainment/music/5203978-CBS-to-air-Prince-tribute-concert-Tuesday-night-with -performances-from-Beck-Usher-and-John-Legend/.

64. Earth, Wind & Fire, *Illumination* (Sanctuary, 2020).

65. Scott Bernstein, "Santana and Earth, Wind & Fire Announce Summer Tour 2020," JamBase, February 25, 2020. https://www.jambase.com/article/santana-earth-wind-fire-tour-dates.

66. "Santana + Earth, Wind & Fire tour [Postponed]," News, Earth, Wind & Fire, last modified 2020. https://www.earthwindandfire.com/category/news/.

67. "Earth, Wind & Fire and Friends—50 Years Anniversary Album," Earth, Wind & Fire, Discogs. https://www.discogs.com/Earth-Wind-Fire-Earth-Wind-Fire-And-Friends -50-Years-Anniversary-Album/release/15979125.

68. Daniel Kreps, "Earth, Wind and Fire Celebrate 'September' With Bouncy 2020 Remix," *Rolling Stone*, September 17, 2020. https://www.rollingstone.com/music/music-news/ earth-wind-fire-september-2020-remix-1061152/.

69. Andrew Unterberger, "Earth, Wind & Fire's 'September' Hits New Digital Song Sales Peak, Triples in Sept. 21 Streams," *Billboard*, September 30, 2020. https://www.billboard .com/articles/business/chart-beat/9457019/earth-wind-fire-september-streams-sales-charts.

70. Kreps.

71. "Events," Earth, Wind & Fire Tickets, Ticketmaster, accessed September 25, 2020. https://www.ticketmaster.com/earth-wind-fire-tickets/artist/734980.

72. Rachel George, "Watch Earth, Wind & Fire Party with Meghan Trainor in New Video for Holidays," ABC News Radio, November 23, 2020. http://abcnewsradioonline.com/music -news/2020/11/23/watch-earth-wind-fire-party-with-meghan-trainor-in-new-video.html.

73. Ericka Blount Danois, "Cosmic Heights," *Wax Poetics* (July/August 2011): 70.

74. Bailey, 225.

AFTERWORD

1. White and Powell, 358.

2. Sheldon Reynolds, Interview by the author, Atlanta, Georgia, February 11, 2017.

3. "Earth, Wind & Fire Stepping Out," *Tri-State Defender*, December 13, 1975, accessed June 30, 2015. http://search.proquest.com.ezproxy.auctr.edu:2051/news/results/.

4. Morris Pleasure, Interview by the author. Grayson, Georgia, March 18, 2017.

5. Ericka Blount Danois, "Cosmic Heights," *Wax Poetics* (July/August 2011): 82.

6. Earth, Wind & Fire, "Biography."

7. "Earth, Wind & Fire," Whosampled.com. https://www.whosampled.com/Earth,-Wind -%26-Fire/.

Bibliography

"After the Love Has Gone." Performed by Earth, Wind & Fire. *I Am*. Columbia. 1979.

"Album Releases." *Cash Box*, November 7, 1987. https://archive.org/details/cashbox51unse_18/page/11?q=.

"Album Reviews." *Billboard*, December 4, 1971, 46.

"Album Reviews." Billboard, February 26, 1983. https://books.google.tt/books?id=EyQEAAAAMBAJ&dq=billboard&q=POwerlight#v=snippet&q=Powerlight&f=false.

"Album Reviews." *Billboard*, March 8, 1975, 84.

"Album Reviews." *Billboard*. November 8, 1972, 24.

Alchetron. "Dick Smith." https://alchetron.com/Dick-Smith-(musician).

Alchetron. "John Paris." https://alchetron.com/John-Paris.

Aletti, Vince. "Head to the Sky." *Rolling Stone*, August 17, 1973. https://www.rollingstone.com/music/music-album-reviews/head-to-the-sky-189912/.

"All About Love." Performed by Earth, Wind & Fire. *That's the Way of the World*. Columbia, 1975.

Allan, Blain. "Musical Cinema, Music Video, Music Television." *Film Quarterly* 43, no. 3 (Spring 1990): 2–14.

"All in the Way." Performed by Earth, Wind & Fire. *The Promise*. Kalimba. 2003.

AllMusic. "Discography." Earth, Wind & Fire. https://www.allmusic.com/artist/earth-wind-fire-mn0000135273/discography.

AllMusic. "JS." Biography. AllMusic. https://www.allmusic.com/artist/js-mn0000119887/biography.

Al McKay All Stars. "Al's Bio." Last modified 2020. Accessed January 21, 2020, http://www.almckay.com/bio.php.

Ancient Egyptian Facts. "Ancient Egyptian Proverbs." Accessed October 30, 2016. http://www.ancientegyptianfacts.com/ancient-egyptian-proverbs.html.

Anderson, Monroe. "Earth, Wind & Fire." *Chicago Tribune*, December 11, 1977.

"And Love Goes On." Performed by Earth, Wind & Fire. *Faces*. Columbia/ARC. 1980.

"Andrew Woolfolk." Earth, Wind & Fire. Jaye Purple Wolf Dot Com. Accessed August 28, 2019. http://www.jayepurplewolf.com/EARTHWINDFIRE/andrewwoolfolk.html.

Anthes, Rudolf. "Egyptian Theology in the Third Millennium B.C." *Journal of Near Eastern Studies* 18, no. 3 (July 1959): 169–212.

Arnold, Chuck. "Picks and Pans Review: Quick Cuts." *People*, October 7, 2013. https://people.com/archive/picks-and-pans-review-quick-cuts-vol-80-no-15/amp/.

Artyfactory. "Cartouches." Egyptian Hieroglyphics—Pectorals and Cartouches. Accessed July 5, 2016. http://www.artyfactory.com/egyptian_art/egyptian_hieroglyphs/pectoral.html.

Asante, Molefi. *Afrocentricity: The Theory of Social Change*. Sauk Village, IL: African American Images, 2003.

Ashby, Muata, ed. *Egyptian Proverbs: Mystical Wisdom Teachings and Meditations*. Miami: Cruzian Mystic Books, 1997.

Ashby, Muata. *Egyptian Yoga: The Philosophy of Enlightenment*. Atlanta: Sema Institute, 1997.

Aston Microphones. "David Whitworth—Earth, Wind & Fire." Aston Microphones. https://www.astonmics.com/EN/artist-details/David-Whitworth-Earth-Wind-and-Fire.

Awards and Winners. NAACP Image Award. http://awardsandwinners.com/category/naacp-image-award/.

Awards and Winners. Soul Train Music Awards. http://awardsandwinners.com/category/soul-train-music-awards/.

"Back on the Road." Performed by Earth, Wind & Fire. *Faces*. Columbia/ARC. 1980.

BackStage360. Legendary Band Earth, Wind & Fire Sets European Tour Dates. https://www.backstage360.com/legendary-band-earth-wind-fire-sets-europe-tour-dates/.

Bailey, Philip. *Love Will Find a Way*. Verve. 2019.

Bailey, Philip. *Shining Star: Braving the Elements of Earth, Wind & Fire*. New York: Viking Adult, 2014.

Bailey, Wade. "Earth Wind and Fire Musical Wizardry: The Powerful Occult Background of EWF." *Lionzman Blog*, March 29, 2013. Accessed March 22, 2017. http://nazaritze-lionzman.blogspot.com/2013/03/earth-wind-and-fire-musical-wizardry.html.

Banfield, William C. *Makings of a Black Music Philosophy: An Interpretive History from Spirituals to Hip Hop*. Lanham, MD: Scarecrow Press, 2010.

Bangs, Lester. "Earth, Wind & Fire." *Rolling Stone*. June 24, 1971. https://www.rollingstone.com/music/music-album-reviews/earth-wind-fire-246411/.

Baraka, Rhonda. "A Conversation with Verdine White, Philip Bailey and Ralph Johnson." *Billboard*, July 14, 2001.

Baraka, Rhonda. "In the Works." *Billboard*, July 14, 2001.

Barbour, Floyd B., ed. *The Black Seventies*. Boston: Porter Sargent, 1970.

Berger, John. "Doctor Is In." *Star Bulletin*. May 23, 2008. http://archives.starbulletin.com/2008/05/23/features/story01.html.

Berklee. "Philip Bailey Delivers Commencement Address." https://www.berklee.edu/commencement/2008.

Bernstein, Scott. "Santana and Earth, Wind & Fire Announce Summer Tour 2020." JamBase, February 25, 2020. https://www.jambase.com/article/santana-earth-wind-fire-tour-dates.

"The Best of Earth, Wind & Fire, Vol. II." Discogs. https://www.discogs.com/release/9951927-Earth-Wind-Fire-The-Best-Of-Earth-Wind-Fire-Vol-II.

Billboard. "Chart History." Earth, Wind & Fire. Last modified 2020. https://www.billboard.com/music/earth-wind-fire/chart-history.

Billboard. "Chart History." Maurice White. Last modified 2020. https://www.billboard.com/music/maurice-white/chart-history/BSI.

Billboard. "Chart History." Philip Bailey. Last modified 2020. https://www.billboard.com/music/philip-bailey/chart-history/BSI.

Billboard. "September." Kirk Franklin. https://www.billboard.com/music/kirk-franklin/chart-history/gospel-songs/song/517279.

Billboard. "Chart History." Various Artists. Last modified 2020. Accessed February 15, 2020. https://www.billboard.com/music/various-artists/chart-history/r-b-hip-hop-albums/song/525333.

Bill Meyers Music. "Bio." http://billmeyersmusic.com/bio/.

"Biography." MauriceWhite.com. Last modified 2014. Accessed May 15, 2015. http://www .mauricewhite.com/bio.html.

Blankson, Naadu. "Breath of Life." *Essence*, July 1993, 22.

Blistein, Jay. "Jay-Z, Cyndi Lauper, Curtis Mayfield Added to National Recording Registry." *Billboard*, March 20, 2019. https://www.rollingstone.com/music/music-news/jay-z-cyndi-lauper -national-recording-registry-library-of-congress-810566/.

Bloomer, George. *Witchcraft in the Pews, Pt. 6.* Accessed March 22, 2017. https://www.youtube .com/watch?v=tuokTHHTlVI&t=189s.

Bogdanov, Vladimir. *AllMusic Guide to Soul: The Definitive Guide to R&B and Soul.* Milwaukee: Hal Leonard Corporation, 2003.

"Boogie Wonderland." Performed by Earth, Wind & Fire. *I Am.* Columbia. 1979.

Bracy, John, Jr., Sonia Sanchez, and James Smethurst, eds. *SOS—Calling All Black People: A Black Arts Movement Reader.* Amherst: University of Massachusetts Press, 2014.

Breithaupt, Don, and Jeff Breithaupt. *Night Moves: Pop Music in the Late 1970s.* New York: St. Martin's Griffin, 2000.

Brodsky, Justin. "Tag Archives: Kimberly Brewer." Artist Reach. https://artistreachofficial .com/tag/kimberly-brewer/.

Browder, Anthony. *Nile Valley Contributions to Civilization.* Washington, DC: Institute of Karmic Guidance, 1992.

Bush, John. "Earth, Wind & Fire." AllMusic. Last modified 2019. https://www.allmusic.com/ album/earth-wind-and-fire-mw0000095039.

Bush, John. *The Need of Love*, Earth, Wind & Fire. Last modified 2019. https://www.allmusic .com/album/earth-wind-and-fire-mw0000095039.

Business Wire. "2004 Grammy Hall of Fame Inductees Announced." https://www.businesswire .com/news/home/20040114005168/en/2004-GRAMMY-Hall-Fame-Inductees-An nounced-Selections.

Business Wire. "Chicago and Earth, Wind & Fire: 3 Hour Extravaganza Brings Together Two of Popular Music's Greatest Hit Makers." *Business Wire*, March 25, 2004. https:// www.businesswire.com/news/home/20040325005516/en/Chicago-Earth-Wind-Fire-3 -Hour-Extravaganza.

Byrd, William. "EWF's Bailey, Dunn Promote New LP." *Atlanta Daily World*, March 3, 1983. Accessed June 30, 2015. http://search.proquest.com.ezproxy.auctr.edu:2051/news/results/.

Cakes, B. "Earth, Wind & Fire Teams with Nile Rodgers & Chic to Bring Us '2054: The Tour.'" SoulBounce, April 25, 2017. http://www.soulbounce.com/2017/04/earth-wind -fire-nile-rodgers-chic-2054-the-tour-dates/.

Campbell, Michael. *Popular Music in America: The Beat Goes On.* Boston: Cengage Learning, 2012.

Campkin, Ben, Mariana Mogilevich, and Rebecca Ross. "Chicago's Wall of Respect: How a Mural Solicited a Sense of Collective Ownership." *The Guardian*, December 8, 2014. Accessed November 28, 2015. http://www.theguardian.com/cities/2014/dec/08/ chicago-wall-of-respect-collective-ownership-organisation-black-american-culture.

"Can't Let Go." Performed by Earth, Wind & Fire. *I Am.* Columbia. 1979.

Carpenter, Roger. *Faces* album cover. Earth, Wind & Fire. CBS Records. 1980.

Carus, Paul. "The Conception of the Soul and the Belief in Resurrection Among the Egyptians." *The Monist* 15, no. 3 (July 1905): 409–28.

Chandler, Wayne B. "Of Gods and Men: Egypt's Old Kingdom." In *Egypt Revisited*, edited by Evan Van Sertima, 117–82. New Brunswick, NJ: Transaction Publishers, 1999.

Christgau, Robert. "Consumer Guide Reviews." Earth, Wind & Fire. https://www .robertchristgau.com/get_artist.php?name=Earth%2C+Wind+%26+Fire.

Christgau, Robert. "Dean's List [1983]." *Village Voice*, February 28, 1984. http://robertchristgau
.com/xg/pnj/deans83.php.

Church Pop. "8 Ancient Christian Symbols and Their Hidden Meanings." Accessed
October 15, 2016. https://churchpop.com/2015/08/14/8-ancient-christian-symbols-and
-their-hidden-meanings/.

Collins, Lisa Gail, and Margo Natalie Crawford, eds. *New Thoughts on the Black Arts Movement*.
New Brunswick, NJ: Rutgers University Press, 2006.

"The Complete List of Grammy Nominations." *New York Times*, December 8, 2005. https://
www.nytimes.com/2005/12/08/arts/the-complete-list-of-grammy-nominations.html.

Connelly, Christopher. "Powerlight." *Rolling Stone*, March 17, 1983. https://www.rollingstone
.com/music/music-album-reviews/powerlight-251290/.

Considine, J. D. "Funk is flying high, 20 years later Roots: The slippery synths, fatback drums,
and heavy bass are as hip now as they were in the 1970s, when they were considered
revolutionary." *Baltimore Sun*, June 23, 1996. https://www.baltimoresun.com/news/bs
-xpm-1996-06-23-1996175170-story,amp.html.

Crawford, Margo Natalie. "Black Light on the *Wall of Respect*: The Chicago Black Arts
Movement." In *New Thoughts on the Black Arts Movement*, edited by Lisa Gail Collins
and Margo Natalie Crawford, 23–42. New Brunswick, NJ: Rutgers University Press, 2006.

Danois, Ericka Blount. "Cosmic Heights." *Wax Poetics* (July/August 2011): 68–82.

Davi. Interview with Maurice White, 2005. Accessed June 10, 2016. www.okayafrica.com/
culture-2/maurice-white-earth-wind-and-fire-african-ness-interview/.

Davidson, Basil. *African Civilization Revisited*. Trenton, NJ: Africa World Press, 1991.

Davis, Robert. "Who Got Da Funk? An Etymophony of Funk Music from the 1950s to 1979."
Dissertation, University of Montreal, 2005.

"Description of the King Tut Mask." History Embalmed. Accessed July 5, 2016. www
.historyembalmed.org/tomb-of-king-tut/king-tut-mask.htm.

"Devotion." Earth, Wind & Fire. *Open Our Eyes*. Columbia. 1974.

Diop, Cheikh Anta. *The African Origin of Civilization: Myth or Reality*. Chicago: Lawrence
Hill, 1974.

"Doug Henning." Biography. *People*. Accessed November 10, 2016. http://www.biography
.com/people/doug-henning-9542367.

Dowu, Omoronke. "Earth, Wind & Fire: In the Name of Love." *Vibe*, October 1997.

Drummerworld. "Gorden Campbell." https://www.drummerworld.com/drummers/Gorden_
Campbell.html.

Drum Solo Artist. "David Romero." http://www.drumsoloartist.com/Site/Drummers2/
David_Romero.html.

DuHamel, Brandon A. "Earth, Wind & Fire: Live at Montreux 1997 Blu-ray Review." Big
Picture Big Sound, November 24, 2009. https://www.bigpicturebigsound.com/Earth
-Wind-Fire-Live-at-Montreux-1997-Blu-ray.shtml.

Duke, Alan. "Stars Gather for 'We Are the World' Recording." CNN. http://www.cnn.com/2010/
SHOWBIZ/Music/02/01/haiti.we.are.the.world/index.html.

Earth, Wind & Fire 2003 Summer Concert. YouTube. https://www.youtube.com/watch?v
=M5CLKEEYxlo.

"Earth, Wind & Fire at Arie Crown." *Chicago Defender (Daily Edition) (1973–1975)*, May 1, 1975.
Accessed June 30, 2015. http://search.proquest.com.ezproxy.auctr.edu:2051/news/results/.

Earth, Wind & Fire. *All 'N All*. Columbia. 1977/1999.

Earth, Wind & Fire. *Another Time*. Warner Brothers. 1974.

Earth, Wind & Fire. *Avatar*. Avex Trax. 1996.

Earth, Wind & Fire. *Best of Earth, Wind & Fire, Vol. 1*. ARC/Columbia. 1978/1999.

Earth, Wind & Fire. *Best of Earth, Wind & Fire, Vol. 2*. Columbia. 1988.

Earth, Wind & Fire. "Bio-Awards." Last modified 2020. Accessed January 29, 2020. https://web
 .archive.org/web/20090307013150/http://www.earthwindandfire.com/bio_awards.html.

Earth, Wind & Fire. "History." Last modified 2020. Accessed January 29, 2020. http://www
 .earthwindandfire.com/history/biography.

Earth, Wind & Fire. "Boogie Wonderland." Sony Music Entertainment. 1979. https://www
 .youtube.com/watch?v=god7hAPv8fo.

"Earth, Wind & Fire." *Chicago Defender (Big Weekend Edition) (1973–1975)*, April 27, 1974.
 Accessed June 30, 2015. http://search.proquest.com.ezproxy.auctr.edu:2051/news/results/.

Earth, Wind & Fire. *The Classic Holiday Album*. Legacy. 2015.

Earth, Wind & Fire. *The Columbia Masters*. Columbia. 2011.

"Earth, Wind & Fire Cometh," *Tri-State Defender (1959–1989)*, April 6, 1988. Accessed June
 30, 2015. http://search.proquest.com.ezproxy.auctr.edu:2051/news/results/.

"Earth, Wind & Fire Creates Euphoria with Dynamic Sound." *Milwaukee Star*, April 25, 1974.
 http://search.proquest.com.ezproxy.auctr.edu:2015/news/results/.

Earth, Wind & Fire. *Earth, Wind & Fire*. Warner Brothers. 1971.

Earth, Wind & Fire. *Earth, Wind & Fire and Friends—50 Years Anniversary Album*. Sony. 2020.

Earth, Wind & Fire. *Electric Universe*. Columbia/FTG. 1983/2015.

Earth, Wind & Fire. *Elements of Love: The Ballads*. Columbia. 1996.

Earth, Wind & Fire. *The Essential*. Columbia/Legacy. 2002/2014.

Earth, Wind & Fire. *The Eternal Dance*. Columbia. 1992.

Earth, Wind & Fire. *The Eternal Vision*. Sony Music. 1992.

"Earth, Wind & Fire Explains the Kalimba." *Chicago Metro News*, August 10, 1974.
 Accessed June 16, 2015. http://infoweb.newsbank.ezproxy.auctr.edu:2051/iw-search/we/
 histArchive?p_action=search.

Earth, Wind & Fire. *Faces*. ARC/Columbia/BBR Records. 1980/2010.

Earth, Wind & Fire. "Fall in Love with Me." Sony BMG Music Entertainment, 1983. Accessed
 June 15, 2016. https://www.youtube.com/watch?v=GfLwdu8Arps.

Earth, Wind & Fire. *Gratitude*. Columbia. 1975/1999.

Earth, Wind & Fire. *Greatest Hits Live*. Rhino. 1996.

Earth, Wind & Fire. *Head to the Sky*. Columbia. 1973.

"Earth, Wind & Fire Headlines Sizzling Summer Tour." *Jet*, September 7, 1998, 61–62.

Earth, Wind & Fire. "Heart & Soul Tour 3.0." News. https://www.earthwindandfire.com/2016/"
 06/heart-soul-tour-3-0/.

Earth, Wind & Fire. *Heritage*. Columbia. 1990.

Earth, Wind & Fire. *Holiday*. Legacy. 2014.

Earth, Wind & Fire. *I Am*. CBS. 1979/2004.

Earth, Wind & Fire. *Illumination*. Sanctuary. 2005/2020.

Earth, Wind & Fire. *In the Name of Love*. Rhino. 1997/2006.

Earth, Wind & Fire. *Last Days and Time*. Columbia. 1972.

"Earth, Wind & Fire Launches '77 Tour." *Chicago Metro News*, November 5, 1977.

Earth, Wind & Fire. "Let Me Talk." Sony Music Entertainment. 1980. https://www.youtube
 .com/watch?v=4uQQm5xtMtU.

Earth, Wind & Fire. "Let's Groove." Sony Music Entertainment. 1981. https://www.youtube
 .com/watch?v=4uQQm5xtMtU.

Earth, Wind & Fire. *Live in Rio*. Kalimba. 2002.

"Earth, Wind & Fire—Live '05 Tribute On Ice Concert." YouTube. https://www.youtube.com/
 watch?v=UWJmGDu6Soc.

Earth, Wind & Fire. *Live in Velfarre*. Rhino. 1995/2010.

"Earth, Wind & Fire Members Receive Honorary Doctorates." UrbanMecca. May 21, 2008. http://urbanmecca.net/news/2008/05/21/earth-wind-and-fire-members-receive-honorary-doctorates/.

"Earth, Wind & Fire Milestone." *Chicago Metro News*, August 12, 1978.

Earth, Wind & Fire. *Millennium*. Warner Brothers. 1993.

Earth, Wind & Fire. *The Need of Love*. Warner Brothers. 1971.

Earth, Wind & Fire. *Now, Then & Forever*. Legacy. 2013.

Earth, Wind & Fire. *Open Our Eyes*. Columbia. 1974/2001.

"Earth, Wind & Fire." Performed by Earth, Wind & Fire. *Spirit*. Columbia. 1976.

Earth, Wind & Fire. *Powerlight*. Columbia. 1983.

Earth, Wind & Fire. *The Promise*. Kalimba. 2003/2009/2014.

"Earth, Wind & Fire 'Promise' New Album, Tour." News, *Billboard*, April 21, 2003. https://www.billboard.com/articles/news/71433/earth-wind-fire-promise-new-album-tour.

Earth, Wind & Fire. *Raise*. ARC/Columbia/IconoClassic/FTG. 1981/2011/2015.

"Earth, Wind & Fire to Release New LP." *Chicago Metro News*, October 31, 1987. http://search.proquest.com.ezproxy.auctr.edu:2015/news/results/.

Earth, Wind & Fire. "Santana + Earth, Wind & Fire tour [Postponed]." News. Last modified 2020. https://www.earthwindandfire.com/category/news/.

Earth, Wind & Fire. "September." Sony Music Entertainment. 1978. https://www.youtube.com/watch?v=Gso69dndIYk.

Earth, Wind & Fire. "Serpentine Fire." Sony Music Entertainment, 1978. Accessed June 15, 2016. https://www.youtube.com/watch?v=XoI1XPqXQ9o.

"Earth, Wind & Fire." *The Skanner (1975–1988)*, December 8, 1977. Accessed June 30, 2015. http://search.proquest.com.ezproxy.auctr.edu:2015/news/results.

Earth, Wind & Fire. *Spirit*. Columbia, Legacy, Sony. 1976/2001/2014.

"Earth, Wind & Fire Stepping Out." *Tri-State Defender (1959–1989)*, December 13, 1975. Accessed June 30, 2015. http://search.proquest.com.ezproxy.auctr.edu:2051/news/results/.

Earth, Wind & Fire. *That's the Way of the World*. Columbia. 1975/1999.

Earth, Wind & Fire. *That's the Way of the World: Alive in '75*. Columbia. 2002.

Earth, Wind & Fire. *Touch the World*. Columbia. 1987.

Earth, Wind & Fire. *The Ultimate Collection*. Columbia. 1999.

Earth, Wind & Fire. "Yamaha's 125th Anniversary Concert." Blog. Last modified 2020. http://www.earthwindandfire.com/2013/02/yamahas-125th-anniversary-concert/.

"Earth, Wind & Fire and Friends—50 Years Anniversary Album." Discogs. https://www.discogs.com/Earth-Wind-Fire-Earth-Wind-Fire-And-Friends-50-Years-Anniversary-Album/release/15979125.

Eddy, Chuck. "In the Name of Love." *Entertainment Weekly*, August 1, 1997. https://ew.com/article/1997/08/01/name-love/.

Egnater Amplification. "Egnater Artist: Gregory "G-Moe" Moore." http://www.egnateramps.com/artists/GMoe.html.

Elias, Jason. "Soul Retrospective: Earth Wind & Fire's 'I Am.'" Accessed April 20, 2017. http://soultrain.com/2014/11/12/soul-retrospective-earth-wind-fires/.

Emerson, Ken. "Open Our Eyes." *Rolling Stone*, May 9, 1974. https://www.rollingstone.com/music/music-album-reviews/open-our-eyes-104019/.

Epstein, Benjamin. "Pianist Ravel Runs Gamut—From 'Sol to Soul.'" *Los Angeles Times*, May 18, 1996. https://www.latimes.com/archives/la-xpm-1996-05-18-ca-6386-story.html.

Epstein, Dan. "Earth, Wind and Fire Groove into Hall." *Rolling Stone*, March 2, 2000. Accessed April 20, 2017. http://www.rollingstone.com/music/news/earth-wind-and-fire -groove-into-hall-20000302.

Erlewine, Stephen Thomas. "Earth, Wind & Fire: Greatest Hits." AllMusic. https://www .allmusic.com/album/greatest-hits-legacy-mw0000045386.

Erlewine, Stephen. "Earth, Wind & Fire: That's the Way of the World: Alive in '75." AllMusic. https:// www.allmusic.com/album/thats-the-way-of-the-world-alive-in-75-mw0000658299.

"Etheridge to Play Nobel Peace Prize Concert." Today, October 18, 2007. https://www.today .com/popculture/etheridge-play-nobel-peace-prize-concert-wbna21369494.

"EWF Chosen for the Crystal Globe Award." *Chicago Metro News*, May 1, 1982.

EWF Fans. News. https://www.ewffans.com/news/index.html.

"EWF Lights Up New Album With Big Boi, Will.I.Am." *Billboard*, June 9, 2005. https:// www.billboard.com/articles/news/62637/ewf-lights-up-new-album-with-big-boi-wiliam.

"EW&F's Touch the World Has Gone Gold." *Chicago Metro News*, January 16, 1988. http:// search.proquest.com.ezproxy.auctr.edu:2015/news/results/.

"Exec Offers to Save Statue of John Lennon." Talent & Venues. *Billboard*, February 5, 1983.

"Exhilarating: Hottest Group on Set Gets Hotter." *Milwaukee Star*, June 19, 1975. http://search .proquest.com.ezproxy.auctr.edu:2015/news/results/.

"Faces—Earth, Wind & Fire (1980)." Let's Face the Music (blog). February 12, 2016. https:// letsfacethemusicblog.com/2016/02/12/faces-earth-wind-fire-1980/.

"Fall in Love with Me." Earth, Wind & Fire. *Powerlight*. Columbia. 1983.

"Fantasy." Earth, Wind & Fire. *All 'N All*. Columbia. 1977.

"Feature Picks: Albums." *Cash Box*, November 26, 1983. https://archive.org/details/cashbox 45unse_24/page/26?q.

Fernie, J. Donald. "Astronomy and the Great Pyramid." *American Scientist* 92, no. 5 (September-October 2004): 406–9.

Ferri, Domenico R. "Funk My Soul: The Assassination of Dr. Martin Luther King, Jr. and the Birth of Funk Culture." Dissertation, Loyola University Chicago, 2013.

Finch III, Charles S. *Echoes of the Old Darkland: Themes from the African Eden*. Decatur, GA: Khenti, 1991

Fiore, Raymond. "Illumination." *Entertainment Weekly*, September 16, 2005. https://ew.com/ article/2005/09/16/illumination/.

"The First Single." *Chicago Metro News*, November 14, 1987. http://search.proquest.com .ezproxy.auctr.edu:2015/news/results/.

"Following a Series of Sold-out Appearances." *Chicago Metro News*, October 13, 1973. https:// infoweb-newsbank-com.ezproxy.auctr.edu:2050/apps/readex/doc?p= .

Fontaine, Carole R. "A Look at Ancient Wisdom: The Instruction of Ptahhotep Revisited." *Biblical Archaeologist* 42, no. 3 (Summer 1981): 156.

"For the Love of You." Earth, Wind & Fire. *Heritage*. Columbia. 1990.

Francois, Anne-Lise. "Fakin' It/Makin' It: Falsetto's Bid for Transcendence in 1970s Disco Highs." *Perspectives of New Music* 33, no. 1/2 (Winter-Summer 1995): 442–57.

"Freddie White." Earth, Wind & Fire. Jay Purple Wolf Dot Com. Accessed September 8, 2019. www.jayepurplewolf.com/EARTHWINDFIRE/freddiewhite2.html.

Gadalla, Moustafa. *Egyptian Cosmology: The Animated Universe*. Greensboro, NC: Tehuti Research Foundation, 2001.

Gallo, Phil. "American Idol: Idol Gives Back." *Variety*, April 26, 2007. https://variety.com/2007/ music/markets-festivals/american-idol-idol-gives-back-1200559880/.

Gardiner, Alan Henderson. *Egyptian Grammar*. London: Griffith Institute, 1996.

Gayle, Addison. *The Black Aesthetic*. New York: Doubleday, 1972.

George, Rachel. "Watch Earth, Wind & Fire Party with Meghan Trainor in New Video for Holidays." ABC News Radio, November 23, 2020. http://abcnewsradioonline.com/music -news/2020/11/23/watch-earth-wind-fire-party-with-meghan-trainor-in-new-video.html.

"Getaway." Earth, Wind & Fire. *Spirit*. Columbia. 1976.

Gilula, Mordechai. "An Egyptian Etymology of the Name of Horus?" *Journal of Egyptian Archaeology* 68 (1982): 259–65.

Gorbman, Claudia. "Aesthetics and Rhetoric." *American Music* 22, no. 1 (Spring 2004): 14–26.

"Got to Get You into My Life." Earth, Wind & Fire. *The Best of Earth, Wind & Fire, Vol. 1*. Columbia. 1978.

Graff, Gary. "Earth, Wind & Fire: Electric Universe." *Detroit Free Press*, December 4, 1983. https://www.newspapers.com/newspage/99166582/.

Grammy Awards. "Earth, Wind & Fire." https://www.grammy.com/grammys/artists/earth -wind-fire.

Grammy Awards. "David Foster." https://www.grammy.com/grammys/artists/david-foster.

Grammy Awards. "Dwele." https://www.grammy.com/grammys/artists/dwele.

Grammy Awards. "Maurice White." https://www.grammy.com/grammys/artists/maurice -white.

Grammy Awards. "Me'Shell Ndegeocello." https://www.grammy.com/grammys/artists/ meshell-ndegeocello.

Grammy Awards. "Philip Bailey." https://www.grammy.com/grammys/artists/philip-bailey.

Greig, Charlotte. *Icons of Black Music: A History in Photographs 1900–1999*. San Diego: Advanced Marketing Services, 1999.

Grein, Paul. "Earth, Wind & Fire—Up from the Ashes." *Los Angeles Times*, December 6, 1987. https://www.latimes.com/archives/la-xpm-1987-12-06-ca-26679-story.html.

Grow, Kory. "Maurice White, Earth, Wind & Fire Singer and Co-founder, Dead at 74." *Rolling Stone*, February 4, 2016. Accessed December 20, 2016. https://www.rollingstone.com/music/ music-news/maurice-white-earth-wind-fire-singer-and-co-founder-dead-at-74-99968/.

Grown Folks Music. "Earth, Wind & Fire—'Guiding Lights.'" New Music. January 3, 2012. https://grownfolksmusic.com/earth-wind-fire-guiding-lights/.

"Guiding Lights." Earth, Wind & Fire. *Now, Then & Forever*. Legacy. 2013.

Guitarist News. "Vadim Zilberstein—Earth, Wind & Fire, Chaka Khan." September 13, 2007. https://www.guitaristnews.com/best/219-vadim-zilberstein.

Hamilton, Andrew. "Elements of Love: Ballads." Earth, Wind & Fire. AllMusic. https://www .allmusic.com/album/mw0000183679.

Harrington, Richard. "Earth, Wind and Fire: Still Shining Stars." *Washington Post*, September 7, 2001. Accessed April 20, 2017. https://www.washingtonpost.com/archive/ lifestyle/2001/09/07/earth-wind-fire-still-shing-stars/cdd8de2e-0455-47a4-9571 -043c90c270b0/?utm_term=.049aebd61foe.

Harris, Howard C., and William Fielder. *Complete Book of Composition/Improvisation and Funk Techniques*. Houston: De Mos Music Publications, 1982.

Hawass, Zahi. *Tutankhamun and the Golden Age of the Pharaohs*. Washington, DC: National Geographic Society, 2005.

Hayes, Rob. "LA City Council Declares Sept. 21 'Earth, Wind & Fire Day.'" ABC7, September 11, 2019. https://abc7.com/society/la-city-council-declares-sept-21-earth -wind-and-fire-day/5529896/.

Henderson, Alex. "Earth, Wind & Fire: All 'N All." AllMusic. https://www.allmusic.com/ album/all-n-all-mw0000105072.

Henderson, Alex. "Earth, Wind & Fire: In the Name of Love." AllMusic. https://www.allmusic
.com/album/in-the-name-of-love-mw0000025282.

Henderson, Alex. "Earth, Wind & Fire: Millennium." AllMusic. https://www.allmusic.com/
album/millennium-mw0000620865.

Henderson, Alex. "Earth, Wind & Fire: That's the Way of the World." AllMusic. https://www
.allmusic.com/album/thats-the-way-of-the-world-mw0000650107.

"Heritage." Earth, Wind & Fire. Heritage. Columbia. 1990.

Hilliard III, Asa G. "The Meaning of KMT (Ancient Egyptian) History for Contemporary
African American Experience." Phylon 49, no. 1/2 (Spring-Summer 1992): 10–22.

"History: Biography." Earth, Wind & Fire. Last modified 2020. Accessed January 21, 2020.
http://www.earthwindandfire.com/history/biography.

Hoerburger, Rob. "Touch the World." Rolling Stone, January 14, 1988. https://www.rollingstone
".com/music/music-album-reviews/touch-the-world-104495/.

Hogan, Ed. "Earth, Wind & Fire: Got to Get You into My Life." AllMusic. https://www.allmusic
".com/song/got-to-get-you-into-my-life-mt0002790588.

Holbrook, Morris B., and Barbara Stern. "The Use of Space-Travel and Rocket Ship Imagery
to Market Commercial Music: How Some Jazz Albums from the 1950s, 1960s, and 1970s
Burned Brightly but Fizzled Fast." Exploration 41, no.1 (Spring 2000): 51–62.

"Hold Me." Earth, Wind & Fire. The Promise. Kalimba. 2003.

Homdrum. "Awards." The Earth, Wind & Fire Experience. http://www.homdrum.net/ewf/
awards.html.

Homdrum. The Earth, Wind & Fire Experience. Accessed February 3, 2020. http://www.hom
drum.net/ewf/.

Homdrum. "Earth, Wind & Fire to Receive ASCAP Rhythm & Soul Heritage Award." The
Earth, Wind & Fire Experience. http://www.homdrum.net/ewf/awards.html.

Homdrum. "The Promise." Album Reviews. The Earth, Wind & Fire Experience. http://www
.homdrum.net/ewf/reviews/promise.html.

"Hot Dawgit." Performed by Ramsey Lewis and Earth, Wind & Fire. Sun Goddess. Columbia.
1974.

Humek, Brian. "Earth, Wind & Fire." Afro-American Gazette, May 2, 1994. http://search.
proquest.com.ezproxy.auctr.edu:2051/news/results/.

Hunt, Dennis. "Earth, Wind & Fire Faces the Music." Los Angeles Times, November 30, 1980.

"In the Stone." Earth, Wind & Fire. I Am. CBS. 1979.

"I Think About Lovin' You." Earth, Wind & Fire. The Need of Love. Warner Brothers. 1971.

"I've Had Enough." Earth, Wind & Fire. Raise! ARC/Columbia. 1981.

Jackson, John G. Introduction to African Civilizations. New York: Citadel Press, 1970.

Jahn, Janheinz. Muntu: African Culture and the Western World. New York: Grove Press, 1961.

"Johnny Graham." Earth, Wind & Fire. Jaye Purple Wolf Dot Com. Accessed January 24, 2020.
www.jayepurplewolf.com/EARTHWINDFIRE/johnnygraham.html.

Johnsen, Linda. "Thoth: Egypt's Greatest Spiritual Teacher." Yoga International, July 17, 2014.
Accessed December 15, 2016. https://yogainternational.com/article/view/thoth-egypts
-greatest-spiritual-teacher.

Johnson, Ralph. Interview by the author. Atlanta, GA, March 16, 2017.

Jones, LeRoi (Amiri Baraka). Blues People: Negro Music in White America. New York: Harper
Perennial, 1963.

Jones, Leroi (Amiri Baraka). "The Changing Same (R&B and New Black Music)." In SOS—
Calling All Black People: A Black Arts Reader, edited by John H. Bracey, Sonia Sanchez,
and James Smethurst, 123–31. Amherst: University of Massachusetts Press, 2014.

Jones. Steve. "'Angel': Synth Pop a la Mode." *USA Today*, October 17, 2005. https://usatoday30
.usatoday.com/life/music/reviews/2005110117-listen-up_x.htm.

"Jupiter." Earth, Wind & Fire. *All 'N All*. Columbia. 1977.

"Kalimba Story." Earth, Wind & Fire. *Open Our Eyes*. Columbia. 1974.

Karenga, Maulana. *Maat: The Moral Ideal in Ancient Egypt*. New York: Routledge, 2004.

"Keep Your Head to the Sky." Earth, Wind & Fire. *Head to the Sky*. Columbia. 1973.

Kellman, Andy. "Now, Then & Forever." Earth, Wind & Fire. AllMusic. https://www.allmusic
.com/album/now-then-forever-mw0002288011.

Kemet University. "Who We Are." Accessed January 30, 2017. www.egyptianmysteries.org/who
-we-are/.

"Kids, Mummies, and the World's Best Museums for Egyptian Art." Hilton Mom Voyage.
Accessed February 2, 2017. http://momvoyage.hilton.com/articles/kids-mummies-and
-the-worlds-best-museums-for-egyptian-art/.

Kisner, Ronald. "Earth, Wind & Fire: New Music, New Magic." *Jet*, February 16, 1978, 14.

Kreps, Daniel. "Earth, Wind and Fire Celebrate 'September" with Bouncy 2020 Remix."
Rolling Stone, September 17, 2020. https://www.rollingstone.com/music/music-news/
earth-wind-fire-september-2020-remix-1061152/.

Kreps, Daniel. "Stevie Wonder, Earth, Wind & Fire to Rock the House." *Rolling Stone*,
February 20, 2009. https://www.rollingstone.com/politics/politics-news/stevie-wonder
-earth-wind-and-fire-to-rock-the-white-house-97203/.

Kyodo. "Nagaoka, Illustrator for Earth, Wind & Fire, Other Bands, Dies at 78." *Japan Times*,
June 27, 2015. Accessed November 10, 2016. http://www.japantimes.co.jp/news/2015/06/27
/national/nagaoka-illustrator-for-earth-wind-fire-other-bands-dies-at-78/#.WBjBV
9IrKUk.

Lacy, Travis K. "Funk Is Its Own Reward: An Analysis of Selected Lyrics in Popular Funk
Music of the 1970s." Dissertation, Clark Atlanta University, 2008.

"Lady Sun." Earth, Wind & Fire. *Raise!* ARC/Columbia. 1981.

Larry Dunn Music. "Bio: Larry Dunn." Last modified 2020. Accessed January 24, 2020. https://
www.larrydunnmusic.com/bio-larry-dunn/.

Leeds, Jeff, and Lorne Manly. "Defiant Dixie Chicks Are Big Winners at the Grammys." *New
York Times*, February 12, 2007. https://www.nytimes.com/2007/02/12/arts/music/12gram
.html.

"Legendary Bands Earth, Wind & Fire and Chicago Announce North American Co-
Headlining Summer Tour." PR Newswire, March 4, 2015. https://www.prnewswire.com/
news-releases/legendary-bands-earth-wind-fire-and-chicago-announce-north-american
-co-headlining-summer-tour-300045156.html.

"Legendary Group Earth, Wind & Fire Perform With the Hollywood Bowl Orchestra for
Two Evenings at the Hollywood Bowl." LA Phil. September 3, 2010. https://www.laphil
.com/press/releases/1089.

Leight, Elias. "Earth, Wind & Fire: Now, Then & Forever." PopMatters. September 22, 2013.
https://www.popmatters.com/earth-wind-fire-now-then-forever-2495723844.html.

Lennon, Mary Ellen. "A Question of Relevancy: New York Museums and the Black Arts
Movement." In *New Thoughts on the Black Arts Movement*, edited by Lisa Gail Collins
and Margo Natalie Crawford, 92–116. New Brunswick, NJ: Rutgers University Press, 2006.

"Let's Groove." Earth, Wind & Fire. *Raise!* ARC/Columbia.

Lewis, Edmund, ed. "Remembering Maurice." *Louisiana Weekly*, February 29, 2016. Accessed
October 30, 2016. http://www.louisianaweekly.com/remembering-maurice/.

Lewis, G. Craige. *The Truth Behind Hip Hop*. Maitland, FL: Xulon Press, 2009.

Lewis, Rebecca. "Earth, Wind & Fire Kick Off Las Vegas Residency to Sold-Out Crowd." News 3 Las Vegas. May 3, 2018. https://news31v.com/news/local/earth-wind-fire-kick-off-las-vegas-residency-to-sold-out-crowd.

Light, Alan. "Kalimba Story." Liner notes, *The Eternal Dance* (CD box set). Sony Music Entertainment. 1992.

"Live in Rio." News. *Billboard*, January 11, 2003. https://www.billboard.com/articles/news/72992/live-in-rio.

"The Los Angeles Chapter of the Recording Academy." *Billboard*, May 29, 2004, 21.

"Love is Life." Earth, Wind & Fire. *Earth, Wind & Fire*. Warner Brothers. 1971.

Lytle, Craig. "Earth, Wind & Fire: Powerlight." AllMusic. https://www.allmusic.com/album/powerlight-mw0000189887.

"Magic Mind." Earth, Wind & Fire. *All 'N All*. Columbia. 1977.

"Magnetic." Earth, Wind & Fire. *Electric Universe*. Columbia. 1983.

Mao, Chairman. "Earth, Wind & Fire: The Promise." *Blender*. https://archive.li/20090510055802/http://www.blender.com/guide/new/52937/promise.html.

Marchese, Joe. "Don't Stop the Music: A Big Break Bounty, Part Two." The Second Disc (blog), August 27, 2014. https://theseconddisc.com/2014/08/27/dont-stop-the-music-a-big-break-bounty-part-two/.

Marcus, Richard. "Music DVD Review: *Earth, Wind & Fire: In Concert*." Blogcritics. https://blogcritics.org/music-dvd-review-earth-wind-fire/?amp.

Martin, Denise. "Maat and Order in African Cosmology: A Conceptual Tool for Understanding Indigenous Knowledge." *Journal of Black Studies* 38, no. 6 (July 2008): 951–67.

Martinez, M. R. "Pick of the Week." *Cash Box*, September 25, 1993. https://archive.org/details/cashbox57unse_1/page/12?q.

Matthews, Donald. "Proposal for an Afro-Centric Curriculum." *Journal of the American Academy of Religion* 62, no. 3 (Autumn 1994): 885–92.

"Maurice White." Obituary. Legacy.com. Accessed April 14, 2017. http://www.legacy.com/ns/maurice-white-obituary/177598358.

Maxile, Horace J., Jr. "Extensions on a Black Musical Tropology: From Trains to the Mothership (and Beyond)." *Journal of Black Studies* 42, no. 4 (May 2011): 593–608.

McCaffrey, Shannon. "Largest State Dinner at White House." AP News, June 20, 2000. https://apnews.com/article/8fa38c79578fadbc27e9b793d71051cb.

McDonald, Sam. "Earth, Wind & Fire and a Whole Lot of Soul." *Daily Press*, August 21, 1998. https://www.dailypress.com/news/dp-xpm-19980821-1998-08-21-9808210191-story.html.

McLeod, Ken. "Space Oddities: Aliens, Futurism and Meaning in Popular Music." *Popular Music* 22, no. 3 (October 2003): 337–55.

Medved, Matt. "Stevie Wonder & Pentatonix Perform 'That's the Way of the World' Tribute to Maurice White at the 2016 Grammys." *Billboard*, February 15, 2016. https://www.billboard.com/articles/news/grammys/6875306/stevie-wonder-pentatonix-thats-the-way-of-the-world-grammys-2016.

Mi2n. "Music Icons Earth, Wind & Fire Lead Stellar List to Be Honored at the 15th Annual Temecula Valley International Film and Music Festival's Awards Gala." http://www.mi2n.com/print.php3?id=122695.

"Mighty Mighty." Earth, Wind & Fire. *Open Our Eyes*. Columbia. 1974.

Milano, Brett. "Earth, Wind & Fire, Holiday (CBS)." *OffBeat*, November 24, 2014. https://www.offbeat.com/music/earth-wind-fire-holiday-cbs/.

Milward, John. "Heritage." *Rolling Stone*, March 22, 1990. https://www.rollingstone.com/music/music-album-reviews/heritage-2-248903/.

Miro, Peter. "The Rhythm." *Cash Box*, August 17, 1996. https://archive.org/details/
 cashbox59unse_43/page/8.
Mitchell, Gail. "Earth, Wind & Fire and Nile Rodgers Accept Top Honors at Ebony Power
 100 Gala." *Billboard*, December 2, 2016. https://www.billboard.com/articles/columns/
 hip-hop/7597324/earth-wind-fire-nile-rodgers-ebony-power-100.
Mitchell, Gail. "Exclusive: Earth, Wind & Fire to Release First Holiday Album." *Billboard*,
 October 1, 2014. https://www.billboard.com/articles/news/6266751/earth-wind-fire
 -holiday-album-release-date.
Mitchell, Gail. "Maurice White." *Billboard*, July 14, 2001.
Mongues, Miriam Ma'At-Ka-Re. "Reflections on the Role of Feminine Deities and Queens
 in Ancient Kemet." *Journal of Black Studies* 23, no. 4 (June 1993): 561–70.
Montreux Jazz Festival. "About Montreux Jazz Festival." Last modified 2020. https://www
 .montreuxjazzfestival.com/en/festival/about-montreux-jazz-festival/.
"Moonwalk." Earth, Wind & Fire. *Electric Universe*. Columbia. 1983.
Morant, Kesha M. "Language in Action: Funk Music as the Critical Voice of a Post–Civil
 Rights Movement Counterculture." *Journal of Black Studies* 42, no. 1 (January 2011): 71–82.
Morrow, Martha G. "Thousands of Sphinxes." *Science News-Letter* 61, no. 12 (March 22,
 1952): 186–87.
MOTU. "MOTU Artist Spotlight: Mike McKnight." https://motu.com/en-us/news/motu
 -artist-spotlight-mike-mcknight/.
Music Existence. "Legendary Bands Earth, Wind & Fire & Chicago Announce 2016
 Tour." https://musicexistence.com/blog/2015/11/12/legendary-bands-earth-wind-fire
 -and-chicago-announce-2016-tour/.
"My Promise." Earth, Wind & Fire. *Now, Then & Forever*. Legacy. 2013.
"NAACP Image Award Nominations Announced." NAACP. December 13, 2016. https://www
 .naacp.org/latest/naacp-image-award-nominations-announced/.
Nathan, David. "The Eternal Dance of Earth, Wind & Fire." Liner notes, *The Eternal Dance*
 (CD box set). Sony Music Entertainment, 1992.
National Recording Preservation Board. "About This Program." Library of Congress.
 https://www.loc.gov/programs/national-recording-preservation-board/about-this
 -program/?dates=2002-2099.
Neal, Larry. "The Black Arts Movement." *Drama Review: TDR* 12, no. 4 (Summer 1968): 28–39.
Neal, Mark Anthony. "Earth, Wind & Fire: That's the Way of the World: Alive in '75." *PopMatters*,
 May 2, 2002. https://www.popmatters.com/earthwindandfire-thats-2495888774.html.
Neal, Mark Anthony. *What the Music Said: Black Popular Music and Black Popular Culture*.
 New York: Routledge, 1999.
"Never." Earth, Wind & Fire. *The Promise*. Kalimba. 2003.
"Newsline," *Billboard*, July 24, 1999, 76.
NewsOne. "Earth, Wind & Fire Makes History by Becoming the First Black Group
 Inducted into Kennedy Honors." Good News. https://newsone.com/3896681/earth-wind
 -fire-kennedy-honors/.
New York Theatre Guide. "Hot Feet to Open on Broadway." November 13, 2005. https://www
 .newyorktheatreguide.com/news-features/hot-feet-to-open-on-broadway-in-april-2006.
Noted Blogs. "Chicago and Earth, Wind & Fire Summer Tour 2005, Chicago and Earth, Wind
 & Fire Return for a Summer of 2005 Tour." West Coast Music, May 19, 2005. https://noted.
 blogs.com/westcoastmusic/2005/03/chicago_and_ear.html.
"Now, Then & Forever." Discogs. https://www.discogs.com/release/4965222-Earth-Wind
 -Fire-Now-Then-Forever.

Obenga, Theophile. "African Philosophy of the Pharaonic Period." In *Egypt Revisited*, edited by Ivan Van Sertima, 286–324. New Brunswick, NJ: Transaction Publishers, 1999.

O'Connell, Sean J. "Rock & Rule Blu-Ray Release: Debbie Harry and Cheap Trick Vs. Cartoon Guitar Mutants (And Lou Reed)." *LA Weekly*, November 10, 2010. https://www.laweekly.com/rock-rule-blu-ray-release-debbie-harry-and-cheap-trick-vs-cartoon-guitar-mutants-and-lou-reed/.

O'Connor, Morris James. Interview by the author. Atlanta, GA, February 24, 2017.

Official Charts. "Magic Mind." Earth, Wind & Fire. Singles. https://www.officialcharts.com/search/singles/magic%20mind/.

Official Charts. "September 99." Earth, Wind & Fire. Singles. https://www.officialcharts.com/charts/singles-chart/19990725/7501/.

Official Charts. "September 99." Earth, Wind & Fire. Dance Singles. https://www.officialcharts.com/charts/dance-singles-chart/19990725/104/.

"On Your Face." Earth, Wind & Fire. *Spirit*. Columbia. 1976.

"Open Our Eyes." Earth, Wind & Fire. *Open Our Eyes*. Columbia. 1974.

Ousley, Brandon. "Revisiting the Black Pop Liberation of Stevie Wonder and Earth, Wind & Fire, 40 Years Later." *Albumism*, September 26, 2016. https://www.albumism.com/features/revisiting-the-black-pop-liberation-of-stevie-wonder-and-earth-wind-and-fire.

Owusu, Heike. *Egyptian Symbols*. New York: Sterling, 2008.

Palmer, Don. "Earth, Wind & Fire: Heritage, Columbia." *Spin*, April 1990.

Palmer, Robert. "The Pop Life." *The New York Times*, December 7, 1983. https://www.nytimes.com/1983/12/07/arts/the-pop-life-093298.html.

Parham, Marti. "The Timeless Appeal of Earth, Wind & Fire." *Jet*, March 13, 2006.

"Past Winners Database." *Los Angeles Times*. https://archive.ph/20061031061437/http://theenvelope.latimes.com/extras/lostmind/year/1979/1979ama.htm.

People Pill. "Raymond Lee Brown. http://peoplepill.com/people/raymond-lee-brown.

People Pill. "Robert Brookins." https://peoplepill.com/people/robert-brookins/.

People Staff. "Picks and Pans Main: Song." *People*, May 26, 2003. https://people.com/archive/picks-and-pans-main-song-vol-59-no-20/.

People Staff. "Picks and Pans Review: Earth, Wind & Fire." *People*, December 19, 2005. https://people.com/archive/picks-and-pans-review-earth-wind-fire-vol-64-no-25/amp/.

People Staff. "Picks and Pans Review: Heritage." *People*, February 19, 1990. https://people.com/archive/picks-and-pans-review-heritage-vol-33-no-7/amp/.

People Staff. "Picks and Pans Review: Touch the World." *People*, January 11, 1988. https://people.com/archive/picks-and-pans-review-touch-the-world-vol-29-no-1/.

Perry, Elle. "Memphis Music Hall of Fame Announces 2017 Inductees." *Memphis Business Journal*, August 22, 2017. https://www.bizjournals.com/memphis/news/2017/08/22/memphis-music-hall-of-fame-announces-2017.html.

"The Phenix Horns." Jay Purple Wolf Dot Com. http://www.jayepurplewolf.com/EARTHWINDFIRE/thephenixhorns.html.

Pleasure, Morris. Interview by the author. Grayson, GA, March 18, 2017.

"The Pop Life." *New York Times*, October 22, 1976.

Pratt, Chuck. "Earth, Wind & Fire: Faces." *Chicago Sun-Times*, January 29, 1981.

Prince, David J. "Chicago and Earth, Wind & Fire Reunite for Summer Tour." *Billboard*, March 9, 2009. https://www.billboard.com/articles/news/269252/chicago-and-earth-wind-fire-reunite-for-summer-tour.

Proctor, Richard A. "The Pyramid of Cheops." *North American Review* 136, no. 316 (March 1883): 257–69.

"Pure Gold." Earth, Wind & Fire. *Illumination*. Sanctuary. 2005.

"Queen Mums 99th A Family Affair." *South Florida Sun-Sentinel*, August 4, 1999. https://www
.sun-sentinel.com/news/fl-xpm-1999-08-04-9908040260-story.html.

Raboteau, Albert J. *Canaan Land: A Religious History of African Americans*. Oxford: Oxford
University Press, 1999.

Raby, Mark. "Monster Gratitude Earbuds are Endorsed by Earth, Wind & Fire." Slash Gear,
February 5, 2012. https://www.slashgear.com/monster-gratitude-earbuds-are-endorsed
-by-earth-wind-fire-05212119/.

Radke, Brooke. "Q&A: Philip Bailey." *Las Vegas Magazine*, March 15, 2019. https://lasvegasmagazine
.com/interviews/qa/2019/mar/15/philip-bailey-earth-wind-fire-venetian-music/.

Raihala, Ross. "CBS to Air Tribute Concert Tuesday Night with Performances from Beck,
Usher and John Legend." Music. *Grand Forks Herald*, April 17, 2020. https://www
.grandforksherald.com/entertainment/music/5203978-CBS-to-air-Prince-tribute-concert
-Tuesday-night-with-performances-from-Beck-Usher-and-John-Legend/.

Rancke, John. "Earth, Wind & Fire—The White Guy." Coach4ADay, June 12, 2012. https://
coach4aday.wordpress.com/2018/06/12/earthwindfire-sergguitar-june-12/.

Rasmussen, Tracy. "Hitmakers Earth, Wind & Fire and Michael McDonald Co-headline
Reading Concert." *Reading Eagle*, September 11, 2008. http://www2.readingeagle.com/
article.aspx?id=105467.

Ray, Michael, ed. *Disco, Punk, New Wave, Heavy Metal, and More: Music in the 1970s and
1980s*. New York: Rosen Education Service, 2012.

Recording Industry Association of America (RIAA). "Earth, Wind & Fire." Gold & Platinum.
https://www.riaa.com/gold-platinum/?tab_active=default-award&ar=EARTH%2C+
WIND+%26amp%3B+FIRE&ti=.

Reed, James, Sarah Rodman, and Jeffrey Gantz. "Music Gift Guide: Holiday Albums." *Boston
Globe*, November 26, 2014. https://www.bostonglobe.com/arts/music/2014/11/26/holiday
-gift-guide-holiday-cds/TFiN1pCHWeeeluVypWMy4L/story.html.

Reed, Teresa L. *The Holy Profane: Religion in Black Popular Music*. Lexington: University
Press of Kentucky, 2003.

Reeves, Mossi, Jason Heller, et al. "Earth, Wind & Fire: 12 Essential Songs." *Rolling Stone*,
February 5, 2016. https://www.rollingstone.com/music/music-lists/earth-wind-fire-12
-essential-songs-26670/.

"Reggie Young." LA Studio Musicians. https://lastudiomusicians.org/reggie-young.

Remo. "Daniel de los Reyes." https://remo.com/team/member/daniel-reyes-de-los/bio/.

"Revolution." Earth, Wind & Fire. *In the Name of Love*. Rhino. 1997.

Reynolds, Sheldon. Interview by the author. Atlanta, GA, February 11, 2017.

Rock & Roll Hall of Fame. "Earth, Wind & Fire." Inductees. https://www.rockhall.com/
inductees/earth-wind-and-fire.

Rockwell, John. "The Pop Life." *New York Times*, June 8, 1979.

Roquemore, Bobbi. "The Yoga Craze." *Ebony* 56, no. 10 (August 2001), 122–26.

Ruggieri, Melissa. "Trumpet Awards to Honor Media Stars, Humanitarians and Leaders."
Atlanta Journal-Constitution, January 6, 2012. https://web.archive.org/web/20120511015820/
http://www.accessatlanta.com/atlanta-events/trumpet-awards-to-honor-1292222.html.

Ruhlmann, William. "Earth, Wind & Fire: Last Days and Time." Last modified 2020. https://
www.allmusic.com/album/last-days-and-time-mw0000318254.

"Runaway." Wyclef Jean, Earth, Wind & Fire, and The Product G&B. *The Ecleftic: 2 Sides II
a Book*. Columbia. 2000.

"Saturday Nite." Earth, Wind & Fire. *Spirit*. Columbia. 1976.

Savage, Mark. "Earth, Wind & Fire: How Maurice White Made a Force for Positivity." *BBC News*, February 5, 2016. https://www.bbc.com/news/entertainment-arts-35500894.

Schmidt, John R. "The Panic of New Year's Eve 1999." WBEZ Blogs, December 31, 2012. https://www.wbez.org/shows/wbez-blogs/the-panic-of-new-years-eve-1999/1bdbe88d -5562-446d-a833-ee765feb1880

Scott, Linda M. "Images in Advertising: The Need for a Theory of Visual Rhetoric." *Journal of Consumer Research* 21, no. 2 (September 1994): 252–73.

Seikaly, Andrea. "Soul Singer Jessica Cleaves Dies at 65." *Variety*, May 7, 2014. https://variety .com/2014/music/people-news/soul-singer-jessica-cleaves-dies-at-65-1201174485/.

Semmes, Clovis E. "The Dialectics of Cultural Survival and the Community Artist: Phil Cohran and the Affro-Arts Theater." *Journal of Black Studies* 24, no. 4 (June 1994): 447–61.

"Serpentine Fire." Earth, Wind & Fire. *All 'N All*. Columbia. 1977.

"Shining Star." Earth, Wind & Fire. *That's the Way of the World*. Columbia. 1975.

"Show Me the Way." Earth, Wind & Fire. *Illumination*. Sanctuary. 2005.

Sieger, Eric. "Six Major Groups in Area This Week." *Baltimore Sun*, September 23, 1979.

"Sign On." Earth, Wind & Fire. *Now, Then & Forever*. Legacy. 2013.

Simpson, Kyausha. Conversation with the author, June 12, 2021.

Sinclair, Tom. "Earth, Wind & Fire." *Vibe*, September 1993.

"Sing a Song." Earth, Wind & Fire. *Gratitude*. Columbia. 1975.

"Sky." Bill Meyers, featuring Earth, Wind & Fire, Munyungo Jackson, and Sonny Emory. *All Things in Time*. Weberworks. 1996.

Smooth-Jazz.de. "Gary Bias." http://www.smooth-jazz.de/Artists2/Bias.htm.

Smooth-Jazz.de. "Keith Robinson." http://www.smooth-azz.de/Artists1/Robinson.html.

Songfacts. "Songs." Earth, Wind & Fire. Last modified 2020. Accessed February 3, 2020. https://www.songfacts.com/songs/earth-wind-fire.

"Songwriters Hall of Fame 2010 Inductee Announcement." PR Newswire, February 16, 2010. https://www.prnewswire.com/news-releases/songwriters-hall-of-fame-2010-inductee -announcement-84474202.html.

SoulTracks. "World Premiere: Long Lost Maurice White Music Pulled from the Vault." https:// www.soultracks.com/first-listen-maurice-white-couldnt-be-me.

Soul Walking. "Robert Brookins." http://www.soulwalking.co.uk/Robert%20Brookins.html.

"Spend the Night." Earth, Wind & Fire. *Millennium*. Warner Brothers. 1993.

"Spirit." Earth, Wind & Fire. *Spirit*. Columbia. 1976.

"Spotlight." *Billboard*, November 8, 1980.

Stanley, Leo. "Greatest Hits Live." AllMusic. https://www.allmusic.com/album/greatest-hits -live-mw0000080523.

"Star." Earth, Wind & Fire. *I Am*. Columbia. 1979.

Stewart, James B. "Message in the Music: Political Commentary in Black Popular Music from Rhythm and Blues to Early Hip Hop." *Journal of African American History* 90, no. 3 (Summer 2005): 196–225.

St. Nicholas, Randee. "Earth, Wind & Fire, 'Sign On': Exclusive Song Premiere." *Billboard*, August 12, 2013. https://www.billboard.com/articles/news/5645769/earth-wind-fire-sign -on-exclusive-song-premiere.

"Sunday Morning." Earth, Wind & Fire. *Millennium*. Warner Brothers. 1993.

"System of Survival." Earth, Wind & Fire. *Touch the World*. Columbia. 1987.

"That's the Way of the World." Earth, Wind & Fire. *That's the Way of the World*. Columbia. 1975.

"That's the Way of the World." Genius Lyrics. Accessed December 10, 2016. http://genius.com/ Earth-wind-and-fire-thats-the-way-of-the-world-lyrics.

Theakson, Rob. "Earth, Wind & Fire: *The Promise*." AllMusic. https://www.allmusic.com/album/the-promise-mw0000030242.

"Thinking of You." Earth, Wind & Fire. *Touch the World*. Columbia. 1987.

Ticketmaster. "Events." Earth, Wind & Fire Tickets. Accessed September 25, 2020. https://www.ticketmaster.com/earth-wind-fire-tickets/artist/734980.

"Top 30 Dance Chart, October 6, 1999." *RPM Weekly*. Library and Archives Canada. https://www.bac-lac.gc.ca/eng/discover/films-videos-sound-recordings/rpm/Pages/item.aspx?IdNumber=9156&.

Top40-Charts. "Earth, Wind & Fire—Maranatha 26th Anniversary." https://top40-charts.com/news.php?nid=23274&cat=.

Top40-Charts. "Grammy-Winning Jazz Trumpeter Chris Botti Tour to Include Dates with Mythic American Funk Band Earth, Wind & Fire." https://top40-charts.com/news.php?nid=24609&cat=.

"Top Album Picks." *Billboard*, May 26, 1973, 52.

Torpedo Bags. "Bobby Burns, Jr." https://torpedobags.com/artists/bobby-burns-jr/.

"Touch." Earth, Wind & Fire. *Electric Universe*. Columbia. 1983.

Tour Egypt. "The Coffins of Ancient Egypt." Feature Stories. Accessed July 9, 2016. http://www.touregypt.net/featurestories/coffins.htm.

Tour Egypt. "The Meaning of the Great Sphinx of Giza." Feature Stories. Accessed July 20, 2016. http://www.touregypt.net/featurestories/sphinx4.htm.

Travel Agent Central. "Earth, Wind & Fire to Play The Venetian Las Vegas in March 2019." https://www.travelagentcentral.com/hotels/earth-wind-fire-to-play-venetian-march-2019.

Tucker, Ken. "Raise!" *Rolling Stone*, February 4, 1982. https://www.rollingstone.com/music/music-album-reviews/raise-247324/.

"Turn on (The Beat Box)." Earth, Wind & Fire. *The Best of Earth, Wind & Fire, Vol. 2*. Columbia/Legacy. 1988.

"Two Hearts." Earth, Wind & Fire. *Millennium*. Warner Brothers. 1993.

Unterberger, Andrew. "Earth, Wind & Fire's 'September' Hits New Digital Song Sales Peak, Triples in Sept. 21 Streams." *Billboard*, September 30, 2020. https://www.billboard.com/articles/business/chart-beat/9457019/earth-wind-fire-september-streams-sales-charts.

"Vance Taylor." Discogs. https://www.discogs.com/artist/318868-Vance-Taylor.

Van Matre, Lynn. "Who Told Maurice White to Record 'Stand by Me'? It Was . . . A Voice." *Chicago Tribune*, December 1, 1985. Accessed June 30, 2015. http://search.proquest.com.ezproxy.auctr.edu:2051/news/results/.

Van Sertima, Ivan, ed. *Egypt Revisited*. New Brunswick, NJ: Transaction Publishers, 1999.

Various artists. *Interpretations: Celebrating the Music of Earth, Wind & Fire*. Stax. 2007.

Vaughn, Wayne. Interview by the author. Atlanta, GA, March 15, 2017.

Verdine White. "Biography," Last modified 2018. Accessed May 15, 2018. http://www.verdinewhite.com/bio.htm.

Verdine White—Maurice White, A Celebration of Life. YouTube. https://www.youtube.com/watch?v=xhU-T8Be1k4.

Vibrato Grill Jazz. "Myron McKinley." http://www.vibratogrilljazz.com/events/2020/02/20/myron-mckinley.

Villasenor, Dan. "Honoring White." *Valley Star*, May 18, 2005. https://web.archive.org/web/20090601180533/http://www.lavalleystar.com/media/ paper295/news/2005/05/18/News/Maurice.White.Honored-953130.shtml.

Vincent, Rickey. "Funk and Black Protest: Recovering a Post Black Power Era." *Colorlines: Race, Culture, Action* 2, no. 2 (Summer 1999): 38–39.

Vincent, Rickey. *Funk: The Music, the People, and the Rhythm of the One*. New York: St. Martin's Griffin, 1996.

Waller, Don. "Grooving to 30 Years of Earth, Wind & Fire." *Billboard*, July 14, 2001, 30, 45.

Walters, John L. "Sound and Vision." *Eye: The International Review of Graphic Design* (Summer 2010): 16–18, 22, 24–25.

"Wanna Be the Man." Earth, Wind & Fire. *Heritage*. Columbia. 1990.

"Wanna Be With You." Earth, Wind & Fire. *Raise!* ARC/Columbia. 1981.

Ward, Brian. *Just My Soul Responding: Rhythm and Blues, Black Consciousness, and Race Relations*. Berkeley: University of California Press, 1998.

Waring, Charles. "'Love Will Find a Way': 'It's Come Full Circle' Says EW&F's Philip Bailey." Udiscovermusic, June 22, 2019. https://www.udiscovermusic.com/stories/philip-bailey -love-will-find-a-way-album/.

Warner, Craig. "Earth, Wind & Fire: *Open Our Eyes, Spirit*." *Vibe*, March 2001, 200.

We Are the Mutants. "Earth, Wind & Fire Panasonic Boombox Commercials, 1980–1983." June 6, 2017. https://wearethemutants.com/2017/06/06/earth-wind-fire-panasonic-boombox -commercials-1980-1983/.

"Week Ending March 10, 1973." *Cash Box* R&B Top 65. http://cashboxmagazine.com/archives -r/70s_files/19730310R.html.

Wellburn, Ron. "The Black Aesthetic Imperative." In *The Black Aesthetic*, edited by Addison Gayle, 132–49. Garden City, NY: Doubleday, 1971.

Werner, Craig. *A Change Is Gonna Come: Music, Race, and the Soul of America*. Ann Arbor: University of Michigan Press, 2006.

Wesley, Joya. "Barry White, Elements Deliver Soul-Stirring Show." Greensboro *News & Record*. Greenesboro.com, September 19, 1999. https://greensboro.com/barry-white-elements -deliver-soul-stirring-show/article_f5b223c5-3127-5ee4-9024-fb2c8b52222b.html.

"When Love Goes Wrong." Earth, Wind & Fire. *In the Name of Love*. Rhino. 1997.

White, Maurice. Interview in 2009. YouTube. Accessed October 10, 2016. https://www.youtube .com/watch?v=uMf83ofyFUk&t=699s.

White, Maurice. *Manifestation*. SoulMusic. 2019.

White, Maurice, and Herb Powell. *My Life with Earth, Wind & Fire*. New York: HarperCollins Publishers, 2016.

White, Verdine. Interview by the author. Atlanta, GA, March 16, 2017.

"Why?" Earth, Wind & Fire. *The Promise*. Kalimba. 2003.

WhoSampled. "Earth, Wind & Fire (1971)." accessed June 2, 2019. https://www.whosampled .com/album/Earth,-Wind-%26-Fire/Earth,-Wind-%26-Fire/.

Wilkinson, Richard H. *The Complete Gods and Goddesses of Ancient Egypt*. New York: Thames & Hudson, 2003.

Wilkinson, Richard H. *The Complete Temples of Ancient Egypt*. New York: Thames & Hudson, 2000.

Williams, Chris. "That Groove Was Undeniable." *The Atlantic*, November 21, 2012. https://www .theatlantic.com/entertainment/archive/2012/11/that-groove-was-undeniable-making -earth-wind-fires-all-n-all/265323/.

Wise, Mike. "Olympics: Closing Ceremony; Games End with a Mixture of Rowdy Relief and Joy." *New York Times*, February 25, 2002. https://www.nytimes.com/2002/02/25/sports/ olympics-closing-ceremony-games-end-with-a-mixture-of-rowdy-relief-and-joy.html.

Wolf, Linda Star, and Ruby Falconer. *Shamanic Egyptian Astrology*. Rochester, VT: Bear & Company, 2010.

Wood, Mikael. "In Praise of Earth, Wind & Fire, Purveyor of Black Excellence for a Half-Century."
 Los Angeles Times, September 12, 2019. https://www.latimes.com/entertainment-arts/
 music/story/2019-09-12/earth-wind-and-fire-september-hollywood-bowl.
World Book Online. "Abu Simbel, Temples of." Reference Center. Accessed November 1,
 2016. http://www.worldbookonline.com/pl/referencecenter/printarticle?id=ar006180.
Wyatt, Hugh. "Earth, Wind & Fire: Raise!" *New York Daily News*, December 13, 1981. https://
 www.newspapers.com/newspage/486109355/.
Wynn, Ron. *Another Time*. Earth, Wind & Fire. AllMusic. https://www.allmusic.com/album/
 mw0000839159.
"You." Earth, Wind & Fire. *Faces*. Columbia/ARC. 1980.

Index

About the Author

Photo by Russell J. Scott III

Trenton Bailey is a historian from Memphis, Tennessee, who currently resides in Atlanta, Georgia. An honors graduate of Morehouse College, he earned his PhD in Humanities with a concentration in African American Studies from Clark Atlanta University. Bailey has taught courses in world history, African history, and African American history at Clark Atlanta University, Georgia State University, and Morehouse College. He has done extensive research on the history of Morehouse College and has taught a course on the same. Bailey was the coordinator for the Morehouse Oral History Project, assistant coordinator for the Morehouse King Collection, and he continues to produce scholarship about Morehouse College. His research interests include classic funk music history, African American ingenuity, and African civilizations. Bailey is a member of various organizations related to African American life and culture.

CPSIA information can be obtained
at www.ICGtesting.com
Printed in the USA
BVHW051237201122
652364BV00003B/5